Theodore Waddell

Theodore Waddell

DRUMLUMMON INSTITUTE Helena, Montana

Rick Newby

with contributions by the Honorable Pat Williams

Robyn Peterson

Bob Durden

Donna Forbes

Mark Browning

Gordon McConnell

Paul Zarzyski

Scott McMillion

William Hjortsberg

Patrick Zentz

Greg Keeler

Brian Petersen

My Montana

Paintings and Sculpture, 1959–2016

Dedicated to the great state of Montana.
She means so much to us.
And dedicated to my Dad.
I think he would have been proud.

Theodore Waddell

Contents

7 Foreword
by the Honorable Pat Williams

8 Preface
by Robyn Peterson, Executive Director,
Yellowstone Art Museum

11 Memories: An Introduction
by Bob Durden

Theodore Waddell: Life & Work
 by Rick Newby

15 Prelude

23 Chapter One: Early Beginnings

39 Chapter Two: An Education in Art and Life

79 Chapter Three: The Teaching & Sculpting Years

105 Chapter Four: The Ranching & Painting Years

177 Chapter Five: The Consummation of Arrival Is
Identification

258 About the Contributors

262 Author's Acknowledgments

264 Author's Bibliography

269 Publications By and About Theodore Waddell

277 Exhibition History

Theodore Waddell: A Tribute

211 *Angus* Paintings, 1982
by Gordon McConnell

215 Thoughts on Ted Waddell
by Mark Browning

217 A Long Friendship
by Donna Forbes

221 Keeler's Bird
by Greg Keeler

223 Three Friends
by Patrick Zentz

231 Montana '89: Our Place & Time
by Scott McMillion

235 Ted
by William Hjortsberg

239 From Captain Woodrow Call to Captain Kirk to
Captain Teddy-Bob Waddell of the Wild Cowpoke
Wild Brushstroke Wild Cosmos West
by Paul Zarzyski

247 A Painter's Almanac
by Brian Petersen

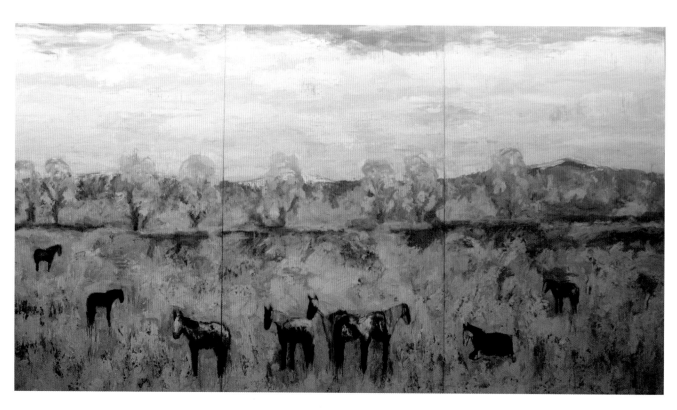

Theodore Waddell. **Argenta Horses,** 2009. Oil and encaustic on canvas,
120 × 218 in. Collection of the artist.

Foreword

Pat Williams

If you can see, look.
If you can look, consider.
 —Book of Exhortations

I write this piece blessed to be a good friend of Ted Waddell's, but cursed to be a poor critic of art. The former pleasures this writing; the latter restrains it—thus my brevity.

Waddell is a Montanan. That birthright grants none of us a status of superiority; rather, the lucky break of opportunity, the chance to consider our extraordinary natural surroundings, to appraise the wild nearby–far away, perched here on a ledge of the big sky.

Ted Waddell takes the land up on its offer to look, and for fifty years his art has, through music, sculpture, and paint, demonstrated his struggle to reflect what he sees. His is a hard-earned triumph of observation, inspection, canvas, and brush.

To me, Ted's work is a conundrum: the alchemy of an artist's sight and sinew capturing for us a glance at Angus through a car's swift window, a moment of moving water seen between blinks, the sky dripping through a sunset. Waddell puts down not images or stills, but rather moments moving in time. His *Firehole River* runs into and through the sky, *Yellowstone Horses* graze through time, Angus bunch up against a hard-moving, bitter wind. Ted freezes our glance, reflects what we noticed while on the move, but looking back it was gone; the view shadowed by a cloud-adjusting light. The sparsity of his painting, what he leaves out as well as what he puts in, restores the memory of our visions.

I prefer to know Ted as a painter who raises a few cattle rather than as a rancher who has a few paintbrushes. Claude Monet was once asked by a friend to show his studio. "My studio," flashed Monet, "I have never had one and personally I don't understand why anybody would want to shut themselves in some room. Maybe for drawing, sure; but not for painting." These Northern Rockies are Waddell's studio. The high plains, mountains, and fields of Angus comprise his subjects.

We are fortunate for Ted's perseverance, trying and then trying again through five decades, moving on until he finds it. Laying paint on the canvas in great waterfall sweeps or more gently as brush strokes creating cattle and clouds, Ted's art, like the land, is interesting, challenging, and those of us fortunate enough to know him and his work are better for it.

Preface

Robyn G. Peterson, Executive Director, Yellowstone Art Museum

Among those whose words follow, I claim the shortest personal association with Ted Waddell. The process of becoming acquainted with an artist primarily through his art has been more acute for me than for this volume's other contributors. My introduction to Ted Waddell occurred synchronously with my arrival to live in Montana in 2006; thus, my awareness of and appreciation for the multi-faceted qualities of both this region and its leading painter have grown on parallel tracks.

Like all deeply interesting individuals, Waddell embodies many paradoxes. His life is a chronicle of accident and intent, rebellion and respect, opportunity and hardship, humor and gravity, intelligence and intuition. He valorizes the nurturing land without sentimentality. He paints as if with the very soil and atmosphere that surround him. He paints generously and cultivates a generosity of spirit. From the raw material presented to him—the quiet, sinewy land, the aromatic versatility of oil paint, and mentors such as Isabelle Johnson—Waddell has forged an aesthetic that is distinctively his own while simultaneously belonging to every one of us.

At this juncture in Ted Waddell's life, he is reflecting upon the journeys his life has taken. He freely confesses missed opportunities (such as his time in New York when "the Poindexter Gallery was right around the corner but I was just a dumb kid and never knew it was there!") and good instincts ("I knew enough to get excited about Motherwell, Kline, and the other Abstract Expressionists."). He credits the accidents of life (such as the failure of a large delivery of his favorite paint to arrive in South Africa where he worked for an extended period) with leading to new approaches borne of circumstance ("I learned about washes; the work became more fluid."). He gives credit to those who have greased his skids ("my career has been promoted by my dealers."). He recognizes his own qualities and limitations ("I'm very social, but I'm not communal."). He values very highly the decades-long relationships he has had with other artists of his generation.

Is the wellspring of ideas slowing as the decades roll by? Not a bit. Ted Waddell paints with a fervor and energy that many younger artists would find enviable. "I have never had 'painter's block'," he states. However, after a life of ranching and success that has made it possible for him to hire others to attend to ranch tasks he once undertook himself, he is discovering that newfound opportunities to paint in the spring and summer seasons present a special aesthetic challenge: "The only thing that scares me is green." It is a confession that reveals a willingness to test new waters and a recognition that much more lies ahead. This pairing of life-seizing eagerness with apprehension about something new repeats the pattern of fertile paradoxes that mark Waddell's entire life and career.

The essayists who have contributed to this volume place Waddell's work within its many contexts. Here, the reader will find more than has ever previously been pub-

lished about Waddell's deep familial roots in the region. The authors analyze the formal significance of his work within recent American art history, and they discuss the subject matter that is so central to most viewers' understanding of his paintings. They analyze the influences, the mentors, and the geography that ground everything for this artist. Ultimately, the story that unfolds is a chronicle of one artist's effort to carve from his artistic heritage a distinctive and contemporary vision that did not deny that heritage. In his foreword, Pat Williams mentions the importance of what Waddell chooses to omit. This goes to the heart of Waddell's achievement; that is, the seemingly impossible task of taking stock of what lay behind him historically and choosing a divergent path without thereby repudiating his forebears. In the end, Waddell fairly skipped along that tightrope . . . and isn't it a hallmark of a leader that he makes a formidable task seem easy? Waddell faced the challenge of infusing the poetic into a subject he loved while skillfully dodging the saccharine and the mythologizing. He assessed the work of his peers and the trends of his own time and distilled their useful essence.

It *is* possible to cherish a place, time, emotion, or memory without sentimentality, and through Waddell's paintings, we see how this can be done with both truth and power. Thank you, Ted.

Theodore Waddell. *Cloud Landscape #5*, 1986. Oil on canvas, 90 × 72 in.
Private collection.

Memories: An Introduction

Bob Durden

This volume, like any good book, is a source of memories. For family, friends, and aficionados of Theodore Waddell's work, it will serve as a reminder of what may already be known and what may have been forgotten. For the newcomer, the book will serve as a comprehensive narrative and examination of the same. And for the future reader, it will document knowledge and become a resource for what might otherwise become forgotten over time.

Though this is not a catalogue raisonné (that would require a hefty reading table to support it, due to the artist's prolific output over the course of nearly six decades), it is loaded with information about the origins of the artist's family, early influences, and the artistic journey to the present. Rick Newby's recounting of all of this is precise and engaging. There are new truths to be found in these pages, which are supported with beautiful illustrations of work that ranges from the sublime to the epic and the experimental to the fully resolved mature works. The memories included in these pages are as rich and marked as the artist's fluid oil and encaustic paintings illustrated herein. Consider *Cloud Landscape #5*, 1986, its canvas burdened with a gusto of heavy impasto, furrowed by brush and finger, and peaked by palette knife. It is difficult to imagine from the best illustration how glorious it is to view such a work and imagine the application of paint, the motion of the artist working the medium, and the absorbing smell of oil and thinners lingering in the air

throughout the duration of the painting's creation. However, the marks that prevail resonate with an abundance, tenacity, and acuity that echoes the life events retold by Newby and other contributors to this book.

To understand an artist's work it is presumed one may know it better armed with knowledge about the artist's origins, influences, and philosophy. This is true to the extent that this knowledge provides a wider contextual framework, rounding out the intuitive perceptual response that occurs when viewing actual work. Knowledge shifts perception, enriches it, and broadens it. In the following pages, Newby provides insights about family origins, the artist's relationship with his family and upbringing in mostly rural and urban settings, degrees of separation that link Waddell to C. M. Russell and Will James, Waddell's education, and his lasting friendships. Like anyone's life, Waddell's has been full of sadness and elation. His work represents it all. The pain of, as he puts it, "the death toll of ranching" lies quietly and faithfully in the background in preference to the artist's reflection on the majesty of the world surrounding him. He has represented the beauty of the West in a singular fashion that has become undeniably his own.

When thinking about one's first impressions of Waddell's work devoid of any prior knowledge, this writer finds it difficult to remember that first instance of discovering his work. Nearly four decades have passed since that occurred. However, the recollection of meeting

"Ted" for the first time continues to linger as a cherished memory—meeting as a young grad student among his professors, peers, and a boisterous, frank, and charming visiting artist, Waddell. Observing his growth from a professional perspective over twenty-five years has brought its own rewards and personal knowledge. Providing stewardship for his work for nearly sixteen years has been greater still. And of course, through it all, the work has evolved—reflecting Waddell's continuing maturation as an artist. That maturation is evident in the beautiful illustrations that follow. Marry these with the impending words from some of those who have known him best and the reader will glean a deeper understanding of the work of one of the American West's best known painters, nay artist. Though most know him for his painting, Theodore Waddell is a studied and practiced printmaker, sculptor, and illustrator—he has collaborated with his wife, Lynn Campion, on three books, with a fourth in the works. As a testament to his success and endurance, Waddell received the Montana Governor's Arts Award in 2015, not the least of his numerous accolades and awards.

In the pages that follow, Newby's words are reinforced by recountings by Mark Browning, former Director of Custer County Art Museum, Miles City, Montana; Donna M. Forbes, former and long-serving executive director of the Yellowstone Art Center (now Museum), Billings, Montana; William Hjortsberg, author; Greg Keeler, performer and professor of English; Gordon McConnell, former assistant director and senior curator at the Yellowstone Art Center and working artist; Scott McMillion, journalist and editor; the Honorable Pat Williams, former congressman from Montana; Paul Zarzyski, poet; Patrick Zentz, former curator of education at the Yellowstone Art Center and working artist; and writer Brian Petersen, another long-time friend and admirer. Their accounts—layering this book with broad memories—are rich with a variety of perspectives that range from visionary to wry to witty, with a bit of hyperbole and rural wisdom mixed in to keep things interesting.

As a United States congressman, representative of the grand state of Montana, the Honorable Pat Williams served his state and the country for nine terms, from 1979 to 1997. During his service, he was a staunch supporter and defender of the National Endowment for the Arts and an advocate for the arts in general. His foreword beautifully captures his association with the artist and the essence of Waddell's work.

Theodore Waddell has established his career broadly throughout the nation, exhibiting in an abundance of museums and galleries and represented in a plethora of private and public collections. But he has never forgotten his roots in Montana and the West, where he chooses to remain—splitting his time between studios in Montana and Idaho. While exhibiting internationally, Waddell remains committed to the region where he cut his teeth. As a testament to that, four former Montana museum professionals have shared their accounts of "Ted," whose career evolved right alongside the development of the state's cultural institutions. Donna M. Forbes was the fourth in a succession of seven executive directors of the Yellowstone Art Museum who have known and supported Waddell's work throughout the years. Forbes knows him and his work perhaps better than anyone, and she recounts pivotal moments in the artist's career. Gordon McConnell, another member of the Art Center staff and one of the most notable and long-tenured writ-

ers on the visual arts in Montana, provides a creative spin on memory, stepping back in time to write a review of an exhibition of Waddell's *Angus* paintings in 1982—the same year in which the two met. His words take us back in time to joint exhibitions that took place at a small local art gallery and the Billings Livestock Commission Company. His inventive review reminds us of Waddell's tenacious, fearless, and often wry attitudes about exhibiting his work. Waddell has exhibited widely, from unusual venues such as taverns to some of the best museums in the country. McConnell's essay reminds us of the connection between Waddell's paintings and his life managing working ranches. We can nearly smell the grit of the stockyard as well as the oil from the paintings as we read along. Patrick Zentz, another former Art Center employee, recounts aspects of Waddell's teaching and ranching days and of the friendships that formed along the way. A final museum-professional account comes from Mark Browning, who knows the difficulties that lie on both sides of the rural museum doorstep and acknowledges Waddell's mid-career years and the artist's involvement with and commitment to then-fledgling art centers and museums that were flung far apart across the vastness of Montana.

Rounding out the book are essays by performers and writers who literally know Waddell from another stage—the creative collaborations that have occurred over the years. Greg Keeler's humorous and cheeky essay reveals Waddell's rebellious and playful side and reminds us of the sassy content in the artist's sculptural works, and of the artistic gatherings that played out around the artist's Ryegate, Montana, ranch. Scott McMillion's and William Hjortsberg's essays capture the essence of those gatherings and record the who's who in the art and literary world who gathered there to exchange ideas, perform, create, imbibe, and gorge themselves on Rocky Mountain oysters. Oh the days, when creative minds merged to share intellect and humor while forming lasting friendships—the kind that sustain one's youthfulness and imagination, and from which mischievous tales can be told. Rounding out this entire affair are the raucous and wry words of poet, friend, and Waddell collaborator Paul Zarzyski. The reader will savor the words that come before his; but Paul provides the dessert after a full meal, and perhaps the cigar and nightcap. And finally, Brian Petersen's journaled account of a three-day trip with Waddell across south-central Montana to recount days of yore is peppered with the flavor of old friends and places that is the seasoning of a life's rich landscape rivaling the artist's own work. And though Waddell is well traveled and known in far-flung places, Brian's writing reminds us that "Ted" remains Montana's son.

Memories—life is richer indeed from better knowing the life and work of Theodore Waddell. As a result, one cannot cross the Northern Plains and Rocky Mountain regions without recognizing the landscape he has portrayed. His work is transformative and leads us to rejoice: "Aha, I see the world in the way he sees it." But only for having known his paintings with their broad renditions of skies enhanced in scale by the domesticated and wild fauna that inhabit them are we able to reimagine the inspirational views that surround us. Readers no doubt have their own memories to recall or new ones to form as they reexamine existing works and look forward to Waddell's continued contributions to the canon of American art.

Rick Newby

Theodore Waddell *Life & Work*

Prelude

The extent of this country [Montana] *is great. Its rolling table-lands are so broad; its fertile valleys so many and wide; its mountain wildernesses so vast, that what little history there is, is hardly enough to go around. . . . But on the other hand the geographical conditions are such that there are a few places towards which everything seems to converge.*

—[Hans] Peter Koch, "Historical Sketch," 1896[1]

The Danish-born pioneer Hans Peter Koch was talking about mountain passes and natural highways in the vastness of the Montana landscape, but his notion of a "few places towards which everything seems to converge" might easily be applied to our artistic geography, to places claimed by certain artists who have helped us to perceive these special places anew—with truly fresh eyes— through acts of the imagination driven by passionate attention, unswerving commitment to individual vision, and consummate artistry.

Painter and sculptor Theodore Waddell, who makes his home in both Montana and Idaho, is one of those remarkable artists. During a distinguished career spanning more than fifty years, Waddell has definitively shaped, altered, and expanded the ways in which we experience the high plains and river bottoms of central Montana, the rugged country that straddles the Idaho/Montana border, and most recently, the varied topography surrounding his home near Sun Valley.

A working rancher for more than twenty years, Waddell's ongoing engagement with animals has been central to his art, and his "landscapes with animals" stand as his central achievement. Often his paintings, drawings, and prints take their titles from favorite places (and animals) within his chosen landscapes: *Alzada Angus, Rock Springs Herefords, Springdale Sheep #2, Pryor Rider Drawing, Twin Bridges Horses, Camas Prairie Reds*. This poetry of place—and Waddell's love of the ranching life—resonate throughout his oeuvre.

Theodore Waddell. **Montana**, 2000 [detail]. Oil and encaustic on canvas, 120 × 216 in. Yellowstone Art Museum Permanent Collection, Billings, MT. Gift of John W. and Carol L. H. Green. 2012.04.01.

15

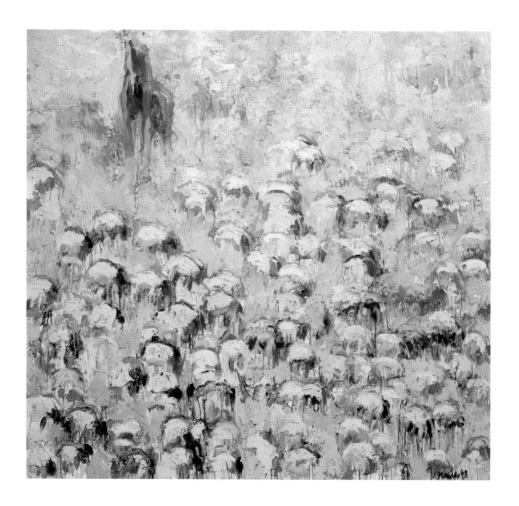

And yet the artist Theodore Waddell, and the work he creates, are not easily categorized. In 1992, during an exhibition of Waddell's work at New York's Bernice Steinbaum Gallery, the gallerist asked the artist if, through his paintings, she "was being invaded by the myth of the West." Waddell countered with great firmness, "I don't know that you could call it a myth,"[2] and he went on to speak about the actual animals with whom he lived, not as mythic beings but as individual creatures with distinct personalities. Writer Lee McCann has noted, "An encounter with the open range, depicted in Waddell's work, goes beyond . . . nostalgia [for] the past to ponder the ominous forces inherent in the physical, natural environment—forces that capture, envelop, and interpret both land and animal."[3]

On another occasion, Waddell asserted that he is neither a realist nor a traditional Western artist, because the realist "opts for the status quo" and the Western artist "opts for nostalgia."[4] In his own estimation, Waddell does "not fit" the usual categories: "The traditional artists don't like me because I'm not realistic enough, and the contemporary artists don't like my work because I'm too realistic." Instead, as he once wrote of the great British iconoclast Francis Bacon (who also did "not fit"), Waddell makes a "great case for

figuration and individuality"[5] within the tradition of modernism. And yet, though much of his work verges on the abstract, he quite legitimately can claim Charles Marion Russell as one of his "cultural antecedents."[6]

In a 2010 interview, Waddell discussed his relationship with Western art:

> I feel like I'm very much a part of a tradition of [C. M.] Russell, [Frederic] Remington, [Maynard] Dixon, and many others. I'm just one generation removed. Russell died in '26 and I was born in '41. It's a continuum. It is changing. . . . I'm just glad to be part of the tradition—it's a tremendous honor.[7]

Certainly, while he stands in the Western tradition, Waddell is one of those artists who has truly driven change within the field. As David G. Turner, former director of the Museum of Fine Arts, Santa Fe, notes: "For an artist who lives among what may be the greatest horizon line ever, separating the big sky from the wandering plains, there is little evidence of this physical phenomenon in [Waddell's] paintings. Most of his work deals with the figure/ground relationship that keeps him aligned with those painters interested in a non-objective style."[8] Waddell's treatment of depth and distance often seems to draw more inspiration from Asian aesthetics than it does from the techniques of one-point Western perspective.

Waddell's modernist influences range widely: a hardy band of early Montana modernists, particularly Isabelle Johnson, his first and most important teacher; the faculties of the Brooklyn Museum Art School and Wayne State University during the 1960s; the minimalism of Donald Judd; debates over "Objecthood" and the future of painting; Robert Motherwell's abstract expressionism; expressionist figuration as embodied in the paintings of Robert De Niro Sr.; the example (as artist and human being) of Montana's ceramic revolutionary Rudy Autio; the music of jazz artists like Thelonious Monk, Stan Getz, and Bud Shank; the Poindexter collections of modernist American painters at two Montana museums; the abstract qualities of blizzards on the Northern Plains. . . .

In part because he has so skillfully bridged the divide between traditional Western art and the modern and contemporary art of the West—while maintaining his fierce individuality—Theodore Waddell has had an impact on both worlds. As a role model, he has proven to younger generations of modern and postmodern artists that it is possible to live, work, and prosper in the Northern Rockies region, while maintaining an uncompromising modernist vision.

At the same time, many of the curators at museums that focus on the art of the West are pleased to claim Theodore Waddell as a key artist linking the Western tradition to modernism. For example, in a recent book from Indianapolis's Eiteljorg Museum of American Indians and Western Art, curator James Nottage notes that the 1989 exhibition, *New Art of the West*, marked the museum's first venture into the field of contemporary Western

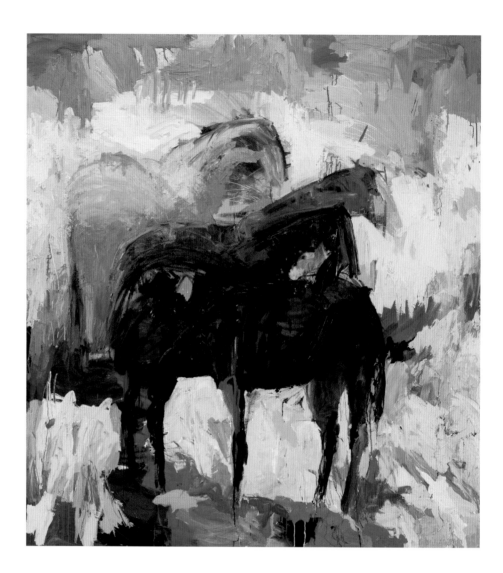

Theodore Waddell. *Ryegate Horses #2*, 1990. Oil on canvas, 78 × 78 in. Collection of the Eiteljorg Museum of American Indian and Western Art, Indianapolis, IN.

art. Out of that exhibition, the Eiteljorg picked Theodore Waddell's *Ryegate Horses #2* for its very first purchase of a contemporary work, launching a new collecting direction that has resulted in a highly "creative and aggressive contemporary art program"[9] within a museum once wholly identified with works by traditional Native artists and such Western luminaries as Charles Russell, Frederic Remington, Henry Farny, Alfred Jacob Miller, Albert Bierstadt, Joseph Henry Sharp, and Nicolai Fechin.

In 2012, the Denver Art Museum's Petrie Institute of Western American Art published the catalog *Elevating Western American Art: Developing an Institute in the Cultural Capital of the Rockies*. With the intent of "further expanding the canon of western art,"[10] *Elevating Western American Art* features thirty wide-ranging essays, including several on modern and contemporary artists working in the West (Waddell's fellow Montanan Deborah Butterfield; Robert Smithson of *Spiral Jetty* fame; environmental photographer David Maisel; Western critical realists like Karen Kitchel, Chuck Forsman, and

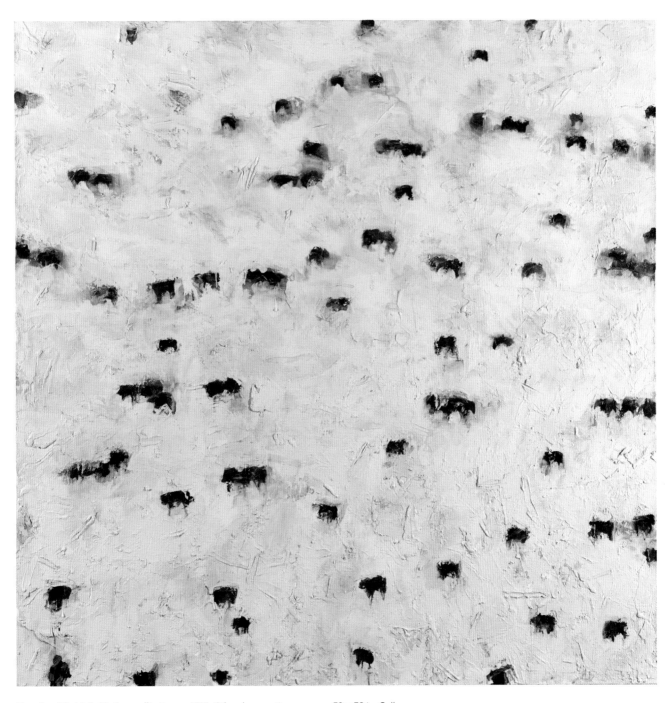

Theodore Waddell. *Motherwell's Angus*, 1994. Oil and encaustic on canvas, 72 × 72 in. Collection of the Denver Art Museum, Denver, CO. Gift of Barbara J. and James R. Hartley. 1999.84.

Don Stinson; and Christo and Jeanne-Claude and their *Valley Curtain*, Rifle, Colorado, 1970–1972).

Among these essays can be found Dean Sobel's "*Motherwell's Angus* by Theodore Waddell: Whose Cattle Are These?" Formerly director of the Aspen Art Museum and past chief curator at the Milwaukee Art Museum, Sobel currently directs Denver's new Clyfford Still Museum, devoted to the works of Still, a first-generation abstract expressionist, North Dakota–born, who spent his formative years on the West Coast. Specializing in twentieth-century art, Dean Sobel brings Waddell's accomplishment into sharp focus. He writes:

> [Waddell] slowly developed a highly personal approach to painting in which the process, gesture, and touch of abstract expressionism were joined with his—and the art world's—new tolerance for images. . . . Waddell became increasingly drawn to the qualities and sensations (and scale) of the American western landscape, which he knew he could make uniquely his own. . . . he would establish a dialogue with not only abstract expressionist artists, but equally with the great artists who define the art

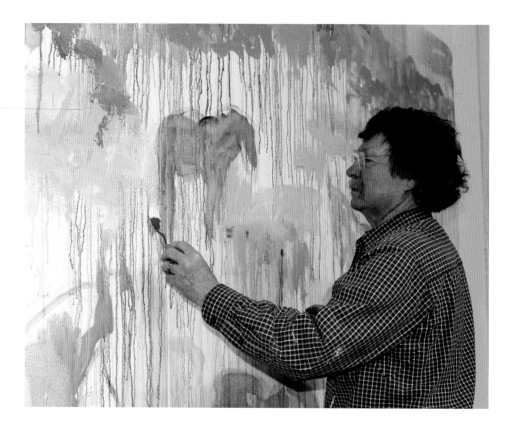

Theodore Waddell at work. Lynn Campion, photographer. Waddell Family Collection.

history of the region, figures like Albert Bierstadt, Frederic Remington, and Charles Russell, whose subject matter and spirit he would reinterpret in contemporary terms.[11]

Of course, paintings like *Ryegate Horses #2* and *Motherwell's Angus* are important, not just because they bring together disparate traditions, but because they stand as emotionally and sensuously resonant works of art that speak with great eloquence of landscapes and animals, life and death, austerity and abundance. They possess, in the words of *Seattle Times* critic Robin Updike, an "immense, poetic dignity."[12]

How did this native-born Montanan come to be a leading figure in the art of the West, bringing the lessons of modernism together with a clear-eyed, deeply felt, and nostalgia-free vision of the high plains and Northern Rockies today? What influences, ambitions, fateful choices, hard work, and serendipities led Theodore Waddell to his place in the world today, still innovating, still immensely productive, a major American artist at the peak of his powers? This book aims to provide, through an in-depth exploration of Theodore Waddell's life and work, "a sense," as art historian Gabriele Guercio puts it, of his "humanity, singularity, and identity in the making."[13]

1 [Hans] Peter Koch, "Historical Sketch: Bozeman, Gallatin Valley and Bozeman Pass," in *Contributions to the Montana Historical Society*, vol. 2 (Helena, MT: Rocky Mountain Publishing Co., 1896), 126–127. To view an e-book of this volume, visit https://play.google.com/store/books/details?id=wrluAAAAMAAJ.

2 Bernice Steinbaum, *Western Mythology Paintings: Theodore Waddell*, video, narration and interview with Theodore Waddell, Bernice Steinbaum Gallery, New York, New York, 1992.

3 Lee McCann, "De-Romanticizing the West with Artist Ted Waddell," *The Tributary*, Bozeman, MT, November 1994, 4.

4 Theodore Waddell, interview by Rick Newby, Hailey, Idaho, March 14, 2013. Hereafter cited as Waddell, Newby interview.

5 Waddell, Newby interview; Theodore Waddell, unpublished journal, entry ca. 1989, in artist's possession. Hereafter cited as Waddell, unpublished journal.

6 Theodore Waddell, quoted in "Ted Waddell: A History of Modernist Marks," *Western Art Collector*, November 2007, 92.

7 Theodore Waddell, interview by Dana Joseph, *Cowboys & Indians*, September 2010, http://www.cowboysindians.com/Cowboys -Indians/September-2010/Theodore-Waddell. Hereafter cited as Waddell, Joseph interview, *Cowboys & Indians*.

8 David G. Turner, introduction to *Theodore Waddell: Seasons of Change* (Indianapolis, IN: Eiteljorg Museum of American Indians and Western Art, 1992).

9 James H. Nottage, "Art Inclusive: Evolving Collections of the Eiteljorg Museum," in *Frontiers and Beyond: Visions and Collections from the Eiteljorg Museum of American Indians and Western Art* (Indianapolis, IN: Eiteljorg Museum of American Indians and Western Art, 2005), 27.

10 Thomas Brent Smith, foreword and acknowledgments, *Elevating Western American Art: Developing an Institute in the Cultural Capital of the Rockies*, ed. Thomas Brent Smith (Denver, CO: Denver Art Museum, 2012), 13.

11 Dean Sobel, "*Motherwell's Angus* by Theodore Waddell: Whose Cattle Are These?" in *Elevating Western American Art*, ed. Thomas Brent Smith (Denver, CO: Denver Art Museum, 2012), 170–171.

12 Robin Updike, "Waddell's Animal Paintings: An Immense, Poetic Dignity," *Seattle Times*, March 1995.

13 Gabriele Guercio, *Art as Existence: The Artist's Monograph and Its Project* (Cambridge: The MIT Press, 2006), 2.

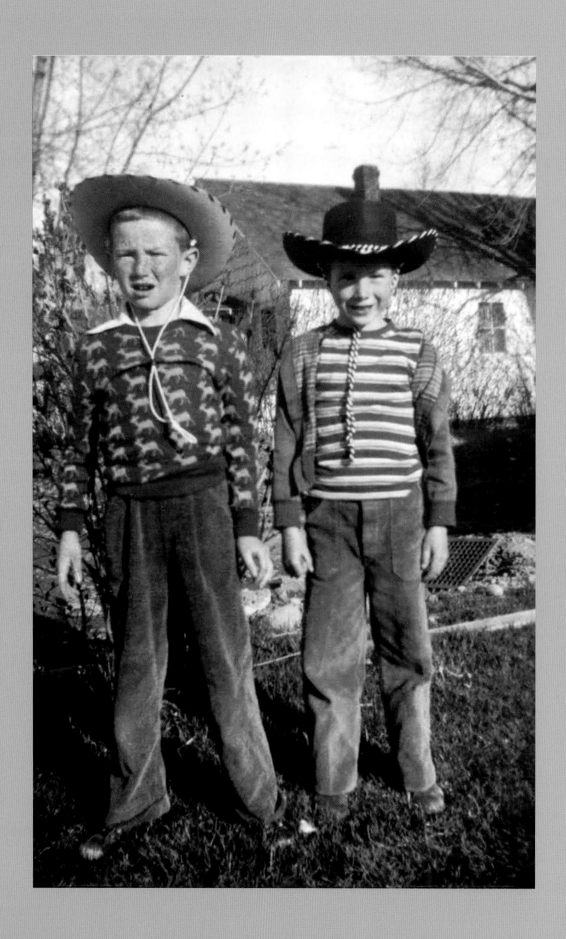

Early Beginnings

*The first time I remember our house I was about three or four and ran across the deep grass
. . . to the old-fashioned front porch. . . . The yard was full of apple trees [with] one side
lined with tall slender elms. Some of the apple trees had low branches, and we used to make
believe they were horses and built saddles from ropes and blankets.*

—Theodore Waddell[1]

You know, within every story there is a grain of truth—if you can find it.

—Theodore Waddell[2]

Born October 6, 1941, in the south-central Montana metropolis of Billings and raised in
the nearby railroading town of Laurel, Theodore Waddell grew up in a working-class
household. His mother, Lillian Katherine "Katie" Kass (1919–2007), was a native of Miles
City and raised in Laurel, and his father, Teddy (1904–1976), spent his early years at
Stanford, in Montana's Judith Basin County, a place fabled for its vast cattle herds and its
resident cowboy artist, Charles Marion Russell. As historians Michael Malone, Richard
Roeder, and William Lang have written, "most inviting of all [Montana's valleys] to the
stockmen was the luxuriant Judith Basin, north of the upper Musselshell."[3]

In a circa 1885 photograph of the cowboys who worked for the Judith Basin Cat-
tle Pool, Theodore Waddell's grandfather Thomas Jefferson Waddell stands just a few
feet away from a seated Charlie Russell.[4] The next year Russell painted *The Last of the
5,000* or *Waiting for a Chinook*, the little watercolor that first established his reputation
as a master chronicler of the West. This, of course, was the terrible winter of 1886–1887,
during which Montana's ranchers lost between 50 and 90 percent of their livestock.[5]

A profile of Thomas J. Waddell, appearing in the July 2, 1931, *Three Forks News*, noted:
"Mr. Waddell is a veritable mine of information concerning events in the early days of
Montana. He was intimately acquainted with Charles Russell, the artist. He shod Rus-
sell's pinto 'Monty' the first time he was ever shod."[6] Monty was the first horse Charlie

Two young cowboys: Ted Waddell
(right) and his neighbor, Brent
Noel. Waddell recalls, "We had cap
guns and cowboy hats. We made
make-believe saddles and horses
using the thick limbs of our apple
trees. We played cowboys and Indi-
ans. We made bows and arrows out
of willows, using fishing line to string
the bow." Waddell Family Collection.

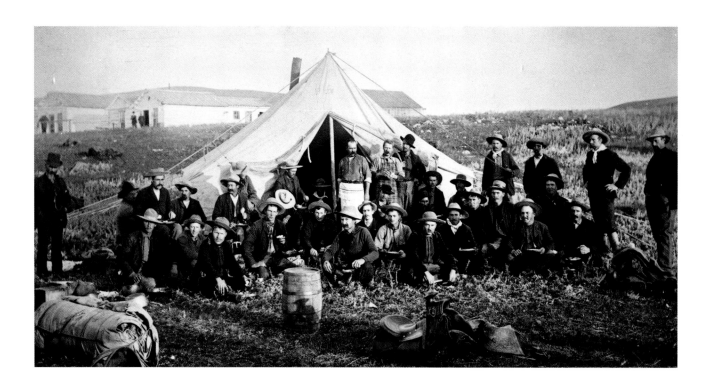

Russell bought in Montana, and horse and man were inseparable for twenty-five years. Russell immortalized the bay pinto—raised by the Crow Indians as a buffalo horse—in his story, "The Ghost Horse."[7]) Thomas Waddell's obituary also reported: "A personal friend of many noted Montana pioneers, Mr. Waddell left several interesting biographical sketches of the early West."[8]

Thomas Jefferson Waddell was, in fact, an important Montana storyteller. Many of his writings chronicling the early days were published in the Stanford *Democrat News* and *Judith Basin Star*, and Marguerite Greenfield, Helena entrepreneur, writer, and historian, had the foresight to collect Thomas's writings, now preserved in the Montana Historical Society Archives.[10]

During the Great Depression, some of his stories were also collected by the Montana Writers' Project of the Works Progress Administration, and in fact, the following story opens, and sets the yarn-spinning tone for, the anthology *An Ornery Bunch: Tales and Anecdotes Collected by the W.P.A. Montana Writers' Project*:

In the winter of '82–'83, the writer and two brothers (Walter and Ed), together with John S. Barnes and his wife, established a camp in the Snowy Mountains between Buffalo and Rock Creek, and engaged in getting out poles and house logs and shaving shingles for our needs on the homesteads.

We put in the long evenings telling yarns, singing, playing cards, and smoking, of course. We had built our cabin under some big red fir trees in the bottom of a deep

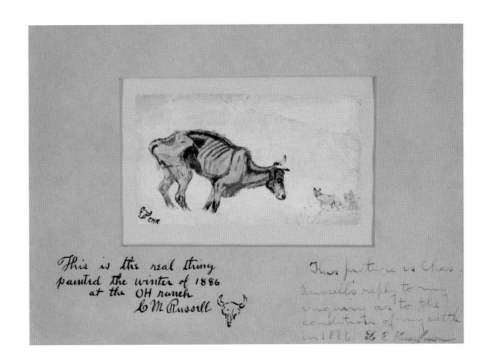

canyon. We had a heavy galvanized wire for clothesline running from a corner of the cabin to a big green tree, and it is owing to this fact, no doubt, which caused the phenomena of which I write to occur. I wondered for years how it possibly could transpire, but the great developments along the lines mentioned—radio, wireless, etc.—my readers will no doubt believe me when I state that the weather turning warmer and the frost beginning to thaw out, we were awakened during the night by what at first sounded like a flock of drunken magpies holding a farmers' convention, but which proved to be a rehash of our many winter evenings' songs and stories thawing out.[11]

As a conscious shaper of the folklore and history of frontier Montana, Thomas Waddell involved himself in an emerging cultural life. A story in the Stanford *Democrat News* recounts T. J. Waddell's impressions of a

literary society organized at that time [around 1899] . . . by Professor B. F. Gordon, then principal of the Buffalo schools [and the man who collected the Thomas Waddell story above for the Montana Writers' Project]. . . . Instructive papers were read, lectures given and debates were held, in addition to frequent dances which *were* dances he said, all of which packed the little log building every time the word went out.

Mr. Waddell says that he wrote weekly criticisms of the preceding programs, calling his paper the 'Babbler' and himself, the editor and publisher, and that he often found himself in difficulties because of his too frank and sometimes caustic remarks about the society's activities and the ideas submitted by some of the members.[12]

Theodore Waddell's grandfather, Montana pioneer blacksmith Thomas Jefferson Waddell late in life. Waddell Family Collection.

Drawing of the Waddell Manure Spreader or more politely, Fertilizer Distributor, from Thomas J. Waddell's U.S. Patent No. 701,778, dated June 3, 1902. U.S. Patent Office.

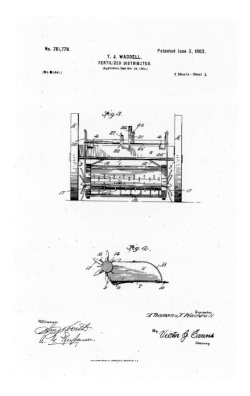

Clearly Thomas Waddell enjoyed participating in the fledgling literary society, but he also enjoyed deflating some of his friends' pretensions—an antic spirit shared by his grandson Theodore when, in the late decades of the 20th century, he entitled some of his mixed-media sculptures *Horse Shit Mallard*, *Trophy #6*, *Cowman*, and *Writer Trophy* in the *Hallowed Absurdities* series. This species of humor, common in the rural West, is akin to that embodied in Charlie Russell's own wry tales about his fellow cowpunchers, involving—in the words of folklorist Raphael Cristy—"outrageous exaggerations" and "good-natured insults."[13]

Born in Illinois in 1855, Thomas Jefferson Waddell came to Montana in 1878 after working as a cattle raiser, miner, and blacksmith in Kansas and Utah. He settled at Old Philbrook and later Stanford in the Judith Basin and became a prominent citizen, raising oats and hay and serving as both postmaster and justice of the peace. It was, however, as a blacksmith that Tom Waddell achieved his greatest success, and Helen Fitzgerald Sanders reported in her 1913 *History of Montana* that Waddell made blacksmithing the "basis of a substantial business." Sanders added, "He is the inventor of the Waddell manure spreader, a machine which is found on many farms of Montana, and the manufacture of which has been a considerable factor in Mr. Waddell's business."[14] Another early Montana history noted that Tom Waddell "is a man of great energy and capacity for work, has mechanical ability and inventive powers, and rejoices in his power to conceive and to execute"—all qualities inherited by his grandson, Theodore.[15]

Because his grandfather started his family relatively late, marrying Emma Montgomery in 1887 when he was thirty-two and then siring several children (Teddy was Tom and Emma's third child, born in 1904 when Tom was almost 50), Theodore Waddell has a more direct line to the glory days of open-range cattle raising—and to Russell, one of the preeminent interpreters of those days—than most members of his generation. Thomas Jefferson Waddell died in 1943 at the age of eighty-seven, when Theodore was two years old, and Ted never met his grandfather. (Thomas did acknowledge Ted's birth, writing to his friend Marguerite Greenfield in 1941, "Another T. J. Waddell was born Oct 6th My 85th birthday. . . . [to] My youngest son Teddy of Laurel Mont."[16] Family lore had it that Thomas J. knew Charlie Russell, but until recently, Theodore was skeptical about a real friendship between the blacksmith and the cowboy artist, noting that so, too, did "many others . . . claim to know Russell."[17]

Despite the younger Waddell's healthy skepticism, it is clear that his grandfather worked alongside Russell and knew him well. And Thomas J. did know the life of open-range ranching in one of its legendary places, where as many as 70,000 cattle grazed together, with forty different outfits collaborating in the Judith Basin Pool. This familial tie to ranching's heyday, it can be argued, must have had a subconscious impact on Theodore Waddell's choice of vocations, at least as rancher and quite possibly as artist of the ranching life.

Waddell's parents, of course, had a more direct influence. From his mother, young Waddell (affectionately known as Butch) learned stubbornness, an essential quality for any budding artist, and he notes that she always supported his art, though "she never ever understood it."[18] His father, on the other hand, actively supported the young Waddell's

Theodore Waddell's parents, Katie and Teddy Waddell, at their home in the small railroading town of Laurel, 1961. Waddell Family Collection.

Teddy Waddell, Theodore Waddell's father, as a young man. An enormously supportive father, Teddy introduced his son to the magic of oil paint. Waddell Family Collection.

pursuit of an artistic life. Teddy Waddell sounds like an extraordinary father, creative, resourceful, eager to share his enthusiasms. Waddell remembers:

> My Dad was a painter of boxcars. He worked in the Northern Pacific [Railway] shops. I used to walk through the round house where they worked on the big steam locomotives, to meet him on his way home. . . . He always smelled like paint, a smell that I love to this day. My Dad was short and funny and pretty smart. He read a lot. We used to go to the library together and check out books by the bags full.[19]

Besides painting boxcars, Teddy tried oil painting in his off-hours:

> In the winter, my Dad . . . did paint by numbers. For the first year he didn't let me help. But then he did. And I still have one of those paintings. He had some friends who were Sunday painters. He would take me over to their houses to see what they were doing. He must have seen that I was interested. . . .[20]

As Waddell told Yellowstone Art Museum curator Ben Mitchell in 2000, Teddy taught him that there is "a magic to oil paint that is unsurpassed by any other medium or activity."[21]

When he was ten, Butch first encountered the works of a well-known artist of the West, one who happened to have made the Billings area his home. Waddell and a schoolmate found drawings by Will James in the Parmly Billings Library, in books like *Smoky the Cow Horse* and *Cowboy in the Making,* and they did their best to copy James's illustrations of bucking broncos and battling wild stallions. "That was my first exposure to . . . art," recalls Waddell. "In those days, the closest you came to an art program in school was a class in mechanical drawing."[22]

Will James (1892–1942), born Joseph Ernest Nephtali Dufault in Quebec, came to the West in 1907 as a youngster enamored with the cowboy myth. The fifteen-year-old first came to the western Canadian provinces of Saskatchewan and Alberta, where he transformed himself from the son of a prosperous middle-class urban family (not unlike Charlie Russell) to Will James, "an adventurer and a desperado,"[23] born in a wagon in the Judith Basin, his father a Texas cowboy and his mother a gorgeous Californio (Californian of Spanish descent) maiden. In this refashioning of identity, young Will James was raised by a French-Canadian trapper, Old Beaupre, after his father died, gored by a long-horned steer.

Despite these inventions, young Dufault quickly learned (and perfected) the skills of a working cowboy and became a gifted bronc rider. He had always been an expert draughtsman. His brother Auguste Dufault remembered him as a boy in Quebec:

Will James. ***All in the Day's Riding, Range Table Etiquette, Fifteen minutes from the time he rides in . . .***, 1928. Watercolor, 19.5 × 14.5 in. Yellowstone Art Museum Permanent Collection. Gift of Virginia Snook. VS1994.009. Used by permission of the Will James Art Company.

Ernest . . . had that perfect coordination which enabled him to translate on paper accurately whatever his mind had pictured. . . . He would spend hours studying horses, cows, and dogs, staring at their movements, their eyes, expressions, the work of the muscles, the legs, the tails, ears, nostrils, etc. Then in the kitchen as he lay on the floor . . . he would draw them on a piece of wrapping paper. As he could not see cowboy life in the making, he would imagine what it would be like.[24]

After his sojourn in western Canada, James worked on ranches in Montana and Nevada, putting in his time as camp cook's assistant and nighthawk, and then graduating to day wrangler. He also spent time, a little over a year, in Nevada State Prison for cattle rustling. It was there, during long lonesome hours, that he began to conceive his first novels. With the publication in 1926 of his third book, *Smoky the Cow Horse*, he became a national sensation. *Smoky* won the 1927 John Newbery Medal for best children's book of the year, and it would sell many thousands of copies. It has remained continuously in print ever since and has inspired three film versions. James continued to write and illustrate his stories, and he eventually published twenty-four books.

In the early 1930s, James's success allowed him to buy his dream ranch, the Rocking R, near Pryor on the Crow Indian Reservation in southern Montana. He would later sell the ranch and move to his new home on Smokey Lane in Billings. Struggling with acute alcoholism, he died on September 3, 1942, in Hollywood.

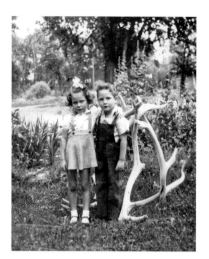

Theodore Waddell, known as "Butch" throughout his childhood, poses with his sister Judy, who died when she was only six. Waddell wrote in his journal: "I remember my Dad kneeling by the stove to stay warm while he cried. [Judy] seemed small and frail and wore brown high stockings against the cold." Waddell Family Collection.

BELOW LEFT
Butch stands in the midst of the Waddell family's flock of chickens. He enjoyed gathering the eggs, but his least favorite chore was to clean the chicken house. Waddell Family Collection.

BELOW RIGHT
On the outskirts of Laurel, Butch Waddell plays with friends in a neighborhood sandbox. Waddell Family Collection.

Like Butch Waddell, many youngsters in the West and elsewhere were enthralled by James's action-packed stories and illustrations. Western photographer Jay Dusard writes:

Will James drew horses that jumped off the pages of books right at you. Those drawings and the stories that went with them quite simply inflamed (some say corrupted) the imaginations of several generations of young males the world over.

Dusard goes so far as to claim, "Maybe it's just because of Will James that there's still cow outfits and working cowboys; certainly the range cattle business is pursued more for quality of life than for profit potential."[25]

When he was in his late teens, Waddell met Virginia Snook, proprietor of the Snook Art Company in Billings. The Snook Art Company, in Waddell's recollection, sold chandeliers and art supplies.[26] Virginia Snook had been a supporter of Will James during his

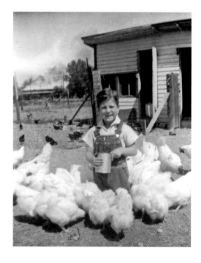

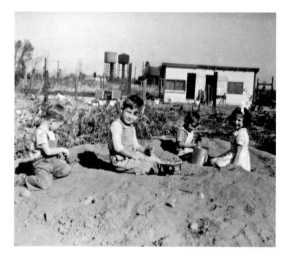

time in Montana, and she collected his work with gusto, trading art supplies for James's paintings. The Snook Art Company served as a locus for the small arts community in those years, and another Billings artist, Ben Steele, worked there part-time around 1940, where he met Will James. Steele ran errands for James and had the opportunity to watch James draw, which "left a lasting impression."[27]

Snook Art Company was where Theodore Waddell could go to view, not reproductions, but actual living drawings and paintings by his artist-hero. Upon her death, Virginia Snook left her collection of Will James materials—today the largest collection of James's writings, artworks, and memorabilia in public hands—to the Yellowstone Art Museum in Billings.

While Theodore Waddell would never follow Will James stylistically, he certainly came to share the artist's love of range animals and the ranching life. Growing up in the rural West, Butch was early exposed to the agricultural life. Waddell recalls: "We lived a mile from town in a house on an acre or so. We had a garden and chickens. My job was to gather the eggs and clean the chicken house."[28] The first time he recalls seeing a horse he was four or five, and "it was standing on my foot."[29] The Waddells' neighbors across the road, the Bernhardts, had a herd of twenty-five Holstein cows. From the Bernhardts, Waddell began to learn the seasonal rhythms, the pleasures and challenges, of agricultural work. He recalls, "They worked long and hard at farming and had a small dairy operation. We bought milk and cream from them."[30]

One Bernhardt son, Don, became a good friend. As Waddell explains "[We] played baseball together until [Don's] dad made him quit to work on the farm. We used to sneak over to his house to ride the dairy calves for fun." The Bernhardts sometimes pastured their dairy cows next to the Waddell home, and Waddell recalls, "When I got my first trumpet and played it in the front yard, all the cows came to the fence, hung their heads over . . . and mooed at me as I played."[31]

Bob, another of the Bernhardts' four sons—"He was dark, strong, and had a great sense of humor"—was a hero to the young Waddell. He recalls:

During the summer, I spent a lot of time at Bernhardts. . . . Often, I would go with [Bob] to irrigate the sugar beets and grain. He drove a '48 Ford pickup that was green and small and neat. Once in a while, he let me drive. During the last of July, the Bernhardts would harvest their grain. They would cut it and shock it—a machine would cut and tie the grain in bundles. They would stack the bundles together in vertical piles with the grain heads pointing skyward.

At harvest time Waddell would drive a tractor for the Bernhardts, hauling bundles of grain to the threshing machine. For two weeks' work, he earned thirteen dollars, "the most I ever had."[32]

Butch Waddell, at four or five, astride his neighbor's "big old horse." Waddell would "ride down the right of way with a neighbor boy who herded the cattle along, so they could graze." Waddell Family Collection.

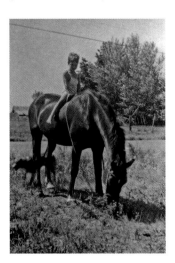

Butch Waddell was never afraid of hard work. Like his grandfather, he possessed "great energy and capacity for work" as well as an entrepreneurial spirit. At the age of ten, a friend of his father's, an engineer on the Northern Pacific, urged him to start tying flies, and using a makeshift vise, he began mastering the art of fly tying. Soon he was producing his own line of flies, and he even had his own label, "Butch's Flies." He had begun working at a sporting goods store, and his employer, Harold Dietrich, gladly carried "Butch's Flies." Young Butch "sold a ton."[33] For the first time, he was earning money for something he had fashioned with his own hands.

The sporting goods store, called the Pastime, was also a card room, and Butch worked there for eleven years, until he turned twenty-one. Every Saturday morning at 5:00 a.m., he mopped and waxed the floors, washed the windows, and cleaned up the sporting goods section. He recalls, "The worst part of this job was cleaning the spittoons—there were six and they were full most of the time. I used to throw up sometimes when cleaning them."[34] Butch also worked as a swamper at the Laurel Bar down the street, and besides his work with the Bernhardts, he cultivated corn and hoed beans for other neighbors. As a sophomore in high school, he went to work for O. M. Wold & Company, the "most prestigious clothing store in the region . . . and at the same time, [he was] playing music."[35]

Ever since he serenaded those cows, music—and jazz, in particular—has played an important role in Waddell's life. By age twelve, he had joined a band, playing trumpet. "There were always country dances in the region; we'd go to Bridger or Rapelje or Molt . . . with a Hammond organ in a '48 Dodge convertible." That first band featured trumpet, clarinet, organ, piano, and guitar, and they were playing the popular music of the day, mostly big-band swing tunes. Later, in college, Waddell joined the musicians' union and played in a combo with saxophonist Dennis Kyle, who was "just as good as Paul Desmond." They sported blue dinner jackets and made as much as $150 per night.[36]

Just as his father had introduced him to the joys of reading and of making art, so too did Teddy Waddell teach his son about the pleasures of fishing and hunting, traditional Western activities that would later inspire some of Theodore Waddell's most edgy, controversial, and downright outrageous works. Father and son were not always the most successful hunters. Waddell recalls:

When I was about 5, my Dad started to take me hunting and fishing. He bought me a B-B gun and instructed me in the rules of hunting. We hunted pheasants and duck, no big game. . . .

We used to get up at 4 a.m. and dress in scratchy underwear with more wool shirts and coats. It would be so cold that I thought I would freeze to death and [then] be sweating by 9:30 a.m. We went hunting on the Yellowstone River about 20 miles from home. Ralph [Norris, a family friend] had set up a blind with decoys on the river. We went many, many times without ever bagging anything but fish ducks [mergansers].

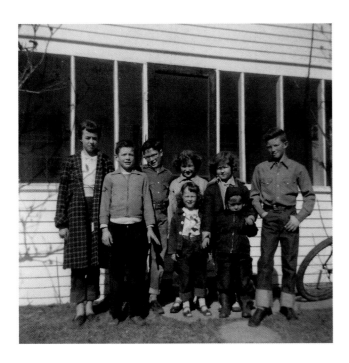

Butch Waddell (third from left) and friends pose in front of the Waddell home. Waddell Family Collection.

Ready to play a country dance, trumpeter Ted Waddell sports a dinner jacket. Waddell Family Collection.

About midmorning, they claimed that no more ducks would fly until dark, so we would go to the Rockvale Bar where they would drink beer and talk. They talked endlessly about nothing. Bitching about how they hated their jobs was always a popular and ever present topic. They would buy me a Pepsi and peanuts. . . . About mid-afternoon, we'd go back to the duck blind for the evening flights of ducks. Most of the ones we saw were out of range, and Ralph's attempts to call them in to the decoys were very funny and failed.[37]

In a 2013 essay about these formative sporting experiences, Waddell notes, "Since we weren't very good hunters, we shot little (only once in my life did I shoot more than a few times on a hunt, and then it made my shoulder hurt)." But the rituals surrounding the hunt profoundly stimulated young Butch's imagination. He recalls:

I really liked the idea of wearing leather boots. We spent half the winter one year looking in the Herter's catalogue for insulated boots. Herter's was a sporting goods mail order place in Minnesota, and it presented a fascinating array of things for a twelve-year-old to dream about and long for. I could get a lot done by fantasizing about things in that catalogue, from boats to bass fishing (which I never have done), to hunting for whitetails in the hardwood forests in Michigan.[38]

Waddell loved all the ritual preparations, waterproofing "those beautiful boots," cleaning his shotgun, and selecting the shotgun shells he'd carry during the day:

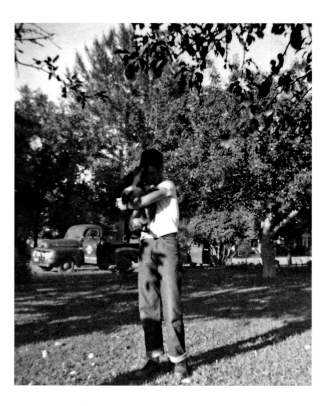

The shells were beautiful with different colors: red, green, a beautiful muted blue, and
yellow. . . . I loved the different kinds and brands—the names themselves, like Rem-
ington and Winchester, conjured up dreams of John Wayne, Red Ryder, and later, for
me, the painter Albert Pinkham Ryder.[39]

Even his father's hunting jacket was worthy of admiration:

. . . the most beautiful coat I've ever seen; it was made from a brownish, yellow-ochre
canvas, and after it was washed many times and faded from the sun, the creases and
wrinkles stayed dark and the rest became a wonderful variety of subtle earth tones,
like coffee with cream in it. It had slits in the back with a big rubber-lined pocket that
would hold any game we got, but I only remember seeing a bird in it once—a pheasant,
with its bright tail sticking out the side.[40]

During these years, Waddell began his lifelong love affair with dogs. He started with
black Labradors (which tended to kill the neighbors' chickens and had to be put down).
Next he acquired a coonhound named Blue and went hunting raccoons along the Yellow-
stone River. He recalls: "[W]e stumbled around in the dark with poor flashlights, trying
to follow the barking dogs until they treed the coon. More often than not, the dogs would

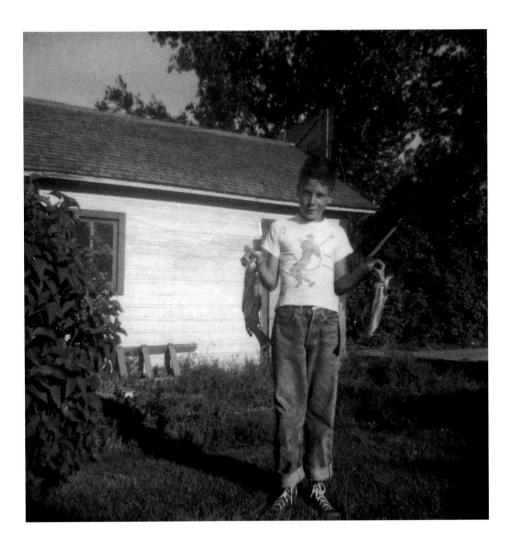

run deer and we'd have to come back for them in the morning." Finally, Butch bought a registered beagle,

who was supposed to be good for hunting rabbits and birds. Joe arrived in a wooden crate nearly frozen to death and cut from the steel bands. He was my partner and I loved him. He never hunted a rabbit or bird and was always there for me. He died at 11 or 12 while I was away in New York at school.[41]

Fishing, too, was a childhood pleasure. Waddell remembers, "My Dad, I think, was a better fisherman than a hunter and I after him as well." They often went to Cooney Dam, an irrigation reservoir fed by Red Lodge Creek. They slept in their '29 Chevy pickup, which had been an ice wagon. They would "roll down the side curtains . . . and sleep inside. It was very cold. We had coats and blankets—sleeping bags were much too

expensive. . . . We wagered 25 cents on who caught the first fish and who caught the most. Once in a while, I would win. Mom fished too. [My sister] Jackie didn't like fishing so she played with her dolls. We had great fun fishing together. . . ."[42]

Another favorite place was Willow Creek, a "beautiful little stream near the mountains, meandering through lovely meadows. The creek was dammed by beaver, forming nice pools. We never caught a lot of fish or any big ones but I remember it fondly."[43]

Theodore Waddell's upbringing, in many ways a typical Western childhood at mid-twentieth century, nevertheless prepared him uniquely for the course his life would take. With unstinting support from his parents, he always felt encouraged to pursue his passions, whether for painting or music or the sporting life. Through familial connections with the mythic West of the open range and his discovery of the artistry of Will James, he had, from the start, a special relationship with ranching traditions and the wide-open landscape of the Northern Plains. And perhaps most important, he possessed tremendous drive and a work ethic that would serve him well as he developed his skills, refined his sensibility, and discovered his true métier.

Notes

1 Waddell, unpublished journal, August 21, 1993.

2 Victoria Taylor-Gore, *Conversations with Theodore Waddell*, part 1, video interview, in conjunction with the exhibition *Theodore Waddell: For Love of the Horse,* at the Amarillo [Texas] Museum of Art, 2012, https://vimeo.com/43203514.

3 Michael P. Malone, Richard B. Roeder, and William L. Lang, "Stockmen and the Open Range," in *Montana: A History of Two Centuries* (Seattle: University of Washington, 1997), 150.

4 For a discussion of the Judith Basin Cattle Pool, see Truman McGiffin Cheney with Roberta Carkeek Cheney, *So Long, Cowboys of the Open Range* (Helena, MT: Falcon Publishing, 1990).

5 See Wallis Huidekoper, "The Story Behind Charlie Russell's Masterpiece *Waiting for a Chinook,*" in *Charlie Russell Roundup: Essays on America's Favorite Cowboy Artist,* ed. Brian W. Dippie (Helena, MT: Montana Historical Society Press, 1999), 99–102; see also John Taliaferro, *Charles M. Russell: The Life and Legend of America's Cowboy Artist* (Norman, OK: University of Oklahoma Press, 2003), 65–67.

6 "T. J. Waddell, Pioneer Justice of Peace, Came to Montana in 1878," *Three Forks* [Montana] *News,* July 2, 1931.

7 Charles M. Russell, "The Ghost Horse," in *Trails Plowed Under* (New York: Doubleday, Doran & Company, 1931), 91–100.

8 *Independent Record,* Helena, MT, October 18, 1943.

9 T. J. Waddell, "Looking Back," *Judith Basin Star,* August 31, 1941, 5.

10 See T. J. Waddell, Greenfield Family Papers, 1807–1975, Manuscript Collection 166, Box 6, Folder 12, Montana Historical Society Research Center, Archives, Helena, MT.

11 Thomas Waddell in *An Ornery Bunch: Tales and Anecdotes Collected by the W.P.A. Montana Writers' Project,* ed. Megan Hiller, Alexandra Swaney, Elaine Peterson, and Rick Newby (Helena: TwoDot Books, 1999), vii.

12 T. J. Waddell, Greenfield Family Papers, MC 166, Box 6, Folder 12, MHS Research Center, Archives.

13 Raphael James Cristy, *Charles M. Russell: The Storyteller's Art* (Albuquerque, NM: University of New Mexico Press, 2004), 4.

14 Helen Fitzgerald Sanders, "Thomas J. Waddell," *A History of Montana,* vol. 2 (Chicago and New York: The Lewis Publishing Company, 1913), 1083. Waddell invented the manure spreader with fellow pioneer Clarence Goodell, also of Philbrook, and the spreader was manufactured by Wood Manufacturing Company of Alden, Iowa; see http://tangledwood.com/histories/chesshistory.php.

15 "Thomas J. Waddell," in *Progressive Men of the State of Montana, Illustrated,* vol. 2 (Chicago: A. W. Bowen & Co., Engravers and Publishers, 1902), 1290.

16 T. J. Waddell, Greenfield Family Papers, MC 166, Box 6, Folder 12, MHS Research Center, Archives.

17 Theodore Waddell, note to Rick Newby, 1-(A), October 1, 2013.

18 Waddell, Newby interview.

19 Waddell, unpublished journal, August 21, 1993.

20 Theodore Waddell, email to Rick Newby, February 22, 2013.

21 Quoted in Ben Mitchell, "Into the Horizon," in Ben Mitchell et al, *Theodore Waddell: Into the Horizon, Paintings and Sculpture, 1960–2000* (Billings, MT: Yellowstone Art Museum; Seattle: University of Washington Press, 2001), 39.

22 Waddell, Joseph interview, *Cowboys & Indians.*

23 Jim Bramlett, *Ride for the High Points: The Real Story of Will James* (Missoula, MT: Mountain Press Publishing, 1987), 10.

24 Quoted in Bramlett, *Ride for the High Points,* 8.

25 Jay Dusard, introduction to Ian Tyson, *Ian Tyson,* LP (Calgary, AB: Columbia Records, 1984).

26 Taylor-Gore, *Conversations with Theodore Waddell,* part 1.

27 "Ben Steele: Introducing 2012 Montana Cowboy Hall of Fame Inductee," Montana Cowboy Hall of Fame website, http://www.montanacowboyfame.org/151001/381239.html. Accessed on June 23, 2013.

28 Waddell, note to Rick Newby 1-(A), October 1, 2013.

29 Taylor-Gore, *Conversations with Theodore Waddell,* part 1.

30 Waddell, unpublished journal, August 21, 1993.

31 Ibid.

32 Ibid.

33 Waddell, Newby interview.

34 Waddell, unpublished journal, August 21, 1993.

35 Waddell, Newby interview.

36 Ibid.

37 Waddell, unpublished journal, August 21, 1993.

38 Theodore Waddell, "My Life with Guns," in *Theodore Waddell: Hallowed Absurdities, Mixed-Media Sculpture* (Billings, MT: Yellowstone Art Museum, 2013), 39–40.

39 Ibid., 41, 43.

40 Ibid., 43, 46.

41 Waddell, unpublished journal, August 21, 1993.

42 Ibid.

43 Ibid.

An Education in Art and Life

I left home at 17, a smart alec kid who was hard on everyone.

—Theodore Waddell[1]

In June 1991, two longtime friends, both painters who happened to be ranchers, mounted an exhibition in Absarokee, Montana. Held in the little farming community's two banks, the exhibition showcased the work of two of Montana's foremost modernists, Isabelle Johnson, age 90, and her most renowned student, Theodore Waddell, 50. A review in the *Billings Gazette* noted that the show included ten works by each artist:

> watercolors, oil[s], wood cuts, pen and ink sketches plus inventive drawings of oil and graphite by Waddell. Both artists—reflecting their native Montana—depict nature, horses, cattle, sheep. Their style[s] are very different but reactions from viewer[s] are similar—Waddell's called "bold," Johnson's called "full of life."

As *Gazette* reviewer Lucile Moses pointed out, when Waddell entered Eastern Montana College in 1959, he soon enrolled in a painting class with Isabelle Johnson (1901–1992),

FACING PAGE

Theodore Waddell. ***Motherwell's Angus***, 1994 [detail]. Oil and encaustic on canvas, 72 x 72 in. Collection of the Denver Art Museum. Gift of Barbara J. and James R. Hartley. 1999.84.

Theodore Waddell and Isabelle Johnson, on the occasion of a joint exhibition, ca. 1987. This is the only known photograph of the two artists together. Waddell Family Collection.

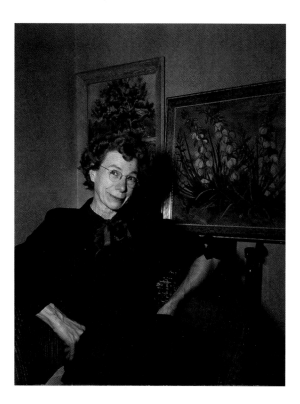

and the two—despite their forty-year age difference—became lifelong friends.[2] Waddell had planned to be an architect, but he recalls, "Within a month or less [of studying with Johnson], I decided that I didn't want to do anything other than make art."[3]

Until recently, Isabelle Johnson's life and work have attracted very little scholarship, but with the publication of *"A Lonely Business": Isabelle Johnson's Montana* (Yellowstone Art Museum, 2015), we now know a great deal more about Johnson's education and influences, the trajectory of her career, her aesthetic philosophy, and the full range of her body of work, which included not only her renowned landscapes, scenes from ranch life, and studies of trees and flowing water, but also accomplished academic works from her student years and arresting images of Indian powwows and city life.[4] In his contribution to *"A Lonely Business,"* Theodore Waddell writes, "I don't think there is any way to over-estimate the influence of Isabelle on all of us."[5]

By all accounts, Johnson was an inspiring and rigorous teacher. Waddell remembers, "Izzie we called her, not to her face—it was a term of endearment. She would take several of us to her house downtown and give us hot chocolate and talk about art." As a freshman, Waddell was "working for the art department, checking out tools [and] . . . working for the railroad on the freight dock, loading freight from 4 p.m. until 3 a.m." Johnson worried about him not getting enough rest, so she "bought a cot for me to take naps in the tool room."[6] Waddell recalls, "She was a figurative painter, but she had this loose, graphic way of applying the paint that drew me to her."[7]

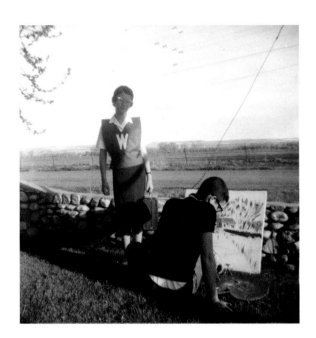

Theodore Waddell painting in the front yard, with his sister Jackie, in the spring of 1960 after meeting Isabelle Johnson in the fall of 1959. Waddell Family Collection.

Theodore Waddell. *Chinese Girl*, 1959–1960. Oil on cardboard, 30 x 21 in. Collection of the Yellowstone Art Museum.

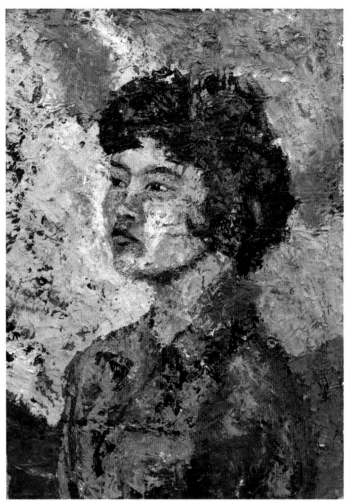

Waddell's friend and fellow painter, the late Jim Poor (1936–2014), credits Johnson with "opening [his] eyes to modernism."[8] Poor, who studied with Johnson earlier than Waddell, has said that Johnson's teaching style represented an "exciting, vivid attitude toward art in touch with life and earth." She was "ahead of her time in teaching the creative process" and always "very, very respectful of each student."[9] Another Johnson student, painter Donna Loos, recalls: "[S]he felt it was a requirement of her job that she push us and lead us to look in other directions that were not traditional, and she did it without saying a mean word about [Charles M.] Russell or any other traditional painter. . . .[S]he opened up our minds until we did it by ourselves."[10]

Isabelle Johnson partook of a distinctly Montana tradition, that of accomplished artists who are also working ranchers. Johnson's family ranch lay in the gorgeous Stillwater country of south-central Montana, and Isabelle's parents, Albert and Irene, both hardworking immigrants from Norway, made a success of the Albert Johnson Land Company, running sheep from 1911 until 1942 and then cattle until their deaths in the late 1950s.

 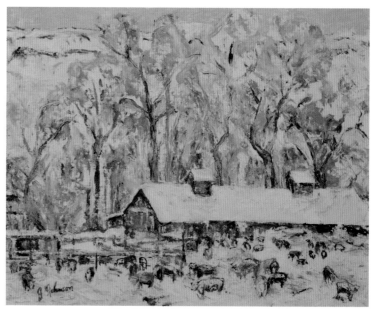

Isabelle Johnson. **Home Ranch**, 1955. Oil on canvas board, 24 x 30 in. Collection of the Yellowstone Art Museum. Bequeathed by Isabelle Johnson. 1992.070-IJ.

Always enterprising, Albert Johnson introduced the first McCormick binder into the Stillwater country, and in the early twentieth century, "because of the demand for draft horses in this newly developing land," Albert and his neighbors "sent to France for a thoroughbred Percheron stallion, named Thomas; the price, $4,000." Isabelle recalled that her father built a "special barn and corral for Thomas . . . and was his devoted guardian for more than 10 years. . . . The Stillwater became noted for its prized draft horses."[11] After her parents died, Isabelle continued to run the ranch with her two sisters, Grace and Pearl, and her brother Ingwald, who served as the principal manager.

At the same time, Johnson had her own career, as historian, teacher, and painter. She received a B.A. in history from the University of Montana and an M.A. from Columbia University, and she taught history and the social sciences in the Billings public schools for some years. But as she turned her passionate attention to the art of painting, she studied variously at the Otis Art Institute, Los Angeles; the Los Angeles County Museum School; the University of Southern California; the Art Students League, New York; Columbia University School of Painting and Sculpture; and the Colorado Springs Fine Arts Center.

By all accounts, the key moment in her journey toward painting came in 1946 when she was selected to participate in an experimental program at Skowhegan, Maine. Organized by Henry Varnum Poor, the influential painter, designer, architect, ceramist, and thinker, this program—limited to twenty-five participants—was a precursor to the important Skowhegan School of Painting and Sculpture, which Poor cofounded that same year.

As Terry Melton, first director of the Yellowstone Art Center (now Museum), noted in 1971, "Poor's inquiring and inventive experimentations affected and continue[d] to affect the painting attitudes of Isabelle Johnson's work."[12] Perhaps even more important

was Poor's advice about *where* Johnson should settle. Curator Gordon McConnell writes, "When she talked with Poor about pursuing opportunities in the East he told her, 'You go home. You belong to the West. The West needs you. Montana is a desert of art. You go home and make it bloom.'"[13]

Isabelle was able, during a 1954 sabbatical from her teaching duties at Eastern Montana College, to spend a year touring Europe, where she undoubtedly encountered the works of her principal influence, Paul Cézanne, and where, during her time in Paris, she spent day after day studying the masterworks in the Louvre. From all of her travels and studies—as poet and photographer Peter Halstead writes—Isabelle "brought home the light from distant worlds. The Hudson River light of Thomas Moran; the chalk glaze of Cézanne; the yellowed clay of the Camargue; the arid, blocky hills and river-like fields of Winslow Homer."[14]

* * *

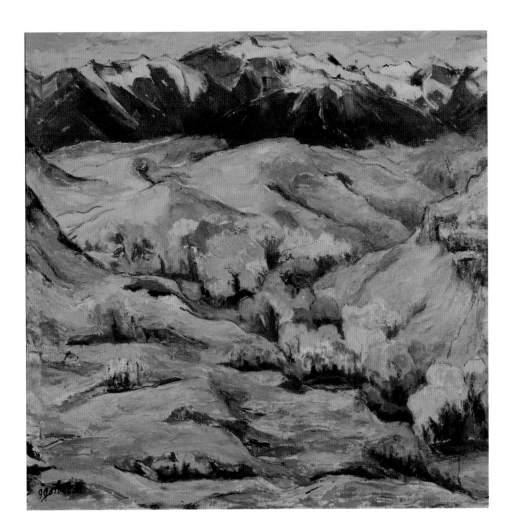

Isabelle Johnson. **Grove Creek, Autumn**, 1970. Oil on canvas, 37.5 × 37.5 in. Collection of the Yellowstone Art Museum. Gift of the Aylette Griffin Irving Estate. 2013.07.01.

Winold Reiss. **Night Shoot—Brave Society**, 1927. Mixed media on paper, 40 × 26.5 in. American Museum of Western Art, the Anschutz Collection, Denver, CO.

Julius Seyler. **Before the Buffalo Vanished**, 1913–1914. Oil on board, 19.7 × 33.5 in. Sigrid Reisch Collection.

Isabelle Johnson is often called Montana's first modernist painter, but that is not strictly correct. It is perhaps more accurate to call her Montana's first native-born modernist who went on to become an influential teacher within the state—and thereby, in Henry Varnum Poor's words, helping to "make [Montana] bloom" with visual expressions congruent with the modern age.

Modernism was indeed slow to come to Montana. In 1920, the Great Northern Railway first brought German painter and designer Winold Reiss (1886–1953), with his art–deco–inflected style, to Glacier National Park. Alongside his accomplishments as a portraitist of Montana's Blackfeet, Mexican revolutionaries, and notable figures of the Harlem Renaissance, Reiss is considered one of the first modernist interior designers in the United States. His design for the Crillon, New York, has been called the "first modern restaurant decoration in the U.S.A."[15] Reiss would have a powerful impact on several Montana painters, especially portraitist Elizabeth Lochrie (1890–1981), through the art school he ran in Glacier Park during the 1930s.

Even earlier, in 1913, another German modernist, Julius Seyler (1873–1958), came to Montana to paint. A shirttail relative of Louis W. Hill, the Great Northern Railway magnate, Seyler is often characterized as a postimpressionist, standing alongside masters like

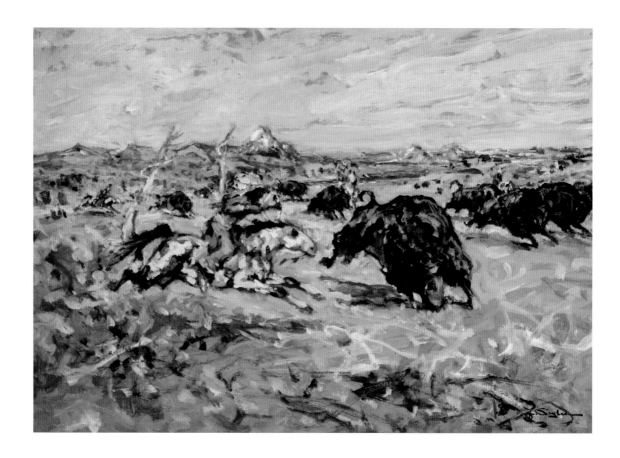

Cézanne, Van Gogh, and Gauguin; one of his works, *Nordischer Fischerhafen* (*Nordic Fishing Port*), appeared in the famous Armory show, the 1913 exhibition that first introduced modernism to a broad American audience.[16]

As historian William Farr writes, Julius Seyler differed markedly, because of his "experimental leanings," from most painters brought to northern Montana by the Great Northern. More commonly, the GN artists depicted "Glacier's scenic grandeur in decidedly realistic terms." Farr adds, "[T]here remained a decidedly loose, sketchy, or incomplete character to much of Seyler's painting that did not sit well in the popular appreciation."[17] Montana painting wouldn't see such experimental leanings and expressive brushwork again until Isabelle Johnson appeared on the scene in the early 1940s.

In the early twentieth century, American-born proto- and premodernists like Joseph Henry Sharp (1859–1953) and Maynard Dixon (1875–1946) also brought modernist elements to their work painted in Montana. Sharp, known as the spiritual founder of the Taos Society of Artists, did not travel very far down the modernist road (unlike many of his Taos colleagues), but his Montana work—especially his magisterial landscapes and scenes of Crow Indian life—hover somewhere between a more traditional European approach, learned during his academic studies in Antwerp and Munich, and the looser impressionism he encountered in Paris. Thomas Minckler, in his study of Sharp's late

 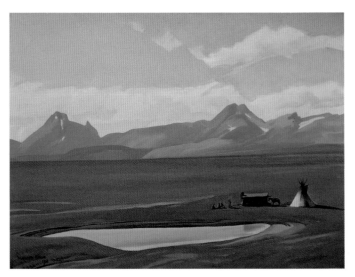

Joseph Henry Sharp. **Winter Landscape with Haystacks**, undated. Oil on paper on panel, 16 × 19 in. Montana Museum of Art & Culture, University of Montana, Missoula, MT. Permanent Collection. Gift of Fra Dana. 49-532.

Maynard Dixon. **Home of the Blackfeet**, 1938. Oil on masonite, 30 × 40 in. National Cowboy and Western Heritage Museum, Oklahoma City, OK. 1998.072.03.

floral still lifes, notes that he knows of only one truly modernist still life in Sharp's entire oeuvre, the graphically bold, angular *Carnations* (no date).[18]

Maynard Dixon, who would become a pure modernist by the mid-1920s, came to Montana in 1917, again under the auspices of the Great Northern Railway, and the work that emerged during that summer partook, in the words of art historian Donald Hagerty, of "a postimpressionist style, with a vigorous, bold, and forceful presentation." In 1915, Dixon had encountered, at the Panama-Pacific International Exposition, San Francisco, some of the latest European avant-garde works, several of which had been featured in the Armory Show two years earlier. Hagerty notes that "Dixon credited the exposition's modernist art with revising his ideas about color and the use of space."[19] His magnificent *Home of the Blackfeet*, painted in 1938, remains perhaps the most powerful evocation of his Montana stay.

In the summer of 1916, even the great American portraitist John Singer Sargent (1856–1925)—whom Theodore Waddell has claimed as an important influence—traveled to Glacier National Park. Though he seems quite conservative today, in the early twentieth century Sargent was considered daring, especially in his nearly "scientific attitude to his material."[20] He was, in the words of fellow painter Kenyon Cox, "a modern of the moderns and, in the broadest sense of the word, a thorough impressionist."[21]

Although Sargent reported from Glacier that "it is delicious to be here among crags and glaciers and pine woods," he apparently did not paint any Montana scenes, but instead waited until he had traveled into the Canadian Rockies, where the "scenery is grander still."[22] There, at Lake O'Hara, Alberta, he would paint one of his few pure landscapes that has, notes Canadian art historian Bruce Hugh Russell, "always been considered one of Sargent's finest paintings." Russell continues, "Apart from the brilliant virtuosity of his brush work, it is his idiosyncratic composition which results in its success . . . avoiding

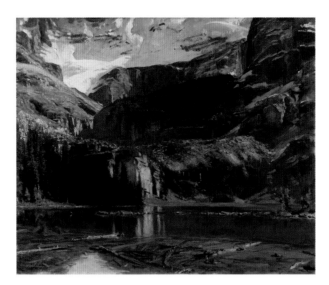

John Singer Sargent. *Lake O'Hara*, 1916. Oil on canvas, 38⅜ × 45¾ in. Harvard Art Museums/Fogg Museum, Department of American Paintings, Sculpture & Decorative Arts. Louise E. Bettens Fund. 1916.496.

the clichés of mountain tops delineated against the sky, and . . . cropping visual comprehension of the extent of the lake's perimeter."[23]

Theodore Waddell's daughter, the curator Shanna Shelby, writes that her father was "greatly influenced" by Sargent, especially in terms of the "application of paint." She continues:

> Waddell learned how Sargent executed the depth of space by working with not only tonal range but also texture. The astute observer can compare how depth is achieved by both artists by using smooth brushstrokes in dark tones and heavy strokes with more paint in lighter colors. It may seem absurd to compare Sargent's elegant socialites to Waddell's Angus portraits; however the subject is secondary to process. As technique it makes perfect sense.[24]

Isabelle Johnson's closest competitor for the role of Montana's first resident modernist painter was surely Fra Dana, another woman rancher whose life and art have been thoroughly documented in *Fra Dana: American Impressionist in the Rockies* (Montana Museum of Art & Culture, 2011) by Montana scholars Valerie Hedquist and the late Sue Hart.[25] Dana was born in 1874 in Terre Haute, Indiana, but by 1892, her family had moved to Dayton, Wyoming, in the foothills of the Big Horn Mountains, near Sheridan. There she was to meet rancher Edwin Lester Dana, and they would marry in 1896. At the same time that she was putting down roots in the West, Fra Dana had always aspired to be a painter, and between 1890 and 1893, she studied at the Cincinnati Art Academy.

A fascinating and complex figure, Dana would go on to spend considerable time in New York, where she studied with the preeminent late-nineteenth-century American artist William Merritt Chase, and Paris, where she encountered the pioneering

Fra Dana. **Old Rat**, undated. Oil on canvas, 15 × 17 in. Montana Museum of Art & Culture, University of Montana, Missoula, MT. Permanent Collection. Gift of Fra Dana. 49-517.

collectors of advanced art, Leo and Gertrude Stein. Dana was a classic impressionist, and she appears to have had little interest in more avant-garde approaches, even though her best artist friend, Alfred Maurer (1868–1932), has been called the first American fauvist.

For some years Dana divided her time between the rural life on the vast Dana ranch, the 2A (home to the largest purebred Hereford herd in North America), at Pass Creek, Montana, on the Crow Reservation and the artistic life in New York and Europe. Unlike Isabelle Johnson, who found her ranch origins congenial, indeed a natural way of being, Fra Dana had deeply mixed feelings about finding herself isolated from the great centers of art. Dana appreciated, and sometimes loved, ranch life, but she also wrote, heartbreakingly:

> If my life is to be bounded by Pass Creek, how can I stand it? I am full enough of life to want friends, music, painting, the theater; all the stimulus of modern movements. . . . I will go back to the ranch and never ask to go away again and try to content myself with the flowers and books, both of which I love. But the loneliness![26]

In another diary entry, written after a "wet, tired, dirty" day of spaying heifers, she wrote, "I speak no more of my vanished dreams."[27] Like noted twentieth-century Montana poet and novelist Grace Stone Coates of Martinsdale, who also lamented her loneliness in this "alien land," [28] Dana could be downright dismissive of her adopted state. In 1907, she confided to her diary, "Beauty of any kind is a thing held cheap out here in this land of hard realities and glaring sun and alkali. There are no nuances."[29] As a mark perhaps of her ambivalence, Dana painted very few Montana scenes, and her strongest works are

richly evocative domestic interiors, often featuring a gentlewoman at her leisure, drinking tea or reading the newspaper.

Beyond her art, which was little known during her lifetime, Fra Dana's greatest contribution to the culture of Montana has undoubtedly been the gift—upon her death in 1948—of her personal art collection to the Montana Museum of Art & Culture, University of Montana. Besides her own lovely work, including portraits, still lifes, florals, domestic scenes, and a handful of landscapes, her collection includes significant works by William Merritt Chase, Alfred Maurer, Douglas John Connah, Joseph Henry Sharp, Hans Kleiber, and E. W. Gollings, as well as French prints (Daumier and Forain) and more than thirty works of Asian art, including Ming Dynasty watercolors and *ukiyo-e* prints by the Japanese masters Hiroshige, Hokusai, and Utamaro.

* * *

While artists like Reiss, Seyler, Sharp, Dixon, and Fra Dana are certainly important in Montana's art historical record, it was Isabelle Johnson who most directly forged the path

to the vibrant and diverse Montana art world of the early twenty-first century. Unlike Fra Dana, Johnson, when she looked at the Montana landscape, saw nothing *but* nuance. As art historian Patricia Vettel-Becker writes about Johnson's 1965 oil, *Little River, Winter*, in *"A Lonely Business,"* "it is a rather unremarkable site [judging by a contemporary photograph], but through her painting she has transfigured it, forcing the viewer to focus on what often goes unnoticed in winter scenes, primarily color. The blues, oranges, and greens that may be missed upon casual glance are here wrestled into view through bold strokes of pigment."[30]

Johnson conveyed this sensitivity to the subtleties of apparently "unremarkable" landscapes to all of her students (and to Theodore Waddell in particular). She admired French symbolist painter Gustave Moreau (1826–1898) as "one of the greatest modern teachers"; Moreau's students at Paris's École des Beaux-Arts had included Henri Matisse and Georges Rouault. In an essay on color, Johnson quoted Moreau in expressing her own ideas of what a young painter should pursue to achieve depth, intimacy, even profundity through the mindful use of color. Moreau had written:

[Y]ou must think color imaginatively. You must copy nature imaginatively, this is what makes the artist. Color should be considered, pondered, reflective, inventive. . . . Believe me, the only painting that will endure is that which has been dreamed

about, thought about, reflected on, created in the mind and not simply with manual facility.[31]

In a 1952 essay addressed to amateur painters, Johnson insisted that the amateur need be "neither a dabbler nor dilettante," but instead should strive to become a serious painter who happens to not "paint for a living," but always learns new things, always perfects his or her craft, always strives for new freedoms:

> Soon the amateur learns that a work of art is a "thing created nearest to the heart's desire." He ceases to think of the postcard, the calendar, the theatrical illustration. He forgets there were ever such things as so-called rules and senses that his work is not a copying of nature but a putting together of elements to create a work of art which responds to its own laws of being rather than to an order imposed by the outer world of our senses.[32]

Robert DeWeese. *Wallpapered Four in Hand*, undated. Mixed media, 63¾ × 39½ × ¾ in. Collection of the Holter Museum of Art, Helena, MT.

Gennie DeWeese. *Early Fall in the Rockies*, 2005. Oil on canvas, 46 × 59 in. Collection of the Holter Museum of Art, Helena, MT.

During the same time that he was studying with Isabelle Johnson, Ted Waddell had another series of encounters that helped cement his commitment to a specifically Montana modernism and community of Montana contemporary artists. In 1960, when he was only seventeen, his friend, Mac Lewis, a graduate student at Eastern, took him to Bozeman to meet the painters Robert (1920–1990) and Gennie DeWeese (1921–2007), painter and printmaker Jessie Wilber (1912–1989), and ceramist Frances Senska (1914–2009).

As he's written, "My association with them lasted for a lifetime," and of the DeWeeses in particular, he says, "I always say that the DeWeeses saw me through puberty, midlife crisis, and Medicare. It was great to visit them. They would sit at the kitchen table, smoking hand-rolled cigarettes and making art. It was everywhere, oozing from their pores They both had immense ability and great personalities." Of Bob DeWeese, he recalls, "He was cool, one of the first artists I knew who had a downtown studio, over the [VFW Club]. His early etchings were magic."[33] Gennie DeWeese was an equally accomplished artist, and she possessed an ability, in both her landscapes and her domestic scenes, to create—in the words of art historian Julie Codell—"a rich painted surface with bold graphic lines that describe and abstract at the same time,"[34] something she shared with the later Theodore Waddell.

Waddell says of Senska and Wilber, both professors of art at Montana State University, along with Bob DeWeese:

> I met Frances and Jessie at the same time as I met the DeWeeses. Frances and Jessie brought modernism to Montana in the late 40s. Frances was, as you know, called the Mother of Potters as she taught all the good ones, [Peter] Voulkos (1924–2002), [Rudy] Autio (1926–2007), [John] Takehara (1929–2009), and countless others.... I saw them as often as I could. I traded Frances pots for sculpture.... I bought her pots whenever I could. She was always kind and always showed up for all art events whenever she could.[35]

In the ceramics world of the midcentury American West, Frances Senska figured large in the dispersion of aesthetic and pedagogical approaches introduced by European émigré artists, especially those associated with the German Bauhaus. As the child of Presbyterian missionaries, perhaps she found it natural to serve as a missionary for modernism.

In 1946, just before moving to Bozeman, Senska took a pottery course (only her second) from Finnish modernist Maija Grotell at Cranbrook Academy. Unlike Julius Schmidt, who would later alienate Ted Waddell with his authoritarian manner, Grotell believed that each artist should find his or her own approach, and she hesitated to critique her students' work, instead encouraging them to search and inquire. Grotell taught, said Senska, "more by example, than by instruction."[36]

Another European émigré would profoundly affect Senska's thinking about pedagogy. He was the Hungarian Laszlo Moholy-Nagy, the Bauhaus master who founded the Chicago Institute of Design. As a young teacher, Senska found a summer class she took from Moholy-Nagy revelatory. "I got a lot of ideas about how to teach from him," Senska has said. "He'd never say, 'Well, you can't do that.' He'd say, 'Well, try it.' ... So that's the technique I used on my students, too."[37]

Frances Senska. **Brickyard**, 1952. Lithograph, 6⅞ × 13⅞ in. Collection of the Holter Museum of Art, Helena, MT. Gift of James Barnaby.

Jessie Wilber. **Huns**, 1956. Serigraph, 15¼ × 24 in. Collection of the Holter Museum of Art, Helena, MT.

Senska went on to transmit this approach to Peter Voulkos and Rudy Autio, two of the most important ceramic artists to emerge in the postwar United States. Both Autio and Voulkos went on to distinguished teaching careers during which they, in turn, influenced hundreds of students. Of particular importance to Ted Waddell's story, at the University of Montana, Autio established a zone of radical freedom in the studio, encouraging his students to experiment and teaching by example.

These elder modern artists who welcomed the seventeen-year-old Ted Waddell so warmly (and whom he took to calling his art aunts and uncles) made up the core of a Montana modern art community that grew slowly during the 1940s, 50s, and 60s and has since expanded exponentially. Waddell recalls:

> It seemed like the art world was pretty finite during the 60s. . . . [T]he number of artists who were serious were few, and most of them knew each other. It was nothing to drive halfway across the state to attend someone's opening. During those years, we all shared what we knew.[38]

Among those he met during these years were Terry Melton, first director of the Yellowstone Art Center, who was to become a principal advocate for, and interpreter of, the younger artist's work. "I [also] met Bill Sage, a potter from Billings, Leo Olson, Billings art teacher, Jim Poor, a life-long friend who had been a student of Isabelle's before me. . . . I met Bill Stockton briefly during that time period, but I didn't become close to him until I ended my stint in Missoula and took over the family ranch west of Billings in '76."[39]

Rancher, painter, sculptor, and writer (author of the classic *Today I Baled Some Hay to Feed the Sheep the Coyotes Eat*), Bill Stockton (1921–2002) was one of Isabelle Johnson's true peers. Waddell remembers:

I was very taken with Bill's notions about art and the fact that he had studied in Paris seemed mystical and magical. . . . I don't know how directly Bill influenced me visually as our work was radically different in most ways. Having said that, we shared a love of the landscape and animals. Bill's use of a nearly abstract approach to his work did have an impact on me. I have always admired his draftsmanship.[40]

Having encountered this small band of committed modernists, Ted Waddell must have felt that a life as a contemporary artist in Montana might, in fact, be possible.

While Isabelle Johnson continued to instill in the young Theodore Waddell her passion for a radical freedom of expression, she had another impact on his development—though as he's said, that wasn't her intention. He recalls, "One day Isabelle was talking with a grad student about applying for a scholarship to the Brooklyn Museum Art School. I thought she was talking to me, so I applied and received a Max Beckmann Scholarship to the Museum."[41] Waddell was only a sophomore at the time, and ordinarily, the "Beckmann scholarship was awarded to college graduates for advanced study in painting."[42] Nevertheless, in the autumn of 1962, off he went to New York, to spend a "wonderful, frightening, marvelous year."[43]

* * *

Miss you all and miss the Montana view.
　—Theodore Waddell, October 2, 1962,
　　letter from Brooklyn to "Mom & Dad & Jacque"[44]

In New York City, Theodore Waddell progressed rapidly in developing his skills and affirming his sense of vocation as an artist. The city and its boroughs were indeed frightening at times—he was nearly mugged his first night in town and, before he learned the subway system, he got seriously lost—but he also immersed himself in the metropolis's immensely rich cultural matrix, a universe that he could scarcely have imagined back home in Montana. Like Peter Voulkos, the legendary Montana ceramic sculptor who first traveled to Manhattan in 1953, until his time in New York, Waddell had scarcely visited a museum, and certainly not one devoted to modern and contemporary work. In the 1960s, Montana's contemporary art museums were just starting to spring up; the first, the Yellowstone Art Center (now Yellowstone Art Museum) in Billings, did not open until 1964.

In Park Slope, Brooklyn, four blocks from the Brooklyn Museum, Waddell found a low-ceilinged attic room to rent, a veritable artist's garret, as he proudly wrote his family. He soon sallied forth to explore the Brooklyn Museum and its school. He wrote, "The museum connected with the school is huge. They have a painting by my favorite painter—Vincent Van Gogh. I spent the entire afternoon there."[45] The first day of school was September 24, and he observed of his classmates' skills: "Some of the students are really bad and some are better than I am, but I think I have more desire than anyone, so should do all right."[46] Whether they were skilled or not, Waddell would find his fellow students highly competitive and therefore secretive about technique—"nobody talked to each other, much"—and he was often "pretty lonesome."[47]

During his year at the Brooklyn Museum Art School, Butch Waddell studied with painter and political illustrator David Levine (1926–2009) and painter Harry Nadler (1930–1990). Levine was better known, renowned for his penetrating caricatures of political and cultural figures that were often featured in the *New York Review of Books*, the *New York Times*, *Newsweek*, *Time*, and other journals, but Waddell did not admire his paintings: "the 'brown gravy school' of beach scenes." Levine was not an engaged teacher—"he would come in, set up a model, and then go to the cafeteria and drink coffee."[48] Levine's more academic approach was also an adjustment, after the freewheeling atmosphere of Isabelle Johnson's classes. Waddell wrote his parents, "This style is the opposite of what I've been exposed to and I am going through a transitional stage and hope I arrive at a good end."[49]

Harry Nadler, on the other hand, was far more approachable, and he helped nurture Waddell's nascent passion for the art of the abstract expressionists (the young Montanan was particularly drawn to the works of Franz Kline and Robert Motherwell). Nadler had started out as an Abstract Expressionist, but soon began creating, in the words of his widow Helen Sturges Nadler, "paintings of strange spaces filled with autobiographical objects." His poetic approach, with its "breaking of edges and boundaries, merging the spatial and temporal," offered in the words of poet Wallace Stevens, "Description

Without Place." Nevertheless, it may have had a quiet impact on the poetics of that most place-based of artists, young Theodore Waddell.[50]

Always a hard worker, Waddell immediately began looking for a part-time job to cover his expenses. He first worked in a grocery store in Park Slope—"had a terrible time because I couldn't understand the accents"[51]—but shortly, Museum School faculty member Dale Munday helped him secure a position with the Mortimer Brandt Gallery on 57th Street in Manhattan. Veteran gallerist Mortimer Brandt specialized in Old Master paintings and drawings and illuminated manuscripts, and he proved to be a "crotchety, but wonderful mentor." He was, Waddell remembers, "like a [second] father to me."[52] Waddell wrote to his family, "Your mama's little boy has a job on the richest street in the world—57th Street in Manhattan—this is the center of the art world. The number of the galleries in this area is countless."[53]

In his late fifties in 1962, Mortimer Brandt was a well-established figure in the New York gallery world. Although his focus had always been on more traditional works, in the 1940s he played a pivotal role in the building of a U.S. audience for European and American modernism. For example, in November 1944, the Mortimer Brandt Gallery, at 15 East 57th Street, hosted the New York stop of the traveling exhibition *Abstract and Surrealist Art in the United States*, which originated at the San Francisco Museum of Art. Curated by Sidney Janis (before Janis opened his own New York gallery), *Abstract and Surrealist Art* featured such artists as Adolph Gottlieb, Arshile Gorky, Hans Hofmann,

Jackson Pollock, Josef Albers, and Willem de Kooning. That same year, Brandt's gallery also hosted the eighth annual *American Abstract Artists* show.

Brandt deepened his involvement in recent art when he hired the young collector and artist Betty Parsons (1900–1982) to open a contemporary section in his gallery. Parsons, whom *ARTnews* called the "den mother of Abstract Expressionism," is said to have "largely defined avant-garde art in America."[54] Her time with Brandt (however brief) helped cement that reputation when, in 1946, she hosted at Brandt's a first New York showing of Mark Rothko's aquarelles—a "huge success." Besides Rothko, she would bring emerging "Ab Ex" masters Barnett Newman, Clyfford Still, and Jackson Pollock to the gallery, as well as less categorizable artists like Joseph Cornell and Walter Tandy Murch. Mortimer Brandt's venture into contemporary art did not prove financially viable, and in the late 1940s he closed his New York gallery and decamped for England, subleasing his gallery space at 15 East 57th to Betty Parsons, where she then launched her own eponymous gallery.

By the early 1960s Mortimer Brandt had returned to New York and, at 11 East 57th Street, was largely dealing in Old Master drawings, with the exception of some contemporary European painters, especially Spanish, and the occasional group show featuring young "Artists of Promise," both painters and sculptors. For Theodore Waddell, working with the seasoned Brandt was an invaluable education. "He taught me a lot about art with his incredible insight and experience. . . . He would smoke his pipe and muse over the things he loved."[55] Waddell added, "He is hard to work for . . . his only virtue is excellence." Clearly the gallerist saw promise in his young protégé. In November 1962, Waddell wrote his parents, "Mr. Brandt asked me if I wanted to go to work for him full time."[56]

Before Butch returned to Montana for Christmas that year, Brandt took him to Brooks Brothers and had him fitted for a suit. "And he gave me a pair of hand-made Italian shoes."[57] Later Brandt would ask Waddell if he wanted to study art history at New York University, offering to help fund his studies, and then Brandt proposed that he consider becoming an art dealer. Waddell wrote his family, "He said it would help my painting and would also be a means of supporting myself until I can make my living by painting alone."[58] Brandt also suggested that, the coming summer, they travel together to Europe and buy paintings for the gallery, "which was something he did regularly, especially Spanish Moderns—he had some terrific painters during that time period." While Waddell must have been flattered by Brandt's belief in his potential, the prospect of a life in the New York art world "scared me," and he recalls:

> Late in the spring [Mortimer Brandt] was gone so I cleaned up the gallery and did the things he wanted me to do and mailed him the key and got into the Greenwich Village outdoor show, which ran for three weeks and made enough money to keep going, so

Diego Rodríguez de Silva y Velázquez. ***The Supper at Emmaus***, 1622–1623. Oil on canvas, 48.5 × 52.25 in. Collection of the Metropolitan Museum of Art, New York. Bequest of Benjamin Altman, 1913. 14.40.631.

I hitchhiked to Provincetown [Massachusetts] up on the Cape with a guy who was a portrait artist.[59]

This was one of those key turning points in Waddell's life. He chose to continue making art (and eventually return to the West) rather than engage, as art historian and gallerist, in the international art world. While, at the time, this might have seemed the safer, less ambitious choice, the passing years would prove otherwise.

Besides his work with Mortimer Brandt and his courses at the Brooklyn Museum Art School, Butch Waddell found much more to edify him in New York City. He visited the Metropolitan Museum every week, where he found himself drawn to Velázquez and spent "at least a hundred hours trying to understand his painting of *Christ with the Pilgrims at Emmaus*." Also known as *The Supper at Emmaus* (1622–1623), Velázquez's masterwork "really hit [Waddell] hard." It was, to a young painter, "technically unbelievable."[60]

The early Sixties was the heyday of the pop artists—in December 1962, the Museum of Modern Art hosted the first symposium on Pop Art, led by curator Peter Selz—but Waddell was "not taken with the Pop people at all." In addition to his passionate regard for the Abstract Expressionists (besides those of Franz Kline and Robert Motherwell, he was drawn to the works of Willem de Kooning, Hans Hofmann, and a "bit of [Jackson] Pollock"), he found other painters working in very different styles to admire. A particular favorite was the singular Walter Tandy Murch (father of legendary cinematographer Walter Murch), who showed at Betty Parson's gallery, next door to Brandt's. The elder Murch (1907–1967) painted "realistic exquisite little paintings,"[61] and it may be that, though Murch painted still lifes in the tradition of masters Jean-Baptiste-Siméon Chardin (1699–1779) and Giorgio Morandi (1890–1964), he drew Waddell's admiration

Walter Tandy Murch. **Clock Face**, 1962. Oil on canvas mounted on wood, 24 × 18 in. Smithsonian American Art Museum. Gift of S. C. Johnson & Son, Inc. 1969.47.68.

because, in painter Winslow Myers's words, he had a "Pollock-like interest in paint for its own sake" and possessed the "willingness to make use of the accident, to throw paint at the surface in an easel-size equivalent of what Pollock did on a larger scale."[62] This notion of the accident would prove integral to Waddell's later practice.

Perhaps, too, Waddell was drawn to Murch's extraordinary independence. As art historian Daniel Robbins wrote in an important 1966 catalog essay, "virtually unclassified and unattached, because he has been classified so many ways—Walter Murch has painted his solitary way, quite detached, though by no means remote, from the turbulent mainstream that contained most of his contemporaries. . . . Murch has been compared by both admirers and detractors to Andrew Wyeth, yet he has also been compared to Jackson Pollock, Jasper Johns, and Jim Dine."[63] Waddell has always admired modern iconoclasts like Murch, Francis Bacon, who shared his fascination for Velázquez, and Cy Twombly.

In addition to being at the center of contemporary art, Waddell was thrilled to find himself in the jazz capital of the world. As a young trumpeter, he took advantage of every opportunity to hear his heroes live:

I saw Stan Getz and Thelonious Monk at the Five Spot in the [East] Village, night after night. I would sneak in so I didn't have to pay the two-dollar cover charge. I went to Birdland [in Midtown] and saw Shorty Rogers and His Giants, Woody Herman and

Theodore Waddell. *P. 25*, 1962. Oil on canvas, 24 × 30 in. Location unknown.

the Herd. You could buy a beer for 25 cents and listen for nothing. I saw Bud Shank in the Village, Mel Tormé and others. A great education for a kid from Montana.[64]

With its improvisatory approach, jazz had an impact on Waddell's modernist aesthetic (though he tended to like straight-ahead jazz and was not drawn to the more discordant works of avant-gardists like Ornette Coleman). He notes:

Jazz has always been important to me and I like to think some of my work is like that— where you have a melody line and you do variations on it. That's my favorite kind of painting.[65]

Theodore Waddell. *P. 29*, 1962. Oil on canvas, 16 × 20 in. Location unknown.

Theodore Waddell. **New York Figure**, 1963. Oil on cardboard, 16 × 19 in. Collection of the Yellowstone Art Museum, Billings, MT.

More than anything else, Waddell had come to New York to paint, and as his letters home reflect, he was tireless in his pursuit of mastery. Soon after settling in Brooklyn, he wrote: "I have finished one painting at home and am working [on] 2 others. Most of my evenings are spent writing painting and reading."[66] Just after Thanksgiving, he wrote his mother that he hadn't been dating much: "I'd rather paint. Mom, I think it's an obsession with me. I can't paint enough. I can't wait to get home every nite so I can paint. I crave it." He was hoping to complete "40 or 50 more things" and then find a gallery to represent his work.[67] In another letter, he wrote, "I have been painting like hell (7 paintings this week)."[68] Few Waddell paintings survive from this period, but those that do range from pure abstractions to portraits to still lifes.

At the same time, he was also turning his attention to sculpture. In the fall of 1962, he wrote his family, "I met a sculptor last week and might try and get into his studio to do some sculpting."[69] Back in Montana, while studying with Isabelle Johnson, Waddell had taken lettering and layout and ceramics classes from the sculptor Lyndon Pomeroy. Though he didn't study metal sculpture with Pomeroy, he recalls, "I visited his studio early on. I became fascinated with welding so learned to weld on my own that fall and early winter using a set of oxyacetylene torches in the art department. I welded and brazed that fall and winter. Two examples of my early work are [a] steer and horse, brazed out of brass and copper and enameled."[70]

After resigning his position at the Brandt Gallery, Waddell—always entrepreneurial— signed up for the spring 1963 Greenwich Village Outdoor Show, where he sought to sell

the fruits of his artistic production from the past six months. On May 20, he wrote his family that the "old kid . . . sold over $20 worth of drawings yesterday." He was planning to spend the summer in Provincetown, making sculpture, and he hoped to sell enough work at the Outdoor Show to "buy the welding outfit for Provincetown."[71] By June 3, he could write, "I have made $120 so far in the Village show. . . . I have made fantastic strides in this show and can't keep up with my sales." By the time he left for Provincetown the following Monday, he had saved up $400, enough to "get set up to do sculpture there."[72]

Earlier, he had told his family about his opportunity in Provincetown. He set the scene:

I met a guy [Paul Schwartz] who has a place in Provincetown called Art in Action. Provincetown, Mass., is the summer place of all the art people on the east coast. It is a tourist town. People go up there to see the beatniks and artists. Many painters make their living by selling paintings at Provincetown. I know a guy who studies . . . at the museum school who made $3000 last summer up there.

Schwartz's Art in Action was housed in a "big shed, 30×60," and artists spent the summer months "painting portraits, doing character studies, quick charcoal sketches, etc.," which they then sold to tourists who "flocked" to watch the artists in action. Schwartz wanted Ted Waddell to paint watercolors and create "small decorative metal sculpture and metal decorative panels" for sale that summer. Art in Action would take 25 percent, and Waddell envisioned a highly lucrative summer ahead.[73]

Ted made his sculptures from metal discards he "scrounged from the dump, cutting up pieces with a pair of hand shears." These small sculptures, assembled from "horse shoe nails and sheet metal,"[74] are reminiscent of the constructions of Russian-American

Theodore Waddell. *Small Cow Sculpture*, ca. 1961. Brass and enameled copper, 5 × 3 in. Collection of the artist.

Theodore Waddell. *Small Horse Sculpture*, ca. 1961. Brass and enameled copper, 8 × 4 in. Collection of the artist.

Provincetown, Massachusetts, as Waddell knew it in 1963. Photograph by Theodore Waddell. Waddell Family Collection.

The Provincetown lobster pot warehouse where Ted Waddell worked in the summer of 1963, welding sculptures and creating small watercolors—and then selling them to tourists. Photograph by Theodore Waddell. Waddell Family Collection.

sculptor Ibram Lassaw (1913–2003), who obtained his "irregular web-like structures"[75] by welding together metal rods with an oxyacetylene torch.

Waddell loved being in Provincetown. He remembers, "It was a very lively scene. Hans Hofmann was teaching at the art school there, and Norman Mailer would show up . . . at the local bars hustling the young women." Despite his enjoyment, the young artist did not find financial success. He recalls, "I spent the whole summer there and I never had more than 20 bucks in my pocket at any one time."[76] Nevertheless, he was exhibiting his usual work ethic, telling his family, "I am putting in 12–20 hrs per day and loving it."[77] In another letter, he noted, "I am more determined and more sure all the time of my capabilities as a sculptor."[78]

As the summer ended, he headed back to New York, where he signed up for the fall edition of the Greenwich Village Outdoor Art Show. This time, he had greater success. He recalls:

> I think I ended up with about $600, which was a lot of money during that time period. At the end of the show, kinda figuring out what I was going to do, I decided I would go home. . . . I went to Newark and flew out . . . on a midnight plane and landed in Billings at about 5 AM and hitchhiked to Laurel from the airport and met my dad before he went to work and had coffee with him. That was kind of the end of the New York time.[79]

* * *

Once home, Waddell had little chance to relax (he'd hoped to "come home to a serene existence free from the pandemonium that exists [in New York]"[80]), but instead he found his induction papers for the U.S. Army awaiting him. Within a few more weeks, he'd been drafted, and off he went to Fort Ord, on California's Monterey Bay. He recalls, "It was not very much fun, and as you know, I don't take instruction well, so it was an uphill

One of the small-scale sculptures Ted Waddell created in Provincetown in 1963. Location unknown. Photograph by Theodore Waddell. Waddell Family Collection.

climb with this kid." He was fortunate, though, because he played the trumpet, and so after basic training and some band training, he found himself assigned to the Fourth Army Band at Fort Sam Houston, Texas—which turned out to be "just a wonderful spot . . . we had some of the best musicians in the country there." Even better, Jerry Perkins, an excellent trumpet player and arranger, created sophisticated Stan Kenton–like arrangements for the Fourth Army Band's sixteen-piece jazz band. They played recruiting tours across Texas, Oklahoma, and Arkansas. "[I]t was great fun. And it was also not your typical Army activity."[81]

The arts—and his own drive to create—further enriched Waddell's Army experience. He applied to teach in a "a small arts & crafts building . . . just a little brick, or stone, building where they taught jewelry and lapidary," right next to the base. He knew nothing about lapidary ("I had to look up what 'lapidary' meant"), but he got the job and taught the art of cutting, polishing, and engraving stones throughout his second year in the Army. As a bonus, he could use the little building as his personal studio, where he "painted [and sculpted] late in the evenings."[82]

Waddell did have a few depressed moments during his Army service. In June 1964, he wrote his father, "The Army is directly contrary to everything I believe in. It is so corrupt, petty and senseless that it is not hard to become drugged by it. I am trying to make every effort to read and learn by setting up a schedule of study, but I have much difficulty."[83] A month later, his good spirits had returned, and he was enthused about his artistic efforts. The director of the Craft Annex had admired Waddell's sculpture and offered him an exhibition that would "travel all over the 4th Army area—(all the southern states & New Mexico & Arizona)."[84]

In March 1965, while in San Antonio, Ted Waddell married his high school classmate, Betty Leuthold. Betty had been born on the Leuthold OK Ranch, west of Billings, a ranch that would come to play a central role in the life and art of Theodore Waddell. Betty had a master's degree in psychology, and during their time in Texas, she worked at the state mental hospital. By the fall of that year, Ted was allowed an "early out" to return to school. And again, he was favored by the fates: "I was about two weeks ahead [of] President Johnson extending everybody for nine months, and many of the people I had served with ended up in Viet Nam."[85]

Back in Billings, Ted Waddell did not take it easy. "I was in a hurry," he recalls. He returned to his art studies at Eastern Montana College, taking as many as twenty-one credits a quarter so he could finish his degree quickly. To make ends meet, Waddell worked in an automobile parts house, sorting parts, and "when I was charged with taking the obsolete parts to the dump . . . bumpers and gears, and what not . . . I took them home and ended up welding sculpture out of them,"[86] as well as creating wall-mounted collage works [see *Untitled (Used Engine Parts Collage)*, ca. 1966, on page 77].

In keeping with his entrepreneurial spirit, Ted, together with Betty, started a gallery on Billings' Southside, the 34th Street Gallery. This "'haven' on 34th" as the *Billings Gazette* dubbed it, was a place for often ignored or embattled contemporary artists to show their work. The *Gazette* noted that the gallery's opening featured "25 puzzling, startling, contemporary paintings" and that the space was intended to "provide an outlet for new artists and more modern work" rather than the usual Montana fare of "traditional western and frontier art."[87] Besides Waddell's increasingly accomplished works, the gallery showed the art of Eastern humanities instructor James Gibson, assistant professor of art William Schulz, and Terry Melton, the first director of the newly minted Yellowstone Art Center, which had opened in 1964. Waddell recalls, "We never sold any work . . . but we had some really good parties."[88]

Graduating in December 1966, Waddell was ready to move on to graduate school. After looking at programs all over the United States, he set his sights on the sculpture program at Cranbrook Academy of Art in Bloomfield Hills, Michigan. He was accepted into the graduate school, but was put on a waiting list. When he visited Cranbrook in early 1967, and after encountering the sculptor Julius Schmidt and watching him teach, Waddell made a quick assessment and decided to look elsewhere. In his view, Schmidt was "not very nice to the students and all of the student work looked like his." Inspired by

Theodore Waddell during a visit home from the U.S. Army in 1964. Waddell Family Collection.

An article in the *Billings Gazette* on an exhibition at Theodore Waddell's 34th Street Gallery, featuring "puzzling, startling, contemporary paintings," ca. 1966.

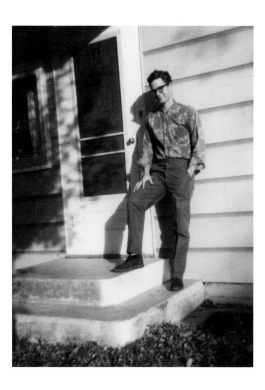

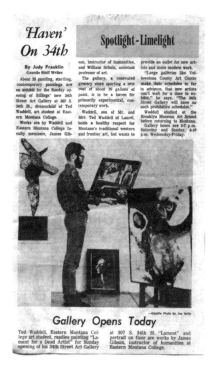

automobile-industry technologies developed next door in Detroit, Schmidt used a direct, or core-sand, process of casting iron, which gave sculptors much greater control and faster results than the traditional lost-wax process. While Schmidt was doing important work, he was clearly not the mentor for Ted Waddell.

Waddell quickly went to Wayne State University in midtown Detroit and signed up as an unclassified graduate student, applying for a slot in the school's graduate program in sculpture. By spring 1967, he'd been accepted, even though he had never taken a formal sculpture class. He studied with the sculptors George Zambryski and Alex Soroka and the printmaker Aris Koutroulis, who had recently launched the new Lithography Workshop at Wayne State. "I went through that program in eighteen months," he recalls. "Again, I was in a hurry."[89]

Waddell became very close to George Zambryski, a Russian immigrant, who was a "wonderful sculptor and a great mentor." Waddell recalls, "He used to come to my studio and we would visit and he was a big help." Koutroulis, a "short, energetic, Greek," also became a close friend—such a good friend that Betty and Ted wanted to name their first child after Aris. But since their first-born turned out to be a girl, they "named her Arin, in honor of him."[90]

In those days, Waddell recalls, "Detroit was the center of the universe with regards to techniques for making sculpture. If you could conceive it, there was a way to make it. I learned to weld aluminum, cast bronze and aluminum, and weld and polish stainless steel."[91]

A visit to Detroit by the revolutionary sculptor Donald Judd had a profound impact on Ted's aesthetic. Up to that point, David Smith had been Waddell's hero, but now the forceful Judd, with his vigorous attacks on the "insufficiencies of painting and sculpture" and the rigor of his theory of the "specific object"[92]—became the young sculptor's most important influence. Waddell remembers, "Judd really formalized that movement—and it's the same today. Nobody has changed the world in the way that he did."[93] By the time he returned to Montana upon graduation, Ted Waddell was passionately committed to making his own specific objects: abstract, minimalist works in steel.

With his MFA in sculpture and printmaking in hand, Waddell went looking for a job. As he recalls,

> I really wanted to stay in Michigan—there were some really nice small schools throughout the state and also small farms that might have been in my price range . . . barely Unfortunately, none of that happened. But I did apply at the University of Montana in Missoula, and thanks to Lyndon Pomeroy, who had been one of my teachers at Eastern Montana College . . . I got the job.[94]

1 Waddell, unpublished journal, August 21, 1993.

2 Lucile Moses, "Old Friends Stage a New Show," *Billings Gazette,* Enjoy, June 28, 1991, 12.

3 Waddell, note to Newby, October 1, 2013.

4 See Robyn G. Peterson, Bob Durden, Patricia Vettel-Becker, Donna Forbes, Theodore Waddell, and Peter Halstead, *"A Lonely Business": Isabelle Johnson's Montana* (Billings: Yellowstone Art Museum, 2015).

5 Theodore Waddell, "Isabelle Johnson," in Peterson et al, *"A Lonely Business,"* 41.

6 Waddell, email to Newby, February 22, 2013.

7 Quoted in Jaci Webb, "Ted Waddell: Redefining the Label of 'Western Artist,'" *Billings Gazette,* November 17, 2014, 1.

8 Quoted in Bob Durden, *Jim Poor: Confluences* (Great Falls, MT: Paris Gibson Square Museum of Art, 2009), 1.

9 Quoted in Rick Newby, "Artists Who Also Teach, Part II," in *State of the Arts,* Montana Arts Council, January/February 2000, 22–23.

10 Quoted in Robyn G. Peterson, "Introduction and Acknowledgments," in Peterson et al, *"A Lonely Business,"* 3.

11 Isabelle Johnson, "Folks Called Johnson," in Jim Annin, *They Gazed on the Beartooths,* vol. 1 (Billings, MT: J. Annin, 1964), 272.

12 Terry Melton, *Paintings by Isabelle Johnson* (Fort Worth, TX: Amon Carter Museum of Western Art, 1971), unpaginated.

13 Gordon McConnell, *Yellowstone Art Museum: The Montana Collection* (Billings, MT: Yellowstone Art Museum, 1998), 28.

14 Peter Halstead, "Photographing Isabelle," in Peterson et al, *"A Lonely Business,"* 42.

15 Robert Kashey, *Winold Reiss, 1886–1953: Works on Paper: Architectural Designs, Fantasies and Portraits* (New York: Shepherd Gallery, 1986), unpaginated.

16 See Milton W. Brown, *The Story of the Armory Show* (Washington, DC: The Joseph H. Hirshhorn Foundation, 1963), 289.

17 William E. Farr, "Julius Seyler: Painting the Blackfeet, Painting Glacier Park, 1913–1914," *Montana The Magazine of Western History* 51, no. 2 (Summer 2001), 61. For a full treatment of Seyler's Montana sojourn, see William E. Farr, *Julius Seyler and the Blackfeet: An Impressionist at Glacier National Park,* Charles M. Russell Center Series on Art and Photography of the American West, Book 7 (Tulsa: University of Oklahoma Press, 2009).

18 See Thomas Minckler, *In Poetic Silence: The Floral Paintings of Joseph Henry Sharp,* ed. Rick Newby (Tucson, AZ: Settlers West Galleries, 2010), 133.

19 Donald J. Hagerty, "Maynard Dixon and a Changing West, 1917–1935," *Montana The Magazine of Western History* 51, no. 2 (Summer 2001), 43, 42.

20 Sarah Burns, *Inventing the Modern Artist: Art and Culture in Gilded Age America* (New Haven, CT: Yale University Press, 1996), 177.

21 Kenyon Cox, "Two Ways of Painting," *Bulletin of the Metropolitan Museum of Art* 7, no. 11 (November 1912), 205.

22 John Singer Sargent, letter to Evan Charteris, July 25, 1916, quoted in Bruce Hugh Russell, "John Singer Sargent in the Canadian Rockies: 1916," *The Beaver: Canada's History Magazine* 77, no. 6 (December 1997/January 1998), 4.

23 Bruce Hugh Russell, "John Singer Sargent in the Canadian Rockies: 1916," *The Beaver: Canada's History Magazine* 77, no. 6 (December 1997/January 1998), 4.

24 Shanna Shelby, "A Daughter's Perspective," in Terry Oldham, Theodore Waddell, Terry Melton, Shanna Shelby, and Kirk Robertson, *Angus Anthem: Theodore Waddell* (St. Joseph, MO: Albrecht-Kemper Museum of Art, 2009), 15.

25 See Sue Hart and Valerie Hedquist, *Fra Dana: American Impressionist in the Rockies* (Missoula, MT: Montana Museum of Art & Culture, 2011).

26 Fra Dana, unpublished journal, September 28, 1911, transcribed by Mildred Walker and quoted in Valerie Hedquist, "Travels with Fra: From Pass Creek to Paris," in Hart and Hedquist, *Fra Dana: American Impressionist in the Rockies,* 71–72.

27 Fra Dana, unpublished journal, undated, transcribed by Mildred Walker and quoted in Ripley Hugo, *Writing for Her Life: The Novelist Mildred Walker* (Lincoln: University of Nebraska Press, 2003), 106.

28 See Lee Rostad, "From an Alien Land: An Introduction," in *Food of Gods and Starvelings: The Selected Poems of Grace Stone Coates,* ed. Lee Rostad and Rick Newby (Helena: Drumlummon Institute, 2007), 17–29.

29 Quoted in Erika Doss, "'I *Must* Paint': Women Artists of the Rocky Mountain Region," in *Independent Spirits: Women Painters of the American West, 1890–1945,* ed. Patricia Trenton (Berkeley: University of California Press, 1995), 222.

30 Patricia Vettel-Becker, "Isabelle Johnson and the Visual Poetics of Home," in Peterson et al, *"A Lonely Business,"* 31.

31 Gustave Moreau, quoted in Isabelle Johnson, "That Wonderful World of Color," in *The Arts in Montana,* ed. H. G. Merriam (Missoula, MT: Mountain Press, 1977), 40.

32 Isabelle Johnson, "For What Is the Amateur Painter Working?," *The Arts in Montana,* ed. Merriam, 170, 172.

33 Theodore Waddell, email to Rick Newby, February 22, 2013.

34 Julie F. Codell, "Scene/Seen Out the Window: The Works of Gennie DeWeese," in *Gennie DeWeese: Retrospective* (Missoula, MT: Missoula Art Museum, 1996), 10.

35 Ibid.

36 Frances Senska, interview by Chere Jiusto and Rick Newby, Bozeman, MT, June 9, 1998, Archie Bray Foundation for the Ceramic Arts Archives, Helena, MT.

37 Ibid.

38 Theodore Waddell, email to Rick Newby, February 22, 2013.

39 Ibid.

40 Ibid.

41 Waddell, note to Rick Newby, 2-(B), October 1, 2013.

42 *Guide to the Records of the Brooklyn Museum Art School 1941–1985* (Brooklyn, NY: Brooklyn Museum, n.d.), 10, https://d1lfxha3ugu3d4.cloudfront.net/archives/BMAS_final.pdf.

43 Theodore Waddell, "Isabelle Johnson," in Peterson et al, "A Lonely Business," 41.

44 Theodore Waddell, letter to "Mom & Dad & Jacque," October 2, 1962, in artist's possession.

45 Theodore Waddell, letter to "Dear Mom, Dad and Jacque," September 12, 1962, in artist's possession.

46 Theodore Waddell, letter to "Dear Family," September 24, 1962, in artist's possession.

47 Waddell, Newby interview.

48 Theodore Waddell, oral history (self-interview), unpublished transcript, Segment 4, Fall 2014, in artist's possession. Hereafter cited as Waddell, oral history (self-interview).

49 Theodore Waddell, letter to "Dear Mom & Dad & Jacque," October 2, 1962, in artist's possession.

50 Helen Sturges Nadler, "Harry Nadler: Biography: Description Without Place," Harry Nadler website, http://www.harrynadler.com/biography.html.

51 Waddell, oral history (self-interview), Segment 4.

52 Ibid.

53 Theodore Waddell to "Dear Peoples," October 20, 1962, in artist's possession.

54 See Cyndi Conn, "Nerve Endings: Betty Parsons, Marcia Tucker, and Alanna Heiss" (master's thesis, Skidmore College, 2010), 5, http://creativematter.skidmore.edu/cgi/viewcontent.cgi?article=1078&context=mals_stu_schol.

55 Theodore Waddell, "New York Notes, etc.," unpublished reminiscence, in artist's possession.

56 Theodore Waddell, letter to "Dear favorite Mooma and family," no date, in artist's possession.

57 Waddell, oral history (self-interview), Segment 4.

58 Theodore Waddell, letter to "Dear Family," December 10, 1962, in artist's possession.

59 Waddell, oral history (self-interview), Segment 4.

60 Theodore Waddell, email to Rick Newby, February 22, 2013; Waddell, Newby interview.

61 Waddell, Newby interview.

62 From Winslow Myers, "The Recreated Image: Walter Tandy Murch at Sixty" (New York: The Artist Book Foundation, 2016, forthcoming). Quoted in Larry Groff, "Walter Tandy Murch," Painting Perceptions website, http://paintingperceptions.com/walter-tandy-murch.

63 Daniel Robbins, Walter Murch: A Retrospective Exhibition (Providence: Museum of Art, Rhode Island School of Design, 1966), unpaginated, http://www.paintingperceptions.com/wp-content/uploads/2011/07/Walter_Murch.pdf.

64 Theodore Waddell, "Music History," email to Rick Newby, June 2, 2015.

65 Theodore Waddell, quoted in Joan Melcher, "Into the Horizon: A look at the mind, motivations, and work of a Montana artist: Theodore Waddell, 1960–2000," The Montanan, Summer 2002.

66 Theodore Waddell, letter to "Dear Family," September 24, 1962, in artist's possession.

67 Theodore Waddell, letter to "Dear favorite Mooma and family," no date, in artist's possession.

68 Theodore Waddell, letter to "Dear Dad," November 10, 1962, in artist's possession.

69 Theodore Waddell, letter to "Dear favorite Mooma and family," undated, in artist's possession

70 Theodore Waddell, email to Rick Newby, June 2, 2015.

71 Theodore Waddell, letter to "Dear Family," May 20, 1963, in artist's possession.

72 Theodore Waddell, letter to "Dear Family," June 3, 1963, in artist's possession.

73 Theodore Waddell to "Dear Mooma, Dadio, & Boy chaser," April 18, 1963, in artist's possession.

74 Theodore Waddell, email to Rick Newby, February 22, 2013.

75 Campbell Robertson, "Ibram Lassaw, 90, a Sculptor Devoted to Abstract Forms," New York Times, January 2, 2004, http://www.nytimes.com/2004/01/02/arts/ibram-lassaw-90-a-sculptor-devoted-to-abstract-forms.html?_r=0.

76 Waddell, oral history (self-interview), Segment 5.

77 Theodore Waddell, letter to "Dear Family," July 16, 1963, in artist's possession.

78 Theodore Waddell, letter to "Dear Family," September 2, 1963, in artist's possession.

79 Waddell, oral history (self-interview), Segment 5.

80 Theodore Waddell, letter to "Dear Family," July 16, 2016, in artist's possession.

81 Waddell, oral history (self-interview), Segment 6.

82 Ibid.

83 Theodore Waddell, letter to "Dear Dad," June 30, 1964, in artist's possession.

84 Theodore Waddell, letter to "Dear Family," July 13, 1964, in artist's possession.

85 Waddell, oral history (self-interview), Segment 6.

86 Ibid.

87 Judy Franklin, "'Haven' on 34th," Billings Gazette, ca. 1966.

88 Waddell, oral history (self-interview), Segment 7.

89 Waddell, Newby interview.

90 Waddell, oral history (self-interview), Segment 8.

91 Ibid.

92 Donald Judd, "Specific Objects," in Judd, Complete Writings 1959–1975: Gallery Reviews, Book Reviews, Articles, Letters to the Editor, Reports, Statements, Complaints (Halifax, Nova Scotia/New York: The Press of Nova Scotia College of Art and Design/New York University Press, 1975), 181.

93 Waddell, Newby interview.

94 Waddell, oral history (self-interview), Segment 8.

Theodore Waddell. *Self Portrait, New York*, 1962. Oil on canvas,
11 × 13 in. Collection of the Yellowstone Art Museum, Billings, MT.

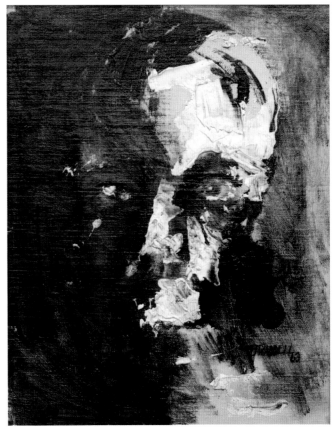

Theodore Waddell. **Head of a Man**, 1963. Oil on canvas, 8 × 10 in. Collection of the Yellowstone Art Museum, Billings, MT.

Theodore Waddell. **Head of a Man #2**, 1963. Oil on canvas, 8 × 10 in. Collection of the Yellowstone Art Museum, Billings, MT.

Theodore Waddell. *P. 5 (Black, White, Gray)*, 1966. Oil on canvas,
48.5 × 36 in. Collection of the artist.

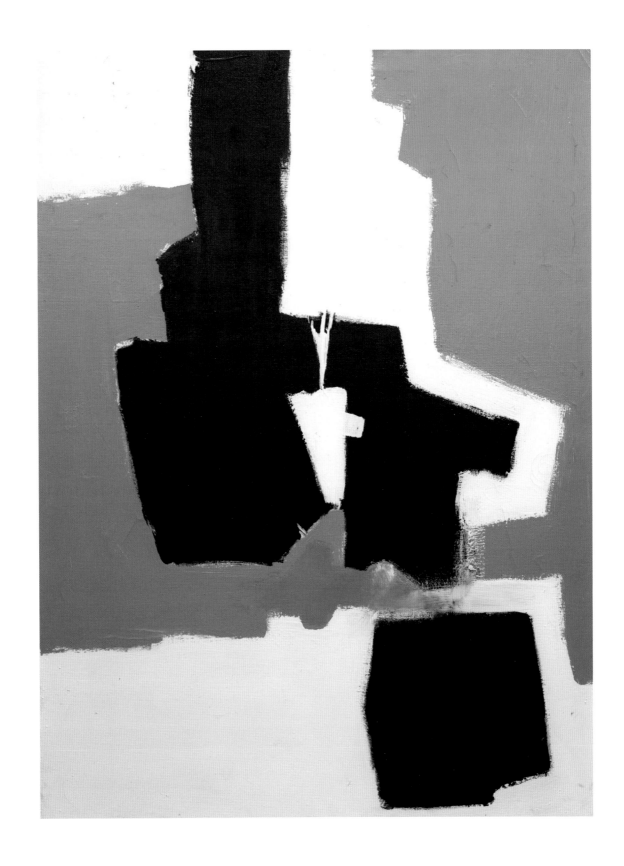

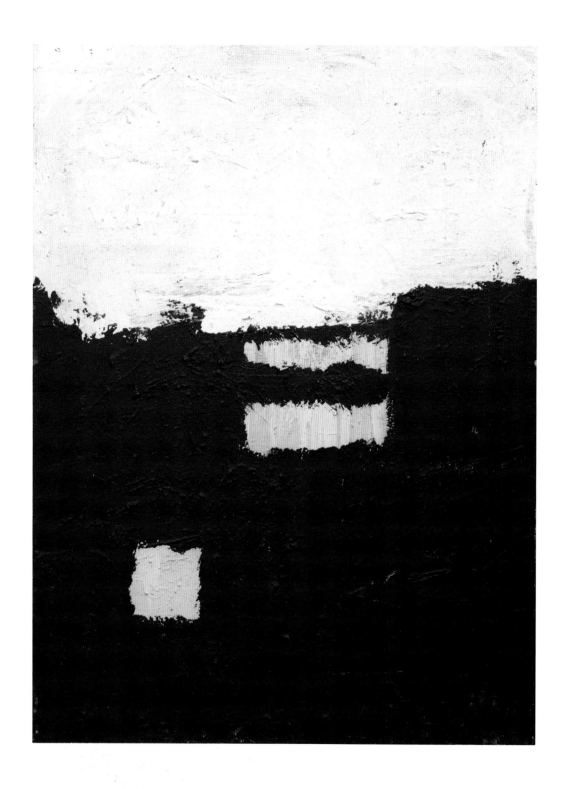

Theodore Waddell. *P. 15*, 1966. Oil on canvas, 32 × 27.25 in.
Location unknown.

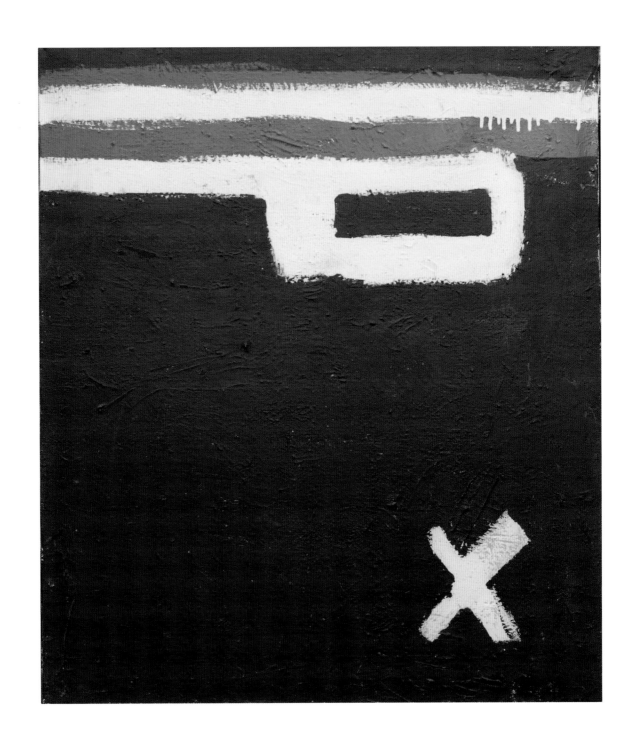

Theodore Waddell. *P. 16 (X One)*, 1966. Oil on canvas, 28.5 × 24.25 in.
Collection of the artist.

Theodore Waddell. *P. 18*, 1966. Mixed media and oil on plywood, 38 × 50 in. Location unknown.

Theodore Waddell. ***Untitled (Used Engine Parts Collage)***, ca. 1966. Mixed media and oil on plywood, dimensions unknown. Location unknown.

The Teaching & Sculpting Years

Theodore Waddell. *Untitled (four-part steel relief)*, 1973 [detail]. Stainless steel, 24 x 24 in. each. Collection of the Missoula Art Museum. Gift of Walter Hook, 1982. Photograph courtesy of the Missoula Art Museum.

The telegram Theodore Waddell received advising him that he had been hired as a visiting instructor in art at the University of Montana, May 3, 1968. Waddell Family Collection.

Ted Waddell with his daughter Arin, two years old, 1970, Missoula. Waddell Family Collection.

When I began teaching, I had no experience at the college level. I suppose that I fell into teaching as do most art people. Having no market for my work, teaching offered a maximum of money for a minimum of time. At any rate, I set out to alleviate some of the objections that I had experienced as a student. I was opposed to the restrictions placed upon me as an undergraduate. I was opposed to the lack of interest shown me by instructors.

—Theodore Waddell[1]

In the summer of 1968, Theodore and Betty Waddell, together with their infant daughter Arin, born in April of that year, pulled into Missoula so Ted could begin his teaching job at the university. As the telegram sent by Charles Bolen, dean of the University of Montana School of Fine Arts, specified, Ted was being hired as a visiting instructor in art. "I arrived in Missoula, hired to teach sculpture and design for $7000, a huge amount

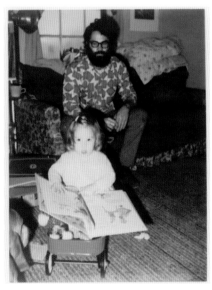

or so it seemed to me. I didn't have any money, so I built outhouses and stacked hay that summer—a come-down for a newly minted MFA."[2] He recalls that, in stacking hay, he worked alongside the farmer's wife, "who was a little tiny woman who weighed about 98 pounds soaking wet and I would have quit except I was too ashamed to admit it was a lot of work."[3]

The Waddell family found a farmhouse in Frenchtown, west of Missoula, with a garage that Ted could turn into a studio, and he started teaching sculpture that fall. He recalls, "The sculpture department wasn't much of anything so the whole tool box . . . tool supplies and whatnot . . . you could put in a medium-sized cardboard box. So it was uphill from there." The resources for his design courses were equally limited: "There wasn't much available during that time period—the only actual book dealing with design was a thing called *Scott's Design Fundamentals* [by Robert Gillam Scott], which had been published in about 1929. So you sort of had to make it up on the fly." Teaching at the college level was new for Ted, and he recalls, "I was so nervous about it that on some days when I would be ready to go to school I would almost throw up out of nervousness."[4]

Theodore Waddell was fortunate in his colleagues. He soon met ceramic sculptor Rudy Autio (1926–2007), as well as printmaker Don Bunse (1934–1994), who had been instrumental in the development of the collagraph print with Glen Alps at the University of Washington. "Both [Autio and Bunse] had great humor and we became lifelong friends." Ted's friendship with Rudy Autio was particularly important. He remembers, "Rudy and I shared an office in the sculpture building—just ceramics and sculpture. It was one of the most special times in my life. Rudy was unbelievable, the most kind and unassuming, and most talented person I have ever known."[5]

Waddell also loved and admired Rudy's wife, Lela, a fine painter and mixed-media artist in her own right. Ted says, "[Lela was] a real pistol. She was . . . the driving force, I think, that kept Rudy pretty much on the 'straight and narrow' most of the time, unless

Theodore Waddell (left) relaxing on the lawn at the University of Montana with friend and colleague Don Bunse, a printmaking professor. They were watching students build a huge piece of sculpture on the lawn in front of the sculpture facilities. Waddell Family Collection.

Theodore Waddell's good friend and mentor, the ceramic sculptor Rudy Autio, in his studio at the University of Montana, 1970s. Waddell Family Collection.

we happened to stray off here and there, which we did."[6] In 2015, Lela Autio (1927–2016) and Theodore Waddell would both receive the Montana Governor's Award for the Arts for their many contributions to Montana's cultural life. Rudy Autio received the very first Montana Governor's Award in 1981.

A native of Butte, Montana, Rudy Autio has been celebrated for many things: as a seminal force in the launching of a modern ceramic tradition that has successfully blurred, even erased, the line between craft and fine art; as a founding artist (with Peter Voulkos) of the Archie Bray Foundation for the Ceramic Arts, Helena, Montana, one of the great centers for ceramic creativity in the world; as the creator of significant works of public art in Montana and beyond; and as an influential teacher whose students have carried the torch of ceramic modernism throughout the United States.

Because of his importance in the ceramics field, Autio drew, in Waddell's words, "all of the best artists . . . to the University—Jim Melchert, Patty Warashina, Paul Soldner (1921–2011), Jim Leedy, and many, many others including Pete Voulkos, a close friend of Rudy's who also befriended me. Pete would come to town off and on and visit and then go to the Archie Bray Foundation to do workshops with Rudy and others."[7]

At the time that Ted Waddell encountered him, Rudy Autio was dividing his time between making the abstract expressionist pots that had helped establish his reputation in the 1950s and fulfilling commissions for large-scale bronze, concrete, and steel sculptures. He was just beginning to contemplate a move away from abstraction and a return to the figure, a direction he would fully embrace by the late 1970s. Upon these works of his maturity—large stoneware (and sometimes porcelain) vessels—Autio would paint lovely

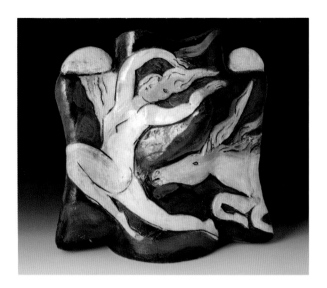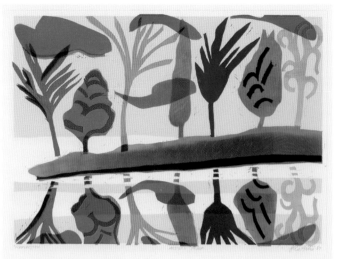

and colorful dreamscapes where women cavort and horses gambol within an impossible, joyous space. This return to figurative work would parallel, in some ways, Theodore Waddell's own return to painting and his embrace of representation within abstraction in the later 1970s.

By 1983, when the University of Montana's School of Fine Arts, the Yellowstone Art Center, and the Montana Historical Society hosted a midcareer retrospective for Rudy Autio, Ted Waddell offered this appreciation of his friend, colleague, and mentor in the exhibition catalog:

> Rudy has developed his own tradition over the years. Because of his . . . commitment to his own personal vision, he has seemed at times to be very traditional when viewed within the context of the changes in sculpture and painting, especially during the sixties and seventies. Primary structures, simplification, and color field paintings were some of the so-called changes taking place. If you look at Rudy's pots, it was all there, all the time.[8]

This appreciation for Autio's independence and devotion to personal vision echoed Waddell's sustained interest in artists like Walter Tandy Murch who were similarly unclassifiable and happily impervious to trends.

At the University of Montana, Theodore Waddell continued to develop the approach to steel sculpture he had begun to explore at Wayne State, especially under the influence of Donald Judd. He recalls, "I made lots of sculpture during those years, with commissions here and there around the state. I have no idea where most of my work went, about 200 pieces over a 20-year period."[9] In 1969, Waddell's old friend Terry Melton, who

Theodore Waddell. **Untitled [four objects]**, 1969. Stainless steel and brown paint, 18 × 24 in. ea. Collection of the artist.

Theodore Waddell. **Untitled**, 1970. Stainless steel and painted steel, 4 × 4 × 18 in. Collection of the artist.

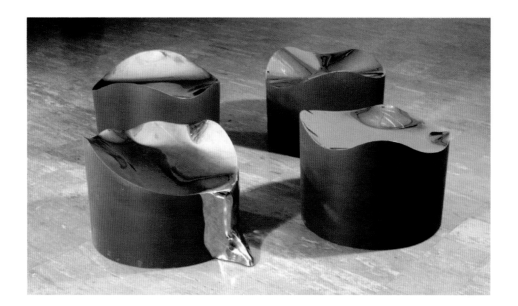

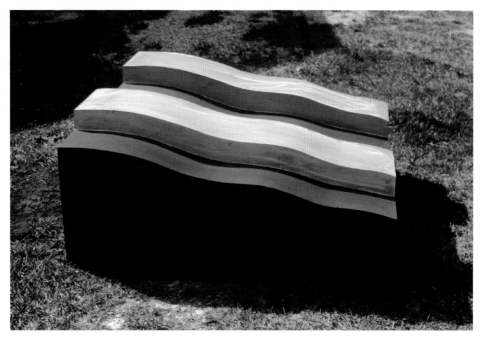

was now the director of the C. M. Russell Museum, hosted an exhibition of Ted's recent sculpture in the Great Falls museum, helping to (re)introduce him to Montana art lovers.

The Waddell family soon moved from Frenchtown to a place in Arlee, "a 10-acre ranchette," on the Salish-Kootenai Reservation, north of Missoula. There, Ted began to work large, with his stainless sculptures stretching as high as twenty-some feet. "When I was making sculpture north of Missoula in those narrow mountain valleys," he remembers, "the scale on which I was working made sense [there]. . . . the pieces would be life-sized to 10, 12 feet high and [their verticality] seemed to fit."[10] His work ethic never

flagged. Despite teaching and family, he managed to "work an average of 10 hours a day 365 per."[11]

In addition to the influence of Donald Judd, Waddell's works of this period show similarities to the *Cubi* series of sculptures by David Smith, created in the early 1960s. Like Smith's stainless *Cubi* works, many of Waddell's sculptures feature circular grind marks that allow their appearance to change under differing light conditions, offering greater surface interest. In Detroit, he had developed his own polishing techniques: "I translated polishing techniques used in re-chroming [automobile] bumpers for use with a hand-held grinder to polish stainless."[12]

Between 1969 and 1977, Waddell would accept commissions in various Montana communities: from his alma mater, Eastern Montana College in Billings (see page 98); Good Shepherd Lutheran Church, Polson; Bozeman Senior High School (see page 102); the city of Great Falls (see page 97); the city of Helena; and the University of Montana (see pages 99 and 103). In one of the earliest articles about his work, he told a reporter that his sculpture on Eastern's campus—erected "In Memory of Those Students, Faculty, Administrators, and Staff Who Faithfully Served Eastern Montana College," weighing 3,000 pounds, and standing twenty-two feet high—embodied the theme of life and death, "best represented (visually) by verticality and by the circle."[13]

Waddell's commissions came not only from Montana patrons. He built a sixteen-foot stainless-steel piece on the campus of Idaho State University, Moscow, Idaho, and in

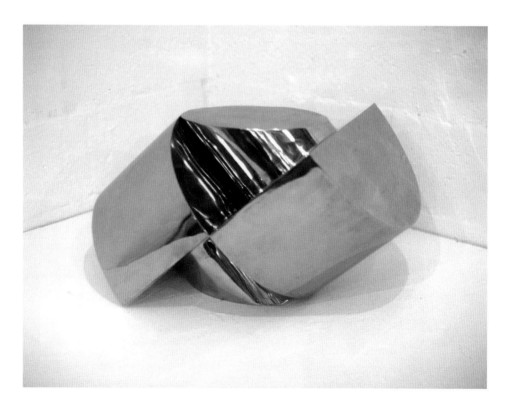

Theodore Waddell. *Untitled*, 1970. Stainless steel, 15 in. high. Collection of the artist.

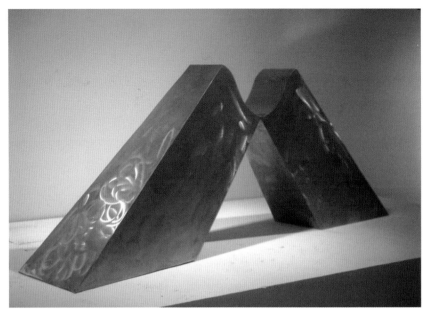

Ted Waddell grinding steel, Missoula, 1970s. Waddell Family Collection.

Theodore Waddell. *Two Part Piece*, 1970. Stainless steel, part A: 29⅜ × 11½ × 2¾ in; part B: 29⅛ × 12 × 4¼ in. Storm King Art Center, Mountainville, NY.

1975, he was commissioned to create a pair of steel works in Arizona, at Phoenix College and Northern Arizona University in Flagstaff (see pages 100-101). Waddell remembers the circumstances:

[Rudy Autio] was always going here and there doing clay workshops. So, I thought that I could do steel workshops. Rudy and I went together to Phoenix and Flagstaff, where he did clay workshops and lectures and I built metal sculptures with student help. I built a two-section, ten-foot-high [COR-TEN] steel piece at Phoenix College in 2½ days and the stainless piece in Flagstaff in the same amount of time. We pretty much stayed up day and night, drinking and grinding steel. At one point, Rudy was helping by grinding the welds. He quit, saying, "Steel is real, wood is good, but clay is the way." That was the end of his grinding.[14]

Even despite his tremendous output and the strength of his work, Theodore Waddell did not achieve the breakthrough he hoped for with his steel sculptures. In 2007, he told Sam Curtis of *Montana Quarterly* that Ivan Karp, owner of the O.K. Harris Gallery in New York, had been interested in his work in 1970, and that Karp initially sold several pieces and then commissioned a big solo show, which Ted worked on for eighteen months. And then, when Karp came out to see the work for the show, he decided, in about three minutes, to cancel the show. Ted told Curtis, "That really almost did me in with art."[15] This refusal must have been absolutely shattering, but at the same time, it can be seen as a key turning point in Waddell's life and art. If he had had the show in New York, and it had sold out, he might never have turned to ranching and then to painting

Theodore Waddell. **_Untitled_**
(torqued form), ca. 1973. Stainless
steel and paint, 43 × 5 × 6 in.
Missoula Art Museum. Gift of Maxine
Blackmer, 2003. Photograph courtesy
of Missoula Art Museum.

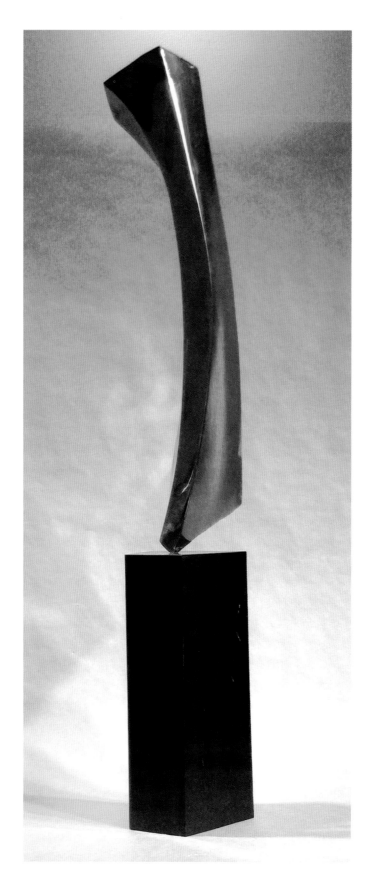

The Waddells' daughters, Arin and Shanna, 1974, Arlee, Montana. Waddell recalls that Arin was in the first grade and Shanna in kindergarten. Waddell Family Collection.

the works that we now think of as quintessential Theodore Waddell—the landscapes with animals.

When he wasn't teaching or making art, Ted Waddell enjoyed living in Arlee. That time, he remembers, "really set me up, at least minimally, to do what I did when I resigned from teaching. It was ten acres and there was a little studio there that I expanded and we had a few cows, and chickens and you know, a pig, this and that, so we learned. It was a good experience—a good place to [raise] my children and get to know the people in the community." Their second daughter Shanna was born in 1970, during their time in Arlee.

Waddell traded welding for calves and other livestock, and he made horse trailers and irrigation pipe trailers for his rancher neighbors. He recalls, "I learned how to weld pretty well . . . so I made a lot of money welding."[16]

At the same time that the Waddells were immersing themselves in the rural experience, Ted was also getting to know the rich cultural life of Missoula. The late 1960s and early 1970s were breakthrough years for the visual arts and literature in Montana. The modernist community that had been slow to grow in earlier decades was reaching critical mass. In Missoula, much of this community building happened in the city's bars and watering holes. Waddell recalls:

We would go to Eddie's Club, where all the artists congregated, drinking and telling stories, and at the end of the evening, to the Oxford [Café] for breakfast. Eddie's Club was legendary. We used to hold graduate orals there in the backroom, and if the student passed, he or she had to buy the first pitcher of beer. Yes, it did happen.

Lee Nye, the photographer and close friend, was a bartender there so I used to take my classes there to draw. Lee did all of the photos of the derelicts who hung out there, fabulous works, over a hundred.[17]

The series of 106 magnificent black-and-white portraits Lee Nye (1926–1999) took at Eddie's Club remains one of the lasting documents of the 1960s and '70s in Missoula. Although, as Ted Waddell notes, most of the images are of "various derelicts, drunks, and whatnot who used to hang out in that area"[18] (Nye's portrait subjects do also include Missoula literary luminaries like critic Leslie Fiedler and poet Richard Hugo), they lent these people on the margins of society tremendous dignity. Nye developed a national reputation, and according to the website that showcases his work, the painter Elaine de Kooning called him "an artist's artist" and purchased four of his prints for her personal collection.[19]

Born in Hysham, Montana, on the Yellowstone River less than one hundred miles from Waddell's hometown of Laurel, Nye became Ted's pool-playing and fishing buddy. In Waddell's recollection:

Lee and I would meet up down there [Eddie's Club] when he was bartending . . . then later on Lee and I would play pool and we were always playing for the Northwest Championship. And the last time I played him in Great Falls on a trip, we did play for the Northwest Championship, I guess, for the last time, and he ran the table on me, and I haven't played pool since. . . .

Anyway, Lee and I used to go fishing together. We would get in the car, either mine or his, and we would drive . . . heading east on the Clark Fork and we would stop along the freeway, because Lee knew all the fishing holes and so Lee was always in a hurry. . . . We'd pull off, and he'd jump over the fence and go and start fishing. So I would start to gather myself together and by the time I was ready to fish, Lee would decide there weren't any fish there. We'd get in the car, have a beer, and go on down to the next hole. . . . We never caught a lot of fish, but we had a great time together.

Also I worked on his car. He had a '55 Chevy that he worked on all the years that I knew him—either on the motor or the body—the body was pretty well hailed out—but the engine was incredible. Ultimately, I bought it from him just because he couldn't stand to work on it anymore and I really wanted it. So I bought it and drove it home and . . . my neighbor could hear me downshift five or six miles away 'cause it had no mufflers on it, just side-runners. But it would do about 135 miles an hour. I finally got rid of it because I decided *I* couldn't work on it any longer and really couldn't afford to. . . .

But it was a great history we had together at Eddie's Club, and fishing and playing pool together and working on his car.[20]

Having studied both literature and visual arts, Lee Nye was just one of the key figures in a Missoula (and Montana) cultural renaissance that focused increasingly on the local and the regional. As Theodore Waddell asserts:

At the same time [as the ferment in Montana visual arts embodied by Rudy Autio, Nye, Waddell himself, and many others], the [UM] English department was equally special. Richard Hugo arrived from Seattle. After him, William Kittredge, Ed McClanahan, Roger Dunsmore, Merrell Clubb, Denny Blouin, and others. Writers in the community were people like James Lee Burke, Annick Smith, and James Crumley (1939–2008). I was very close to Crumley until his death. The writers hung out at the Eastgate Liquor Lounge most of the time although I had many good times with Hugo at Eddie's and at the Milltown Bar. A very vibrant time and we all knew and respected each other. I don't know that anyone knew how special this was until it was over, somehow.[21]

While the emergence of a powerful regional art was a national phenomenon in the last decades of the twentieth century (see Lucy Lippard's *The Lure of the Local*, which traces the rise of place-based art from the 1960s to the end of the 1990s), Montana has had a long and fruitful history of encouraging regional expressions, indeed has been a leader in what one critic called "aggressive regionalism."[22]

In the 1920s, H.G. Merriam, a young professor at the University of Montana—raised a Westerner in Colorado and one of the first crop of Rhodes Scholars—acted upon his belief that Westerners were capable of expressing with distinction their particular experience in this particular place. He sought to nurture this regional expression, both by founding at Montana the second creative writing program in the nation (after Harvard's) and publishing a literary journal, *The Frontier* (later *Frontier and Midland*) devoted to the new Western writing.

In 1928, in an editorial he entitled "Endlessly the Covered Wagon," Merriam stated his intentions for *The Frontier*:

The Northwest . . . needs to show itself spiritually alive. Culturally it has too long either turned for nourishment toward the East or accepted uncourageous, unindigenous "literary" expression of writers too spiritually imitative and too uninspired. We in this territory need to realize that literature, and all art, is, if it is worth anything at all, sincere expression of real life. And the roots for literature among us should be in our own rocky ground, not Greenwich Village dirt or Mid-west loam or European mold or, least of all, in the hothouse sifted, fertilized soil of anywhere. Out of our soil we grow, and out of our soil should come expression of ourselves, living, hating, struggling, failing, succeeding, desponding, aspiring, playing, working—being alive.[23]

Merriam, of course, did not invent literary regionalism. Instead, he was the leader, in the Northern Rockies, of an intellectual movement encompassing regional consciousness—emphasizing regional characteristics over national ones—that had

growing currency during the Depression years. And his intentionality, his drive to create a truly regional literature, bore fruit among talented students like Dorothy Johnson, A. B. Guthrie Jr., and D'Arcy McNickle and among the writers he published in *Frontier and Midland*, writers like Grace Stone Coates, Frank Bird Linderman, and Wallace Stegner.

The 1970s, with its ongoing literary renaissance, represented a second wave of tremendously gifted Montana poets and storytellers. The decade saw the publication of many seminal works in this statewide resurgence: Richard Hugo's *The Lady in Kicking Horse Reservoir* (poems, 1973), *What Thou Lovest Well, Remains American* (poems, 1975), and *31 Letters and 13 Dreams* (poems, 1977); James Welch's *Riding the Earthboy 40* (poems, 1971) and *Winter in the Blood* (novel, 1974); Thomas McGuane's *The Bushwhacked Piano* (novel, 1971); Roger Dunsmore's *On the Road to Sleeping Child Hotsprings* (poems, 1972); James Crumley's *The Wrong Case* (novel, 1975) and *The Last Good Kiss* (novel, 1978); Mary Clearman Blew's *Lambing Out* (stories, 1977); Norman Maclean's *A River Runs Through It* (novella and stories, 1976); Ivan Doig's *This House of Sky* (memoir, 1977); William Kittredge's *The Van Gogh Field* (stories, 1978); Madeline DeFrees's *When Sky Lets Go* (poems, 1978); Dirck Van Sickle's *Montana Gothic* (novel, 1979); and Wally McRae's *It's Just Grass and Water* (poems, 1979). At the same time, Tom McGuane was writing screenplays for films set in Montana like *Rancho Deluxe* (1975) and *The Missouri Breaks* (1976), and Annick Smith produced her important film, *Heartland* (1979), based on the frontier memoir by Elinore Pruitt Stewart entitled *Letters of a Woman Homesteader*.

All of this ferment, this lyrical cacophony of strong voices, with a few exceptions, did exactly what H. G. Merriam had called for back in 1928: these writers were making powerful literature out of "our own rocky ground," using as their materials the living experience of Western, and specifically Montana, men and women. There can be no doubt that this upsurge in an art of the local would have an impact on the thinking and practice of Theodore Waddell.

As his journals reflect, Waddell thought a great deal about his place in the art world. An artist committed to the making of objects, he was skeptical of the "entire development of conceptual art" and the "social-cultural artistic situation that appears to be supporting aimless excessive mental masturbation." He poked fun at conceptual art with the following recipe:

Conceptual Art Kit
20 feet of rope
150 feet of string
Pile of sand (50 lb)—optional—pile of gravel
2 logs 1 in.–3 in. 4–6 ft long
5 sticks—pine, cottonwood, or anything
1 instruction booklet by K. Foster

Instructions: 1. Go down to a local bar with a couple of friends.

A. Option 1 Go any place with anybody or by yourself.

2. Drink enough to be euphoric, expansive, depressed, excited, sad, or indifferent.

3. Think of some neat thing to do that's unique and exciting or mundane.

4. Go home and sober up. Option 1—forget about the whole thing. Chalk it up to beer talk and return your kit to the hobby shop for a refund. Do it anyway because it represents your best thinking.

But he was serious about his critique. Conceptual art, he wrote,

seems to be predicated on the attention given it by the artist community, university community, and critics writing for the periodicals. The widespread dissemination of the so-called importance of the movement is prompted mainly by the critics—most of whom are not artists. Next, you have the university community interpreting the periodicals to their students, thus extending the validity because of the modicum of respect (however minimal) that students seem to have, at times, for professors. So, the perpetuation of the movement, for the moment at least, seems assured.[24]

He acknowledged his prejudice against conceptualism, but went on to ponder the notion of the "object" in relation to shifts in aesthetic philosophy. He wrote, "Changes in attitudes have always resulted in changes in the objects with an interdependent supportive relationship existing between object and attitude. The shift in attitude towards light during the impressionist era to introverted psychological examination with abstract expressionism caused profound changes in the object. Further, minimalism, primary structure, hard edge, op, and pop philosophical positions have had impact on the object."[25]

Perhaps he was contemplating a shift in attitude and a concomitant shift in the objects he created. He certainly, at times, grew weary of academic life. He wrote in 1973:

I'm tired.

I'm tired of faculty who do not work.

I'm tired of faculty who do not work and hypocritically pass judgment on students.

I'm tired of dilettante students who obfuscate their work by inflated rationales regarding their worth. I'm tired of do-nothing students who do not have the energy to make any decision regarding involvement.[26]

In 1983, curator, critic, and painter Gordon McConnell assessed Theodore Waddell's time at the University of Montana. Waddell was, in McConnell's words, "chairman of

Theodore Waddell. *Untitled*, ca. 1974. Stainless steel. Montana Museum of Art & Culture, University of Montana, Missoula, MT. Donated by Ken Little. 1989.01.3. Photograph courtesy of the Montana Museum of Art & Culture, University of Montana.

the sculpture area in the Art Department. . . . a solid part of the system, tenured, tough-minded and challenging as a teacher, massively productive of neo-Minimalist welded steel sculpture. His work was moderately well known; shown from coast to coast and fixed in public places throughout Montana, it represented an informed and honest, if academic engagement with the authority of geometric form and industrial-age fascination with construction, the analysis of the cut, the synthesis of the weld."[27] And then everything changed.

The question remains: Why, in 1976, did Theodore Waddell end his teaching career and even his whole way of working as an artist—and trade teaching and the narrow valleys of western Montana for ranching amid the broad grasslands and island mountain ranges of south-central Montana? Was it because he had grown bone-weary of the academic life? Did he feel that he had exhausted the possibilities for his neo-Minimalist objects? Was he, like his literary contemporaries, seeking an expression more closely related to "our own rocky ground"? Was it simply that new opportunities offered themselves? No doubt it was all of the above.

Ted Waddell has long said that he "always felt that teaching was a contract between the student and the teacher, and if one didn't keep up his end, he should quit." He elaborated:

In '75 and early '76 I felt like I wasn't doing a good job teaching. . . . it was me who wasn't doing a good job. And perversely, I always say that I wanted to get tenure and quit. And so I did quit the year I got tenure. . . . [The university] was a good place for me to be for most of the time, and I had some really good experience with students and not the least of which was Pat Zentz who became a lifelong friend, and still is. . . . And I wanted to do something different . . . and so the opportunity came to take over Betty's family's ranch, west of Billings at Molt. And we spent the summer moving . . . we took, oh I don't know how many trips, lots of trips, to get moved.[28]

1 Waddell, unpublished journal, 1970.

2 Theodore Waddell, email to Rick Newby, February 22, 2013.

3 Waddell, oral history (self-interview), Segment 8.

4 Ibid.

5 Theodore Waddell, email to Rick Newby, February 22, 2013.

6 Waddell, oral history (self-interview), Segment 9.

7 Theodore Waddell, email to Rick Newby, February 22, 2013.

8 Ted Waddell, "Rudy Autio," in Sister Kathryn A. Martin, James G. Todd, Ted Waddell, and Matthew Kangas, *Autio: A Retrospective* (Missoula, MT: University of Montana, School of Fine Arts, 1983), 4.

9 Waddell, oral history (self-interview), Segment 18.

10 Ibid.

11 Waddell, unpublished journal, 1982.

12 Theodore Waddell, email to Rick Newby, February 22, 2013.

13 "Sculpture to be erected," *Billings Gazette*, November 8, 1974.

14 Theodore Waddell, email to Rick Newby, March 30, 2015.

15 Sam Curtis, "On Home Ground: Montana master Theodore Waddell embraces the contradictions of contemporary western art," *Montana Quarterly* 3, no. 3 (Fall 2007), 104.

16 Waddell, oral history (self-interview), Segment 12.

17 Theodore Waddell, email to Rick Newby, February 22, 2013.

18 Waddell, oral history (self-interview), Segment 10.

19 See the website, Lee Nye Imagery, http://www.nyeimage.com/home.

20 Waddell, oral history (self-interview), Segment 10.

21 Theodore Waddell, email to Rick Newby, February 22, 2013.

22 Glen A. Love, ed., *The World Begins Here: An Anthology of Oregon Short Fiction* (Corvallis, OR: Oregon State University Press, 1993), xviii–xix. See also "Reading the Region: Aggressive Regionalism," University of Washington, Center for the Study of the Pacific Northwest website, http://www.washington.edu/uwired/outreach/cspn/Website/Classroom%20Materials/Reading%20the%20Region/Aggressive%20Regionalism/Aggressive%20Regionalism%20Main.html.

23 H. G. Merriam, "Endlessly the Covered Wagon," *The Frontier*, November 1928. See "Aggressive Regionalism: Texts: 4. *The Frontier*," University of Washington, Center for the Study of the Pacific Northwest website, https://www.washington.edu/uwired/outreach/cspn/Website/Classroom%20Materials/Reading%20the%20Region/Aggressive%20Regionalism/Texts/4.html.

24 Waddell, unpublished journal, 1974.

25 Ibid.

26 Waddell, unpublished journal., 1973.

27 Gordon McConnell, "Ted Waddell: Country Flesh and Bones," *ARTSPACE: Southwestern Contemporary Arts Quarterly*, Summer 1983, 22.

28 Waddell, oral history (self-interview), Segment 13.

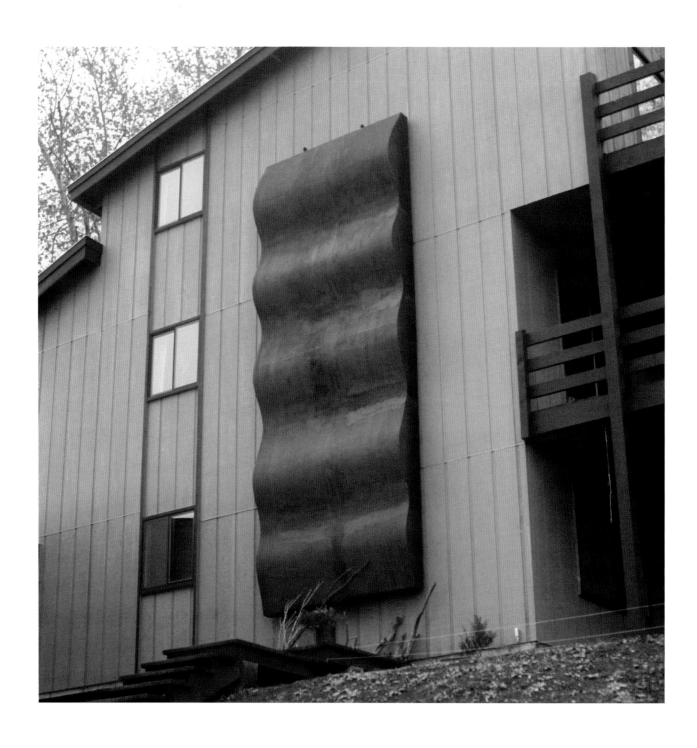

Theodore Waddell. **Untitled**, 1970. COR-TEN steel, 7 × 19 ft.
Private collection.

Theodore Waddell. **Untitled (four-part steel relief)**, 1973.
Stainless steel, 24 × 24 in. each. Collection of the Missoula Art
Museum, Missoula, MT. Gift of Walter Hook, 1982. Photograph
courtesy of the Missoula Art Museum.

Theodore Waddell. **Untitled**, 1975. Brushed stainless steel,
23 × 16 × 24 in. Collection of Arin Waddell.

Theodore Waddell, **Untitled**, ca. 1975. COR-TEN steel, Collection of the Paris Gibson Square Museum of Art, Great Falls, MT. Gift of the City of Great Falls. Photograph courtesy of Paris Gibson Square Museum of Art.

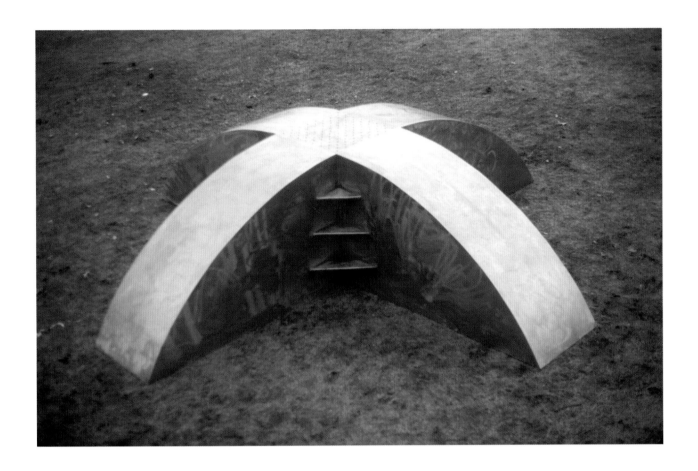

Theodore Waddell. **Untitled**, 1974. Brushed stainless steel; base concrete, 24 × 6 ft. Montana State University, Billings, MT. Photograph courtesy of MSUB University Relations.

Theodore Waddell. **Playground Slide**, 1974–1976. Brushed stainless steel, 3 × 12 × 12 ft. University of Montana, Missoula, MT. Photograph courtesy of Montana Museum of Art & Culture, University of Montana.

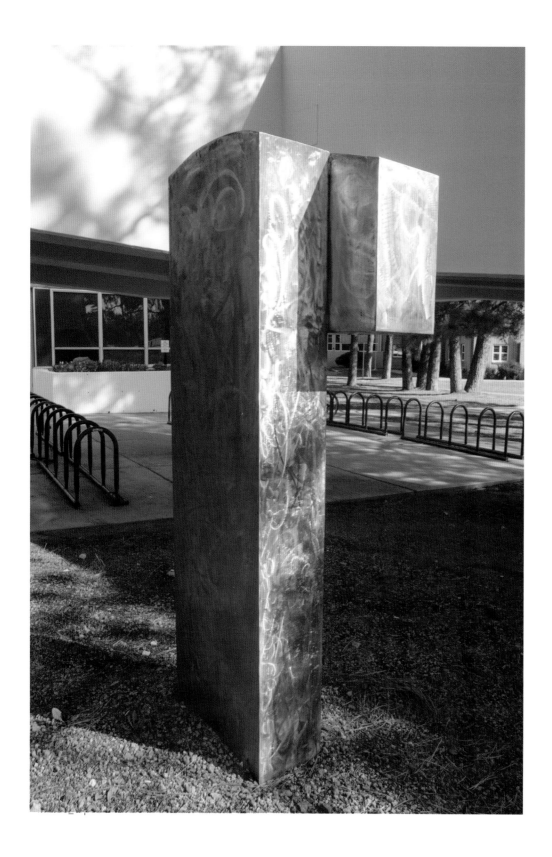

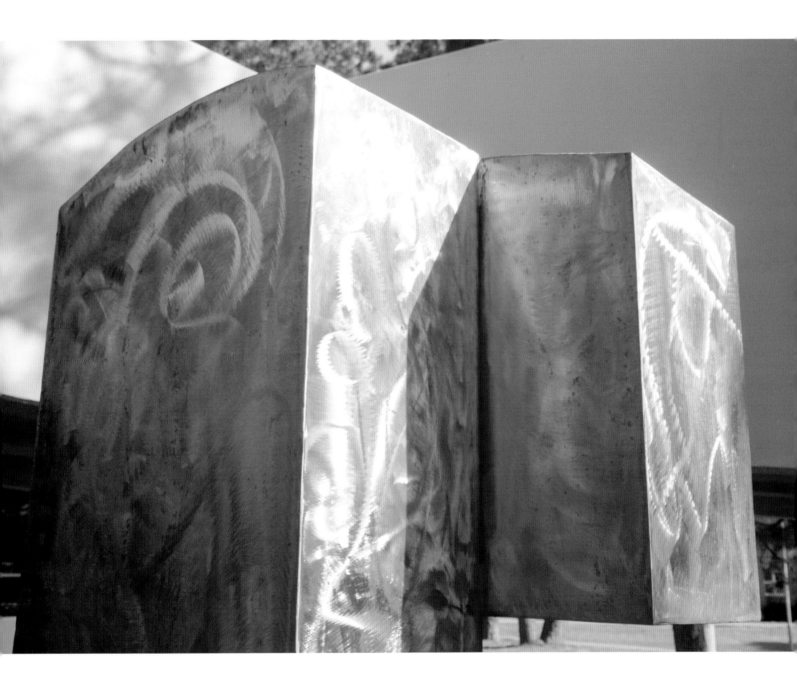

Theodore Waddell. **Untitled**, 1975. Brushed stainless steel, 86.5 × 33.5 × 23.5 in. Northern Arizona University, Flagstaff, AZ. Photograph by David Slipher, Slipher Photo.

Theodore Waddell. **Untitled** (detail), 1975. Brushed stainless steel, 86.5 × 33.5 × 23.5 in. Northern Arizona University, Flagstaff, AZ. Photograph by David Slipher, Slipher Photo.

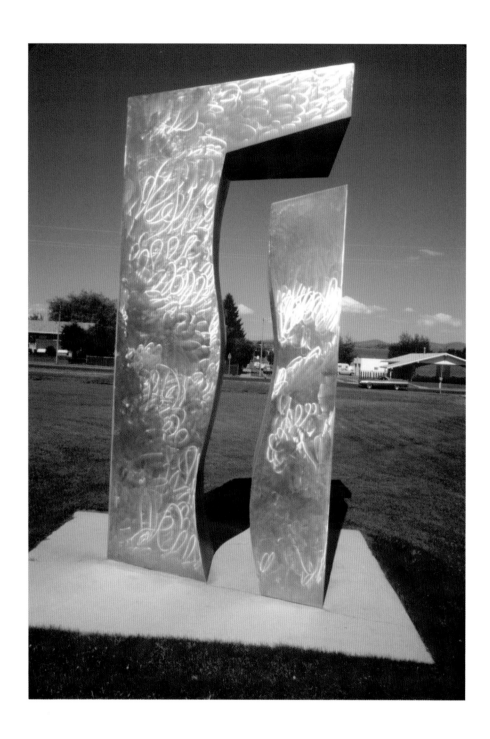

Theodore Waddell. **Untitled**, 1975. Brushed stainless steel, 12 ft. tall. Bozeman High School, Bozeman, MT.

Theodore Waddell. **Persistence**, 1976. Brushed and non-brushed stainless steel; base concrete, 5 × 6 ft. University of Montana, Missoula. Photograph courtesy of Montana Museum of Art & Culture, University of Montana, Missoula, MT.

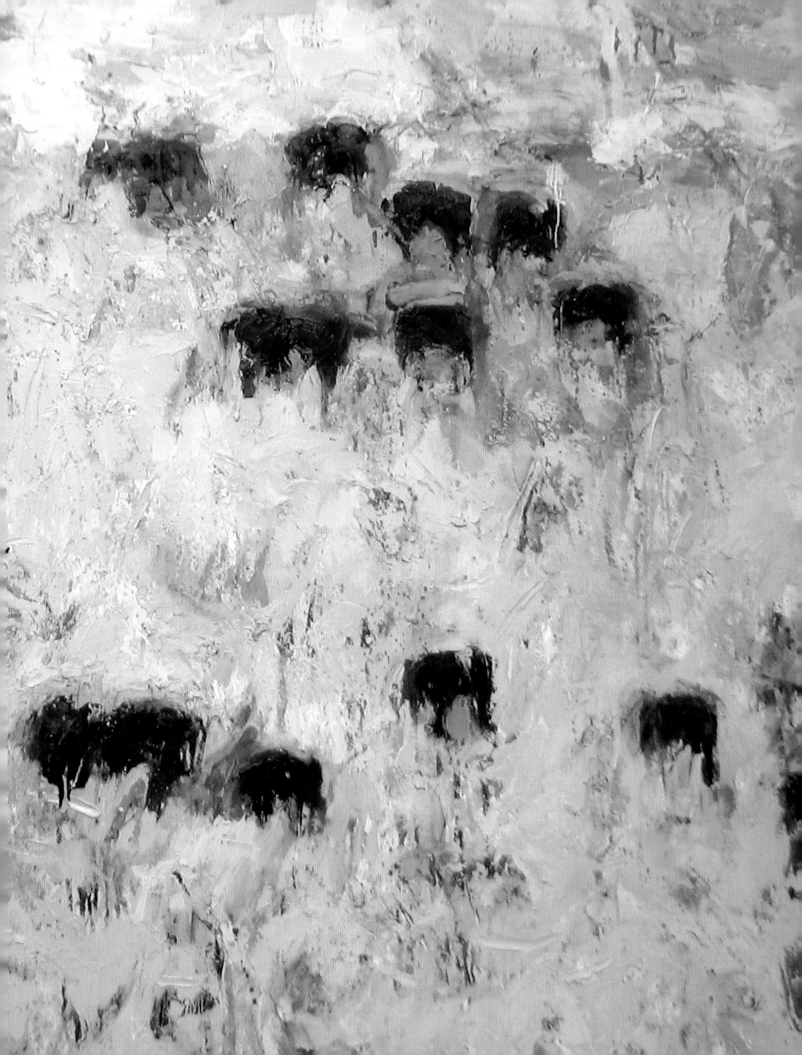

The Ranching & Painting Years

Living in Montana is not merely existing; it is a vital experience. It is difficult to survive here, requiring a special kind of person. The weather, isolation, and geography are tough, individual, and independent. In spite of the odds, Montana artists have survived. One need only . . . witness the broad variety of work to feel the strong character of the land, which has helped to shape the nature of each response. I am proud to be part of this response.

—Theodore Waddell[1]

[T]he most important American experiences in the new art were tied to the landscape as it looked in the most desolate regions, where the grand scale is inevitable and where the freedom to measure oneself against something other than the art of civilization is manifest and real. The new art is the result of the new scale. The gaze of the artist has strayed out of the city and out of the museum space. . . . The world has grown larger.

—Eric Steffensen[2]

As Ted and Betty Waddell and their two young daughters settled into life on the Leuthold OK Ranch near Molt, Montana, they faced enormous challenges. Despite his childhood jobs working alongside his farmer neighbors and his time in Arlee, where the Waddells kept a few cows and chickens, Ted recalls, "We had no experience particularly. . . . Nothing prepared us for this."[3] He also remembers, "The locals thought we were egg-headed intellectuals as per my experience as well as that of my ex-wife, Betty, who has a PhD in experimental psychology."[4]

The Waddells were now faced with running a real ranch. The scale of things, in every respect, must have overwhelmed them. Nevertheless, in Waddell's words, they "learned to run cattle and got to be very good at it. We hayed 800 acres and had about 600 acres in grain, plus pasture. At the end . . . I competed with all of the locals and beat them with weaning weights and production per acre."[5] As he saw it, by taking on the ranching life, he had returned to his roots.

FACING PAGE
Theodore Waddell. *Jatte's Angus #2*, 1995 [detail]. Oil on canvas, 75.5 × 76 in. Collection of the Missoula Art Museum, Missoula, MT. Gift of Miriam Sample, 2007.

Waddell found life on the ranch difficult at times, but he soon learned not to complain too loudly. As he recalls, "I met Adam Thompson [a neighboring rancher] one day a couple years after we'd been there and I asked him how things were going and he said, 'OK,' and I was kinda complaining about stuff and he just looked at me and kinda grinned and said, 'Well, you know it was pretty tough for the first thirty years, or so, but it got easier after that.' Boy, that shut me up."[6]

In establishing a herd, Waddell recalls,

We bought black cows . . . Black Angus cows . . . because after researching them as much as we could we discovered because of their dark pigmentation that they didn't get blister-bag, or cancer-eye, like the lighter pigmented Hereford cows. I did after a while run Hereford bulls on these black cows and we ended up with what they call a Black Baldy . . . a black/white face cross. Very, very healthy good hybrid figure and did very well for us. I loved the black cows.[7]

* * *

I love winter. I don't know why, quite. I think it must have something to do with the notion of surviving and the notion of purification, perhaps. Maybe it makes spring all that much more sweet.

—Theodore Waddell[8]

The Waddell ranch house at Molt. Waddell Family Collection.

Ted and his truck. Waddell Family Collection.

Winter became Waddell's favorite season on the ranch. He has written:

[Artist and rancher] Bill Stockton used to call January and February the "aesthetic months" because all we had to do during that time period was to keep the cows alive and keep them fed and watered. And so we could work at our art a fair amount. . . . It really was a marvelous time.

Snow and winter changes everything. Your perception is changed, your behavior is changed. Everything. And it provides a good excuse for not doing something if you don't want to do it. You can always say, "Well, there's too much snow." We lived in that country west of Molt for eleven years. At one point we were snowed in for 30 days, and so we made our way over the top of ridges and used snowmobiles.

Winter on the high plains provided plenty of challenges. Waddell recalls a pair of unnerving winter adventures:

Waddell's cattle, "200 mommas," in the corral at Molt. They were Black Baldies, the result of crossbreeding between Herefords and Aberdeen Angus. Black Baldies are noted for their excellent mothering skills and their resistance, because of their black bodies, to sunburn. Waddell Family Collection.

Theodore Waddell: Life & Work

I had bought a tractor—traded my house for a tractor, and I didn't have enough sense to buy chains for this tractor, so I'm down trying to pick up hay . . . a mile away, and I got my tractor stuck. And my daughter, Heather [Arin], was with me, and we decided to abandon the tractor and walked home in the snow and the blizzard, and the last three or four hundred yards, I wasn't sure I could make it. I was carrying her piggyback and the snow was about two-and-a-half feet deep. So we slogged through the snow and we got home OK.

Later, when I was calving, we would be out looking at the cows that would be close by in the small pasture and the blizzard would come up, and the only way I knew how to get home is I found the fence and I followed the fence around to the house because I couldn't see anything. Because I had fixed that fence off and on for a number of years, I knew where I was. It was still pretty scary.

If you were willing to work long and hard enough, spring could be prime aesthetic time as well. Waddell recalls:

In the spring, the early spring, when we were calving heifers, I would get up at 2 a.m. to check the heifers and then stay up and paint. Often, I would paint seven, eight, or nine hours before most people were out of bed or doing much. And that was pretty special for me, too. I don't do that anymore, but it was really grand years doing that on the ranch.[9]

* * *

It was a very idyllic childhood.

—Arin Waddell[10]

The Waddells raised their two daughters on the ranch, and as Arin Waddell—who became an artist like her father—has said, "You learn that as farmers and ranchers, some years are bad and some years are good. You just have to be persistent, work hard, and stay humble."[11] Daughter Shanna, who is now a curator and art historian, recalls her father's tremendous work ethic, both the hard, physical labor of ranch work and the more intro-spective labor of rising early each morning to paint before taking on the myriad ranching tasks.

The Waddells sought the best education for their daughters. In Ted's recollection, "The closest town to us was 10 miles away at Molt, a population of 32. And my kids went to school there, and the first year there were about 12 kids, one teacher, and she taught kindergarten through 8th grade. It was a great year for them. The second year my two were the only two in the school" and so the Waddells pulled their daughters out and tried homeschooling. County officials told them, in Ted's words, that "we were not qualified to

do that, even though Betty had a Ph.D. in experimental psychology, and I had an MFA in art. So we moved them to Rapelje which was a 21-mile bus ride one way. . . . There were 65 students from 1st grade through 12th grade. The class size was 3 to 5." Eventually, the Waddells bought a house in Billings, and the girls "moved from 65 students to 2,300 at Billings West High," from which both daughters graduated.[12]

<p style="text-align:center">* * *</p>

Work and family life on the ranch were deeply engaging, but they never foreclosed the possibility of making art, even in the busiest months. In fact, when Theodore Waddell first came to the ranch near Molt, he had a commission to complete. His client was the city of Helena, Montana, and the work was quite different from his sleek and soaring stainless-steel pieces that adorned the campuses of Eastern Montana College and Northern Arizona University. Already he was making a turn toward a more organic and earthy approach.

Unlike those highly polished vertical steel works, this new large-scale horizontal sculpture's "steel form [was] textured with brass, copper, stainless steel, and nickel,"[13] representing the minerals taken from Helena's famed Last Chance Gulch. Variously called the *Mountain Fountain* or *Mount Helena* (after the capital city's iconic mountain), the work, fourteen feet wide and nine feet tall, was intended for the new Walking Mall in downtown Helena, part of an urban renewal effort.

Waddell's sculpture-in-progress drew the attention of the *Stillwater News*, from nearby Absarokee, Montana, which ran a feature story about its creation on July 21, 1977. Clearly, the novelty of having a local rancher at work on a site-specific sculpture helped connect the Waddells to their new neighbors. The reporter noted, "When we visited the

Shanna, Betty, and Arin Waddell with Sophie, the basset hound, 1985. Waddell Family Collection.

Arin Waddell on her horse Muffin, Molt, ca. 1986. Waddell Family Collection.

In his Molt studio, Theodore Waddell works on the commission, *Mountain Fountain*, for the Helena, Montana, downtown walking mall, 1977. *Mountain Fountain* now resides on the grounds of the Federal Reserve Bank of Minneapolis, Helena Division. Waddell Family Collection.

Article in the Helena *Independent Record* announcing the installation of Waddell's *Mountain Fountain*.

A crane lifts the Mountain Fountain into place. (Staff photo by Randy Mills)

Mount Helena moves to the downtown mall

sculpture, it was almost complete and neighbors from the area were stopping by to see the thing work after observing its progress and some even helping on its work for the past year with a mixture of awe and incredulity."[14]

Creating the fountain while running a ranch underscored the challenges of doing both. The *Stillwater News* quoted Waddell: "At first, things went pretty smoothly. I was putting in a lot of hours and I had the farm to keep up, but I had it pretty well scheduled so I could go back and forth between the two." But then, the hay crop ripened two weeks early, and Ted had to drop everything to harvest the hay and ask for a month's extension on his contract. "After that," the *News* reported, "it was 18-hour days trying to catch up, improving the water system, and adding new dimensions to the mountain's contours so that the right . . . runoff effects were achieved." With 60 gallons per minute running down its sides, and 700 gallons recycling through the piece, the *Mountain Fountain* was "designed for people to cool their heels in, wade in, and if they're small enough they can probably swim in it, too."[15]

With the *Mountain Fountain* complete, Ted Waddell turned his artistic focus away from steel sculpture (with the occasional exception; see *Feed Block*), completely reorienting his conception of what art—both two-dimensional and three-dimensional—should be.

* * *

I have always loved this country, big time. It's full of plains, and cottonwoods, and scrub pines, and coulees, and valleys and then you can look west and see the mountains. And you can look east, or north, and see for a hundred miles. Human-scale sculpture made sense in [the narrow valleys of western Montana] but when we moved to the high plains west of Billings in '76, human scale didn't make sense. . . . So, I went back to drawing to start with and then painting.

—Theodore Waddell[16]

The drawings that Waddell began to make during this time explored the "relationship between the sky and the horizon, looking out east in the morning when the sun came up." He recalls, "while I was having my coffee, I would look east and see the Adam Thompson buildings and so I did some drawings called 'New Thompson Sunrise'" (see pages 112, 149–151). These small drawings, completed between 1977 and 1980, shared qualities—combining "economy of form and neatness of surface with fullness of color"[17]—with the hard-edge painting movement (part of the minimalist impulse), which began in the early 1960s in California in reaction to the looseness and excess of expressivity in abstract expressionism.

Waddell's younger daughter Shanna recalls those first years at Molt, describing his studio:

A converted car garage with a large adjoining auto shop, the space was necessitated by large farm equipment and inevitable repairs. I remember the small studio being very

Theodore Waddell. *Molt Series: New Thompson Sunrise Drawing #2*, 1977. Oil on paper, 15 × 22 in. Collection of the artist.

cold and I know my father painted in his Carhartt jacket, winter overalls and wool hat. The only heat came from the wood-burning pot-bellied stove.

The small horizontal windows of the garage door faced east across the plains toward Adam Thompson's buildings two miles away. Each day Dad welcomed the rising sun. The early morning sunrise paintings of those years illustrated the stark, flat horizon line of the dry-land farm. Sky was the artist's subject and the composition contrasted the dark rich earth beneath the pink sunrise above. Learning from the French Impressionists, Dad emphasized light and its changing qualities.[18]

By the late 1970s, Waddell had begun to show this new body of work. The Custer County Art Center (now the WaterWorks Art Museum) in Miles City, Montana, was among the first venues to invite him to show his new drawings and paintings in a group show (see Mark Browning's essay in this volume, page 215). The next year, both the Yellowstone Art Center and the Paris Gibson Square, Great Falls, offered him solo exhibitions. Always in a hurry, Theodore Waddell was well launched as the creator of distinctive landscape drawings and paintings, far indeed from the steel sculpture of only a few years earlier.

In an important 1981 essay written after he'd been on the ranch for four years, Ted Waddell talked about his efforts to adapt philosophically and as a working artist to his new environment:

The most critical characteristic of living on the high plains is the horizon line. I believe this is true everywhere, but it is unavoidable here. Even though the horizon line is constantly changing, we fix it, I think, in order to give ourselves perspective, trying to orient ourselves in space. One can walk to the horizon that one sees, and it is no longer there but has changed. You can walk over the ground that you farm, but when you step back, it changes.

The intersection between the sky and the ground that forms the horizon line is difficult to handle. Intellectually we know that the line formed by this intersection is not really a line. This is confirmed physically as we move over the landscape. Because our relationship to the intersection seems to be constant, we tend to fix it both physically and emotionally.

In attempting to handle the other part of this intersection, the sky space, we tend to use colors and symbols. Again, we know intellectually that the sky space is not flat or hemispherical but deep, open, unending. In order to manage this, we convert it into terms with colors and with spheres to represent the sun and moon.

How do we deal with the sensation of this relationship? Necessarily we must alter the space into manageable terms—most of the time, a rectangular format. This is very frustrating and, at the same time, challenging. As an artist, I'm not sure that using a very large canvas or piece of paper would be any more effective in my attempts to understand and record my response than the modest sizes I am using. I do know that the urge to make large scale pieces is strong. It seems as if the scale and space require it.[19]

The hard-edge, oil-on-paper horizon drawings were most often only 15 x 22 inches, but by 1982, Waddell had begun to work considerably larger. In the mid '80s, some of his canvases were as large as 72 x 90 inches (6 x 7.5 feet). Size wasn't the only change. He felt that the hard-edge works were not capturing everything he wanted to say, and as he looked around him, he found that the "organic notion of the plains and ranch"[20] made him want to alter his entire approach, to a radically more expressionist style related to the works of his early heroes Motherwell, Kline, and Pollock—precisely the antithesis of hard edge.

What was Ted Waddell seeing and feeling that led him to this decidedly nonminimalist expression? The key, as it turned out, were those black cattle that the Waddells had recently purchased for their herd. He notes, "I once started looking at them in terms of

Poster for one of Waddell's first solo exhibitions—at Paris Gibson Square Museum, Great Falls, Montana—after his return to painting in the late 1970s.

Granaries on the ranch at Molt. Waddell Family Collection.

Theodore Waddell. *Angus #12*, 1981.
Oil on canvas, 30 × 48 in. Collection
of the Yellowstone Art Museum,
Billings, MT.

Robert Motherwell and saw these blobs kinda emerging out of the snow. So that was the beginning of the entire painting activity for me . . . and [it] has continued until this day."[21] As he said in 2013, "The animals in the landscape give a focus to it that cannot be understood in any other way. . . . I have done some just straight-up landscapes, but the animals somehow for me cause an excitement, and then an intensity, and a clarification I don't see any other way of doing. And I still feel that way."[22]

Theodore Waddell's response to the wide-open Western landscape had clear parallels in the notions and visions of the abstract expressionists who so impressed him during his Brooklyn stay. As Betty Parsons, the "den mother of Abstract Expressionism" who worked for Ted Waddell's mentor Mortimer Brandt in the 1940s, once said, "[Jackson] Pollock released the historical imagination of this country. I've always thought that the West was an important factor in the art of the 1940s and 1950s here. Pollock came from Wyoming, Clyfford Still grew up in North Dakota, and Rothko in Oregon—all those enormous spaces. They were all trying to convey the expanding world."[23]

Even Robert Motherwell, Waddell's favorite abstract expressionist, came from the West. Born in Aberdeen, Washington, and raised in the San Francisco Bay Area, Motherwell told the *New York Times* how the northern California landscape impacted the colors—"yellow ocher, vermilion, orange, cadmium green and ultramarine blue"—he used in his paintings. The Bay Area, he said, was "on the same meridian as Barcelona and northern Greece, and with the same kind of light. It was sunbaked yellow ocher, with arid blue skies, green on the blue ocean, and black, sharp-edged shadows. In that bright sunlight, everything was clear, as in the hill towns of Italy, or Spain in the middle of the day."[24]

Far inland and to the north, Theodore Waddell was inspired by a different West. As he noted in his 1981 essay, "Dealing with Horizons," "The geography of Montana is unique. The topography presents almost violent changes in relatively short distances. On the east slopes of the Rockies, only a few miles separate the high plains space from the mountains." The clarity of the air also skewed one's sense of space. Waddell wrote, "From some points on the ranch, I can see the Crazy, Beartooth, and Belt Mountains, even though we

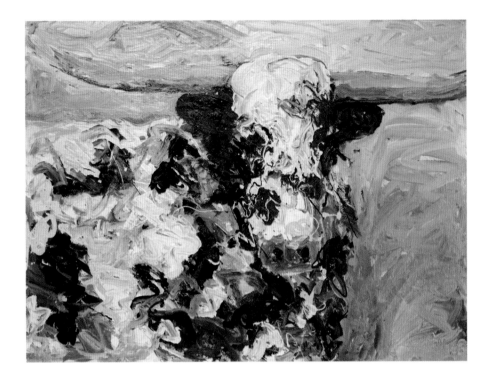

Theodore Waddell. *Longhorn #13*, 1983. Oil on canvas, 36 × 48 in. Collection of the Holter Museum of Art, Helena, MT.

are a long ways from them. This is unique when compared to the views of mountains on the eastern seaboard states. It is also quite different from the aspect of mountains in Arizona; there, I believe that the atmosphere causes the mountains to look like cardboard cut-outs, flat silhouettes."[25]

In the interface between the high plains and the mountains, color had a whole new meaning. During his years in western Montana, Waddell noted, "Color did not concern me . . . because of the dominant green, except for the tamarack (western larch) changing color in the fall. The colors of the plains seem to be more varied and more subtle. The quality of the atmosphere seems to be different here. The colors of the sunrises are different."[26] Working the land, too, brought a whole new perspective. "As a farmer," Waddell wrote,

I have developed a strong respect and feeling for weather and seasonal changes. Everything we do is dependent upon the weather. It seems we spend most of the year preparing for winter and most of the winter preparing for spring. The changes in weather cause visual changes that are remarkable. The winters completely change one's response to the land. Snow reduces the entire landscape to tonal values and, I think, allows one better access to the landforms, as color is not there to divert the attention.[27]

Like many agriculturalists, Ted Waddell felt a deeper connection with place than might those in other, more abstracted or dislocated professions. He declared, "My decision to

Ted Waddell branding cattle with friend and neighbor Don Eklund, Ryegate. Waddell Family Collection.

begin farming . . . was due partially to the growing realization that the environment has a tremendous impact on all that we do—in every context. A farmer learns the physical aspects of the land he works. The information gained is unique to the process, information that one can get only by doing. Learning the characteristics of the ground is both sensual and gratifying, even though it may be hard for some to connect a tractor and tool bar with sensuality. I feel that I am . . . a participant in a marvelous spiritual process."[28] In 1986, he wrote in his journal, "There is a spiritual and physical payback by being at the ranch. Other forms of living are not [as] reciprocal."[29] Another Montana rancher echoed Waddell's sentiments when he told Montana State University professor of architecture Máire O'Neill: "Being located where you've got all the benefits of life that you'd want, and still have the beauty and the mountains and the good and bad in the weather. . . . I don't know where you'd go anyplace and have a better deal."[30]

This profound connection to place and the dailiness of agricultural work is what Montana/Idaho writer Mary Clearman Blew might mean by her phrase "bone deep in landscape," and what Montana novelist and rancher Scott Hibbard has called the "communion of people with land, working in unison, for mutual benefit, where land is shaped by people and people by land. A cause essentially of heart. . . ."[31] This bonding with place—all senses alert and engaged—led to Theodore Waddell's new way of working, in a truly expressionist manner. As he noted in his journal in 1986, "I think that part of the reason that I like heavily textured paintings is that most of my world here is tactile—everything seems to have a texture and a smell all its own—quite unlike much of urban life."[32]

In a 1984 catalog essay on Theodore Waddell's expressionist paintings, Yellowstone Art Center curator Gordon McConnell captured, with great eloquence, the artist's new and singular way of working:

Coming to painting from a background in constructive sculpture, Waddell carries with him a strong regard for the purity of geometric form and the integrity of the plane. His definition of cattle, simplified in their native blockiness, breadth, and stolidity, with wedge-shaped faces and board-like legs as support, is corollary to the essentializing formal tendencies of a sculptor. Waddell also tends, like many other sculptors when they paint or draw, to treat the plane surface schematically, isolating figures on it as if arranging them in a plaza or field. . . .

Working the canvas on a horizontal plane, propped like a table top across saw horses, Waddell practically "farms" the surface, plowing his brushes through layer upon layer of paint. The resulting life in many of the paintings, both metaphorically and literally, comes out of the muck. Nature and the nature of the medium are made to congeal together. The dark breathes and gives off heat, and the light is the hard cold of the high plains, snow fields and icily translucent sky.[33]

In his journal in November 1985, Waddell wrote further about the role texture plays in his paintings—another artifact perhaps from the time when he was so influenced by Donald Judd's notion of the specific object; he was seeking to transcend, to break out of, the limitations of "whatever is on or inside of"[34] the rectangle of the painting:

> One of the reasons that I'm interested in texture is while the canvas draws us in intellectually with the givens—illusion, scale, etc., it has a strong presence as an object. Depending on actual size and presentation, this presence can be emphasized. The use of texture enhances the quality of the painting as an object.
>
> Secondly, all paintings have texture simply because they have a surface. I am trying to make the surface interesting as well as use texture to carry some of the idea just as color and value and structure add to the concept.[35]

Waddell's massively impastoed paintings from this period reflect, as Gordon McConnell wrote at the time, "a sculptor's concern for the object in space, object above all." These paintings with their "layers of paint, the sheer thickness and heaviness of accumulation,"[36] became objects in their own right, rather than mere painterly representations. In his study, *Representing Place: Landscape Painting and Maps,* philosopher Edward Casey says of more sculptural paintings, "the physicality of the representing work, and more particularly the sensuous quality of its surface, is made to subserve the task of representation. . . . the represented place is conveyed *through another place:* the place of the painting itself."[37]

* * *

Theodore Waddell. *Coyote #1*, 1982–1986. Mixed media on canvas, 48 × 72 in. Collection of the artist.

At the same time that Theodore Waddell was incorporating sculptural qualities into his paintings, he had begun a new approach to three-dimensional work—true sculptures—far distant from anything he had done before. On the ranch and on Montana highways, he was continually encountering evidence of death. In the early 1980s, a *Bozeman Chronicle* reporter wrote, "Montana artist Ted Waddell got an idea for one of his latest art series after seeing the corpse of a coyote flattened on the highway. He picked up the body and created a wall hanging around it."[38]

This *Coyote #1* would lead to a whole body of sculptural work over the next thirty-plus years. Waddell's mixed-media sculptures can be broken down into subseries: Roadkill, Body Bags, Trophies, and Guns. As he has written:

My sculpture began with my collecting skulls that were on the ranch property, mostly cow skulls. . . . I began to integrate them into my work as a method of dealing with death and our view of it. Our attitudes toward each other are reflected by our treatment of and response to animals.[39]

While this body of work—with its ironies and rough-and-ready references to death in the rural West—would never draw as much attention as Theodore Waddell's paintings, it has served a vital role in his artistic practice. His paintings can be seen as meditative and even sacred works, painted, as the French scholar François Jullien has written of classical Chinese landscapes, "between 'there is' and 'there is not,' present-absent, half-light, half-dark, at once light–at once dark." Such paintings, writes Jullien, "rediscover a continuous, progressive, nondisjunctive weaving of the course of things." They inhabit us as much as we inhabit them.[40]

In his Molt studio in the early 1980s, Theodore Waddell shows friends his new nonsteel sculptures, including several of the haunting mixed-media works (featuring cow skulls) that he dubbed "Trophies." Waddell Family Collection.

Critic Bruce Richardson captured this quality in Waddell's work when he wrote:

The play of color and paint texture lets Waddell create a sense of place transformed by weather—snow, rain, dust, wind, heat. The land does not just sit for its portrait, but is translated into swirling, atmospheric paint until you cannot distinguish the one from the other. This works especially well in my personal favorite, *Cut Bank Sheep*, which echoes Asian art and the softer color effects of contemporary artists such as Joan Mitchell.[41]

On the other hand, Waddell's mixed-media sculptures, which have been called "Hallowed Absurdities,"[42] are truly profane works, foregrounding the harshness and humor of life. Theodore Waddell once wrote, "Myths that have developed and evolved here in the West would best be described as tall tales. . . . The typical westerner tends to deal with information by exaggeration."[43] And like his grandfather, Waddell continues to enjoy, and participate in, that species of Western humor that, according to folklorist Raphael Cristy, is characterized by "outrageous exaggerations" and "good-natured insults."[44] This is not to say that Waddell's hallowed absurdities lack serious intent. As he told the *Bozeman Chronicle*, "Some of this [roadkill sculpture] is tongue in cheek, but it's stuff you can learn from."[45]

Critics have noted that this body of work bears certain connections with pop art, especially the work of Andy Warhol, and with the raw energies of California Funk. Brian Petersen has written, "The elevation of the mundane to art; the color, stylishness, and audacity; the inescapable suggestion of a send-up or spoof—all are as evident in the trophies and roadkill works as in Warhol's Coke bottles, Campbell's soup cans or the moody, moving Marilyn Monroe post-mortem dreams."[46]

As a Westerner, too, Waddell was no doubt aware of the Funk movement that emerged in the 1960s in northern California. Funk was a powerful force in American ceramic arts,

led by Robert Arneson at the University of California, Davis, but it seems to have had relatively little impact among Montana ceramists, with the exception of Rudy Autio's student, the Native American artist Ben Sams (1945–2002). Waddell's *Writer Trophy*, 1988 (see page 164), though infinitely more gruesome, seems a kind of tribute to Robert Arneson's famed *California Artist*, 1982.

A number of works by Texan Ken Little, Theodore Waddell's colleague at the University of Montana in the mid-1970s, can also be seen as falling within the continuum of Funk art; his animal sculptures of the early 1980s bear some resemblance, at least in feeling, to Waddell's roadkill pieces and trophies. As writer and sculptor Kathleen Whitney once wrote of Ken Little's sculptures: "Westerners have a different relationship to their surroundings than do other Americans. The treacherous landscape surrounding them is in constant opposition to civilized living. . . . The high plains leak into everything; their dust, animal and insect life insist on sharing the territory."[47]

Peter Selz, the curator who in 1962 hosted that first symposium on pop art at New York's Museum of Modern Art, wrote in his groundbreaking 1967 essay on Funk:

Funk is at the opposite extreme of such manifestations as New York "primary structures" or the "Fetish Finish" sculpture which prevails in Southern California. Funk art is hot rather than cool; it is committed rather than disengaged; it is bizarre rather than formal; it is sensuous; and frequently it is quite ugly and ungainly. . . . It is symbolic in content and evocative in feeling. Like many contemporary novels, films, and plays, Funk art looks at things which traditionally were not meant to be looked at.[48]

Gallerist John Natsoulas writes that Funk was "an insurgence against conventional aesthetic values, a reaction to the more serious and regulated art of minimalism; Hilton Kramer called this new work 'dude ranch dada' in a 1971 *New York Times* article on William T. Wiley, titled *Wiley of the West*."[49] As one reviewer of Dennis Voss and Theodore Waddell's 1991 Spokane exhibition, *True Objects and Stories from Two Dot*, pointed out: "The main difference between 'Dude Ranch Dada' . . . and this show is that Dennis Voss and Theodore Waddell are real ranchers as well as artists who live in eastern Montana, and their art is an ongoing reflection of that dual existence."[50]

In 1983, Julie Cook, curator at the Custer County Art Center, Miles City, put together the exhibition *Contemporary Sculpture in Montana*, featuring a wide range of works by eighteen Montana sculptors, including *Trophy #8* by Theodore Waddell. In the exhibition catalog, Colorado curator and critic Jane Fudge wrote that Waddell's *Trophy* "literally reveal[s] the bone beneath the flesh, to display the skull's uncanny and imperishable structure in place of familiar muscle, skin, and hair. It has the look of a totem, the bucranium [literally the skull of an ox alluding, in Greek and Roman tradition, to ceremonies of sacrifice] displayed for the sacrificial memento that it is rather than the decorative element we understand it to be."[51] Fudge noted that works by Montana sculptors Sarah Craige, Stephen Morse, Guy Klaas, and Michael Peed also had the "mordant wit and aggressive, craft-transcending imagery that once pervaded California's Bay Area 'funk' art."[52]

* * *

In the early 1980s, as Theodore Waddell developed new modes of painting and sculpting, a dramatic invitation brought his remarkable new paintings before the larger world's gaze. His earlier encounter with Ivan Karp and New York's OK Harris Gallery hadn't led to the success he had hoped for, but now with a call from Clair List, a curator at the Corcoran Gallery of Art in Washington, DC, his life would alter irrevocably.

In 1983, in concert with the Western States Arts Federation (WESTAF), the Corcoran was devoting its *38th Corcoran Biennial Exhibition of American Painting* to works by artists from the western states. Championed by the staff at the Yellowstone Art Center, Waddell was one of a handful of Montana artists invited to participate (sculptor and printmaker John Buck and painter and printmaker Jaune Quick-to-See Smith, who was now living in New Mexico, were others).

He recalls List's visit to his studio to select work. He asked how long List would need the paintings, and, in his recollection, "She said, 'a couple of years,' and I said, 'Oh, I don't know if I could be without them for that long,' and at that point, Donna Forbes, director of the museum [Yellowstone Art Center], kicked me in the shin from under the table."[53] Waddell relented, and List selected several paintings for the Biennial.

A few months later, Waddell received a letter saying that attire for the opening would be "black tie optional." He wasn't sure what that meant, and he called up the Corcoran

The portrait Waddell used for his breakthrough participation in the *38th Corcoran Biennial Exhibition of American Painting/ Second Western States Exhibition*, 1983. Thereafter, he would treat himself to a new cowboy hat each time he had an important show opening. Waddell Family Collection.

for clarification. He recalls, "I told them in Molt that [black tie] was when we wore our new overalls." In the end, all he had to wear for the opening was a green suit, and when he showed up wearing the suit and a big gray Stetson, a "lot of people there, all dressed in black and gray," thought he had worn his outfit as a "put-on, but I didn't; I didn't have anything else to wear."[54] (This is reminiscent of the time that Charlie Russell attended a formal event in Santa Barbara wearing, yes, a tuxedo, but also his Red River Métis sash and his beloved riding boots; as Frank Bird Linderman said, "He had gone his limit in dressing up for the occasion."[55]) The Waddells also didn't have anything for their two little girls to wear, so Betty went to the Salvation Army and "bought some formals . . . they looked like little flowers with crinoline and whatnot."[56]

Theodore Waddell drew considerable attention at the Corcoran opening, not just because of his distinctive garb and his ready wit, but because his paintings, with their gravity, depth, and sheer emotional power, stood out from the other works in the exhibition. Grace Glueck, writing in the *New York Times*, praised Waddell's "dense, dark paintings of livestock notable for their expressive brushwork."[57] Paul Richard, in the *Washington Post,* noted, "There are so many jokes, quick hits, and references to familiar older art in this exhibition, that Theodore J. Waddell's cattle paintings somehow seem quite special. Dark animals, not clearly seen, breathe softly in the darkness, and become

part of the landscape. Waddell, a Montana cattle rancher, offers us the opposite of flashy art."[58]

Leslie Berger chose to feature Waddell in a separate *Washington Post* story, only mentioning two other artists in her report:

"The cows provide an excuse for making a painting," said Montana artist Ted Waddell. . . . "I *have* to live there. There are only 600,000 of us," he said, referring to the state's sparse population. "The art's all part of the process of living on the ranch. You farm that ground and it's one thing; then you look at it and it's something else visually. It's the landscapes, the intersection of sky and horizon. . . ."

"People often categorize [Western art] as nostalgia." Waddell said, "That's very inaccurate, and this show provides good evidence. I would say we're all trying to claim [the West] in a different way."[59]

Berger also interviewed Montana Arts Council executive director David Nelson, chair of the Western States Arts Federation, cosponsor of the biennial. Nelson asserted that the "'scale of the landscape' resulted in the show's many sprawling canvases, . . . and [that] the 'romanticism' and 'remoteness' of the West have attracted many artists." Texas artist Chuck Dugan was quick to note, "This is not cowboy stuff."[60]

Eleanor Heartney, who reviewed the exhibition when it made a stop a year later at Waddell's alma mater, the Brooklyn Museum, felt that the art in the biennial was not distinctively Western enough. "Actually," she wrote in *Arts*, "the show seems more like a sampling of the range of styles and subjects one might expect to find in any reasonably aware contemporary survey." But there was one exception: "[T]he Western label rests comfortably on only one artist here. Theodore Waddell manages a cattle ranch in Montana. His somber representations of cows verge on abstraction; their hulking forms blend together in the shadows like looming land masses. There is a solemnity and even a reverence that sets these paintings apart from the coy Westernisms of the more self-consciously regional works in the show."[61]

Writing in *ARTnews*, Lee Fleming too found much to savor in the Montanan's work: "Waddell, who comes from Montana, is the sleeper of this exhibition. In his paintings of cattle, the subtlety of the chiaroscuro, the shadowy mounds of the herd that seem at a distance to be less cow, more landscape, even the depth of his heavily varnished surfaces, create a remarkable atmosphere. We can almost feel the impassive hills brooding beyond the darkness of the animal forms."[62]

The *38th Corcoran Biennial Exhibition of American Painting/Second Western States Exhibition* eventually traveled to the San Francisco Museum of Modern Art; the Museum of Albuquerque, Albuquerque, New Mexico; Long Beach Museum of Art, Long Beach, California; and the Brooklyn Museum, thereby widening its impact.

The year 1983 brought further national recognition for Theodore Waddell—and his cohort of fellow Montana contemporary painters, ceramic artists, sculptors, and performance artists. In October 1983, *Newsweek* art critic Mark Stevens (later winner of the Pulitzer Prize and the National Critics Book Circle Award for his and Annalyn Swan's biography of Willem de Kooning) devoted one of his features to "Art Under the Big Sky" (see Donna Forbes's essay in this volume for the backstory for this article, page 217). Stevens—who has deep roots in Big Sky Country; his grandfather established the American Fork Ranch near Two Dot, Montana—wrote of Waddell and his work, "At its best . . . his brushy style, heavy but fast, evokes both the quirks of cattle and their almost eerie rootedness—their magnificently dumb, earthy force." Other Montana artists featured in Stevens's article were Bob and Gennie DeWeese, Rudy Autio, Deborah Butterfield, John Buck, Patrick Zentz, Dennis Voss, Jude Tallichet, Page Allen, Russell Chatham, and Clarice Dreyer.[63]

The early 1980s was, of course, the heyday of the neo-expressionists, and while Theodore Waddell's figurative expressionism was certainly of its time (partaking of what critic Hal Foster has called the "Return of the Real"), his work differed markedly from that of

Theodore Waddell. *Angus #24*, 1982. Oil on canvas, 48 × 60 in. Collection of the artist.

the American neo-expressionists: in its sincerity, its unvarnished authenticity, its absence of irony. In 1983, Mark Stevens, who was admittedly a conservative critic, told a University of Montana art history class that, in his view, while neo-expressionists (he mentioned Julian Schnabel, David Salle, and Susan Rothenberg) "have re-introduced recognizable figures and images into contemporary art . . . their drawing style is primitive and child-like, often cartoony." Stevens continued his indictment of this new trend, as reported by Missoula critic Dan Rubey:

> Their drawing is never from life. It always suggests past art styles, one style layered on top of another, "images of images," Stevens says. It's art done by art students who have looked at slides and reproductions of other artists' works more than they've looked at the natural world around them. These juxtapositions may reflect divided contemporary sensibilities, Stevens says, the modern sense that things no longer mesh. Neo-Expressionism, he feels, is the art of the 1970s' "me decade," a period of flamboyant self-display and loud, shallow narcissism. . . . In that sense, Neo-Expressionism is an "authentic portrait of an inauthentic time," a period which no longer has shared convictions about art, politics or sex.[64]

In contradistinction to his harsh views on the neo-expressionists, Mark Stevens lauded Theodore Waddell for having "turned the pile-on-the-paint, expressionist idiom . . . into a kind of mucky sublime." In *Newsweek*, Stevens went on to say, "In Waddell's work a person can almost smell manure and the hot sweet hay breath of a herd."[65] This passionate connection with observed reality, this willingness to fully engage the natural world, was likely what had drawn the attention and enthusiasm of so many of the critics who reviewed Waddell's work during that watershed year.

The enthusiasm of the critics translated into attention from gallerists, and in 1984, Theodore Waddell had one-person shows at prestigious galleries in San Francisco (Stephen Wirtz), Los Angeles (Cirrus), Birmingham, Michigan (Halsted), and Reno, Nevada (Stremmel), as well as in museums (Yellowstone Art Center; Hockaday Museum of Art, Kalispell, Montana; and Mandeville Art Gallery, University of California, San Diego). That same year, he was in eight group shows, from Scottsdale to Chicago, Long Beach to Miles City.

The critical reception to his work continued to be positive. In the *San Francisco Examiner*, critic Al Morch noted that Waddell was one of those "non-corny Montanans who manage to make good art apart from the mainstream, by drawing upon what's original in their outdoorsy circumstances." Morch went on to say, "The results are striking documentations of a herd, stacked like so many earth-hugging boulders, weathering a blizzard. . . . The brushstrokes are quick; and deep blues and whites have been added to the palette, making the cattle seem that much more mysterious and quirky."[66]

Theodore Waddell in San Francisco with his friends Bill and Rudy Bliss, 1983. A fellow painter, Bill Bliss has been one of the major collectors of Waddell's work. Waddell Family Collection.

In *Artweek*, reviewing a show at Costa Mesa's Turnbull, Lutjeans, Kogan (TLK) Gallery, Robert Ewing appreciated the formal qualities of Waddell's work. He wrote, "Waddell's cows, for instance, are so weighted down with paint and so embedded into his surfaces that it is impossible to respond to this dumb show of serenity without recognizing that it is the paint that provides the gravity. Moreover, by rejecting details and emphasizing silhouettes, Waddell transforms his motifs of paired and grouped cows into a resonant play between recognizable and nonobjective shapes."[67]

All of this critical success translated into sales of his work, and on July 7, 1985, Theodore Waddell could write in his journal, "TODAY IS THE DAY. INDEPENDENCE DAY. I'M GOING TO MAKE ART FULL TIME."[68]

* * *

In 1987, because of a conflict with Betty's family about management of the Leuthold OK Ranch, Ted and Betty and their two girls left the ranch behind. "We were on the ranch west of Molt for 11 years," Waddell recalls. "I [then] bought a small place, 30 acres on the Musselshell, west of Ryegate. I ran it into 800 acres with 50 cow-calf pairs. Did very well." He found Ryegate congenial and "spent a lot of time at the Ryegate Bar, trading lies with locals who became great friends." He recalls that they would "make fun of me as a long-haired hippy but if any stranger did, they would protect me. A great time."[69]

Waddell's daughter Shanna described Waddell's new studio at the Ryegate ranch, a 5,000-square-foot machine shed that Waddell remembers as "marvelous":

Throughout my father's life, consideration of the studio was the most important aspect of any real estate transactions. The . . . studio in Ryegate . . . was twice the size of its predecessor and thankfully much warmer. The palette, which was actually a table, also grew in size and became mobile when casters were attached. A running length of wall provided a way for Dad to contemplate larger-scale works in progress. . . . These years were prolific for my father because the ranch was smaller and we owned fewer cattle. Less time working the land meant more time painting it.[70]

As Ted Waddell's career flourished, he continued to have multiple solo exhibitions, as many as eight, each year. In 1988, he even had an opportunity to travel to South Africa, paint the local animals—among them zebras and several varieties of monkey (see pages 128, 161, and 162)—and exhibit his work at the renowned Everard Read Gallery in Johannesburg. His South African experience, almost by chance, had a dramatic impact on his painting methods. He had been painting with tremendous quantities of paint, especially now that he had achieved financial stability. He notes, "I used so much paint that one of my dealers suggested that my paintings should be sold by the pound."[71]

In preparing for his journey to South Africa, he ordered fifty-five gallons of paint from his usual supplier, Bay City Paint of San Francisco. He recalls, "I didn't want to run out. Unbeknownst to me, my paint was held on the dock . . . since it was flammable material. Consequently, the shipment arrived nine months after I returned home. I was forced to buy tubes of very expensive paint, so I had to try to learn to paint without using as much paint. . . . I learned to use thin paint and washes."[72] He also recalls that, after his time in

Poster announcing Theodore Waddell's exhibition at the Everard Read Gallery, Johannesburg, South Africa, 1988.

Theodore Waddell. *Zambezi Monkeys*, 1992. Oil and encaustic on canvas, 54 × 60 in. Collection of the artist.

Africa, "I became more interested in shades of green. In Africa, there were at least six different kinds of grasses, and each had a unique green color."[73]

As his daughter Shanna has noted, the scale of Waddell's work was also changing. Back in 1981, he had contemplated the possibility of working larger than his hard-edge drawings, mostly 15 x 22 inches, writing, as noted previously, "The urge to make large-scale pieces is strong. It seems as if the scale and space require it."[74] After he encountered the enormous landscapes—often more than 100 square feet—by John Fery (1859–1934) in Glacier National Park, he began working larger and larger, though he says, "I believe that for every idea there's a scale that's appropriate."[75] By the mid-1980s, his paintings stretched as large as six feet by seven-and-a-half feet; they would later grow even larger. Perhaps he was beginning to feel, with Edward Casey, that "no matter how colossal the subject of a painting may be in actual perceived reality . . . a diminutive rendition will act to undercut its monumentality."[76]

John Fery, born in Austria, was educated under Peter Janssen (1844–1908) at the Düsseldorf Academy and immigrated to the United States in 1886. Like so many artists who came to northern Montana in the late nineteenth and early twentieth centuries, Fery was hired by the Great Northern Railway to create paintings—often hung in railway stations—that would entice travelers to visit Glacier and other sites along the railroad's route.

* * *

A cosmopolitan regionalism—a regional perspective which does not exclude a knowledge of the wider world, but is concerned with and appreciative of the little traditions within the great traditions of human history, and of ways in which small and great traditions are connected. . . .

—Jim Wayne Miller[77]

The Kentucky poet Wendell Berry has written wisely and well about a new sort of regionalism in the arts. In his essay, "The Regional Motive," he argues against a regionalism "based on pride, which behaves like nationalism" and against a regionalism "based on condescension, which specializes in the quaint and the eccentric and the picturesque, and which behaves in general like an exploitive industry." Instead Berry writes, "The regionalism that I adhere to could be defined simply as *local life aware of itself*," in which a person can bring to "bear on the life of [his/her] place as much as [he/she] is able to know."[78]

This new regionalism, which might be called cosmopolitan regionalism, is the version practiced by Theodore Waddell and his fellow Montana contemporary artists in consciously countering a Montana art steeped in nostalgia and outdated mythologies. The most authentic representative of the old view was Charles M. Russell, but as historian Dan Flores argues, Russell's heartfelt regret at the loss of "our ancient connection to our life in nature" has since been appropriated and commodified into, in Wendell Berry's terms, an exploitive industry. Now, Flores notes, "the material objects of the Old West—the saddles, camp gear, boots and hats, firearms, the ethnographic detail of Indian life," not to mention paintings and bronzes of a "West That Has Passed" (Russell's term) and the wide-open landscape itself, have become highly marketable.[79]

Instead of dwelling in a haze of nostalgia (and consciously ignoring broader trends in the art world), Montana rancher-artists Theodore Waddell, Patrick Zentz, and Dennis Voss (see Patrick Zentz's essay, "Three Friends," in this volume, pages 223–230), along with their distinguished modernist predecessors, Isabelle Johnson and Bill Stockton, have brought to bear on the life of their place everything they are able to know: all the skills needed to run a ranch *and* to make cutting-edge art; theories about minimalism, performance art, kinetic sculpture, and abstraction; a profound knowledge of the land and its limits; an abiding curiosity about the wider world *and* a passionate engagement with local history, traditions, and people. These artists—and many others—make up what Gordon McConnell has dubbed the "Rural Avant-Garde."[80]

Theodore Waddell made his own artistic goals abundantly clear in 1981:

Realism records what is, and Western art opts for nostalgia. Montana is not the same as it was when Charlie Russell lived. It still refers strongly to that history, but it has also become something else. I hope that I can do something that reflects both the history and the change.[81]

Both farmers and artists are independent problem solvers.

—Theodore Waddell[82]

On March 30, 1989, the *Times-Clarion* of Harlowton, Montana, gave advance notice that Ted and Betty Waddell were planning something extraordinary in celebration of Montana's statehood centennial. The event, scheduled for June 9–11 on the Waddells' spread near Ryegate, aimed to "honor and showcase contemporary artists and writers who live in Montana and invite others to join in celebrating the visual and literary arts as vital activities for all Montanans in our second century of statehood."[83] This unprecedented occasion would prove to be one of the signal gatherings, cultural or otherwise, of the state's centennial year.

The new literary and visual arts energies that Theodore Waddell had witnessed and participated in during the 1970s in Missoula had achieved critical mass by the late '80s. Waddell himself—along with such colleagues as Rudy Autio, Deborah Butterfield, John Buck, Jaune Quick-to-See Smith, and Russell Chatham—was the very model for the new kind of Montana visual artist: renowned at home and celebrated nationally (and even internationally), having achieved both financial and critical success.

On the literary front, the outpouring of Montana novels, memoirs, and collections of poetry begun in the '70s had only increased in quantity and quality. Another emblematic Montana centennial project was the publication, in 1988, of *The Last Best Place: A Montana Anthology*, the mammoth (more than 1,100 pages) blockbuster that put a self-conscious Montana literature on the national map, selling over 75,000 copies to date. Edited by William Kittredge and Annick Smith, together with an editorial board made up of novelist James Welch, memoirist and fiction writer Mary Clearman Blew, literature scholar William Bevis, and historians Richard Roeder and William L. Lang, the anthology received lavish praise regionally and nationally. It was heralded as a model for other state anthologies (though many other states had to admit that they did not possess the literary riches that Montana could boast).

As Montana scholar Alan Weltzien points out, in 1992, *U.S. News and World Report*, in an article about the "Intermountain Literary Renaissance," offered a list of "Places [in the region] Where There Are Too Many Writers": Albuquerque, New Mexico; Portland, Oregon; and "all of Montana."[84] (Lest Montanans get swelled heads about their alleged literary dominance, Idaho scholar Ron McFarland points out that, while "some writers speak jokingly of a Montana Mafia," others "would argue that the proper literary capital of the Rockies is not Missoula but Denver—or perhaps Salt Lake City."[85])

By 1989, the Montana literary and visual arts communities had a growing sense of solidarity and the giddy feeling that they were riding the crest of a wave of achievement and recognition. On the governmental level, however, the powers-that-be did not feel the same, and no monies were set aside for significant centennial celebrations of the arts

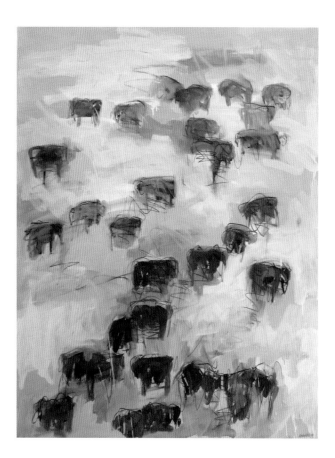

(aside from the Montana Committee for the Humanities' support of the publication of *The Last Best Place* the year before). Fortunately, Montanans have always had a libertarian streak, and as Patrick Zentz points out in his essay in this volume (see page 230), after numerous efforts to garner state support, Ted and Betty Waddell decided, as a purely citizen effort, to move forward with their arts gathering.

The preparations for *Montana '89: Our Place & Time*, as the Waddells' gathering came to be called, could have been for a hip church bazaar or a fund-raiser for an artsy rural fire department. The community pulled together and made things happen. The *Times-Clarion* reported, "[A]rea folks have been 'just great' in helping prepare for the conference. Many ladies have been baking and preparing food for the large group, and others have done countless things to help make it a successful event."[86] At the same time, the Waddells brought their own considerable organizational skills to bear. Their friend Brian Petersen wrote in the *Billings Gazette*:

> The Waddells split the duties, at times on a kind of crisis management basis. Betty designed a brochure and developed a mailing list of 1,300. Posters have been printed and sent, and media outlets, some on the national level, contacted. Betty arranged meals while Ted has tracked down chairs, grills, portapotties, and the like. Endless hours were spent on the phone.[87]

All these preparations led to an exceptional event. In Waddell's studio, a large metal building which "Ted and some helpers have been busy finishing the inside of,"[88] fifty-plus works (with a "total retail value of $143,000"[89]) by many artists went on exhibit, and tables displayed books by the Montana writers in attendance. The poster for the event listed a veritable who's who of Montana cultural figures: painters, printmakers, sculptors, and ceramic artists; poets and fiction writers; musicians, collectors, gallerists, and curators. The Waddells anticipated as many as three hundred attendees.

Besides the opportunity to view (and purchase) the art and have books signed by one's favorite writers, the program offered intensive exposure to five prominent Montana artists: Ted's friend and mentor, ceramic revolutionary Rudy Autio; sculptor Patrick Zentz, Ted's former grad student and fellow rancher; fiction writer, memoirist, and former rancher William Kittredge, known as the "Godfather of Montana writers"; Thomas McGuane, novelist and raiser of cutting horses; and poet and satirist Greg Keeler.

Each of these principal presenters was given three hours to interact with the audience. The intention was to allow attendees "to think about and discuss what it means to create

Theodore Waddell welcomes the crowd to *Montana '89: Our Place & Time*. David Arnold, photographer. Waddell Family Collection.

Poster for *Montana '89: Our Place & Time* arts conference, Theodore and Betty Waddell's ranch, Ryegate, June 1989.

Rudy Autio, *Montana '89: Our Place & Time* gathering, 1989. David Arnold, photographer. Waddell Family Collection.

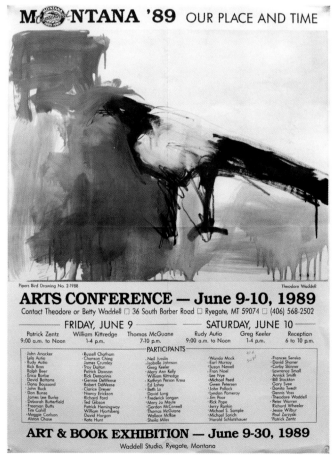

original work while living in Montana." The *Times-Clarion* gave this description of the gathering's key events: "[The five presenters] will show slides of visual work; read from their work; sing their poetry; they'll listen and look at others' work; they'll demonstrate and tell about their crafts; they will talk about their lives as artists working in Montana; they'll answer questions."[90] Above all, *Our Place & Time* was meant to "be an informal time, and a great opportunity for everyone to mingle, talk to and get acquainted with some of the best known names in their fields."[91]

By all accounts, *Montana '89: Our Place & Time* was an enormous—an unqualified—success. (For multiple views of the conference, see the essays by Greg Keeler, page 221; Patrick Zentz, page 223; Scott McMillion, page 231; and William Hjortsberg, page 235, in this volume.) Ted Waddell was particularly pleased by the response of the writers to his invitation to participate. As Brian Petersen wrote:

> For 30-year veteran artist Ted, the most positive development has been the enthusiasm of the writers. He said he had a feel for how they'd respond but no idea so many good writers would sign on so eagerly. "Everyone, the artists and writers, have been more than willing. They've been wonderful—haven't asked about the cost, or time involved."[92]

Certainly, the Montanans attending *Our Place & Time* found much to savor during that historic weekend, but an outsider's perspective, written by someone who had no expectations for his visit to the Ryegate area, nicely captured the spirit of the event. In a playful bit of reportage he entitled "The Testicle Festival in Ryegate, Montana" (*Our Place & Time* was held the same weekend as Ryegate's annual Testicle Festival), legendary American poet Edward Dorn (1929-1999) told of traveling, in the company of his friend, poetics scholar Peter Michelson (both taught at the University of Colorado,

At center (left to right): painter and professor of art, Montana State University, Bob DeWeese; sculptor Patrick Zentz; Miriam Sample, Montana's preeminent collector and patron of contemporary art; and painter Gennie DeWeese, *Montana '89: Our Place & Time* gathering, 1989. David Arnold, photographer. Waddell Family Collection.

Theodore Waddell's early teacher at Eastern Montana College, sculptor Lyndon Pomeroy, chats with sculptor and printmaker John Buck, *Montana '89: Our Place & Time* gathering, 1989. David Arnold, photographer. Waddell Family Collection.

Ceramic sculptor Rudy Autio visits with Valerie Serpa, executive director of the Oats Park Art Center, Fallon, Nevada, *Montana '89: Our Place & Time* gathering, 1989. David Arnold, photographer. Waddell Family Collection.

Poet, scholar, and singer/songwriter Greg Keeler with his friend, poet Ed Dorn, *Montana '89: Our Place & Time* gathering, 1989. David Arnold, photographer. Waddell Family Collection.

Boulder), to a "destination . . . not actually Ryegate, but a nice spread upriver to the west owned by Muddy Waddel[l], the number one most adventurist and the second most 'well known' painter in Montana."[93] (It is unclear who Dorn considered the first most well-known painter in Montana—Charlie Russell, perhaps?)

Dorn found the scene "très Montana. This is a Montana that Hollywood is thankfully not interested in. This is a Montana that anybody who truly loves Montana can probably count on."[94] Incidentally, Dorn had long been fond of Montana. In his 1965 poem, "Idaho Out," he wrote about a trip to Missoula from his home in Pocatello, Idaho, where he was teaching at the university: "My son . . . was delighted that a state / so civilized as Montana / could exist, where the people, / and no matter how small the town, / . . . / could be so welcoming to a lad." [95]

Dorn described the gathering at the Waddell Ranch that weekend in 1989 as similarly welcoming: "Long Beds and various camper vehics parked along the cottonwood lined avenue leading to Muddy's house. We parked and followed the jovial crowd to a kind of colossal modern tool shed under which a large crowd had gathered. . . . The early summer energy and testosterone enlightenment, the sense of distance and destination as purely one abstract thing was overpowering."[96]

As Dorn and Michelson arrived, Dorn's good friend, Montana poet and troubadour Greg Keeler (or as Dorn dubbed him "Gregory O'Keeler") was telling the mock-epic tale of his vasectomy and then "struck up the chords of his outriver masterpiece, *Ryegate, Montana, Testicle Festival Time*" (see Greg Keeler's "Keeler's Bird" in this volume, page 221). Dorn continued, "Swept away by such madness, the bemused audience drifted out of the huge post-modern tool shed for a break in the intensity, forming knots of discussion while some took in the various viands over in the smokey section."[97]

Dorn was pleased to meet the novelist William "Gatz" Hjortsberg, whom he immediately called "Lord Gatzburgh," and he then, in a "remarkable moment," heard his friend "Thomas McGrain" (Tom McGuane) "read a story of the deep south about . . . hunting

A group portrait of those attending *Montana '89: Our Place and Time*. David Arnold, photographer. Waddell Family Collection.

dogs" (the story, "A Man in Louisiana," from McGuane's 1986 collection, *To Skin a Cat*) "who wouldn't do anything but go home when sold or traded, and who seemed somehow very profoundly to summarize all our instincts and impulses and habits, and poignancies. Dogs are still the best guides to human behavior."[98] McGuane was equally admiring of Edward Dorn; he has called Dorn's long poem in six parts, *Gunslinger,* "a fundamental American masterpiece."[99]

Dorn completed his travelogue by describing the Testicle Festival in nearby Ryegate. "The town is so classic," he wrote, "it almost makes me stutter in the attempt to compress a description which would be equal to it. An elevator, a couple of sidestreets, a vacant (?) lot? . . . And then the corner tavern—that's the festival—lock, stock, and barrel."[100]

Dorn, who called himself a "poet of the West—not by nativity but by orientation,"[101] concluded:

And so the evening ran out with the ever intensifying quizzicality of a crowd dining on testicles, including the women. I could see no serious flaws in it. I've been subjected to a lot of jokes in my time in the west, haven't we all. But this little gathering of the genre was one of the pleasantest.[102]

* * *

In the early 1990s, Theodore Waddell tried his hand at group portraits—of humans (see pages 170 and 171). He had been creating the occasional self-portrait throughout his career, but now he sought to, in his words, "examine my own history and relationships to people in the way . . . I have examined animals and the landscape."[103] His grandmother's funeral stimulated this body of work. At this gathering of the clan, Waddell realized, according to one reporter, that "the family is . . . a kind of place where people live, even if they don't choose it."[104] In some ways, his group portraits resemble Max Beckmann's crowded works with multiple figures, such as *Family Picture* (1920, Museum of Modern Art, New York). Beckmann spoke of the "objectivity of the inner vision,"[105] and certainly Waddell's group portraits suggest an objectivity that remains enigmatic, even mysterious, full of tensions and tenderness.

These paintings also bear a resemblance to certain Robert De Niro Sr. figurative works—part of the George and Elinor Poindexter Collection at the Yellowstone Art Museum[106]—that Waddell saw during his years on the ranch. In a tribute to De Niro, Waddell wrote, "He was the bridge for me, helping me to understand where I had been and where I was and where I am headed. He made great use of subject matter, coupled with the basic expressionist demand for the presence of the paint and canvas."[107]

Considered one of the New York School Figurative Expressionists, Robert De Niro (father of the actor) was heavily collected by George and Elinor Poindexter, who donated many American modernist works to two Montana museums, the Yellowstone Art Museum and the Montana Historical Society. George Poindexter had deep Montana roots, his family having registered the very first cattle brand in Montana Territory. Elinor Poindexter ran New York's Poindexter Gallery, which represented many of the second-generation abstract expressionists, as well as West Coast artists like Richard Diebenkorn and James Weeks. De Niro and his fellow figurative expressionists (including Nell Blaine, Nora Speyer, and George McNeil, also in the Poindexter Collection), in the words of curator and critic April Kingsley:

> build their figures out of the paint itself. They don't simply re-surface or decorate the figures with painterly touches to blend them into a unified statement. To most of these artists the presence of the figure, however inexactly imaged, means a hold on reality in its barest form, a thereness, which is like a lifeline in a maelstrom of conflicting emotions and ambiguous signs.[108]

Theodore Waddell's paintings of human groupings possess just this sort of *thereness*. Waddell told journalist Richard Myers in 1994 that, when painting these portraits, "I've learned to bypass my intellect and trust my vision and I have a portrait that I think is more true."[109]

* * *

The early 1990s brought more attention to Theodore Waddell's *Hallowed Absurdities*, the mixed-media works involving roadkill, skulls found on the ranch, and even some occasional horseshit. During Waddell's 1991 exhibition with Dennis Voss in Spokane's Cheney Cowles Museum, *True Objects and Stories from Two Dot*, Dan Webster reported in the *Spokesman-Review*, "Some of Waddell's works, which literally are road kill, apparently contained fly larvae that hatched in the warmth of the museum's main gallery. Two chemical foggings by a professional extermination service quickly took care of the flying pests, but not before the situation was reported in a front-page newspaper story."[110]

Although the museum's curator seemed traumatized by the hatch, Waddell took a more philosophical view. He recalls that, as a result of the newspaper coverage, he was called by the national media, "CNN and NPR and whatnot," and when reporters asked him what he made of the situation, he told them, "If I'd [known I'd get] this kind of attention for the flies, I'd have put them in my work twenty years earlier."[111] Perhaps because of the media attention, *True Objects and Stories from Two Dot* got plenty of critical scrutiny. In the local paper, Dan Webster wrote, "Forget the flies, ranchers' exhibit is truly fascinating," and he concluded, "By offering their own views of the landscape and animal

population that they love, [Waddell and Voss] force us to question how we're treating, how we're abusing, what we have. And they do it in a typical, often casual Western manner—with skill, grace and, most important, humor."[112]

Frances De Vuono, writing in *Reflex: The Northwest's Forum on the Visual Arts,* noted:

Voss and Waddell let viewers into a world whose daily activities are as foreign and exotic to most urbanites as that of Faulkner's Yoknapatawpha County. But unlike that southern county, Two Dot emerges as a little sea of sanity, a respite from confusion, a place where an honest day's work may consist of feeding cattle and end with conceptual art. . . . Waddell is a punster: Much of his share of the exhibit is taken up by over 20 "trophies." These objects—both fish and beast—are *faux* trophies: part joke, part homily. They range from funny, ecological statements . . . to more portentous ruminations on life, death, and art.[113]

* * *

Theodore Waddell. *Musselshell Angus #6*, 1991. Oil on canvas, 70 × 66 in. Collection of the Albrecht-Kemper Museum of Art, St. Joseph, MO.

Theodore Waddell: Life & Work

The year 1992 brought Theodore Waddell his first major solo museum exhibition. As noted in the Prelude, the Eiteljorg Museum of American Indians and Western Art, Indianapolis, had purchased Waddell's *Ryegate Horses #2*—as its very first acquisition in the field of contemporary Western art—after it held the museum's first group show dedicated wholly to that genre, *New Art of the West*. Two years later, the Eiteljorg launched *Theodore Waddell: Seasons of Change*, an exhibition featuring fifty-six paintings and drawings and a handsome full-color catalog with essays by Jennifer Complo, the Eiteljorg's Associate Curator for Exhibitions, and David G. Turner, Director of the Museum of Fine Arts, Santa Fe. The catalog also included insightful brief essays by Waddell about each of the seasons, both in terms of his work on the ranch and his artistic endeavors. *Seasons of Change* was one of the first Eiteljorg exhibitions to travel elsewhere; it was also hosted by the Nevada Museum of Art, Reno.

Theodore Waddell's growing renown brought ever more opportunities. The year 1990 found him showing in New York gallerist Bernice Steinbaum's group exhibition, *The New West*. The Bernice Steinbaum Gallery would then host his first solo show in New York in 1992, and he would show with the Steinbaum Gallery (later Steinbaum Krauss) through the year 2000, even after Steinbaum had moved the gallery to Miami.

Meanwhile, back home, Waddell was digging deeper into the artistic traditions of his native Montana. In 1992, he and Betty—Ted as artist and Betty as poet—were invited to participate in a float down a fabled stretch of the Missouri River documented by the Swiss-French artist Karl Bodmer (1809–1893) in 1833. Accompanying an expedition led by Prince Maximilian zu Wied-Neuwied of Germany, Bodmer was charged with providing a "a fine portfolio of plates" to accompany the prince's narrative. In addition to representing the "Indian nations with great truth, and correct delineation of their characteristic features,"[114] Bodmer captured the magnificent landforms the expedition

Theodore Waddell with daughters Arin and Shanna in Soho, New York City, ca. 1992. Waddell Family Collection.

Karl Bodmer. *Ansicht der Stone-Walls am obern Missouri/View of the Stone Walls on the Upper Missouri*, 1833. Aquatint, from *Maximilian, Prince of Wied's Travels in the Interior of North America, during the years 1832–1834*.

encountered along the Missouri. As critic Kay Larson wrote, reviewing the 1985 Metropolitan Museum exhibition, *Karl Bodmer's America*, "Two thousand miles of river- and prairiescape interjected itself into Bodmer's consciousness with an immediacy still vivid 150 years later. His portrayal of white cliffs along the Missouri is especially fine."[115]

One hundred and sixty years later, invited by the Paris Gibson Square Museum of Art, Great Falls, Montana, the Waddells—together with eight other Montana writers and artists, two Japanese artists, two museum curators, and four river guides—set off on a three-day journey by canoe and raft that would culminate in an exhibition, catalog, and seminar at the Paris Gibson in early 1993. The intention of the expedition was, in the words of museum director Elizabeth Kennedy, to allow "echoes of the past [to] reverberate in their [the artists'] attempts to describe their response to the landscape in contemporary terms."[116] For Theodore Waddell, it was not only the landscape that reverberated. He was impressed, too, by the artists of the past who had sought to depict that same region. He felt a kinship not only with the works of Bodmer, but also with those of George Catlin (1796–1872), who had traveled up the Missouri as far as Fort Union in 1830, and Charles M. Russell, the artist whose influence Waddell had so vigorously avoided as a young modernist.

Poet Sandra Alcosser, who would later become Montana's first poet laureate, wrote of the 1992 expedition in her essay, "Glyphs":

Ted Waddell cooling off in the Missouri River during the three-day float from Coal Banks Landing to Judith Landing that resulted in the 1993 exhibition *Missouri River Interpretations*. Waddell Family Collection.

We floated three days over hundreds of millions of years of exposed sea floor, through old marshes, broken tablelands and wheat stubble, past yellow-faced flannel mullein, shypoke, milk sow thistle. . . .

Lewis and Clark found images of Palladian architecture in the sandstone as they cordelled and catalogued the Missouri Breaks. . . . Prince Maximilian followed thirty years later and saw white castles and ancient Gothic chapels in the same shale. We came . . . seeking the lost voices of the past, and the rock formations we paddled through became catacombs, sloughing cliff faces draped with blue sage, torsos of ghosts huddled together, open-mouthed chalkstone waiting to tell their stories.[117]

Theodore Waddell's *Missouri River Drawings* from the expedition describe the same landscape, but in thoroughly contemporary terms—not as scientific description or mythic overlay, but as one exceptional artist's late modernist vision and a truthful contribution to the pictorial record which, as Alcosser suggests, goes back to "petroglyphs rubbed and pecked into sandstone, figures superimposed over each other like palimpsests."[118]

* * *

It seems like it's time to push on somehow. Relics and anxieties seem to gather like baggage to be carried to the next place. I don't know how to carry it with me.

—Theodore Waddell[119]

Theodore Waddell. *Missouri River Drawing #4*, 1992. Oil, graphite, and encaustic on paper, 21.5 × 29.5 in. Collection of the Missoula Art Museum, Missoula, MT. Gift of Theodore Waddell, 1999.

Life continued to be busy and productive for Theodore Waddell. At the same time, he was undergoing dramatic personal changes. In 1995, after thirty years of marriage, he and Betty decided to divorce. They sold the Ryegate place, and Ted moved near Bozeman, Montana. As his journal and other writings reveal, not only was he on the cusp of wrenching marital changes, but he found that he could no longer sustain relations—as they had been—with the profession of cattle raising. In a meditation on the painful necessity of selling the cattle under his care for slaughter, he wrote:

> Unless you have the ability to make the hard decisions about what cows get shipped, what calves go to the feed lot, which replacement heifers are saved, your business does not survive and you do not survive. Making the hard choices is necessary and inevitable. . . . The endless love for this life, the grass and sky, prairie and wind, mountains and snow, animals and friends, is tempered by the presence and necessity of these

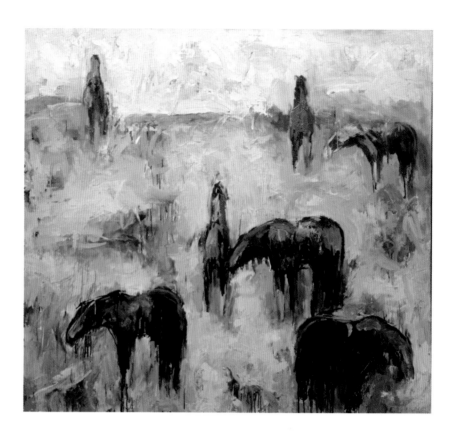

Theodore Waddell. *Crazy Mountain Horses #2*, 1994. Oil and encaustic on canvas. 64 × 70 in. Collection of the Amarillo Museum of Art.

choices. . . . Anyone who shrinks from this should not be doing it. Since I did, I quit. I lost my edge and moved to town where I have become what I call a nickel-plated cowboy.

In the quiet moments . . ., when revisiting and remembering how good the cows treated you, the finality of the decisions hits hard. Reality overshadows the illusions of a good fall. The gut-wrenching aching finality of what you have done to these wonderful creatures who have lived with you, shared their lives with you, given their all for you, only to be slaughtered for that last little bit of gain, is untenable.[120]

Years earlier, Theodore Waddell had quit hunting, but now he contemplated stopping even taking friends out to favorite hunting grounds. In October 1992, he wrote in his journal, "I don't think I can go hunting any more. The antelope that I helped John to kill haunts me. I was his friend, and instead of hiding him, I helped kill him by revealing his hiding place."[121]

Although no one who knows him would call Theodore Waddell a nickel-plated cowboy, he was indeed once again transforming his life. Just as he had left the secure world of the university for the challenges of the ranch, he now stepped out of one life and into another. He had once written, "I hope to get beyond my boundaries—exceed my background."[122] The next twenty years would see Theodore Waddell further realize that prophetic hope.

1 Theodore Waddell, "Dealing with Horizons: As Farmer, as Artist," *The Windmill*, September/October, 1981, 9.

2 Erik Steffenson, "Per Kirkeby: The 1960s," in *Per Kirkeby and the "Forbidden Paintings" of Kurt Schwitters: Retrospective*, ed. Siegfried Gohr (Brussels, Belgium: Bozar Books, 2012), 33.

3 Waddell, oral history (self-interview), Segment 13.

4 Theodore Waddell, email to Rick Newby, February 22, 2013.

5 Ibid.

6 Waddell, oral history (self-interview), Segment 18.

7 Ibid., Segment 14.

8 Ibid., Segment II.

9 Ibid.

10 Arin Waddell, quoted in Jaci Webb, "Arin Waddell Carries on Art Tradition Started by Her Father, Ted," *Billings Gazette,* March 3, 2016.

11 Arin Waddell, quoted in Bonnie Gangelhoff, "Emerging Artist: Arin Waddell," *Southwest Art*, September 1, 2010.

12 Waddell, oral history (self-interview), Segment 14.

13 "Mount Helena Moves to the Downtown Mall," Helena *Independent Record*, July 20, 1977.

14 "Mountain Fountain . . . Moves from Molt to Helena," *Stillwater News*, July 21, 1977, 1.

15 Ibid.

16 Waddell, oral history (self-interview), Segment II.

17 Lawrence Alloway, "Systemic Painting," in *Minimalism: A Critical Anthology*, ed. Gregory Battcock (Berkeley: University of California Press, 1995), 45.

18 Shelby, "Artistic Evolution: A Daughter's Perspective," 122.

19 Waddell, "Dealing with Horizons," 1.

20 Theodore Waddell, email to Rick Newby, February 22, 2013.

21 Waddell, oral history (self-interview), Segment 18.

22 Waddell, Newby interview.

23 Betty Parsons, quoted in John Russell, "Betty Parsons," *Reading Russell: Essays 1941–1988 on Ideas, Literature, Art, Theater, Music, Places, and Persons* (New York: Harry N. Abrams, Inc., 1989), 152.

24 Robert Motherwell, quoted in Grace Glueck, "The Creative Mind: The Mastery of Robert Motherwell," *New York Times*, December 2, 1984; http://www.nytimes.com/1984/12/02/magazine/the-creative-mind-the-mastery-of-robert-motherwell.html?pagewanted=all.

25 Waddell, "Dealing with Horizons," 9.

26 Ibid., 1.

27 Ibid., 9.

28 Ibid.

29 Waddell, unpublished journal, February 26, 1986.

30 Unidentified rancher, quoted in Máire O'Neill, "Learning Rural Perceptions of Place: Farms and Ranches in Southwest Montana" (PhD diss., Montana State University, 1997), 219. See also Máire O'Neill, "Corporeal Experience: A Haptic Way of Knowing," *Journal of Architectural Education*, September 2001, 3–12.

31 See Mary Clearman Blew, *Bone Deep in Landscape: Writing, Reading, and Place* (Norman: University of Oklahoma Press, 1999);

and Scott Hibbard, "A Matter of Blood," *Montana Spaces: Essays and Photographs in Celebration of Montana*, ed. William Kittredge (New York: Nick Lyons Books, 1988), 112.

32 Waddell, unpublished journal, May 18, 1986.

33 Gordon McConnell, *Theodore Waddell* (Billings, MT: Yellowstone Art Center, 1984), 5–6.

34 Donald Judd, "Specific Objects," in Judd, *Complete Writings 1959–1975*, 182.

35 Waddell, unpublished journal, November 9, 1985.

36 McConnell, "Ted Waddell: Country Flesh and Bones," *ARTSPACE*, 23.

37 Edward S. Casey, *Representing Place: Landscape Painting and Maps* (Minneapolis: University of Minnesota Press, 2002), 121.

38 Kim Brown, untitled article, *Bozeman Chronicle*, undated clipping, ca. 1984.

39 Quoted in Bob Durden, "An Introduction," in Robyn G, Peterson, Bob Durden, Terry Melton, Shanna Shelby, Bob Roughton, Theodore Waddell, Billy Bliss, and Brian Peterson, *Theodore Waddell: Hallowed Absurdities, Mixed Media Sculpture* (Billings, MT: Yellowstone Art Museum, 2014), 12.

40 François Jullien, *The Great Image Has No Form, or On the Nonobject through Painting*, trans. Jane Marie Todd (Chicago: University of Chicago Press, 2009), 4, 8.

41 Bruce Richardson, "New twist to cowboy art at the Nicolaysen," *Casper Star-Tribune*, Wyoming Weekend, April 17, 1994.

42 See Robyn G. Peterson et al., *Theodore Waddell: Hallowed Absurdities*.

43 Waddell, unpublished journal, August 28, 1985.

44 Raphael James Cristy, *Charles M. Russell: The Storyteller's Art* (Albuquerque: University of New Mexico Press, 2004), 4.

45 Brown, untitled article, *Bozeman Chronicle*.

46 Brian Petersen, "Guns of Plenty, Bones of Dust," in Robyn G. Peterson et al., *Theodore Waddell: Hallowed Absurdities,* 54.

47 Kathleen Whitney, "Little Changes" in Paula Owen, Patrick Schuchard, Kathleen Whitney, and Dave Hickey, *Ken Little: Little Changes: A Survey Exhibition and New Works* (San Antonio, TX: Southwest School of Art and Craft, 2003), 24.

48 Peter Selz, "Notes on Funk," *Funk* (Berkeley: University Art Museum, University of California, Berkeley, 1967), 1.

49 John Natsoulas, "Funk," in Peter Held, John Natsoulas, and Rick Newby, *Humor, Irony and Wit: Ceramic Funk from the Sixties and Beyond* (Tempe: Arizona State University Art Museum, Ceramics Research Center, 2004), 6.

50 Ron Glowen, "True Objects and Stories from Two Dot, Montana: Theodore Waddell and Dennis Voss," *Artweek*, February 27, 1992, 22.

51 Jane D. Fudge, "Contemporary Sculpture in Montana," in Julia A. Cook and Jane D. Fudge, *Contemporary Sculpture in Montana* (Miles City, MT: Custer County Art Center, 1983), 6.

52 Ibid., 5.

53 Waddell, oral history (self-interview), "Corcoran Biennial."

54 Ibid.

55 Frank Bird Linderman, *Recollections of Charley Russell*, ed. H. G. Merriam (Norman: University of Oklahoma Press, 1963), 77.

56 Waddell, oral history (self-interview), "Corcoran Biennial."

57 Grace Glueck, "Two Biennials: One Looking East and the Other West," *New York Times*, March 27, 1983; http://www.nytimes.com/1983/03/27/arts/gallery-view-two-biennials-one-looking-east-other-looking-west-washington.html.

58 Paul Richard, "The Range of the West," *Washington Post*, Style, February 2, 1983, D1, D4.

59 Leslie Berger, "Visions of a New West," *Washington Post*, Style, February 2, 1983, D4.

60 Ibid.

61 Eleanor Heartney, "West of the Hudson: Regional Art on Exhibition in New York," *Arts Magazine*, Summer 1984, 100.

62 Lee Fleming, "The Corcoran Biennial/Second Western States Exhibition," *ARTnews*, May 1983, 127, 129.

63 Mark Stevens, "Art Under the Big Sky," *Newsweek*, October 31, 1983, 99.

64 Dan Rubey, "Critic Leads the Way to Art World," *Missoulian*, May 6, 1983, A-5.

65 Stevens, "Art Under the Big Sky," 98–99.

66 Al Morch, "A Cattleman's Down-to-Earth Montana Art," *San Francisco Examiner*, January 9, 1984.

67 Robert Ewing, "Enduring Romantic Idioms," *Artweek*, June 2, 1984.

68 Waddell, unpublished journal, July 7, 1985.

69 Theodore Waddell, email to Rick Newby, February 22, 2013.

70 Shelby, "Artistic Evolution: A Daughter's Perspective," 123–124.

71 Theodore Waddell, "Materials," in Gordon McConnell and Waddell, *Theodore Waddell: Five Decades, Selected Paintings and Works on Paper* (Fallon, NV: Oats Park Art Center, Churchill Arts Council, 2011), 8.

72 Ibid., 9.

73 Theodore Waddell, "Spring/Summer," in Mike Leslie, Jennifer Complo, David G. Turner, and Theodore Waddell, *Theodore Waddell: Seasons of Change* (Indianapolis, IN: Eiteljorg Museum of American Indians and Western Art, 1992), 28.

74 Waddell, "Dealing with Horizons," 1.

75 Waddell, oral history (self-interview), Segment II.

76 Casey, *Representing Place*, 120–121.

77 Jim Wayne Miller, "Anytime the Ground Is Uneven: The Outlook for Regional Studies and What to Look Out For," in *Geography and Literature: A Meeting of the Disciplines*, ed. William E. Mallory and Paul Simpson-Housley (Syracuse, NY: Syracuse University Press, 1987), 13.

78 Wendell Berry, "The Regional Motive," in *A Continuous Harmony: Essays Cultural and Agricultural* (Berkeley: Counterpoint, 2012), 76, 79.

79 Dan Flores, *Visions of the Big Sky: Painting and Photographing the Northern Rocky Mountain West* (Norman: University of Oklahoma Press, 2010), 206–207.

80 See Gordon McConnell, *Gennie DeWeese/Bill Stockton: The Rural Avant Garde* (Clearmont, WY: Ucross Foundation Art Gallery, 2002).

81 Waddell, "Dealing with Horizons," 9.

82 Waddell, unpublished journal, March 19, 1986.

83 "Arts Conference Planned at Waddell Studio near Barber," *Times-Clarion*, March 30, 1989.

84 Cited in O. Alan Weltzien, "The Literary Northern Rockies as the Last Best Place," in *A Companion to the Literature and Culture of the American West*, ed. Nicolas S. Witschi (Oxford: Wiley-Blackwell, 2011), 170–171.

85 Ron McFarland, "Literature," in *The Rocky Mountain Region*, in *The Greenwood Encyclopedia of American Regional Cultures*, ed. Rick Newby (Westport, CT: Greenwood Press, 2004), 318.

86 "Arts Conference is this Weekend in Barber," *Times-Clarion*, undated clipping, 1989.

87 Brian Petersen, "'Our Place and Time' Begins: Painter, Teacher Host Public to Ranch for Artistic Forum," *Billings Gazette*, undated clipping, 1989.

88 "Arts Conference at Barber Growing into Big Affair," *Times-Clarion*, May 25, 1989.

89 "Arts Conference is this Weekend," *Times-Clarion*.

90 "Arts Conference Planned," *Times-Clarion*.

91 "Arts Conference is this Weekend," *Times-Clarion*.

92 Petersen, "'Our Place and Time' Begins," *Billings Gazette*.

93 Edward Dorn, "The Testicle Festival in Ryegate, Montana," in *Way West: Stories, Essays & Verse Accounts: 1963–1993* (Santa Rosa, CA: Black Sparrow Press, 1993), 275–276.

94 Ibid., 275.

95 Edward Dorn, "Idaho Out," in *The Collected Poems, 1956–1974* (Bolinas, CA: Four Seasons Foundation, 1975), 113–114.

96 Dorn, "The Testicle Festival," *Way West*, 276.

97 Ibid., 277–278.

98 Ibid., 280.

99 Thomas McGuane, blurb, back cover, Ed Dorn, *Slinger* (Berkeley: Wingbow Press, 1975).

100 Dorn, "The Testicle Festival," *Way West*, 280.

101 "Edward Dorn, 70, Writer on the American West," *New York Times*, December 21, 1999; http://www.nytimes.com/1999/12/21/arts/edward-dorn-70-writer-on-the-american-west.html.

102 Dorn, "The Testicle Festival," 281.

103 Theodore Waddell, "People Portraits," in Mike Leslie, Jennifer Complo, David G. Turner, and Theodore Waddell, *Theodore Waddell: Seasons of Change* (Indianapolis, IN: Eiteljorg Museum of American Indian and Western Art, 1992), 54.

104 Richard Myers, "Theodore Waddell's exhibition, *Painting and Sculpture*, at the Holter Museum of Art," Helena *Independent Record*, January 7, 1994, 11D.

105 Max Beckmann, quoted in Peter Selz, *Max Beckmann* (New York: Museum of Modern Art, 1964), 26.

106 For the story of the Poindexter Collections at the Yellowstone Art Museum and the Montana Historical Society, see Rick Newby and Andrea Pappas, *The Most Difficult Journey: The Poindexter Collections of American Modernist Painting*, ed. Ben Mitchell (Billings, MT: Yellowstone Art Museum, 2002).

107 *Poindexter Collection/Poindexter Legacy,* ed. Yvonne Seng (Helena, MT: Holter Museum of Art, 2012), 22. Http://www. holtermuseum.org/janda/files/home/1357147098_MT%20 AB%20EX_Booklet.pdf

108 April Kingsley, *Emotional Impact: New York School Figurative Expressionism* (San Francisco: The Art Museum Association of America, 1984), 9.

109 Myers, "Theodore Waddell's exhibition, *Painting and Sculpture,"* 11D.

110 Dan Webster, "The Road-Kill Show," *The Spokesman-Review,* February 28, 1992, D1.

111 Waddell, oral history (self-interview), "Fly Hatch."

112 Webster, "The Road-Kill Show," D6.

113 Frances De Vuono, "Rancher Art," *Reflex* 6, no. 3 (May/June 1992): 22.

114 Prince Maximilian zu Wied-Neuwied, "Author's Preface," in *Maximilian, Prince of Wied's Travels in the Interior of North America,* vol. 1, trans. Hannibal Lloyd (Carlisle, MA: Applewood Books, 2007), 27.

115 Kay Larson, "Indian Country," *New York Magazine,* July 29, 1985, 53.

116 Elizabeth Kennedy, "Acknowledgments," in Paintings, Prose, Poems and Prints: *Missouri River Interpretations,* ed. Barbara Racker (Great Falls, MT: Paris Gibson Square Art Museum, 1993), 2.

117 Sandra Alcosser, "Glyphs," in *Paintings, Prose, Poems and Prints,* 30, 31.

118 Ibid., 30.

119 Waddell, unpublished journal, November 5, 1988.

120 Theodore Waddell, "Cheatgrass Dreams" (unpublished manuscript, Version 2), edited January 8, 2009, unpaginated.

121 Waddell, unpublished journal, October 19, 1992.

122 Waddell, unpublished journal, July 6, 1986.

Theodore Waddell. ***Molt Series: New Thompson Sunrise Drawing #3***, 1980. Oil on paper, 15 × 22 in. Collection of the artist.

Theodore Waddell. *Molt Series: New Thompson Sunrise
Drawing #2*, 1977. Oil on paper, 15 × 22 in. Collection of the artist.

Theodore Waddell. ***Molt Series: New Thompson Sunrise
Drawing #4***, 1980. Oil on paper, 13 × 15 in. Collection of the artist.

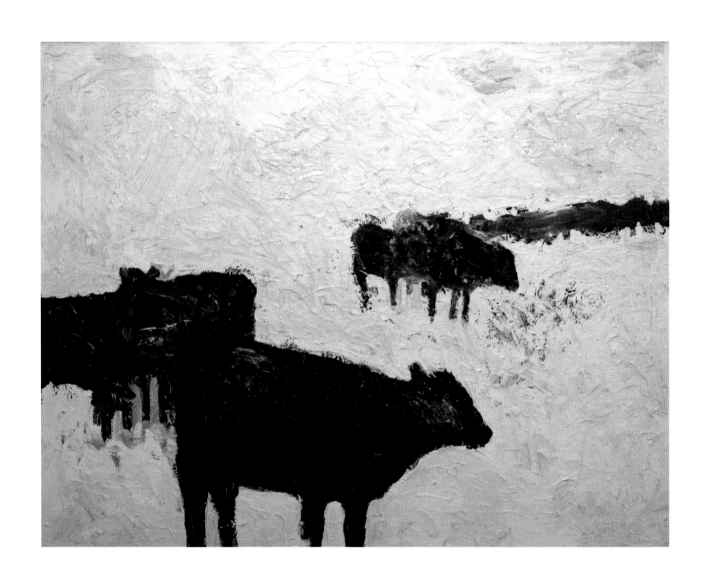

Theodore Waddell. *Angus #81*, 1984. Oil on canvas, 60 × 78 in.
Collection of the artist.

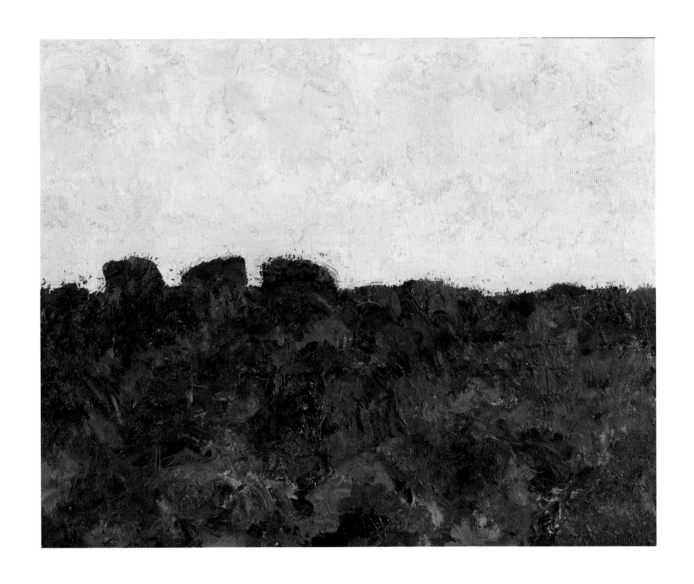

Theodore Waddell. *Angus Sunrise #5*, 1985. Oil on canvas, 48 × 60 in. Collection of the Holter Museum of Art. Gift of Eric Myhre.

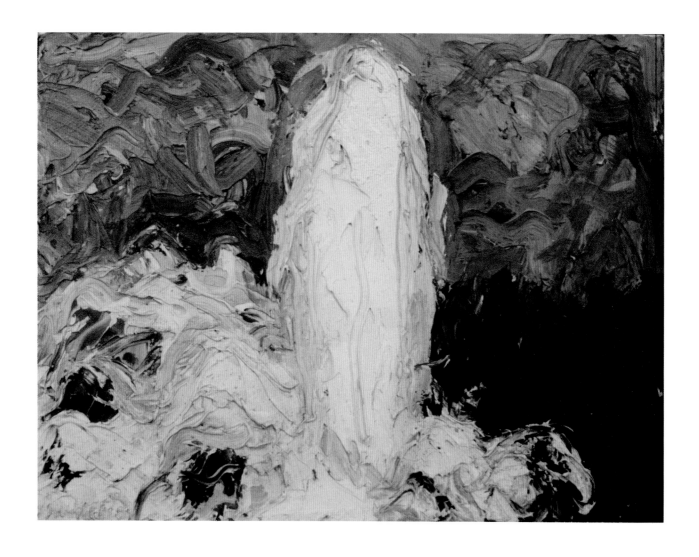

Theodore Waddell. **Old Faithful**, 1987. Oil on canvas, 18 × 24 in.
Collection of the Buffalo Bill Center of the West, Whitney Western
Art Museum, Cody, WY.

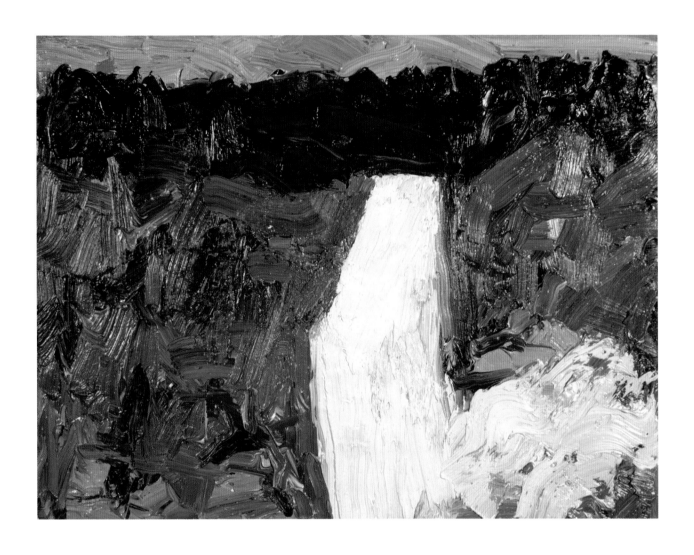

Theodore Waddell. *Yellowstone Falls #4*, 1987. Oil on canvas, 19 × 25 in. Collection of the Autry Museum of the American West, Los Angeles, CA.

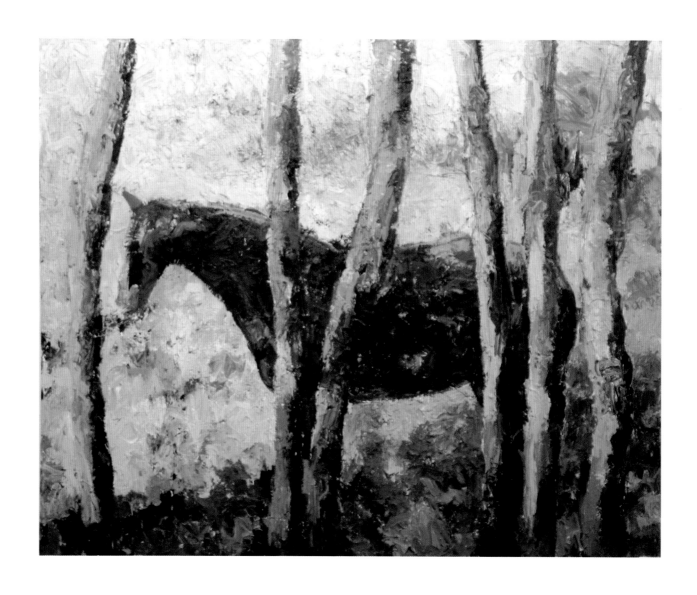

Theodore Waddell. *Horse #13*, 1985. Oil on canvas, 72 × 90 in.
Collection of the Phoenix Art Museum, Phoenix, AZ.

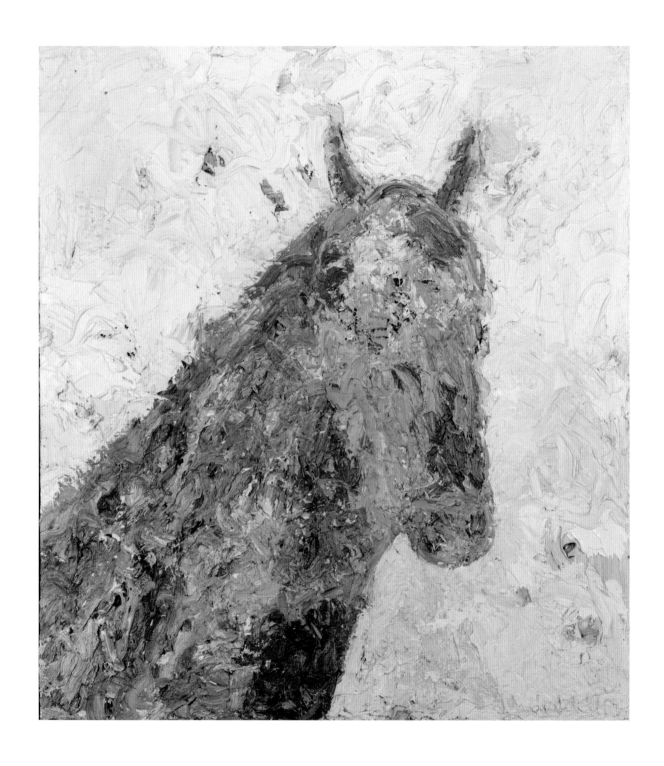

Theodore Waddell. *Horse #26*, 1986. Oil on canvas, 90 × 72 in. Collection of the Holter Museum of Art. Gift of Betty Whiting, H. C. Arin Waddell, and Shanna B. L. Shelby.

Theodore Waddell. **Trophy #14**, 1986. Mixed media, 19 × 33 × 34 in. Collection of the artist.

Theodore Waddell. **Portrait of Rudy** [Autio], 1983. Oil on canvas, 36 × 30 in. Collection of the Holter Museum of Art. Gift of Rudy and Lela Autio.

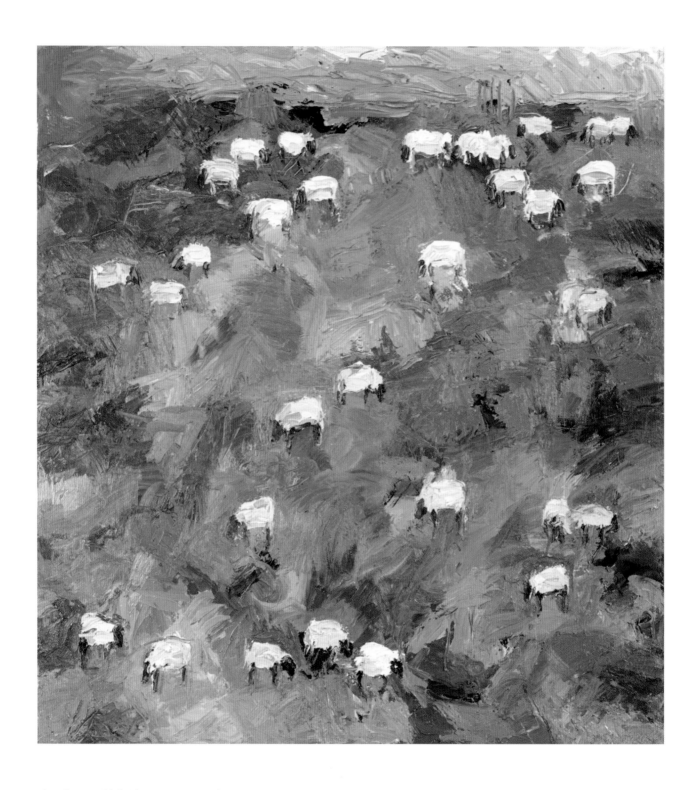

Theodore Waddell. *Sheep #1*, 1987. Oil on canvas, 78 × 72 in.
Collection of the Yellowstone Art Museum, Billings, MT.

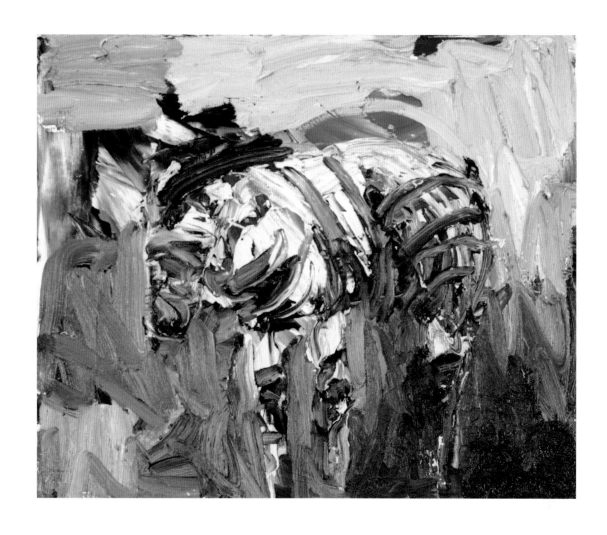

Theodore Waddell. *Zebra #10*, 1988. Oil on canvas, 20 × 24 in.
Collection of the artist. Location unknown

Theodore Waddell. **Botswana Baboons**, 1992. Oil on canvas,
72 × 72 in. Collection of the Yellowstone Art Museum, Billings, MT.
Gift of Betty Whiting.

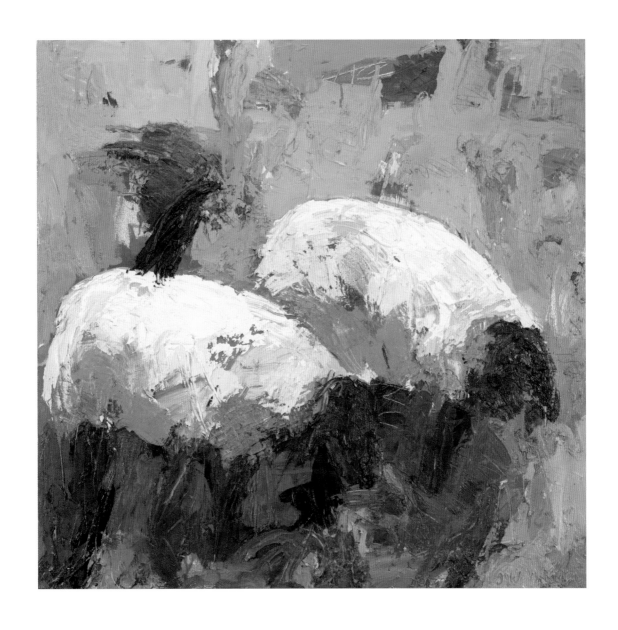

Theodore Waddell. *Sheep and Blackbird*, 1989. Oil on canvas,
40 × 42 in. Location unknown.

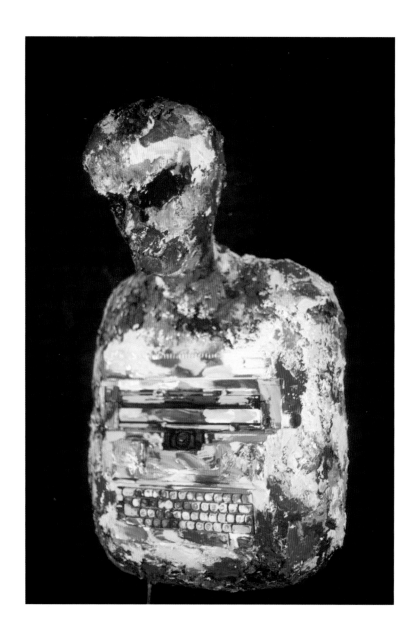

Theodore Waddell. **Writer Trophy**, 1988. Mixed media,
23 × 40 × 19 in. Collection of Arin Waddell.

Theodore Waddell. **Chatham's Bonefish**, 1989. Mixed media,
19 × 45 in. Collection of the artist.

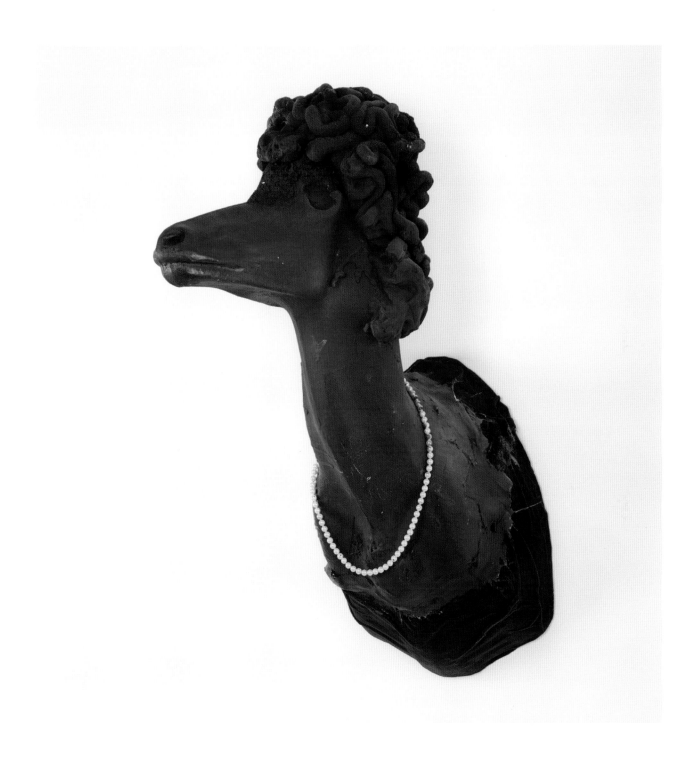

Theodore Waddell. **Tumbleweed Ladder**, 1988. Mixed
media, 3.75 × 24 × 73.5 in. Collection of the artist.

Theodore Waddell. **Anderson Deer**, 1991. Mixed media,
12 × 32 × 21 in. Collection of the artist.

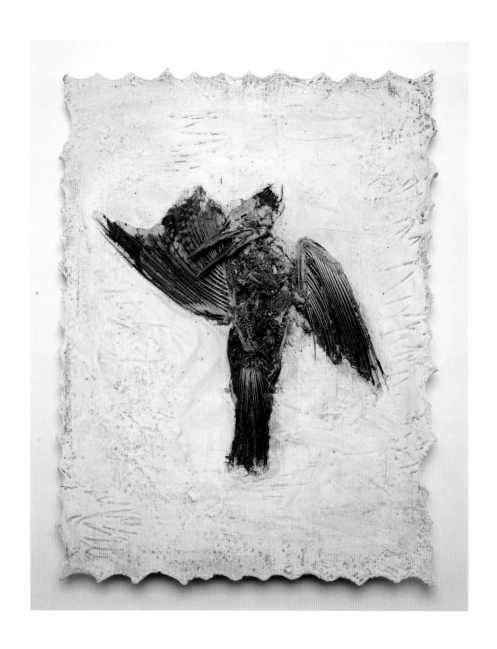

Theodore Waddell. *Kingfisher Bird Stamp*, 1990. Mixed media,
14 × 18 in. Collection of the artist.

Theodore Waddell. *Snakecharmer*, 1992. Mixed media,
5 × 33 × 5 in. Collection of the artist.

Theodore Waddell. *American Family #1*, 1991. Oil and encaustic
on canvas, 66 × 64 in. Collection of the artist.

Theodore Waddell. *Kass Family Portrait #2*, 1998. Oil on canvas, 72 × 90 in. Collection of the Yellowstone Art Museum, Billings, MT.

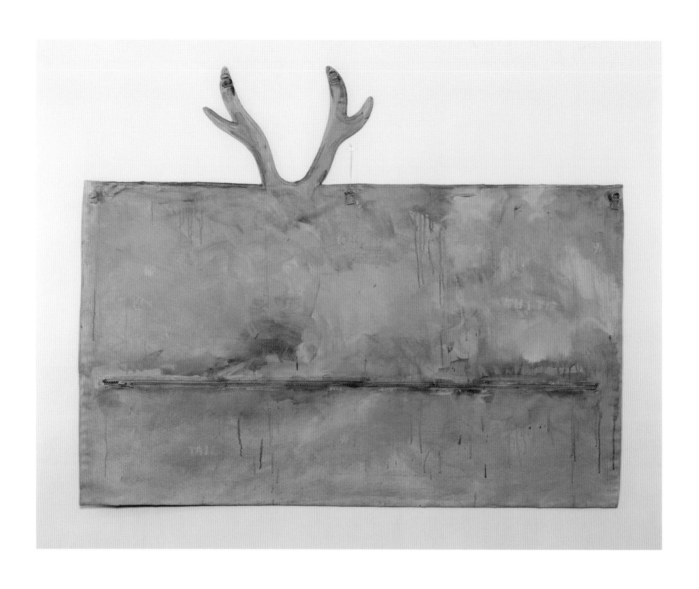

Theodore Waddell. ***Body Bag for a White Tail Deer***, 1994.
Mixed media, 46 × 56 in. Collection of the artist.

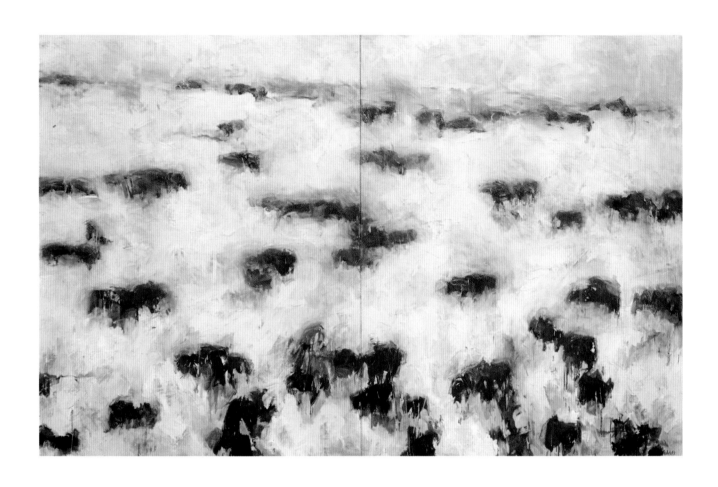

Theodore Waddell. **Alzada Angus**, 1992. Oil and encaustic on canvas, 72 × 144 in. Collection of the Yellowstone Art Museum, Billings, MT.

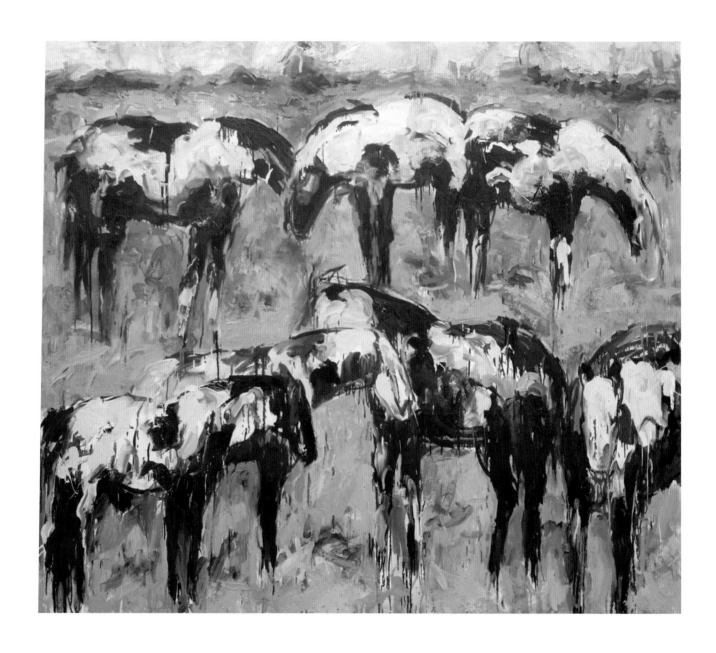

Theodore Waddell. *Snake River Paints #4*, 1993. Oil and encaustic
on canvas, 78 × 90 in. Collection of the Amarillo Museum of Art.

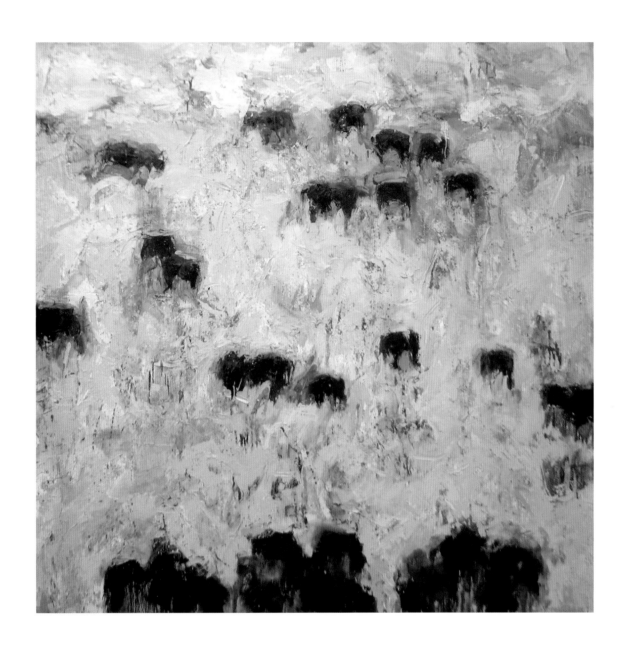

Theodore Waddell. *Jatte's Angus #2*, 1995. Oil on canvas, 75.5 x 76 in. Collection of the Missoula Art Museum, Missoula, MT. Gift of Miriam Sample, 2007.

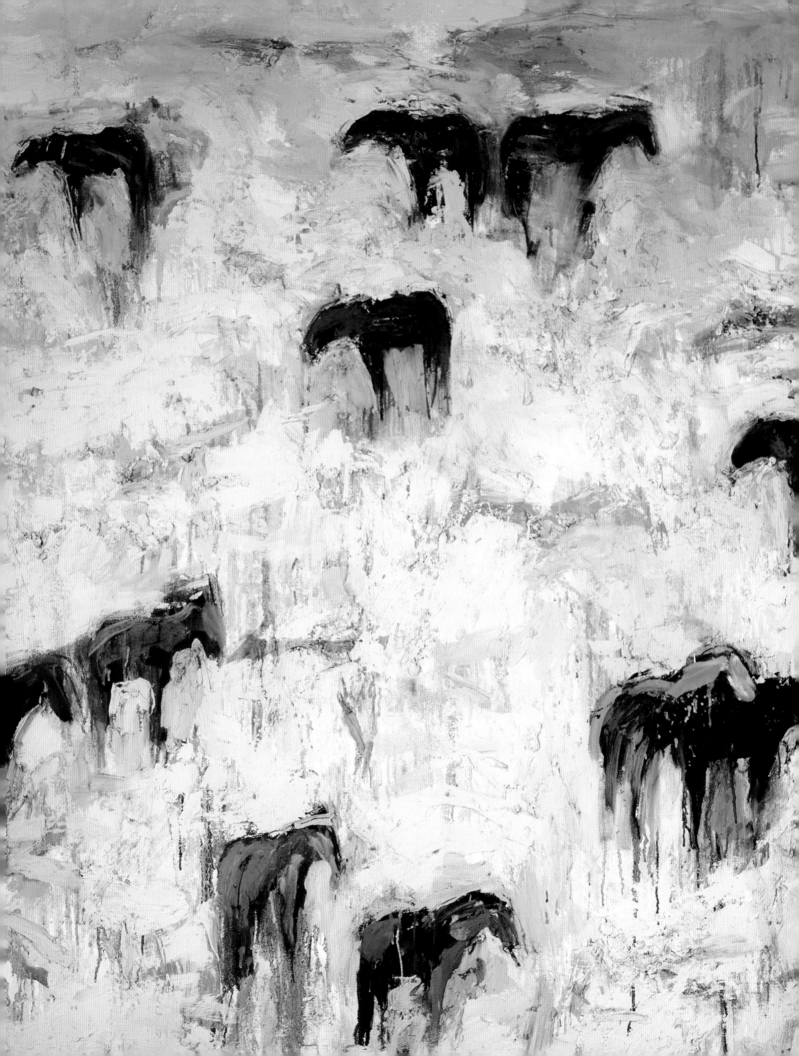

The Consummation of Arrival is Identification

Landscape painting is the thoughtful and passionate representation of the physical conditions appointed for human existence.

—John Ruskin[1]

In the Crazies, I go a long way off, I achieve distance.

—David Strong[2]

In 1985, when Theodore Waddell wrote in his journal that henceforth he was free to make art full time, he was engaging in a bit of hyperbole—that Western predilection for exaggeration he championed. With his newfound financial success as an artist, he was certainly on his way, but he was still operating the ranch near Ryegate, albeit a much smaller one than the Leuthold OK Ranch at Molt had been. True freedom to pursue his art full time only came in 1996, when he and his second wife, Lynn Campion, bought a small spread at Manhattan, Montana, near Bozeman, where he could paint to his heart's desire.

Meanwhile, as early as 1986, he had begun developing relationships with galleries in the ski town of Ketchum, Idaho, when he first showed at the Sun Valley Art Center, and in 1988, he began showing regularly at Ketchum's Anne Reed Gallery. In the 1990s, the Sun Valley Art Center asked him to teach drawing workshops in Ketchum, and it was at one of these workshops that Theodore Waddell met Lynn Campion, who became his second wife.

Lynn Campion made her home in Hailey, Idaho, next door to Ketchum, and so, following their marriage Lynn and Ted divided their time between Manhattan and Hailey. In their Manhattan studio, in daughter Shanna's words, Waddell "looked east across the pastures full of cows, to Ross Peak in the Bridger Mountains and south to a portion of the Spanish Peaks range."[3]

In Idaho, he found himself in a horse-centric world. Writer and photographer Lynn Campion is a nationally recognized cutting horse rider, and she has written and created

FACING PAGE
Theodore Waddell. *Red Lodge Horses*, 2008 [detail]. Oil and encaustic on canvas, 72 × 80 in. Collection of the Buffalo Bill Center of the West, Whitney Western Art Museum, Cody, WY. Gift in Memory of Isabelle Johnson.

177

Theodore Waddell. **Bridger Mountain Horses #2**, 1999. Oil and encaustic on canvas, 78 × 108 in. Collection of the Foosaner Art Museum, Melbourne, FL.

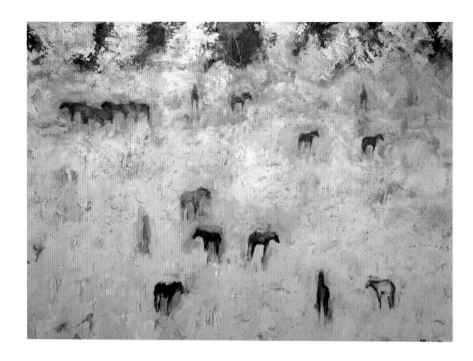

Theodore Waddell. **Fawn Creek Aspens**, 2005. Oil and encaustic on canvas, 40 × 36 in. Collection of the Artist.

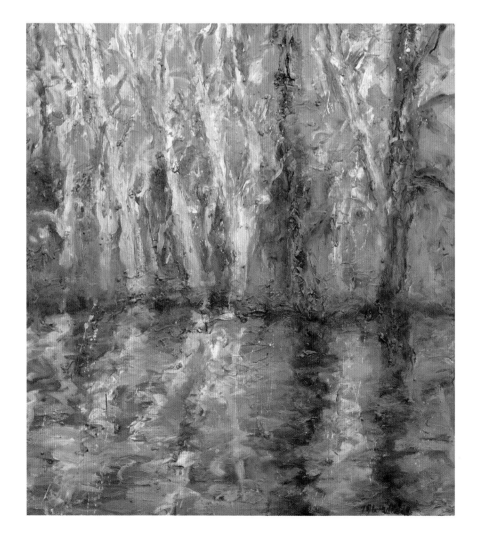

Theodore Waddell painting. Photograph by Lynn Campion. Waddell Family Collection.

Poster for Theodore Waddell's **Rodeo Series** exhibition, Steinbaum Krauss Gallery, New York City, 1996.

Theodore Waddell
Rodeo Series
21 September through 26 October 1996

STEINBAUM KRAUSS GALLERY
132 Greene Street New York City 10012
Tel 212.431.4224 Fax 212.431.3252

the photographs for two books, *Training and Showing the Cutting Horse* (Prentice Hall, 1990) and *Rodeo: Behind the Scenes at America's Most Exciting Sport* (The Lyons Press, 2004). One reporter noted that Lynn Campion "rode English-style as a child, but, she says, 'I was always looking over my shoulder at cowboys.' After not riding for years, she began to ride cutting horses, which separate cattle from the herd."[4] Originally from Colorado, Campion comes from a horse-loving family. According to the *Denver Post*, her mother, Barbara Johnson Hartley (1920–2009), was an avid horsewoman and "at age 10 . . . was named princess for the National Western Stock Show, riding her horse, General Pershing. A few years later, she was named Best Girl Rider of the West."[5]

In 2010, Waddell's daughter Shanna Shelby wrote:

A visit to Dad's studio in Sun Valley, Idaho, today is to
experience the chief subject of his paintings—horses. No
longer does my father have to divide his studio to accommodate
farm equipment. Now, he willingly shares his space
with the physical presence of the large, graceful animals.
Dad paints portraits of his horses much the way he did cows in the 1980s.[6]

Theodore Waddell and Lynn Campion, with four of their Bernese Mountain Dogs. Waddell Family Collection.

Of course, in the years since the mid-1990s, Theodore Waddell has painted much more than horses. He continued to paint his beloved Angus, he painted wildlife (especially elk and bison), and sheep began to appear in his work more regularly—in the early 20th century, as historian Wendolyn Spence Holland notes, "Hill City [about 65 miles from Ketchum] and Ketchum shared the distinction of shipping more sheep than any other depot in the country."[7] He has continued to create his hallowed absurdities, focusing especially on the Western fascination with firearms. And in his quieter moments, he has illustrated three children's books, centered around a good-natured Bernese Mountain Dog named Tucker.[8] For many years, Waddell and Lynn Campion have raised Berners, as Bernese Mountain Dogs are affectionately known.

Theodore Waddell continued to work tirelessly, and his works grew ever larger. For years, he had relied on eight-foot two-by-fours for his stretchers. He recalls, "I would go into the lumberyard and have them cut 2 x 4's at an angle in 3- x 4-foot and 4- x 5-foot lengths. So I would have 3- x 4-foot canvases, 4 x 5, 3 x 5, but they were all based upon eight-foot 2 x 4's. I used irrigation canvas." But as his success continued, he turned for his stretchers to a Wisconsin company called Dead Straight. He says, "They make the most wonderful stretchers for me, made out of alder. And they're terrific because you can order a large set of those stretchers and they don't warp."[9]

With the ability to go much larger without fear of warping and inspired by the example of John Fery, Waddell created vast triptychs, in some cases with each panel measuring six by ten feet, and the entire triptych stretching to ten by eighteen feet. (See, for example, *Montana*, 2000, on page 14.) He says, "That was the beginning of a whole series of these ten- by eighteen-foot pieces of various places, primarily in Montana. And then expanding that, I did a six-and-a-half . . . or seven-foot by twenty-eight-foot painting for a show at the Denver Museum a couple of years ago."[10]

He goes on: "I've been very fortunate to be able now to pick anything I want to paint, and [since] I believe that for every idea there's a scale that's appropriate. . . . I can pick amongst about a hundred stretched canvases—various sizes—to decide how to move forward with a painting notion."[11]

In 1999, Theodore Waddell was invited to participate in the Art in Embassies Program of the U.S. State Department. That year, his first works were placed in the U.S. Ambassadorial Residence in Lusaka, Zambia, and over the next two decades, his paintings have appeared in ambassadorial residences and embassies from Togo, West Africa to Ulaanbaatar, Mongolia to Stockholm, Sweden to Moscow, Russia. In 2004 Theodore Waddell was honored at the White House for his participation in the program.

Originally created by the Museum of Modern Art, New York, in 1953, and formalized at the State Department a decade later, the Art in Embassies Program mounts about sixty exhibitions—expertly curated—each year around the world. For example, the 2012 exhibition at the U.S. Embassy in Moscow featured three paintings by Waddell alongside works by prominent fellow Westerners Joan Brown, Richard Diebenkorn, Pirkle Jones, Fritz Scholder, and James Weeks.

Most recently, with the naming in 2014 of former Montana U.S. Senator Max Baucus as ambassador to China, Waddell's works hang in the ambassadorial residence in Beijing, alongside works by fellow Montanans Deborah Butterfield, Russell Chatham, Rudy Autio, Harry Koyama, and Carol Spielman. Ironically, the year 2014 was the year of the horse, and so Baucus and his wife Melodee Hanes chose works that honored that "symbol of hard work, diligence and strength, according to the Chinese Zodiac." In a feature in *Western Art & Architecture*, Baucus and Hanes are depicted in front of a pair of Theodore Waddell horse paintings. Hanes told writer Seabring Davis, "It was serendip-

Theodore Waddell. **Wood River Angus**, 2004. Oil and encaustic on canvas, 78 × 108 in. Collection of the Boise Art Museum, Boise, Idaho.

Theodore Waddell. **Arco Sheep #4**, 2011, Oil and encaustic on canvas, 30 × 32 in. Private Collection.

ity when we found out it was the year of the horse," and Baucus noted, "We have a per-
sonal connection to the art at the residence. Montana is part of who we are; it's home."[12]

For Theodore Waddell, Montana has always been home, and so when he gave up his
place at Manhattan, he needed to find another Montana foothold. He found just the right
one in the tiny southwestern Montana town of Sheridan (population 642). There, daugh-
ter Shanna writes, Waddell finds perfect quiet for serious painting in a

> 100-year old house and horse barn converted into a two-room studio, completely
> stocked with paint, paper and canvas. To the south, the studio looks out toward the
> Ruby River drainage and Ruby Mountains. North are the Tobacco Root Mountains.
> Dad can see both from the studio. "I hear cows mooing when I get up, deer in the yard
> sometimes and sandhill cranes talking in the summer," he says.[13]

Campion and Waddell continued to make Hailey, Idaho, their principal home, and
given their shared interests, they sometimes focused on the same subjects. In 1997, the
Anne Reed Gallery, Ketchum, hosted the exhibition, *Two Visions: Trailing the Sheep*, fea-
turing Campion and Waddell's photographic and painterly takes on the annual autumn
trailing of the sheep through the Wood River Valley.

In 2001, *Sun Valley Magazine* writer Marie-Christine Loiseau wrote that, during a trip
through Montana's Madison Valley, Campion and Waddell had encountered an aston-
ishing sight:

> In the middle of a 2,000-acre pasture were fifteen to twenty white mares, all with foals.
> The couple noticed that the youngest foals were black, but the others seemed to be
> getting lighter as they grew older. They couldn't stop thinking about those horses,
> and went back many times. Lynn started photographing them, and after three years,
> Waddell is still painting them.[14]

 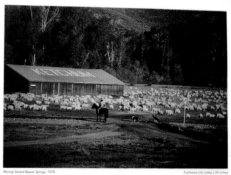

THEODORE WADDELL LYNN CAMPION

TWO VISIONS — TRAILING THE SHEEP

August 29–September 30, 1997

A N N E R E E D G A L L E R Y

620 SUN VALLEY ROAD POST OFFICE BOX 597 KETCHUM, IDAHO 83340 208.726.3036 FAX 208.726.9630 e-mail: annereed@micron.net

In 1999, images of these *Ennis Horses*, including Ted's 1997 six-foot-square painting, *Lynn's Narcissus #3*, had been featured in a second Waddell/Campion exhibition, titled *Double Vision*, this time at Sherry Leedy Contemporary Art in Kansas City, Missouri. As a reviewer noted in the *Kansas City Star*, "*Lynn's Narcissus #3*, . . . is [Waddell's] abstracted, painterly response to Campion's color print *Narcissus*, showing a white horse gazing at his reflection in a blue pool."[15]

While Theodore Waddell was enjoying exploring new subject matter and new terrain, he was also, in the year 2000, returning home to the Yellowstone Art Museum in his birthplace of Billings for a major mid-career retrospective, *Theodore Waddell: Into the Horizon, Paintings and Sculpture, 1960–2000*. The Yellowstone's curatorial staff, especially Donna Forbes and Gordon McConnell, had long been supportive of Waddell's work and had significantly contributed to his breakthrough as a major artist of the American West, most notably by introducing him and his paintings to Clair List, the Corcoran curator, back in the early 1980s.

Now, almost two decades on, he began working with a new YAM curator, Ben Mitchell, to put together a retrospective that chronicled his career to date. The substantial catalog, co-published by the Yellowstone and the University of Washington Press, documented the range of Waddell's work, from the early paintings to soaring steel sculptures to his breakthrough paintings of Angus on the high plains to his Funk- and pop-inspired roadkill sculptures to his new preoccupation with the equine.

Peter H. Hassrick, the distinguished authority on Western art, wrote the introduction, and Waddell's old friend and YAM founding director Terry Melton contributed an insightful essay, writing that the "regional attitudes and the close horizons of Waddell's

painting push us to an awareness of a harmony we might miss if we assume the world begins elsewhere."[16] Poet, critic, and curator Kirk Robertson—one of the foremost interpreters of Waddell's work—wrote in his essay, "Seizing the Ephemeral":

> [Waddell] literally sees the landscape as colors, tubes of color—alizarin crimson, cerulean blue, yellow ochre. His work is a painted fiction, but not necessarily a straightforward narrative. The paintings simultaneously have the ability to be frighteningly stable—arising from specific, real places—Monida, Ennis, Two Dot—and totally unstable, capable of dissolving into nothing but a joyous concatenation of paint. . . .[17]

Curator Ben Mitchell, in the catalog's principal essay, underscored Theodore Waddell's place in a lineage made up of the American transcendentalists (Emerson, Thoreau); Cezanne and Monet; American impressionists like Childe Hassam, John Henry Twachtman, Joseph Henry Sharp, and even the late "impressionist" Remington; and of course, the abstract expressionists. Mitchell concluded, "With an abundant vocabulary of line and mark-making, an acute apprehension of color, and with ferocious intimacy and passion, [Theodore Waddell] is bringing news back to us about a land and an essence we risk forgetting."[18]

<div align="center">* * *</div>

That land from which Theodore Waddell brings us news—the Northern Plains and Northern Rockies—has benefited not only from his artistic outpouring, but also from his passionate belief in the necessity of building cultural capital there. He began early, founding his little storefront gallery/studio on Billings' 34th Street in the mid-1960s to show the "puzzling, startling, contemporary" works of struggling local modernists. In the 1970s, while teaching in Missoula, he was an active partner in a cooperative gallery in Great Falls, traveling east 170 miles each month for openings. And of course, in the 1980s, he participated wholeheartedly in a burgeoning late modern/postmodern art scene on the southcentral Montana high plains, culminating with *Montana '89: Our Place & Time*, the epic gathering that he and Betty hosted on their ranch near Ryegate. Gordon McConnell remembers that, for many years, Waddell was "elite art auctioneer Peter Stremmel's favorite foil at the [Yellowstone] Art Center's Annual Auctions, where he spent some of his earnings purchasing the works of other artists."[19]

But perhaps Waddell's greatest contribution to a thriving contemporary arts community in Montana has been as a role model. The gifted sculptor Tracy Linder—who happens to live at Molt near where the Waddells spent eleven years on the Leuthold OK Ranch and whose own work "deeply meditates," in the words of curator Lisa Hatchadoorian, "on the plants we grow for food, animals that we eat and live with, and the farm machinery that performs grueling labor"[20]—has written:

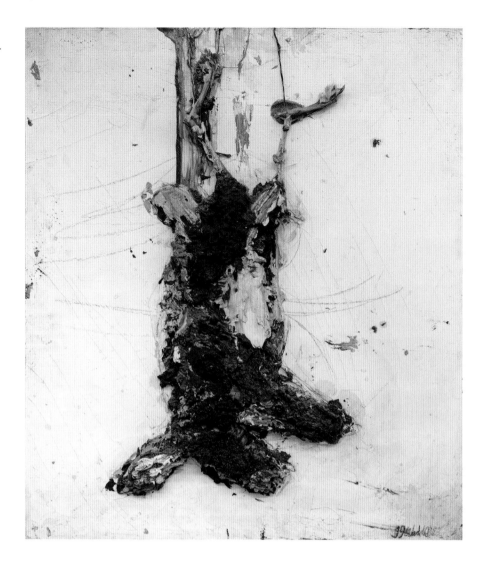

Theodore Waddell. ***A Rabbit for Frank***, 1998. Mixed media, 36 × 32 in. Collection of the artist.

Ted is infamous in my zip code. Living on the high plains in Molt does require a recognition of the circle of life. The weather, the seasonal cycles, and life, both wild and domestic, play out their natural sojourn before our eyes. Survival tactics are revealed every day. You can't ignore it or change it, you must accept it at some point.

Ted's paintings played a significant role in my development as an artist. He was that perfect bridge of Modernism meets Contemporary with a Western twist. His art work, his commitment and work ethic gave me the knowledge and hope that my way of life, my environment and my connection to the land and animals were relevant and engaging. He was proving it through his succinct images of his experiences and hard-earned knowledge of ranching on the prairie. While I heard him once jokingly refer to himself as a nearsighted realist, I know, too, the atmospheric effect that the light of day can bring to what is otherwise a tragic event of life and death. You must carry on and move forward with a certain regard for that which has come before.[21]

* * *

In the 21st century, Theodore Waddell continues to move forward with undiminished vigor. In 2001–2002, his retrospective traveled to the Plains Art Museum, Fargo, North Dakota; the Polk Museum of Art, Lakeland, Florida; and the University of Montana. Each subsequent year brings multiple exhibitions, and the critical reception remains laudatory and sometimes downright eloquent. In 2005, Kirk Robertson reviewed an exhibition at the Stremmel Gallery, Reno, where Waddell was paired with his old friend Bill Bliss. Robertson was most taken with a "series of moody black-and-white, oil-encaustic paintings and large-scale drawings" inspired by Waddell's high regard for the work of Robert Motherwell:

> The *Motherwell Angus* are dense, magisterially worked, worked and re-worked, edge-to-edge pieces. They succeed because, although grounded in a specific "real" place, they also use that real ground to translate and convey a mood that reality prompted. The artist conjures Angus as the citizens of his own imaginary elegiac republic.
>
> Here Waddell's tendency toward abstraction has escalated to the point that the Angus are densely layered—agitated and animated—black splotches that we see as cows only because we know that they are what Waddell paints. They are analogous to a jazz soloist who returns to pick up the melody, albeit in a different place than where he left it.[22]

Certain museum exhibitions resulted in catalogs—those at the Albrecht-Kemper Museum of Art, St. Joseph, Missouri, *Angus Anthem,* 2009; the Paris Gibson Square Museum of Art, Great Falls, Montana, *The Weight of Memory,* 2010; and the Yellowstone Art Museum, *Hallowed Absurdities,* 2013—and other museum exhibitions, especially those at the Denver Art Museum, *Abstract Angus,* and the Amarillo Museum of Art, *For Love of the Horse,* both 2012, helped cement Waddell's standing as a preeminent artist of the contemporary West.

Of particular importance was curator Bob Durden's essay in *The Weight of Memory* catalog which, for the first time, placed Waddell firmly within the tradition of Western art. Durden wrote:

> Theodore Waddell became one of the artistic voices who lit the way for modern and contemporary art developments in the region, and though obvious visual differences abound, an empathy and continuity exists between the works by Waddell and his artistic ancestors.

Ironically, Durden argues, though "any artist working in the region prior to the mid-1950s found it difficult to veer from the path of [Charlie] Russell," now that Waddell's mentors, Waddell himself, and his many peers had firmly established modernism as a

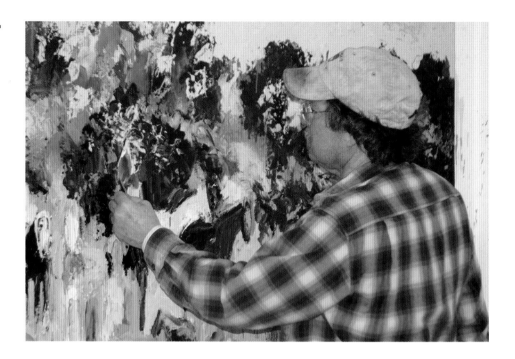

Theodore Waddell paints in his Idaho studio. Waddell Family Collection.

viable form in Montana, it became possible to see the continuities—and not just the differences—between the older tradition and the new. Waddell began looking at more traditional Western artists with fresh eyes and found much to admire. He's grown particularly fond of Remington's sketches and the works of Victor Higgins, Frank Tenney Johnson, Maynard Dixon, and Joseph Henry Sharp. But as curator Gordon McConnell told art writer Michele Corriel, Waddell's "subject matter of the ranchlands with horses and cattle and mountain vistas is within the set of Western icons. The Western collections he's in—like the Denver Art Museum or the Buffalo Bill Center of the West—he's out on the left wing of the artists in those collections. But he bridges the regional subject matter with the international currents of Modern art."[23]

This bridging of traditions adds a special importance to the life and work of Theodore Waddell, beyond simply his accomplishment as painter and sculptor. In recent years, he has been honored by the people of his native state for his undoubted artistry but perhaps just as much for the impact he has had in bringing together what might have seemed utterly incompatible traditions. In 2015, he was awarded the Montana Governor's Arts Award, and Robyn Peterson, the executive director of the Yellowstone Art Museum, wrote in her letter of nomination that Theodore Waddell "has done more than any other living painter to develop a distinctive Montana-based vision that brings Modernism into the 21st century."[24] Peterson added that Waddell is a true role model, generous to and supportive of younger generations of artists, and he has been an avid collector of others' work, much of which he has donated to the state's public collections. That same year, Waddell was also named the Yellowstone Art Museum's Artist of the Year.

* * *

When Harry Nadler, Theodore Waddell's teacher at the Brooklyn Museum Art School, looked to Wallace Stevens' long poem, "Description without Place," for inspiration in creating his "paintings of strange spaces filled with autobiographical objects,"[25] he must have felt empowered by Stevens' formulation:

Description is revelation. It is not
The thing described. . . .[26]

Theodore Waddell, on the other hand, has always—since 1976 and his turn to the ranching life—opted for description *with* place. As he's said recently, "I can't paint anything I can't see."[27] If he were to have a patron saint among American modernist poets, that poet might be William Carlos Williams, the bard of Paterson, New Jersey. Wendell Berry, another masterful interpreter of place, has championed "all those lovely poems that had grown out of and so heartily savored the life of [Williams'] places," poems that leave the reader "wonderfully comforted and relieved."[28] Wendell Berry goes on to assert:

[Williams] knew . . . that a man has not meaningfully arrived in his place in body until he has arrived in spirit as well, and that the consummation of arrival is identification. What he accomplished was a sustained and intricate act of patriotism in the largest sense of that word—a thousand times more precise and loving and preserving than any patriotism ever contemplated by officials of the government or leaders of parties.[29]

For his 70th birthday, Waddell celebrated with a week-long trip into Montana's fabled Bob Marshall Wilderness Area. Waddell Family Collection.

Ted with one of his Bernese Mountain Dogs, Milly, Deer Creek, Hailey, ID. Waddell Family Collection.

The geographer Yi-Fu Tuan wrote, "Places are centers of felt value."[30] William Carlos Williams understood that and created his art accordingly, championing a uniquely American idiom in the face of the Eurocentric biases of fellow American modernists like T. S. Eliot, Ezra Pound, and H. D. (Hilda Doolittle). So does Theodore Waddell, whose enterprise for the past forty years has been to give profound voice to places in the contemporary West that might otherwise be known only to those few who inhabit them. The French thinker Roland Barthes once wrote, "Among the views elevated . . . to aesthetic existence, we rarely find plains (redeemed only when they can be called fertile),"[31] and yet in Waddell's oeuvre, the semi-arid high plains are given pride of place, resonating with felt value. Just as his mentor Isabelle Johnson transfigured unremarkable sites in southcentral Montana into marvelously evocative paintings, Theodore Waddell has given us a vast body of revelatory paintings and sculptures that speak of particular places. Jim Poor, his old friend and fellow painter, said of Waddell, "I know of no other artist who has so wonderfully connected to his experience with the land, animals, light, weather, and feeling."[32] This is exactly what Wendell Berry must have meant—this profound and inextricable connection with place that Theodore Waddell truly embodies—when he asserted that the "consummation of arrival is identification."[33]

1 John Ruskin, *Lectures on Landscape: Delivered at Oxford in Lent Term*, 1871 (Project Gutenberg Ebook, 2006), 1.

2 David Strong, *Crazy Mountains: Learning from Wilderness to Weigh Technology*, (Albany: State University Press of New York, 1995), 108.

3 Shelby, "Artistic Evolution: A Daughter's Perspective," 124.

4 "Cutting-horse riding," *Kiplinger's Personal Finance Magazine*, January 1992, 71.

5 Virginia Culver, "Foundation Chief Had a Quiet Generosity," *The Denver Post*, July 4, 2009; http://www.denverpost.com/2009/07/04/foundation-chief-had-a-quiet-generosity/

6 Shelby, "Artistic Evolution: A Daughter's Perspective," 124.

7 Wendolyn Spence Holland, "From Silver to Sheep: 1892–1935," *Sun Valley: An Extraordinary History* (Ketchum: The Idaho Press, 1998), 131.

8 See Theodore Waddell and Ted Beckstead, *Tucker Gets Tuckered* (Phoenix, AZ: Flash of Brilliance, 2006); Theodore Waddell and Lynn Campion, *Tucker's Seasonal Words of Wisdom* (Helena, MT: Bar R Books, 2014); and Theodore Waddell, Lynn Campion, and Stoney Brown, *Tucker Tees Off* (Helena, MT: Bar R Books, 2015).

9 Waddell, oral history (self-interview), Segment II.

10 Ibid.

11 Ibid.

12 Quoted in Seabring Davis, "Collector's Eye: Max Baucus and Melodee Hanes," *Western Art & Architecture: From Cowboy to Contemporary*, August/September 2015; http://westernartandarchitecture.com/Article/collectors-eye19

13 Shelby, "Artistic Evolution: A Daughter's Perspective," 124–125.

14 Marie-Christine Loiseau, "Theodore Waddell," *Sun Valley Magazine*, Summer/Fall 2001, 78.

15 Alice Thorson," Landscape and Livestock," *Kansas City Star*, February 12, 1999, 13.

16 Terry Melton, "The Challenge of Seeing," in Ben Mitchell, Peter Hassrick, Terry Melton, and Kirk Robertson, *Theodore Waddell: Into the Horizon, Paintings and Sculpture, 1960–2000* (Billings, MT/ Seattle: Yellowstone Art Museum in Association with the University of Washington Press, 2000), 19.

17 Kirk Robertson, "Seizing the Ephemeral," *Theodore Waddell: Into the Horizon*, 27–28.

18 Ben Mitchell, "Into the Horizon," *Theodore Waddell: Into the Horizon*, 69.

19 Gordon McConnell, "Theodore Waddell: Abstract Pastoralist," in McConnell and Theodore Waddell, *Theodore Waddell: Five Decades, Selected Paintings and Works on Paper* (Fallon, NV: Oats Park Art Center, Churchill Arts Council, 2011).

20 Lisa Hatchadoorian, "Tracy Linder," in Hatchadoorian and Connie Gibbons, *Tracy Linder: The Obligation to Endure* (Casper, WY: Nicolaysen Art Museum, 2012), 4.

21 Tracy Linder, email to Rick Newby, October 25, 2014.

22 Kirk Robertson, "Theodore Waddell and Bill Bliss at Stremmel Gallery," *Artweek*, September 2005.

23 Michele Corriel, "The Expressionism of Theodore Waddell," *Big Sky Journal Arts 2014*, July 2014, 86.

24 Robyn Peterson, quoted in Jaci Webb, "Billings Native Ted Waddell to Receive Governor's Arts Award in June," *Billings Gazette*, April 21, 2015; http://billingsgazette.com/entertainment/arts-and-theatre/visual/billings-native-ted-waddell-to-receive-governor-s-arts-award/article_b50ebf98-cc8f-595c-8c79-60b64c344931.html

25 Helen Sturges Nadler, "Harry Nadler: Biography: Description Without Place," Harry Nadler website, http://www.harrynadler.com/biography.html

26 Wallace Stevens, "Description without Place," *The Palm at the End of the Mind: Selected Poems and a Play*, ed. Holly Stevens (New York: Alfred A. Knopf, Inc., 1971), 275.

27 Corriel, "The Expressionism of Theodore Waddell," 84.

28 Wendell Berry, "A Homage to Dr. Williams," in *A Continuous Harmony: Essays Cultural and Agricultural* (Berkeley: Counterpoint, 2012), 71.

29 Ibid., 70.

30 Yi-Fu Tuan, *Space and Place: The Perspective of Experience* (Minneapolis: University of Minnesota Press, 1977), 4.

31 Roland Barthes, "*The Blue Guide*," in Barthes, *Mythologies*, trans. Annette Lavers (New York: Hill and Wang, 1972), 74.

32 Jim Poor, "Thoughts about Art & Healing," presented at St. Patrick's Hospital, Missoula, MT, May 12, 2003.

33 Berry, "A Homage to Dr. Williams," 71.

Theodore Waddell. ***Horizon Horses***, 2008. Oil and encaustic on
canvas, 72 × 90 in. Private collection.

Theodore Waddell. *Jackson Paints #2*, 2001. Oil and encaustic on canvas, 66 × 72 in. Private collection.

Theodore Waddell. **Saturday Night Special**, 2002. Mixed media, 4 x 10 x 14 in. Collection of the artist.

Theodore Waddell. **Prairie Placebo**, 2007. Mixed media, 5 x 21 x 3 in. Collection of the artist.

Theodore Waddell. **The Yellowstone River at Big Timber**, 2004. Oil and encaustic on canvas, 120 x 216 in. Collection of the Oats Park Art Center, Fallon, NV.

Theodore Waddell. **Red Lodge Horses**, 2008. Oil and encaustic on canvas, 72 x 80 in. Collection of the Buffalo Bill Center of the West, Whitney Western Art Museum, Cody, WY. Gift in Memory of Isabelle Johnson.

Theodore Waddell. *Yosemite #16*, 2006. Oil on canvas, 74 x 74 in.
Collection of the Autry Museum of the American West.

Theodore Waddell. *Quarterhorse Noon*, 2007. Oil and
encaustic on canvas, 60 x 66 in. Private collection.

Theodore Waddell. *Ruby Mountain Buffalo #4*, 2010.
Oil and encaustic on canvas, 72 x 72 in. Private collection.

Theodore Waddell. *Thunderstorm Paints #3*, 2011.
Oil and encaustic on canvas, 40 x 60 in. Private collection.

Theodore Waddell. ***Tobacco Root Angus #3***, 2012. Oil on canvas,
78 x 84 in. Private collection.

Theodore Waddell. *Bailey and the Magpies #2*, 2016. Oil and encaustic on canvas, 36 x 42 in. Collection of the artist.

Theodore Waddell. *Iris Creek Angus #2*, 2012. Oil and encaustic
on canvas, 96 x 132 in. Private collection.

Theodore Waddell. *Dillon Paints #4*, 2015. Oil on canvas, 60 x 54 in. Collection of the artist.

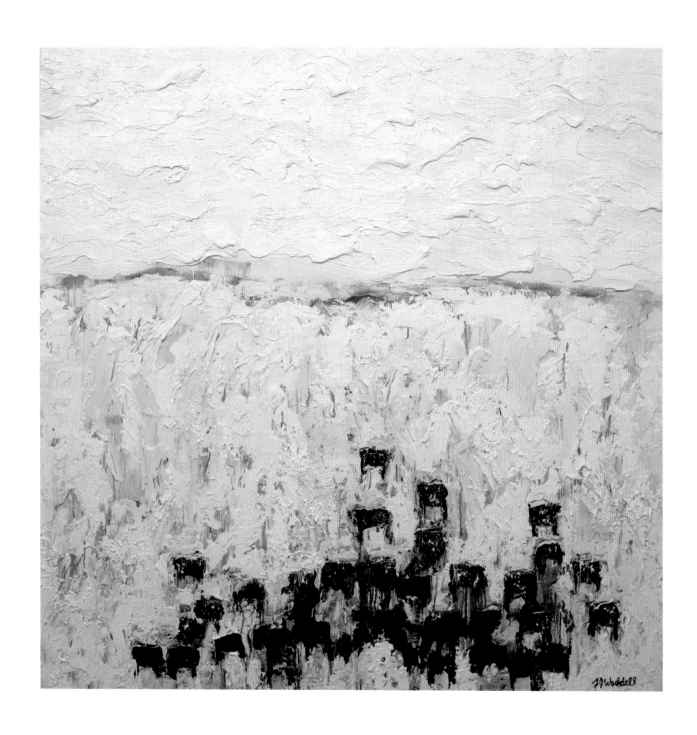

Theodore Waddell. ***Winter Angus #3***, 2014. Oil on canvas,
72 x 72 in. Private collection.

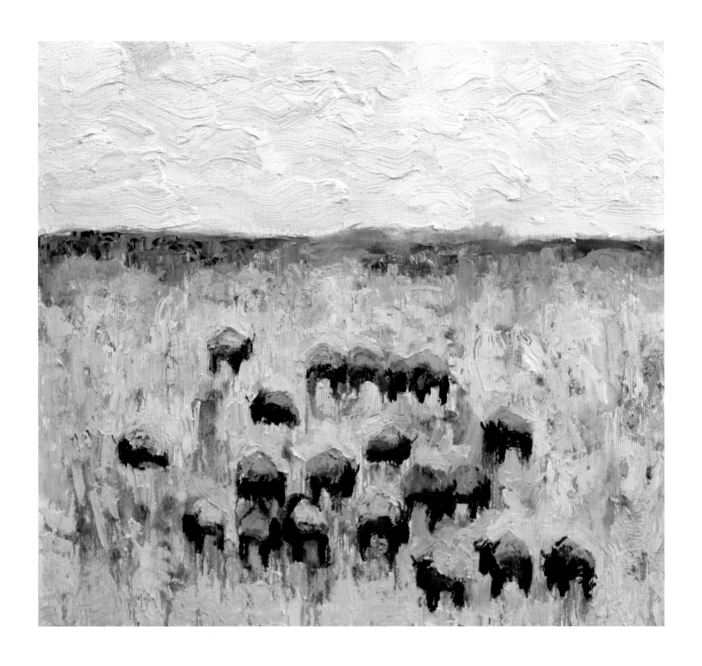

Theodore Waddell. **Gallatin Buffalo**, 2014. Oil on canvas, 54 x 60 in. Collection of the National Museum of Wildlife Art of the United States, Jackson, Wyoming.

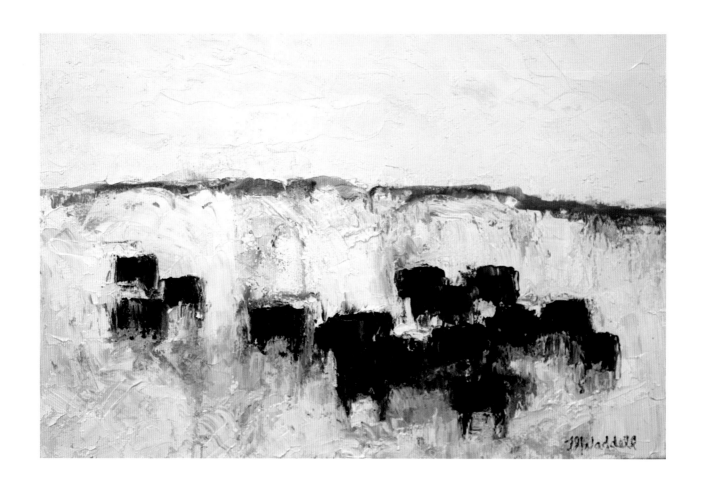

Theodore Waddell. *Monida Angus # 22*, 2015. Oil on canvas,
24 x 36 in. Collection of the artist.

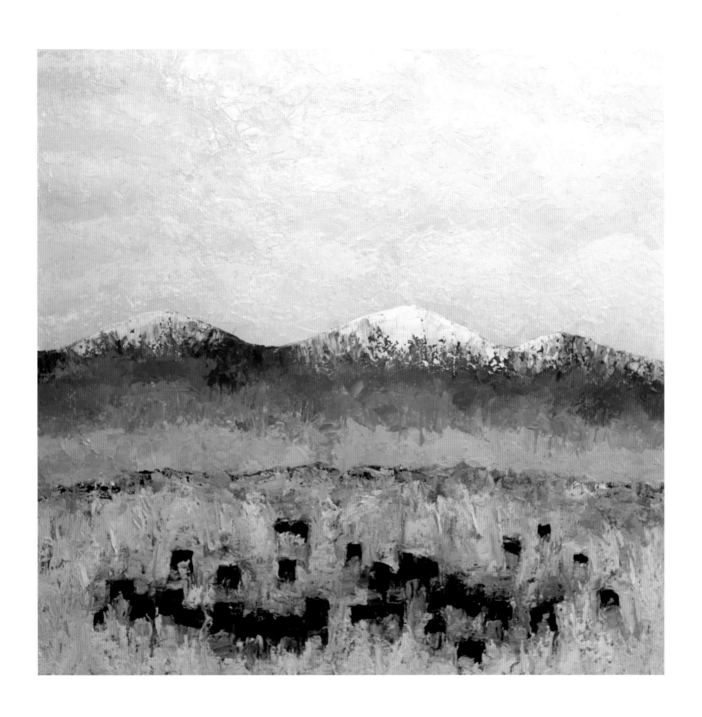

Theodore Waddell. **Beaverhead Angus #19**, 2016. Oil and encaustic on canvas, 60 x 60 in. Collection of the artist.

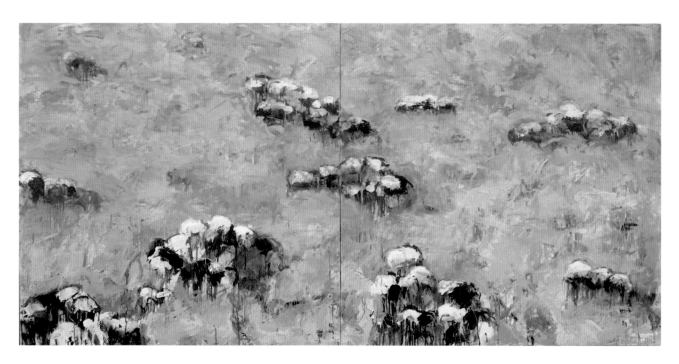

Theodore Waddell. *Monet's Sheep*, 1994. Oil and encaustic on canvas, 78 × 120 in. Private collection.

Theodore Waddell *A Tribute*

with essays by Gordon McConnell

Mark Browning

Donna Forbes

Greg Keeler

Patrick Zentz

Scott McMillion

William Hjortsberg

Paul Zarzyski

Brian Petersen

Angus Paintings, 1982

Gordon McConnell

[**Essayist's note:** The writer attempts to travel back in time and review the early *Angus* series paintings when they were new.]

The painting is present tense. It telescopes through time, its surface registering the deliberately spontaneous activity of the painter, preserving his decisions, his marks, his process. Committed to the kinetic gesturalism of abstract expressionism, his left-handed slashing and scrubbed brushwork has piled up in clotted and furrowed layers—white, and blue and ochre blended with white, in a flattened, worked-over field. In the center of the three-by-four-foot canvas, carved out of this abstract space, is an Aberdeen Angus cow. Simplified in outline, she stands in the snow as if she were posing for a portrait, or, more likely, looking to a human for food. It's an arresting image—funny, beguiling, soulful, and full of life.

This is *Angus #25*, 1982, a painting numbered like a Pollock abstraction or an ear-tagged cow in a cattleman's herd register. The painting is beautifully reproduced on a poster designed by Frederick R. Longan for the exhibition: "*Angus* Paintings 1982, by Theodore J. Waddell." Opening March 29, 1982, this is the first showing of the *Angus* series paintings. Many of them were completed over the preceding winter in an urgent rush of inspiration. The brush marks are bold and spontaneous, and the paintings still smell of linseed oil and turpentine. In this exhibition, the painter most effectively exploits the graphic contrast between black cattle and snowy landscape—the weight and heat of their dark bodies modeled with highlights picked out in tones of blue. The cattle, singly, in cow-calf pairs, and in clusters, are fresh but elemental subjects that inhabit the canvases with relatable legibility.

The exhibition sprawls across two venues: Longan Galleries, on the fourth floor of the Stapleton Building downtown, and the Billings Livestock Commission Company, off the interstate to the east. Hanging on walls above the sale ring, Waddell's primal, neo-expressionist paintings are an unexpectedly provocative element in this utilitarian commercial setting. Knowingly inserting his paintings into the gap between art and life, he puts them

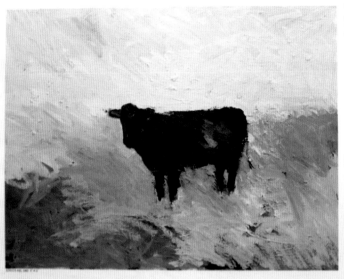

ANGUS PAINTINGS
1982

by
THEODORE J.
WADDELL

EXHIBITION
BILLINGS LIVESTOCK
COMMISSION COMPANY
Lockwood, North Frontage Road
March 29-April 2, 1982
LONGAN GALLERIES
Level 4-Stapleton Building
Billings, Montana
March 29-April 29, 1982

up where the painted subjects of his work, Black Angus, and crossbred Black Baldy cattle, are brought to market, where animal flesh is converted into a commodity. He is symbolically closing the circuit between subject and object, inspiration and execution, and, at the same time, making a kind of spiritual offering.

The situation he's creating is aesthetically and socially edgy. It is more daring than presenting the paintings in the supportive context of a gallery or museum. It is also particularly meaningful and generous. The usual people at the sale ring are not self-selected art patrons. They are buying and selling cattle, not paintings. Attentive to the qualities of the cattle in the sale ring—age, weight, conformation, origin, and breeding—they certainly recognize the beauty of good beef cattle, but not in a purely aesthetic sense. To the extent that they appreciate painting, these pragmatic people are likely to have a soft spot for a Western regional brand of romantic realism—accurately described and delineated details of landscape, animals, and people alight with the glowing colors of the "golden hour" and nostalgia for an earlier, ostensibly simpler, time. Waddell's paintings are much more about the contemporary West and his immediate experience as a rancher. Less "finished" or predetermined than traditional representational painting, his works supply more questions than answers and expect more from the viewer. He does not condescend to this audience; he understands and respects them because he is one of them. He's also inviting his contemporaries in the art world to see these paintings inside a nerve center of the regional livestock industry, to mingle with ag-sector producers and brokers and consider the connections.

Among the auctioneers, cattle buyers, and his neighbors and fellow ranchers, Waddell is known as a successful cattleman. It might be little more than rumored that he holds a graduate degree in art and has been a tenured professor at the University of Montana, or

that his large, abstract, stainless-steel and COR-TEN sculptures stand on college campuses and civic plazas across Montana. (Some are even strewn, little noticed, about the yard at the ranch.) Such credentials and achievements don't particularly earn credibility in cattle country. Neighbors who might know about his past, and met him when he was beginning to farm and ranch in 1976, now interact with him as a peer, perhaps considering his history as a tolerable eccentricity. Even if his Carhartts are smeared with artist's colors, he dresses like them and he speaks their language. He is serious and knowledgeable about livestock and crops, concerned about the markets and the weather, irreverent about politicians and government agencies. He gets along well in the sparsely populated rural community around Molt and Rapelje. His girls, Heather and Shanna, go to local schools; his wife, Betty, teaches at Rocky Mountain College in Billings.

He has become a successful rancher and farmer, but he is also a respected member of Montana's contemporary art community—a multigenerational, geographically far-flung group of artists and their supporters. A painter and curator, Christopher Warner, calls them "the rural avant garde." Many, like Bob and Gennie DeWeese and John Buck and Deborah Butterfield, live in the country. Some, like Waddell, depend for their living on ranch and farm income. These include his friends Isabelle Johnson, Bill Stockton, and Patrick Zentz. The professor who inspired him to become an artist, and whose paintings and philosophy partially inform his own, Isabelle Johnson, is retired and living with her sisters on the family ranch in the Stillwater Valley. Bill Stockton, a crusty, bohemian sheep rancher who lives near Grass Range, is an abstract expressionist and figurative painter, sculptor, and writer. Waddell also has regular contact with Patrick Zentz, a former student of his at the University of Montana, who ranches south of Laurel. A keen intellect, whose work is conceptually driven, Zentz is fabricating "terregraphy instruments"—beautiful, one-of-a-kind apparatuses he deploys as an "interface" with the land and the elements.

Waddell has many other art world friends in Bozeman, Missoula, Helena, and Great Falls. In Billings, he is close to Donna Forbes, the ambitious and visionary director of the Yellowstone Art Center, the main institutional home of Montana's progressive artists. Patrick Zentz and Christopher Warner are also on the program staff there. In 1980, the Art Center mounted an exhibition selected from some six hundred drawings Waddell had done since he moved to Molt—analytical considerations of the dawn horizon, the ruled geometry of summer fallow, self-portraits hatched with vigorous wave forms, like the chartings of high-frequency energy.

The paintings in the show at the Billings Livestock Commission are a major body of work, made all the more remarkable by the fact that Waddell made them in his free time, before and after he did his chores—caring for about 200 head of cattle, 100 sheep, and 4,500 acres of pasture and cropland. The authentic products of real experiences, the cross-fertilization of agriculture and art, they encapsulate the passionate perceptions of a cattleman, and they expand the field of painting with fresh subjects and a vigorous,

apposite style. They also surge with the pulse of global cultural currency and beg to be compared with recent paintings by artists such as Philip Guston, Susan Rothenberg, Julian Schnabel, Richard Bosman, Frank Auerbach, Georg Baselitz, Anselm Kiefer, and others. Though they come from a remote location, Waddell's paintings are part of the zeitgeist. The *Angus* series paintings merit wide exposure, but they are particularly relevant where he first presents them, in Montana.

Postscript

I met Ted Waddell May 27, 1982, the day I started work as assistant director of the Yellowstone Art Center. Soon, I got to see those early Angus paintings at the auction barn, at Longan Galleries, and in his studio. He's been a great friend and an inspiration ever since. I helped gather slides from several dozen Montana artists for Corcoran Gallery curator Clair List's review and then drove her out to the Molt ranch to meet Ted and see his work and cows in June that year. He was the sole Montana artist she selected for the 38th Corcoran *Biennial Exhibition of American Painting/Second Western States Exhibition*, which opened in Washington, D.C., in February 1983. His work was singled out for praise by critics in the *Washington Post*, the *New York Times*, and *ARTnews*, and he soon signed with several important galleries. An exemplary professional artist, prolific and disciplined, he has risen to every opportunity and has mounted several shows a year for more than thirty years. He is celebrated today as an important American artist, his works collected by major museums, private collectors, and corporations, but he remains as close to this place and its people as he did that day in 1982 when he installed his neo-expressionist *Angus* paintings at the Billings Livestock Commission Company.

Thoughts on Ted Waddell

Mark Browning

My memories of Ted Waddell and his art are mostly anecdotal. In trying to write a piece about him and his production as an artist, I'm reminded of how very often I've been annoyed with others' written reviews of artists.

My first contacts and impressions of Ted and his varied art forms grew from my job as curator/director of a newly formed outpost art center on the eastern edge of Montana. Over time, Ted proved a loyal participant and generous contributor to exhibits, fundraisers, and the permanent collection of Miles City's WaterWorks Art Museum, aka Custer County Art & Heritage Center.

This began in the 1970s when start-up galleries and art centers were being networked across the state. It felt like a "movement" was occurring, and Ted was surely in the midst of that, along with a handful of other talented, freethinking individuals, united largely by a respect for each other's efforts.

Ted owned the courage and general orneriness to stay true to his own directions to pursue new projects throughout his career. The stainless-steel sculptures, the oil on paper drawings, the oversize canvases, lithographed series, mixed-media sculptures, all expertly executed, accumulated to a huge "body of work" over time. These periods were interspersed with some more devilish series such as the "road-kill" pieces and his "horse-turd" paintings that responded to critics. I didn't witness it firsthand but, at a distance, I found good humor in the account of one of his "road-kill" exhibits gaining resurrected life, causing the museum to close and fumigate. I guess it wouldn't have been so funny in "my" gallery.

Eventually, Ted's dedication paid off, as he developed critical success, a following of believers, and demand and a market for his works. Over the last several decades, Ted Waddell has emerged and survived as one of Montana's premier contemporary artists whose popularity extends far beyond the state's borders.

A Long Friendship

Donna Forbes

When a friendship spans over a half-century, the details of each year blend and fade into a mosaic of memories, with highlights glistening from special days and events. These reminiscences reflect some of those highlights in my long friendship with Ted Waddell.

I met Ted when he was twenty, a student at Eastern Montana College (EMC) studying painting and art history under Isabelle Johnson, who became his most important mentor. Isabelle, artist and art professor at EMC, came from a Montana ranching family. She had studied at fine universities and art schools and was recognized by a select few as one of the state's outstanding modernist painters, though Montana's isolation from the larger art world meant her work would not receive the recognition it deserved. From Isabelle, Ted learned about the greatest painters and sculptors in the history of art. "You must go to the masters. That is where you will learn," she told him. Isabelle saw in this young Montanan a commitment essential to a lifetime of making art. Throughout her life she continued to be his strongest critic and supporter, ever the teacher.

Isabelle was also my mentor and lifelong friend, and I met Ted through her. I was married and raising a family; he was going to school all day and working most of the night at the railroad yards. Isabelle would say to me, "He's going to burn out. No one can go without sleep that way. What am I going to do with him?" Ted would grab some sleep on a cot in her office just to silence her worries. Making art was what mattered. He was young, full of energy and a desire to leave the state and study in a larger city.

With Isabelle's encouragement Ted enrolled in the Brooklyn Museum Art School. From Montana to the Big Apple. Art museums with riches to astound a young art student. Fine commercial art galleries showing the recent work of nationally prominent artists. Ted saw the work of Robert Motherwell, the great abstract expressionist painter, and has felt his influence to this day. "Go to the masters." That year, 1962–1963, was life-changing for this young student artist.

I saw little of Ted during the years he was finishing his education and then teaching sculpture at the University of Montana. After Ted left the university, our friendship was renewed when he and his family moved to a family cattle ranch near Molt in 1976, only

thirty miles from Billings. Ted was up at four every morning to paint during the hours
before chores began. Gradually, his focus narrowed to the Black Angus cattle he was
raising. They became his lifelong passion. I had become the director of the Yellowstone
Art Center in Billings, and a fine curatorial staff and I watched the artist as he explored
the possibilities of paint defining those great animals he had come to know so well. Then
an invitation to be a part of the *Third Western States Biennial* at Washington, D.C.'s
Corcoran Gallery of Art in 1983 brought good reviews of his work in the *Washington Post*
and the *New York Times*, a strong validation of his *Angus* paintings. A number of serious
galleries took notice, and Ted was on his way.

Another highlight of 1983 was a phone call from *Newsweek* magazine. Mark Stevens,
the magazine's art critic, was writing an article about Montana artists and sending out
a *Newsweek* photographer, James Wilson from San Francisco. Would I take him to the
Waddell and Patrick Zentz ranches? Pat, a sculptor, was twenty miles southwest of Bill-
ings and Ted thirty miles to the northwest. We left early on a weekday morning, driving to
the Zentz ranch on a plateau facing the Beartooth Mountains. It was summer, a beautiful
day with the Montana landscape showing off in the sunshine. Then on to Ted's ranch,
following section lines for miles on the prairie where I was sure I was lost a number of
times. Ted was waiting with fresh coffee when we finally arrived. James and I followed
in the car as he drove his pickup far out onto the prairie where a great herd of Black
Angus were grazing. Five distant mountain ranges rose on the surrounding horizon. The
photographer and Ted walked among the herd where a number of images were taken,
Ted patting affectionately many of those large, black, beautiful animals. When the shoot
was completed, Ted pointed to a large farm truck parked nearby, hopped in, and said,
"Donna, you drive the pickup and James can drive your car back to the ranch" and off
he went. I turned to see a stricken face and hear, "Don't leave me here." Though James
was an experienced war photographer for *Newsweek*, the great, wide-open spaces of the
Western prairie country can be disorienting. The article came out in the October 31,
1983, issue: two pages with six color photographs, one of Ted with his herd, an *Angus*

painting (1982) reproduction; one of Pat on a bale of hay, and an image of a *Wind Drawing Machine* (1978–1979). Mark wrote, "Theodore Waddell, under that big sky, hugs the earth close." And, "In Waddell's work, a person can almost smell manure and the hot sweet hay breath of the herd." The article was a tribute to the small group of Montana artists who were making significant work in this isolated state. "They are not major figures in American art, but their modest success (more deserving than many a major New York success) offers an instructive example of how to make good art apart from the mainstream."

In 1987 Ted and his wife Betty bought a smaller place on the Musselshell River near the small town of Ryegate, still close enough to Billings to buy supplies and for me to visit. Owning his own place meant a smaller herd of Angus and no sheep. More time to paint. And more galleries and museums were now interested. Ted traveled extensively, taking the time to deliver his work. He and his family stayed on the Musselshell ranch until 1995. Ted never forgot his many artist friends scattered across the state and one summer created his Testicle Festival to bring them together, along with a number of writers, collectors, and friends, for two full days at the ranch and, of course, the Ryegate bar.

In 1995 a major change saw Ted divorcing and moving to a ranch near Manhattan, Montana. He remarried, to the writer and photographer Lynn Campion. A large studio gave him the space to create several enormous "big sky" paintings. In smaller canvases the great sculptural forms of the cattle in the early work became small dark specks in vast landscapes, Black Angus always recognizable as they drifted across the prairie. Many of his best works are powerful statements about the land and frequently remind me of that old Chinese proverb, "First you see the mountains in the painting. Then you see the painting in the mountains." As Isabelle would say, "You have to look and see." How she would have loved to critique these past twenty years of Ted's work as he has carried on her passion.

The Yellowstone Art Museum began acquiring Waddell paintings in 1980 and now owns nearly thirty. Several large exhibitions of his work have been mounted over the years in galleries and a number of museums, including the Yellowstone. Most of these exhibitions have been accompanied by full-color catalogs and essays by curators, painters, poets. Ted always sends me one. On my eightieth birthday he drove hundreds of miles to Billings to present me with a painting of a mountain. My friend.

Keeler's Bird

Greg Keeler

I can't believe I let my oil-soaked bird carcass slip away. It sort of summed up my friend-ship with Ted Waddell and had held an honored place in my garage for years until one day I went out to retrieve it from a couple of decades of clutter and it was gone.

When he gave it to me back in the early nineties, he warned me that it leaked and was "about a quart low." I think he made it after listening to "Little Bitty Bugs," a song I wrote about all the gas I burned driving to perform at environmental rallies. Part of the chorus goes as follows:

> Little bugs and diatoms
> All compacted into scum
> And left to rot for several hundred million years,
> A couple of acres of protozoic plants,
> A pterodactyl or two and a bucket of ants
> Just to fill my tank with gas and get me here.

To create his version of this, Ted made a small plastic aquarium, epoxied a decaying bird carcass to the back of it, filled the bottom part with oil, and sealed the whole thing up with a plastic top. It worked a little like a reverse Etch-A-Sketch in that you'd tip it on its back, soak the bird with oil, then tip it upright so that the oil dripped horribly off of the carcass. In short, he made me my own private oil spill.

Ted called it *Keeler's Bird*. Even though it wasn't supposed to leak, that seemed to enhance the art since it tended to contaminate whatever was around it. When I took it home, my wife, Judy, said, "Very nice, Greg. I can tell that Ted has a special place in his heart for you. It will look swell in the garage. Why don't you take it out there before it drips on the carpet?" So I took it to the dirt-floored garage and made a little alcove where it could leak oil to its heart's content. My sons called it "The Shrine of the Oily-Bird."

It was easy for me to relate to Ted's piece because, for a few years, he and I had become part of each other's take on things. In the late eighties and early nineties, I accompanied

him around the country and performed my songs at his openings in Indianapolis, San Antonio, and Ketchum. I felt right at home singing my songs next to pieces such as a road-killed coyote awash in thick brush strokes of oil, and Ted felt I provided an appropriate ambience.

Unfortunately, I missed one of the more exciting exhibits in Spokane where one of Ted's road-kill pieces "hatched out." He didn't quite get it sterilized enough and the gallery filled with flies. That seemed a bit like my leaky bird but on a grander scale.

Fortunately, I still have another piece Ted gave me. It's a painting of three sheep on black paper. In the mid-nineties I was going through some hard times, so I decided to make a pilgrimage out to Ted's ranch to get cheered up, since he and his work always had that effect on me. As I remember, it was a bleak day in early spring and when I got there, he was out in his vast studio drinking Miller Light and blotting sheep on a big canvas with the side of his hand. He was surrounded by smaller paintings of sheep, and, though he seemed to be about as depressed as I was, he said, "Keeler, you look like you could use some sheep," and he handed me one of the paintings.

A couple of years before that, Ted's generosity extended to writers and artists from around Montana when he put on a festival for us at his ranch. He opened his studio to readings, performances, discussions, and exhibits and saw to it that everyone had a good time. Though he covered many of the expenses himself, Ted ran into a few glitches seeking support from the Montana Arts Council. Several of the discussions at the event concerned the shock value of art, since the Mapplethorpe controversy was still fresh in the news—as was the NEA-supported *Piss Christ*. Inspired by the discussions, I wrote "Waddell's Grant Song" to poke a little fun at the tension between artists and granting agencies.

The event was arranged in tandem with the Testicle Festival at Marty's Bar in nearby Ryegate, so I wrote "The Ryegate Testicle Festival" to commemorate the spirit of the thing.

> . . . It's Ryegate, Montana's Testicle Festival time
> Where you can pig out on calf nuts for hours and it don't cost a dime.
> There's artists and ranchers and drunk two-step dancers
> And grannies who've just reached their prime
> At Ryegate, Montana's Testicle Festival time. . . .

Ted has been an inspiration to me both in his art and in his life. His paintings and sculptures are full of humor, tragedy, life, love, death, and the vast Montana landscape. So is Ted. Though I haven't seen him in years, all I have to do to conjure him up is look at my three sheep. They literally glow with his energy. And though my oil-soaked bird carcass has leaked out of existence, it will always, to quote Judy, hold a special place in my heart.

Three Friends

Patrick Zentz

"Hey, Pat!" I heard as I descended the steps of the student union building at the University of Montana. It startled me because I hardly knew anyone on campus. After graduating from college in California, my wife (Suzie) and I moved to Billings, my hometown, where we worked for a few months. I had a biology degree, but was interested in studying art, and we had just arrived in Missoula to see what the university's graduate school had to offer. I turned to see who had called out my name. A young man defined by a black mustache and jazzy welder's cap was hustling down the steps.

He asked to discuss a couple of comments I made earlier in the week during his sculpture class's first session. He was animated and serious with an engagingly wry sense of humor. That moment changed my life; I had found the place where I would study art and I would study it with Theodore Waddell. It was 1970.

Ted was a rigorous and disciplined teacher. He demanded precise articulation of ideas and expected seriously considered contribution in critiques. But that was the easy part; what you created was what really mattered. He insisted on clearly stated intent and explicit rationale for the resolution of ideas. I had taken very difficult, intellectually challenging classes as an undergraduate in science. Ted's courses required similar determination to survive. But, through the process, I learned how to say what I meant. I relished every moment and am grateful for the experience to this day.

The art department was a highly charged environment during the early '70s. Rudy Autio, Don Bunse, Arnold Cherullo, and several other significant artists were teaching along with Ted at that time. Also, critically, the faculty understood the importance of exposing students to the ideas of working contemporary artists and supported an active artist residency program. It created opportunities for students to have personal contact with artists like Nancy Holt, Robert Smithson, and Dennis Oppenheim.

After graduation in 1974 we moved to Bozeman with our new baby son, where I was to begin teaching sculpture at the high school. It was a well-organized and equipped art department under the inspired direction of Ray Campeau. Additionally, it featured a yearlong Montana Arts Council (MAC) Artists in Schools and Communities program.

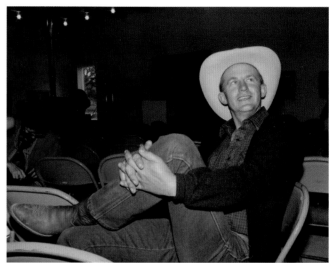

Theodore Waddell, 1989. David Arnold, photographer. Waddell Family Collection.

Dennis Voss, 1989. David Arnold, photographer. Waddell Family Collection.

Lela Autio was the resident artist during my first year. After studying with Rudy Autio at the university, this was an unanticipated opportunity to work with his wife, a veritable dynamo!

Also, around that same time Ted and Betty had assumed management of the Leuthold Ranch from Betty's family. With their two young daughters, they had begun the arduous process of moving from their home in Arlee across the state to Molt. The move understandably took several months, and Ted would frequently stop by the high school as he passed through Bozeman with his pickup and trailer loaded with their possessions. Once when he came by with a wire feed welder, he spontaneously backed his truck up to the department's shipping door and conducted a welding workshop on the spot. Montana, at that time, was still pretty much of a "Mecca" for Western art. Contemporary art ideas could actually precipitate a fight given the right circumstances in the wrong bar. It was incredibly helpful to have Ted's impromptu support for the current art concepts I was developing with my students. His brief visits also afforded a continuation of conversations we'd begun while I was at the university.

One day during class, I glanced up from a conversation with a student and saw an unfamiliar, smiling young woman on the stairway that led up to my office. As I approached to investigate, it was apparent that she was watching a workshop being conducted in the department's spacious shared area. A rangy young man was rolling out clay in the midst of a bunch of students. He was pressing the disassembled parts of old cowboy boots into the clay, thereby transferring their fancy embroidered patterns. He would then cut out the impressions and assemble them to form clay boots.

I must have had a quizzical look on my face because when he saw me, he said, "I do other stuff, too!" Over a quick interchange we agreed to have lunch. I then introduced myself to Jude Tallichet, the lady on the stairs who was his wife at that time. Although Jude had other obligations, Dennis Voss and I spent the entire noon break engaged in

224

dynamic conversation. We filled the blackboards of a small lecture room with drawings and ideas, compared notes on our families and ranching backgrounds, and were non-plussed by the parallels. The lunch hour ended, but these highly charged exchanges would continue for well over a decade.

I don't remember Ted and Dennis meeting for the first time, but it was while I was in Bozeman because I distinctly recall a workshop they did for me there. A two-inch-thick by ten-foot-square slab of clay was rolled out over a polyethylene sheet on the floor. Then they (and several students) took turns crawling laboriously under its suffocating weight. After chatter from the induced claustrophobia had settled down, the resulting surface was examined as though it were a landscape. The kids were mesmerized and the dialogue predictably inspired. The important issue for me was this: significant ideas that were currently being discussed in the global art press were being examined, even extended, in a high school classroom.

One day Dennis dropped by the school to say that he had been offered the Artist-in-Residence position for the Great Falls Public Schools. It was a perfect fit for him. Jim Poor, the citywide director for art education, was wide open to the kind of educational experimentation that Dennis would bring to the program. An artist himself, Jim was also a good friend of Ted's. The mutual interests we all shared facilitated heightened informal collaborations in which new ideas regarding art and learning were constantly zipping about.

After teaching four years in Bozeman, I decided to intensify my focus on my art. Suzie and I, now with two little boys, had talked of returning to ranching for some time, and we were fortunate to lease a place adjacent to my parents' wheat and cattle operation near Billings. Ray Campeau had mentioned that Donna Forbes, the director of the Yellowstone Art Center there, was looking for an education curator and that I should give her a call. Donna amenably implemented a schedule that accommodated my new agricultural

responsibilities while working two days a week for the center as well. Within a couple of years, she had also hired Gordon McConnell and Chris Warner, whose broad talents added immeasurably to the art center's capabilities.

In my role as education curator, I began to assume program coordination tasks. Recalling the benefits of visiting artists' perspectives at both the University of Montana and Bozeman High School, I immediately advocated inviting prominent artists and critics for broader public exposure to current art ideas. Ted was an early guest. One comment I clearly remember him making to a docent group was that as an artist all he really wanted was "to participate in the conversation." He meant, of course, by "conversation," the continually evolving discourse of the arts within the culture. At the time, that was more of a challenge than one might imagine for artists living in the rural West, away from the urban centers.

Gradually, the art center was able to host an impressive roster of speakers from across the nation. One particular guest, who understood Ted's comment implicitly, was Mark Stevens. Although living in New York City, he had family connections to a historic Montana ranch at the foot of the Crazy Mountains.

Significantly, he was the art critic for *Newsweek* magazine. After meeting with artists throughout the state on a visit in 1983, Mark published a fresh perspective in *Newsweek*, giving generous exposure to Montana's contemporary artists. Ted, Dennis, and I were delighted to be included.

Addressing the issue of artists in the rural West, Mark began his story as follows:

A serious artist, according to the conventional snobbery, lives in New York. A "regional" artist, minor but worthy, lives in San Francisco, Chicago, Los Angeles—even Texas, if his art has an interesting twang. No artist in his right mind lives in Montana. The state does not have enough collectors, critics, or museums.

The article continues in accolade of the variety of serious work being done in the state despite the conventional wisdom assuming that to be impossible. It inspired us all.

After moving to the ranch, Ted's work had begun to transmute from sculpture to painting. He was intensely interested in the landscape and the animals. I remember some very early black-and-white drawings he made with pronounced horizons and graphic flecks of cattle. He gave one to Suzie, and it still grabs my attention. Ted has said that "sculpture no longer made sense" once he had moved to the ranch with its spacious vistas and the scale they entwined. In many ways, however, I see the same concerns persist in his painting that were present in his earlier stainless-steel sculpture. Discrete attention to morphology, richness of texture, and the allusion to depth are all there. In some ways, I don't really think his paintings are about cows at all. I think they are his comprehension of the fecund distillation of life and land that the prairie is.

One of the annual spring duties on a ranch is to fertility test bulls. The procedure involves confining each animal in a squeeze chute and collecting a semen sample. A slide is then prepared and oftentimes, if the weather is good, examination can occur on-site. On one occasion my veterinarian asked me to have a look at a specimen through the microscope set up on the tailgate of his pickup. Peering into the eyepiece, I observed the mass of wriggling future hopefuls and intently studied details narrated by the vet. When finished I looked up and was stunned by the almost hallucinatory scene that enveloped me. To the north over immense expanses of grassland I could see the Bull Mountains, and by turning clockwise, bring the Big Horn, Pryor, Beartooth, Bridger, Crazy, Little Belt, and Snowy Mountain ranges into view one after the other. In the instant transition from the manic tumult of the magnified microworld to the incomprehensibly tranquil yawn of the peak-rimmed plains, it came to me. This vast prairie was a composite of intimacies. Myriad minute and delicate pieces both animate and not, orchestrated into an exquisite, synergistic whole.

I think Ted knows this sense of prairie, too; his paintings embody it. It's what a piece titled *Angus #63*, that's hung on our living room wall for the past thirty years, tells me as I begin each day. The cows are in there alright, but it always has seemed more like an object to me than a surface. It's so rich in the early morning light at times that its abstractions teem organically.

Good fortune can be precipitated by hard work, and just prior to the *Newsweek* article, some fell Ted's way. Several paintings were juried into the *Second Western States Biennial Exhibition*. The show opened at the Corcoran Museum of Art and traveled across the country. His work received positive review at virtually every stop. More importantly, Ted was finding his voice; better yet, it was being heard.

Nothing ever seemed static during this period. Finally, after ranching for several years and showing work everywhere he could, including bars, galleries, isolated small-town art centers, and even the Billings Livestock Commission Company's auction ring at one point, Ted was busy readying paintings for the important *Western States Biennial* in Washington, D.C. Concurrently, Dennis had become an assistant professor at the University of Montana, was appointed to the National Endowment for the Arts Artists-in-Education (AIE) panel, and was in the early planning stages for several critical performance works.

In the meantime, I was ranching, working at the Yellowstone Art Center (I resigned my position there in 1983), producing sculpture, and had been appointed to the Montana Arts Council. Also, our third son was born. It was a heady, productive, and often exhilarating time.

We communicated extensively over our coil-corded, rotary-dial telephones. A new idea or spontaneous question could tether us to them for hours in intense dialogue, vacillating between animated debate and amity. If we weren't encumbered by pervasive sea-

sonal ranch work or other obligations, it was nothing to drive a couple of hundred miles or more to an opening, lecture, or symposium; as Stevens quotes Dennis in the *Newsweek* article, "like moths to light."

Dennis can draw. He's one of the best I know. This talent is complemented by an imagination of such opulence that I'm not sure it didn't, in fact, mandate his drawing facility. Two-dimensional works, germinated by rangeland experiences, manifest themselves graphically in breathtaking blizzards of symbols, images, and artifacts extracted from memory. We traded work with each other frequently over those years, and his drawings preserve actual moments of time; they are uncanny suspensions of the past, alive still on the walls of our home.

Dennis and Jude separated during this period, and he began to visit us during the late summers to help with the grain harvest. If rain or other interruptions halted agricultural operations, we would frequently meet up with Ted to parley. Many of our late-night conversations focused on performance work. Dennis was formulating ideas that involved creating personae who would expose dynamic intimate connections with the land. In 1984, *Blue Man Moving, Blue Rocks* was an early critical piece, as was another called *Night Rider*.

In the first work Dennis appeared out of dense brush as a blue figure in a steep ravine. A handful of invited guests were seated on folding chairs scattered about the landscape, some at great distances from the performer. The partially naked "blue man" could be seen carrying, stacking, and rolling painted rocks. The incorporation of the audience as a designated component of the work is noteworthy.

In a typed handout for the event, Voss wrote to his viewers, "You are also part of the cast. Passing the story on to others completes part of the documentation. Each vantage point involves limited access to the event . . . [and] subsequent dialogue about each event forms the complete work."

Dan Ruby, writing in *High Performance Magazine*, summarizes, "Voss is clearly in touch with some of the deep resonances of living and working on this land, and his approach involving audiences directly is innovative and important."

Linda Frye Burnham, founding editor of the Los Angeles–based *High Performance Magazine*, was an early and enthusiastic supporter of the land performances. Like Mark Stevens, who provided informed and original criticism, she created connection with the outside world. Linda also frequently wrote for other magazines such as the *Drama Review* and *Artspace*. I remember well, sitting next to her on a high ridge around midnight while watching Dennis in his performance of *The Mechanic of Isolation as the Night Hunter*. She was there to write a review for *Artforum* covering the performances Dennis and I had planned over the 1985 Labor Day weekend.

The performances were the culmination of efforts that had begun much earlier. The Yellowstone Art Center had produced a major exhibition titled, *Dennis Voss: The*

Mechanic of Isolation / Patrick Zentz: Instruments for DAY earlier in the spring and now it was time to conduct the performances for which the objects had been created. So there we were, a few friends and family, watching the bobbing lantern of Voss's Night Hunter apparatus as it approached from a half mile away some two hundred feet below us on the valley floor. The events that unfolded those two days are beautifully documented in a catalog that the Yellowstone Art Center produced.

My sound instruments from the *DAY* performance were selected for the 1986 *Third Western States Biennial Exhibition*. It opened at the Brooklyn Museum in New York and an additional benefit was being invited to participate in a symposium there, as well. I mention this in passing to point out that we were all gaining broader platforms from which to express ideas that were coupled to the actual exhibition of our work. Not only were critics coming here to see art being done in Montana, but we were being asked to articulate ideas on the national stage. Countless unpredictable connections across the country began to develop. It was not unusual after a lecture in some distant place to have a stranger approach and say, "I know Ted Waddell. He suggested that I introduce myself." The desire Ted had earlier expressed was starting to be fulfilled. We were beginning to be able "to participate in the conversation."

Dennis was meeting some interesting people in his work with the National Endowment for the Arts AIE panel. Jock Reynolds was one of the most prominent. Currently, he's director of the Yale Art Museum, but in 1987 Jock was the director of the Washington Project for the Arts (WPA) in Washington, D.C. It turned out to be the last venue for a collaborative exhibition between Dennis and me. Mel Watkin, curator at the WPA and a former student of Dennis's, organized the exhibition, entitled *Demon Stag / Crank*. Voss's work consisted of a large performance machine made from the full-body mount of a bull elk. The taxidermy was fitted with a flower-festooned wagon wheel protruding from one side in addition to other, sometimes severe, modifications. I installed a twelve-foot-square by four-foot-high kinetic instrument incorporating six bass drums that transformed the movement of pedestrians around the city block (where the WPA was located) into percussive sound. Linda Burnham was there from L.A. for the opening, as was Erica Borbé. She and Dennis had been married the previous year and were looking for a ranch to buy. Erica was eager to tell Dennis about a place she had found in his absence near Two Dot. Big changes were in the making, and they would soon be ranching fulltime.

Ted and Betty, along with their two daughters, had also moved during this interim and were living along the Musselshell River near Ryegate. Their new place had a large building that Ted was converting into a studio. He needed the additional space to handle the increased demand for his paintings subsequent to the fantastic success he'd seen from the *Western States Biennial*. In addition to their regular busy schedules, Ted and Betty were also cooking up plans for an ambitious new project. Ted called one day and asked if I would be willing to be a speaker at an arts event. I asked him who else would

be on the program, and he answered, "William Kittredge, Thomas McGuane, and Rudy Autio, as well as satirist Greg Keeler in performance." It would have been pretty hard to say no to that!

As it turned out, the Waddells had discovered that no one was planning to celebrate the arts for the upcoming state centennial, so they decided to produce *Montana '89: Our Place & Time*. The brochure they published announced, "The purpose is to honor artists and writers living in Montana and to celebrate the arts as vital activities for all Montanans during our Centennial."

Fantastic as the idea was, no one could have imagined how difficult raising funds for the project would be. Following many disappointing attempts, Ted forwarded a copy of a lengthy and beautifully handwritten letter Betty had sent to the Montana Committee for the Humanities. It critically lamented the profusion of bureaucratic obfuscations that state and federal agencies proffered in excusing themselves from funding assistance. In his accompanying letter to me, Ted states, "The objections ultimately are the same as you and I have fought all of our lives—with little success. This doesn't seem like the time to cave in." And with that, as was typical with their "get-er-done" determination, he and Betty proceeded to fund the entire project themselves. It was a huge, one-of-a-kind success. In addition to all of the well-attended events, an exhibition featuring the work of over seventy-five notable Montana artists was installed in Ted's new studio. In the end the funding difficulties were ameliorated by Miriam Sample who, upon hearing of the problem, purchased a major painting from Ted. It was a typical gesture from perhaps the greatest patron of contemporary art this region has known.

The exhibition was the last time that Ted, Dennis, and I exhibited work together. Our lives and interests have all traversed separate paths since then. I have been asked many times over the years since, what the "magic" was during that period.

I remember this. We had common interest in the land. We addressed that separately and derived relevant personal abstractions. Those abstractions were coerced into concrete form through drawing, painting, sculpture, performance, sound, or other invention. Critique was candid. We persisted and even had some lucky breaks along the way. If there was magic, it was from confidence gained in knowing the resolute support from the others. My hat is off to them both, for the incomparable, improbable times we shared.

There are many people left unmentioned in the events recounted herein. During those years they were a source of much encouragement, assistance, camaraderie, and love. Thank you all, dear families and friends alike.

Montana '89: Our Place & Time

Scott McMillion

It was hot and I was nervous. I wanted very much to be a Montana writer and I had no idea how to be one or even what that meant. But I had a notion that there was some kind of club, or maybe a fraternity, and I was hoping they'd let me in. Or at least let me peek through the curtains without anybody laughing at me.

It was 1989 and the *Los Angeles Times* had recently labeled Montana "the literary capital of the country." If that was true, the ward bosses were gathering in a hay meadow along the Musselshell River for an arts conference called *Our Place & Time*. Some painter named Ted Waddell was organizing it on a ranch he owned.

It sounded like fun, so I convinced my editor at the Bozeman newspaper to let me go, or at least not to dock my pay for being away from the phone for a couple days. It turned out to be quite a weekend. People set up tents, tugged their coolers into the shade, and some of them recited poetry and sang around the campfires. They set up easels and they gave speeches. They read from published works or works in progress. They gossiped about publishers and agents and movie deals and signing first editions for collectors. All pretty heady stuff for a young man with aspirations.

Many of us made a side trip to the nearby Ryegate Bar to gorge on Rocky Mountain oysters and coleslaw. I learned that writers are generally pretty interesting and none of them were as scary as the female ranch hand I saw scarfing calf nuts at the bar. And I met a lot of people who became friends. One of them is the poet Paul Zarzyski.

"I don't remember all the details," he told me recently. "But I remember the energy, the voices, the palpable spirit. People still talk about it. Nothing's been done like it since."

I agree with Paul. The details have faded, but the memory stands tall. There were fifty-five established artists and twenty-seven published authors sidestepping cow pies on Waddell's ranch that weekend, which is something you aren't going to find in most places. There was plenty of booze and lots of laughter, along with some serious contemplation of the creative process. There was a lot of talk about regionalism and nativism and universalism and some of it was silly but some of it was profound. And the good bits sunk in, at least for this aspiring writer from Montana.

"Nobody could be more regional than Dostoevsky, Sophocles, or Homer," Bill Kittredge pointed out, and people are still reading what those guys had to say about their home turf and its people.

And there was this from Tom McGuane, who knows how to cut to the chase: wherever you live and work, nothing counts as much as the quality of the writing.

"Either you have to be able to stuff the ball or you can't play," McGuane told the crowd. A few people grumbled at that, but it made sense to me.

Today, at seventy-three, he keeps on stuffing the ball, writing books, publishing short stories in the *New Yorker*, and spending as much time as he can on horseback, or with a flyrod or a shotgun.

After forty-six years in Montana, he still rankles a little at efforts to pigeonhole him with geography, gets a little impatient with the "territorial claiming" that can happen in Montana literary circles.

A discussion of turf "doesn't have a lot to do with literature," he said.

Still, Montana has its hooks in him, as it does so many of us.

"The West Boulder River is the ditch I plan to die in," McGuane told me.

* * *

After twenty-five years earning my living as a writer, and though I now publish a Montana-based literary magazine, I'm still not sure how to define a Montana writer. Periodically, somebody on one coast or another publishes a list. Jim Harrison is a staple on those

Poets Greg Keeler and Paul Zarzyski, with William Kittredge in the background, *Our Place & Time* gathering, 1989. David Arnold, photographer. Waddell Family Collection.

Novelist William "Gatz" Hjortsberg and poet Wally McRae, *Our Place & Time* gathering, 1989. David Arnold, photographer. Waddell Family Collection.

Fiction writer, essayist, and editor William Kittredge, *Our Place & Time* gathering, 1989. David Arnold, photographer. Waddell Family Collection.

Novelist Thomas McGuane, *Our Place & Time* gathering, 1989. David Arnold, photographer. Waddell Family Collection.

lists, though he only recently bought a permanent home here and sets most of his novels in his home state of Michigan. Tim Cahill is in the club, though he travels widely and rarely writes about the state. The late Jim Crumley made the roster. All of them became friends of mine over the years, and I've never heard any of them give the concept much thought. They are artists, more concerned with their work than their reputation.

I, too, have come to think the label doesn't matter so much. A friend in Washington, D.C., recently referred a young writer to me. She's living in Missoula, pondering whether to put down roots there. She asked my thoughts on being a Montana writer.

"Writing is a lonesome chore for most people," I wrote to her. "Doing it well means long stints of solitude. But in Montana we get to interrupt them with great scenery, interesting weather, cool communities and friends who respect that you're a writer but also expect you to pull your own weight in camp."

In that big camp at Ted's ranch twenty-five years ago, it seemed to me that everybody pulled their weight and then some. I'm sure a few people left to others the chores of

Poet Paul Zarzyski, letterpress printer and poet Peter Koch, and fiction writer Rick Bass, *Our Place & Time* gathering, 1989. David Arnold, photographer. Waddell Family Collection.

gathering firewood or burning the eggs, but it wasn't really that kind of campout. Rather, it was a place for the airing of ideas, to share them over beer while squinting through the woodsmoke in a place where the Blackfeet and Crow had made a living chasing buffalo a little more than a century earlier. Like most Montanans, the artists and writers appreciated spending a few fine days in a cottonwood grove, among friends. When it was over, they went back to their work and their lives.

But the weekend made a dent. Ted recently told me that he'd tried to get a state grant to fund the event, but things got twisted as bureaucrats tried to skew events toward the state's centennial celebration that year, to things that would draw in some tourist money.

"We said, 'Screw that,'" Ted recalled. "We're going to celebrate people instead of places."

And I think he had the right idea. He drew a bunch of smart people to a hay meadow, offered a few formal talks to provide some conversational fodder, then let the big hosses ride.

It's like Zarzyski said. They're still talking about it.

Ted

William Hjortsberg

As far back as I can remember, I always wanted to be an artist. I had a gift for drawing as a kid and was forever copying favorite cartoon characters from the funny papers or making freehand reproductions of the framed nineteenth-century English racing prints lining the walls of my father's Greenwich Village restaurant. My ten-year-old self defined *artist* quite literally. Painters (like the ones you saw in museums), illustrators (the weekly magazines—*Colliers*, the *New Yorker*, *Liberty*, the *Saturday Evening Post*—featured lots of commercial art), and my beloved cartoonists, all made the grade. It never occurred to me to think of writing as an art. I was a voracious reader, making up stories at an early age. I remember beginning what I called a "novel" in the sixth grade, scribbling down about six pages before I ran out of steam.

Someone once told me "an artist should never do anything hard." I thought he was quoting Jean Cocteau but was misinformed. Nevertheless, I adopted this philosophy and became an art major. Taking studio courses certainly provided the easiest path to an Ivy League degree. Along the way, I learned an essential fact. Trying to become an accomplished painter wasn't all that easy. It proved to be the hardest thing I'd ever tried. So hard in fact, I gave up and became a writer instead.

Art seemed like magic to me. I knew firsthand the impossibilities of easel painting. Only a wizard could turn my muddy fumbling into anything remotely resembling real art. Music remained even more mysterious. How blowing into a trumpet or scraping a bow across a violin produced any sounds beyond bleating duck honks or the nocturnal screech of mating cats provided an eternal puzzle. I liked hanging out with musicians and painters. Their work, so close to sleight-of-hand, provided pleasures too profound to comprehend. You don't need to know how the trick is done to enjoy the dexterity of the magician.

In early June of 1989, it came as a pleasant surprise when an invitation arrived for an arts conference called *Our Place & Time*. A two-day gathering of local musicians, painters, and writers promised precisely the sort of creative turbocharge I hungered for. The event was being held at Theodore Waddell's ranch on the Musselshell River a few

miles east of Harlowton. I had never met Ted but figured he had to be a pretty cool dude for hosting such a shindig and for timing the event to coincide with the annual Ryegate Testicle Festival, a few miles down the road from his place. Fried Rocky Mountain oysters and coleslaw augmenting the beer and burgers menu of *Our Place & Time*. How cool was that?

Ted turned out to be the same age as me, an energetic guy sporting a Charles Bronson mustache. He had a twinkle in his eye and laughed easily, greeting me clad in jeans and a rancher's goat-roper baseball cap. The frames of his sunglasses glowed bright as a neon tavern sign. Ted showed me into his equipment-shed-sized studio. Except for the paintings on the walls, it might well have housed farm implements. The canvases were Waddell's. From a distance they were starkly modern, like work I might have seen in New York as a college student hanging around over holiday breaks at Leo Castelli's uptown gallery off Madison. Large pieces, mostly white with random splotches of color.

Walking closer, I saw those colorful spots were actually cows and horses. What first I misperceived as abstractions were actually sophisticated modern landscapes. Waddell was the real deal and had me hooked. His paintings provided an eloquent backdrop for a number of literary readings. Quite a lineup. Tom McGuane, Bill Kittredge, David Long, Paul Zarzyski, Greg Keeler, Wally McRae, and a host of others, including me. A folding table had been set up for selling and signing books. I did my share and bought forty bucks' worth.

There was a good crowd of fellow artists in attendance—poets, painters, musicians, and writers from all around the state. Ted had encouraged everyone to bring tents and

Tom McGuane and Gatz Hjortsberg, *Our Place & Time* gathering, 1989. David Arnold, photographer. Waddell Family Collection.

sleeping bags. Many came only for the first big day and headed home when long afternoon shadows signaled its end. Even so, by nightfall Waddell's backyard transformed into an impromptu gypsy campground.

I wanted to stay for the whole enchilada but had no interest in camping out, so I took a room at the Graves Hotel, ten miles away in Harlowton. The Graves (along with the Murray in Livingston and the haunted, trackside Hotel Metlen in Dillon) was one of the last surviving grand old Montana railroad town hotels. In those days, a room at the Graves with a tub and toilet down the hall cost $15.00. The cheap quarters ranked only a notch above bunking in a flophouse. My sagging bed might not have been comfortable, but at least I wasn't sleeping on the ground.

Those who didn't stick around for the full shindig not only missed out on a swell party, they were also "off the bus," as Ken Kesey sagely observed. Back in the mid-1960s, spontaneous theatrical art events called "happenings" sprang up like zany wildflowers across the country. They epitomized the anarchy inherent in every artistic endeavor. The joyful collective spirit of Ted Waddell's inspired event transformed his rural bohemian beer blast into a work of art, an impromptu happening on the banks of the Musselshell.

My own fragmented memories include lengthy conversations with Ted, listening to Greg Keeler, David Bottoms, and others play and sing outside the studio beside a horse trailer, reconnecting with painter Fran Noel, a fellow art major at Dartmouth, and flirting with several attractive lady poets who wouldn't give me the time of day. To commemorate the occasion, Ted handed out souvenir tee shirts silkscreened with his sketchy image of a standing raptor posed against an abstract background in various shades of green. I still have mine more than a quarter century later. Faded from multiple washings, folded and safe at the bottom of a bureau drawer, it serves as a reminder of a more innocent era in Montana, a time when artists came together to celebrate themselves just for the joy and fun of it.

I didn't cross paths with Ted very often, but whenever we got together there was always laughter and excessive good spirits. Waddell's work continued to excite me, and the next summer after *Our Place & Time*, I was back at the Ryegate studio for an early-August opening of Ted's amazing new paintings. Once again, the show swept me into a magical world beyond my understanding. All I could do was gaze in wonder at Waddell's splendid thaumaturgy.

At some point around that time, Ted and I both attended a fund-raiser for the Vigilante Players at the American Legion Hall on Babcock Street in Bozeman. He looked far more uptown in a blue blazer and silk necktie than when clad in ranch garb. I almost didn't recognize this prosperous, dapper fellow. We reconnected over beverages right away.

The Vigilantes were a four-person experimental theater company who traveled throughout Montana giving zany performances in small rural communities. They had adapted "The Dog Who Loved Trains," one of my magazine articles, into a madcap,

semi-improvisational stage piece. I never saw the Vigilantes' production of my story but greatly enjoyed their interpretations of Greg Keeler's whacky musical plays.

Greg was also in attendance at the Legion Hall that night. He and I, along with Gennie DeWeese and several other artists and musicians, were part of an innovative evening staged by the Vigilantes. We were all given short amounts of time to come up with improvised examples of our various *métiers*. Ted did not participate in this frenzied activity, content with being a spectator. Everybody's work would be auctioned off at the end of the evening to benefit the Vigilantes. I wrote an odd short story called "The World's Last Elvis Impersonator" on a lined, yellow legal pad and read it to the gathered crowd, while the four Vigilantes, decked out in makeshift costumes, struck odd poses and mimed the action behind me. Probably most of the laughs were for them.

When my original handwritten manuscript went on the auction block, I figured it would fetch ten or twenty bucks at most. To my surprise, the price immediately escalated, soaring stratospherically as a bidding war erupted between two determined buyers. When the dust settled, the winner turned out to be Ted Waddell. In a glorious, extravagant gesture, he bought my story manuscript for $1,500. It was a magical moment. Ted had turned a fund-raiser auction for a performing quartet into a personal piece of performance art. That was beyond cool.

From Captain Woodrow Call to Captain Kirk to Captain Teddy-Bob Waddell of the Wild Cowpoke Wild Brushstroke Wild Cosmos West

Paul Zarzyski

I'm bucked off over the dashboard, hung up, dragged/rag-dolled around the rodeo arena, stomped on finally hard enough to pop my gripper outta the riggin', and hauled off in a *MASH* meat wagon to the hospital or the Toe-Tag Hotel, when it comes to palaverin' about art and the prowess of artists who make, or *channel* it. Which conjures up an antithetical old yarn about two line camp cowpunchers lying in their bunks and staring at the ceiling one night when suddenly a far-off lowing implodes the silence of the laconic waddies. "Steer," offers up the first. "Nope, bull," replies the second. The next day, as one of the cowboys is lashing his bedroll behind the cantle of his saddled horse, his partner initiates the following "conversation":

"Leavin'?"
"Yup."
"Problem?"
"Too much arguin'."

As my dear departed Mother was prone to pronounce, toward extravagant or hyper-analytical discourse, in her northern Italian dialect, *"No ge niente de studiadi."* There's nothing to study—it is what it is. This said, however, we're not just talking *any* ol' Montana rancher-artist here—we're talking Theodore Waddell, or, as I playfully refer to him during our Red Grooms' *Ruckus Rodeo*-esque telephone conversations resounding with laughter, "Teddy-Bob Waddell." Therefore, I'm willing, one last time, to wax cowpoke poetically about an artist friend's contribution to what's left of the iconoclastic un-cloned cowboy West, of which I still catch rare wild glimpses, thanks to his fearless, unfettered sensibilities, work ethic, and/or talent.

Years back in a *Montana Quarterly* piece, esteemed writer Sam Curtis quoted Ted as saying, "I learned that ranching and making art are the same in that when you get up in the morning you don't know what will happen by the end of the day. You just know

Paul Zarzyski's poem, "Grace," 2004, a broadside in *Tender*, a collaboration between Zarzyski and Theodore Waddell. Printed at Tucker Press, Hailey, Idaho.

it's going to be different. I loved that." To be candid and fair, a painter, potter, poet, etc., pulling eight-to-fives busting tires at the shop or shuffling numbers in some office cubicle could stake claim to a similar proclamation. Minus the colorful vistas of natural landscape, however, and that's an immense "minus." Ted's point taken a bit further involves a craving for the difficulty (at times, impossibility) an artist encounters while literally living in, working in, playing in, *breathing in* the molecular make-up of his very subject matter—dander, pollen, vapor, dark matter, light matter, residue, stardust, fumes, ash, you name it. Imagine the challenges—first to observe, respire, ingest, absorb, and then to *realize*, to transcribe, to symbolize, how said "daily differences" or surprises manifest themselves just as physiologically on the canvas, in the clay, on the page, as they do in the moment in which they are lived. "How goes the painting, Ted," I asked during a recent phone conversation. "Well, I'm still trying to figure out the color green" was his sanguine, humble response. Imagine! Imagine living aboard such the palette that Ted calls home. Imagine wrapping your canvas around coarse topographical bark of a colossal two-hundred-year-old cottonwood tree growing up through the palette's thumb-hole and casting its wavering, illusive shadows over every variation of every hue, every tint and tinge, every shade of every infinitesimal gradation of green, all in constant flux. And *that*, in Montana, ladies and gentlemen, is during *just one* of the numerous seasons! And, moreover, during just one of the daylight's schizophrenic weather personalities, no two ever alike, changing by the minute—thank you, Zeus, for your incessant mood swings.

240

Doesn't it then become a simple hop across the meandering meadow runnel to extrapolate how someone in the field of psychiatry might adopt this phantasmagorical metaphor as the quintessential poster image for insanity? On the contrary, for the artist nurtured by—and perpetually high *on*—such heavy doses of unknowns, *Elysium*, not madness, is perhaps the more apt correlation. "I'm still trying to figure out the color green," indeed. Ted's intimation that the rancher's variegated ecosystems—or ecospheres!—lend themselves to fresh perspectives coincides precisely with a mantra I coined for myself years back, "*creat*ivity rhymes with *in*finity." The retrospective compositions of Theodore Waddell, traversing such wide swaths of the creative universe's mediums—most of which fit mystically under the heading, "Water, Grass, Sky, Space & the Critters They Nurture"—certainly reach deep into that "*in*finity."

A decade or so ago, when Ted asked for "a poem" with which to accompany one of his woodcuts as a broadside he'd print at his Tucker Press, my enthusiasm caused me to overreact. In a gesture to accommodate my friend to the utmost, I submitted a veritable salvo of works engaging a wide array of focuses and sensibilities. Ted zeroed-in on ten poems, plucking them lickety-split out of the herd—as keen as his wife Lynn Campion forked "with feel" to a good horse in the cutting pen—and eventually printed the suite titled *Tender*. Aside from the mostly subordinated speaker of these poems (yours truly) and several additional unidentified, generic humans with cameo roles, the main characters are our furred, finned, scaled, feathered, haired-n-hooved animal brethren, our fellow beings. We're talking horse poems (with cows and cow dogs between the lines) as well as trout, deer, cat, ant, snake, rabbit, owl . . . poems. And perhaps paramount among Ted's chosen *subjects*, landscape, *who*—yes, *who*—perpetually plays the lead role as the most critical living entity of our inimitable West.

From "Love the Color of Trout":

Smoldering, after rain all day, the sun
sets fire to saffron yellow logs
the barn hunkers on. Coffee Creek
cuts a swath we hop across,
green to more green,
and whitetail deer, sudden
as stump mushrooms and rust red
with summer hair, browse
brisket-deep—dash of paprika
on this timothy green. . . .

Or, from "Grace":

> . . . And as millenniums meander by
> like birthdays to the earth, what thrill
> a saffron blade of grass, blue sage, scrub oak
> still brings us on our daily jaunt
> across the land, our daily poem, our prayer.

I found it both revealing and reassuring that Ted had chosen to echo visually my echoing of the seminal lines of our friend Richard Hugo—the very lines from Dick's poem "Driving Montana," which, in 1972, fueled my application to the University of Montana's creative writing program. Hugo changed my life dramatically forever when, to close the poem, he wrote:

> You are lost
> in miles of land without people, without
> one fear of being found, in the dash
> of rabbits, soar of antelope, swirl
> merge and clatter of streams.

Ted, I'm sure, especially recognizes, to this day, an affectionate kinship with another of the poem's images:

> ". . . the soft brown forms of far off Bison."

This line, *via* its meticulous (and, yes, painterly) synergistic mix of alliteration and assonance, alludes to that panoramic dominance of Western landscape that we, along with Hugo, find so easy to venerate, to cheer—casting it (I'll say it again) as the central character, as the actor, *or actress*, playing the leading role in a film that might be titled *Theodore Waddell, Artist-Rancher, Rancher-Artist*. As a fitting sound track to such a film, *why not* the 1930s lyric, "Give me land, lots of land, under starry skies above—*don't fence me in* . . ."? (Thank you, Cole Porter, and especially thank *you*, Montana cowboy poet, Bob Fletcher, for your poem, "Open Range.")

I can't think of an artist, non-Western or otherwise, deceased, living, futuristic, or otherwise, less fenced-in than Ted, especially when I'm pondering his boundless, bound-*ary*-less, "reach" into the soulful—especially while I'm surrounded by a gallery exhibit of Waddell art, none of which ever feels two-dimensional, all of which feels far greater than three-dimensional. Put simply, Ted's work intoxicates with awe those willing to drink from its smoldering grail without first cautiously needing to ask, "What's in it?" Some of

us "drinkers," my unruly self included, guzzle the stuff with not one scintilla of a discerning palate developed or influenced (or *interfered* with!) by a comprehension of the history of art. We guzzle it instead out of an organic, inherent, spontaneous, and, yes, naïve, need or thirst to be time-traveled; we guzzle it to be stampeded right out of our Blucher or Paul Bond boots, out of our Stetson or Resistol beaver lids, out of our ornately printed-on-silk Buckeye Blake wild rags, our Walt LaRue hand-painted buckin'-hoss-twister, or twist*ed* Salvador Dali, cravats; we guzzle it to venture to a place in the West where our hearts and minds, our spirits or psyches, have yet to visit, thank goodness and/or God and/or Stephen Hawking and/or Captain Kirk's *Star Trek* mission "To go *boldly* where no one has gone before." Yes "guzzle"—sipping be damned when it comes to the elixirs that quenched the thirsts of Van Gogh, Picasso, Toulouse Lautrec, de Kooning, Pollock, Diego Rivera, Frida Kahlo . . . and, now, Waddell. Stand before a Ted Waddell oil painting, quaff from the bottomless chalice, cock your hammer, shake your face for the chute gate, get your holts, and be transported ("Beam me *out there*, Scottie.") to a place so lit with otherworldly artistic vision and wisdom that you'll forever-after regret the re-entry into what we deem "reality." Kind of like strolling cautiously out of a great opera, or, for many of those in Ted's circles, a great *horse* opera—strolling out of, say, a picture show screening of *Lonesome Dove*, and head-on into the humdrum modern world with not one Captain Woodrow Call in sight. For those "cow folks" who I most admire, receiving and assimilating Ted's art involves far more of a blue-collar visceral intercourse than it does an esoteric intellectual one. *Why* then, I ask, would some consider it a sacrilegious

Paul Zarzyski's poem, "The Meaning of Intimacy," 2004, a broadside in *Tender*, a collaboration between Zarzyski and Theodore Waddell. Printed at Tucker Press, Hailey, Idaho.

misconception to associate in any way, shape, or form, the artwork of Ted Waddell with that of Charlie Russell? Because there might be a skosh less of a narrative bent painted into Ted's canvases? Sorry, ye ol' Cowboy "Artists" of America purists—that, in itself, is nowhere *near* reason enough. It's so much easier, wiser, to love equally both Charlie's and Ted's interpretations of the West, their counterpoised renderings of horses, of livestock, of the wilds made oftentimes all the wilder by the presence of wilder beings than we—"nature's people," as Charlie dubbed them. To align the two generations in kindred terms, you got your Teddy Blue Abbott and you got your Teddy Blue (or Bob!) Waddell. Any "waddie" or "ranahan" hailing from the artistic open range ought to be *hand*-enough to run with that corollary, with that juxtaposition and the lineage or pedigree thereof. Like ol' Charlie said in his *Trails Plowed Under*, "These twisters of to-day are made of the same leather as the old-time ones. It ain't their fault that the country's fenced an' most of the cows are wearin' bells." Substitute "painters" for "twisters" and Charlie's dictum holds equally true, says I.

Which brings me to a specific Ted Waddell canvas with which I feel a most personal relationship. Recall how landscape rules the Western roost for me as a poet, especially so as a *cowboy* poet. My hierarchal perspective goes something like this: no large expanses of wide-open Western range upon which to graze livestock, no need for the horse; no

need for the horse, no need for the cowboy; no need for the cowboy, no large expanses of wide-open range upon which to graze livestock, and, therefore, no Theodore Waddell cattle, sheep, buffalo, horses, as I mostly know and love them, which is to say occupying oftentimes (though not always) the smaller acreage of the *canvas's* expanse. I will forever remember standing—in Fallon, Nevada's Churchill Arts Gallery—for the first time before the ten-by-five-foot diptych, *Sun River Horses*, the image which adorns the cover of my collection, *Wolf Tracks on the Welcome Mat*. Instead of my drinking *it* in, the painting swallowed me into its being like a *T. rex* ingesting a no-see-um. I recall noticing the freshly refinished blond hardwood floors in the gallery. I remember wondering why the curators, our friends Kirk Robertson and Valerie Serpa, had not taken precautions to drop-cloth the handsome tongue-and-grooved craftsmanship, likely that of some long-ago master woodworker. I mean, at the risk of going over the *Star Trekian* biblical cosmic top (I *am*, in fact, a fan of the History Channel series *Ancient Aliens*) it became an easy leap of creative faith for me to correlate the stigmata tales regarding iconic religious statues, as I stood there before the deific figures and symbols that inform *my* spirituality. I'm talking the Rocky Mountain Front's foot-hilled east slope, *peopled* soulfully—yes, as in beings bearing souls—by a small cavvy of grazing horses. "If I stand here long enough," I believed, spellbound in the midst of that moment, "this painting will eventually bleed the chlorophyllous greens of *my* personal gods or shamans." The same greens I breathed in, I drank from, for eight years while living on an old ranch in that very landscape. And not just any greens, either, but *the* greens of Theodore Waddell.

Which, in closing, is all to say, may the heavens' distilleries and the Patron Saint of Boozed-Up Virtuoso Painters, Jackson Pollock, save our tag-along-into-creative-*in*finity hearts from bursting with sozzled fervor—as well as protect the walls and floors *and* ceilings *and* roofs of galleries across endless light years of The Ol' Cowpoke Cosmos—should Teddy-Bob ever definitively "figure out the color green."

A Painter's Almanac

Brian Petersen

[**Editor's note:** In September 2014, Montana writer Brian Petersen, the artist's longtime friend, traveled with Theodore Waddell through the landscapes that had meant so much during Ted's youth and the years of his ranching career. Here Petersen offers his insights into the impact of this retrospective journey.]

Theodore Waddell and I first crossed paths in Billings in the mid-1980s, when he took to showing up at the bookstore where I worked. I saw a small, purposeful, alert-looking fellow, wearing Carhartt coveralls, four-buckle overshoes, and a gimme cap crammed down on his wiry black hair, the whole package—including the hair—flecked and spattered with blue, black, and purple shades of paint. The automotive section, I figured, or maybe construction; or even animal husbandry, judging by what was caked on the boots.

"Do you have these books?" He handed me a slip. Maxine Kumin. James Merrill. May Swenson. William Stafford. We looked at each other a moment. I told him I could order them and off he went.

He returned the following week to pick them up, and he had another list. Amy Clampitt. Kenneth Rexroth. Ann Sexton. Langston Hughes. Some of the finest poets one might read.

At last it dawned on me. Theodore—Ted as he suggested—had been in regularly, once or twice in street clothes, no less. Always ordering terrific poetry, all of a certain pedigree, I came to see. "So you're a fan of Writer's Almanac on NPR?"

"Yes. You?"

"Yes. I don't always get to hear it when I work."

"Same here. Poetry is new to me. We should talk about it sometime."

Today wasn't a street-clothes day. More a heavy spatter day. I knew the story of the poetry. But not the man. "Do you mind," I began. The dark eyes were on me. "Do you mind my asking what you do for a living?"

"I'm a painter."

"You mean like . . . barns?"

That's a Waddell moment. Thus a friendship of more than thirty years begins. A deeply serious man, there are few things Ted likes more than a good laugh. Offer him amusement, attention, loyalty, and a touch of intensity: He will return the same upon you twenty-fold.

I got to watch him paint which is a rare privilege with Ted. He introduced me to the concept of "making art," when I had always thought it something delivered from on high. I went to work for him (loosely speaking); I worked for art, for beer, for conversation. I apologized for my town boy's lack of skills. "Frankly," he told me, "I'd probably pay you just to bullshit."

A year or so ago he called and asked me to accompany him on a trip to Billings, from whence we had both been gone a decade and more. He wanted to see old sights, meet old friends, recall old times. For me, and I think him, the visit prompted reactions ranging from sweetness and gratitude to longing and remorse. This was the kind of journey one might wish to take with one's father, which for me Ted Waddell has in a sense been.

Monday, September 15

Ted and I set out at noon, as planned. He wanted to stop in Big Timber for a quick lunch, in part I think because Big Timber held for him a couple of small memories that remained important.

One was simply of the viewscape of Big Timber's main street, otherwise called McLeod Avenue. Years ago Ted had a Chevy pickup he didn't much like and it seems he would bring it to Big Timber for repairs. He would drop it off and stop at the Timber Bar for lunch, then retrieve the pickup and head back home toward Molt.

The brief visual memory that has stayed with him came the very cold day he stepped out of the Timber Bar to walk the two or three blocks up the street to Bob Faw Chevy. The image Ted still holds is one of vehicles lined up at the curb stretching the length of the cold, cold street, one after another . . . and every one of them a pickup.

The other recollection is one of evident emotional weight, and has to do with an old ranch cowboy named Selmer (I believe) who worked north of Big Timber. Selmer had a beloved cattle dog on the job with him up there, a dog that could do most anything Selmer asked. Ted had encountered the old fellow in the Timber Bar, and he learned from him—after one meeting or more, I don't know—that Selmer was leaving the ranch, retiring, I believe . . . but the ranch company had decided that the friendly, incomparable dog belonged to them, not Selmer. Selmer was terribly hurt at having to leave the dog behind, and soon was hurt even more to learn that the dog had been run over. Ted would see Selmer's obituary not long after the dog was killed. He remembers sending a card to the family.

The story no doubt stays with Ted because the little guys, the ranch hands, miners, railroaders, farmers—those who do the hard work of the world, as Ted's father had and as Ted himself learned to do—have remained important to him. Ted's own endless labors have carried him to a place, in a sense, far from those kinds of jobs, but the people in them still exert a great hold. At every turn in this trip there were stories of desperate toil and the men and women caught up in it, including Ted himself and his family for many years. Sometimes the stories are of hardship and privation but just as often of achievement and reward.

After leaving Big Timber we headed to Columbus where we drove through town in order to turn north toward Molt. It had been years since either of us had taken the backroads route, and we had to explore a bit to find it: at one point Ted pointed at what used to be the old Davy Ford auto and implement dealership (now Beartooth Ford), and mentioned that he'd once made a commissioned piece of art, a stainless steel single-blade plow, in trade with Mr. Davy for a stereo system to be installed in Ted's tractor—one of countless such bargains and barters Ted can point to over the years. The road to the old Leuthold farm, once we found it, turned out still to be long and empty and given to teasing the driver into uneasiness over lost landmarks and missed turns. But as we finally drew near the place, where Ted and Betty had farmed, his intensity and perhaps apprehension increased. It is a place of many memories, among the most important of his life. He pointed to the shelter belt he had planted, to the site of the old surface gas line (from natural gas wells in the area) that was used, imperfectly, to heat their home in winter. As we pulled into the empty yard, every structure, every fence, every shadow held significance. The present owners were in Billings, but three Mexican men were at work setting ties for a new corral. Ted stayed busy pointing to the buildings he had used and the improvements he had made. He later said that moving to this farm—hard work and hardships and family struggles included—was one of the great good fortunes of his life. His life changed here, where he began to find time and direction for his art. Where he began to paint.

We left the ranch and drove to the gate of a nearby friend or relative or two, about whom Ted recalled a story or two. We drove into Molt where he talked about the school, his church, and a few more friends. Then we aimed toward Laurel, enjoying the familiar high plains countryside (but for the new subdivisions) as we drove. I probably should note that Ted pointed to an old bar/dancehall where as a young man he played trumpet in a stage band on weekends, a detail from his life I had known but forgot. And I should say too that early in our acquaintance I helped Ted make the move from the Leuthold farm to the ranch near Ryegate, and recall a number of stories and observations from those important times, for him and for me as well.

In Laurel we visited Ted's boyhood friend Les Frank and his wife, a mandatory stop for Ted on every trip into the Laurel city limits, at least in my experience. Les is virtually chairbound now, but he loves to hear of Ted's latest travels and achievements. There is almost a fatherly satisfaction taken by Les from these stories, even though he and Ted are close in age. During this visit, as in others, Les was heard to say, "If my poor father was here right now he would say 'No way was that little blankety-blank Teddy Waddell able to do all those things.'"

This is a pattern in his visits to his old stomping grounds. Ted isn't bashful about telling his old friends, the ones who stayed close to home, about the things he has done and the places he has been, and in general how splendidly things have worked out for him after all. Oddly enough you see little but appreciation and admiration in most of these friends for Ted—they seem as pleased as he that his life has blossomed, year upon year. I've been with him in these and similar situations often, and I think that one of the reasons the locals are impressed by him, and happy for him, is that when he is with them—working cattle, say, or in the pub—he is not only one of them, he is one of the most popular of them. His wit and banter and his ready laugh make him greatly welcome in the tavern, and for that matter out in front of the tavern on the street. Ted may talk of galleries and famous people and far-flung locales, but he also gives and takes the badinage with the best of them. Small town and rural folk tend to trade in a pretty rough brand of humor, but Ted is an expert. His quick and gleeful laughter—and his willingness to grab the tab, always, even back when money was tight—makes him known and welcome most everywhere.

To end the day we drove past Ted's home and the railyards where his father worked and where Ted himself first worked too, as a "call boy," I think he termed it. Railroad cars and other structures were adapted as sleeping quarters for the railroaders between runs, and the young call boy would rouse the men who were due up, time being of the essence, of course. Ted also talked about working at the dairy farm across the road, and about tying fishing flies to be sold for a little pocket money, and about other jobs—farm tasks, painting, clerking at the department store—in order to make a few bucks.

Tuesday, September 16

I was wary of the breakfast interview scheduled with Patrick Zentz and Gordon McConnell (at the Dude Rancher café), thinking it might be something of an awkward, delicate fêting of Waddell. I couldn't have been more wrong. Instead it was a two-hour-plus discussion, brisk, smart, funny, wide ranging, at times abstract and at other times deeply personal. The artists talked about themselves, their own art and others', their pasts and present, as well as some of the more meaningful people and moments in their long careers. Quite easily and honestly they were able to point to one another as fundamentally important, each to each.

The essential message came from Pat Zentz repeatedly speaking of the seriousness Ted brought to the consideration of art, first as a teacher of Pat's at the University of Montana, later as a fellow artist in Billings, and always in Ted's own relentless pursuit of making and selling good art.

They talked about the many other artists and people involved in the Billings/Montana art scene over the years, such as Fred Longan who was working hard to make art (photography) but also realized the quality and importance of the work going on around him, and who was instrumental in an early exhibition by Ted, Pat, Fred, and others at the Billings Livestock Commission. Pat and Ted especially emphasized the importance of Donna Forbes in all of this, as the touchstone, the bedrock of it all, including Donna's ability to seek out and cultivate loyal donors and benefactors, like Miriam Sample, for instance. I had no idea of the early efforts and struggles to shape and define the Yellowstone Art Center, but all three of the artists had been deeply involved in it, each in his own way, and each of them through their work with—and battles with—Donna and some of the other early supporters of the YAC. Pat is easily the most theoretical and, in a word, programmatic of the three and appreciates logic and rationality above all else; Ted operates on passion and fierce resolve; while Gordon is, and it seems always has been, a peerless facilitator, who indeed brought a calming presence to bear during turbulent—"frothy" was Pat's word—formative years of the YAC.

They spoke of the charged meetings and discussions at the Art Center and—Ted in particular here—at the Monte Carlo Bar & Restaurant downtown. He described the raucous lunches there, everyone eating and drinking and arguing fervently . . . then leaving the table as friends. He told of the young Pat in loud, heated disagreements with the older, quieter Donna Forbes about the direction of the YAC; Pat responded with an account of Ted quarreling at such length that the ash on the cigarette he held grew and grew, until Donna finally rose and wrestled the offending butt away. Ted mentioned as well that Gordon's writings and support at the time brought him, Ted, much needed attention and

Church and abandoned building, Ryegate, Montana, 2015. Waddell Family Collection.

The Ryegate Bar & Café, home of the famed annual Testicle Festival, 2015. Waddell Family Collection.

exposure, including the purchase and placement of one of Ted's works at the Corcoran Gallery in Washington, D.C.

The discussion itself underscored Pat's insistence that Ted's demand, in his teaching and in his life, that *art be taken seriously*, had been a guiding principle not only for Pat but for many around him. Pat spoke of being a callow young man in Ted's class in Missoula, full of eagerness and interest in art, but left shaken and driven to work harder by Ted's near-fury at times over the importance of what they were trying to do. Pat was challenged and exhilarated by a figure like Ted telling him, another hopeful, creative farmboy, that his ambitions were not only valid but worthy of respect, even reverence. Moreover, Gordon's own passion for art has persisted long enough that even now he is drawing the largest audience of his career. How can one doubt that, as he mastered his many different roles and duties at the Art Center, Gordon was also influenced by the dedication and eventual successes of artists like Pat and Ted? And who could be more gratified than one who has heard the call, and heeded it, and after thirty or forty years has seen the rewards come his way?

After we left the cafe Ted and I headed north and west to visit Ryegate and his former ranch. As usual we encountered no few acquaintances of Ted, each of them entirely fortuitously: First there was Mike Smith (I think) at the Ryegate gas pumps, where he and Ted instantly resumed a conversation probably left off some fifteen years ago . . . next was the young lady at the cash register who, reading Ted's name on his credit card, inquired as to whether he was still painting. Next was a quick stop for a photograph outside the Ryegate Bar, where—as if on cue—Ted's friend and former employee (fence-builder) Vern walked across the street and directly into Ted's waiting grin. "I got your picture hung up," Vern informed him gratefully. (Ted later told me that Vern had owned one of Ted's works some years ago but had lost it in a home fire, and Ted had sent him a new one.) They traded insults—of course—and bits of gossip and health reports, then we drove on as abruptly as we had stopped in.

More of the same in Harlowton, where we visited to see if the Graves Hotel had reopened (it hadn't) and if any of Ted's old beer-drinking cronies had survived the years (at least one had). We found the former owner of Biegel's Bar at the joint across the street—what was it? not the Oasis...the Sportsman? . . . I can't now recall the name— where Ted answered questions regarding his whereabouts, his travels, his success, the price of his paintings ("a lot," he told the man) in his familiar teasing jocular manner and was received with the same kind of wonder and pleasure and pride as he almost invariably is.

He is received that way because he treated the gentleman with the same warm regard years ago, before Ted was Theodore Waddell, treated him that way over and over, and now is regarded not so much as the one who went away and prospered as the one who went away and prospered and still makes time to come back.

The Graves Hotel, Harlowton, Montana, 2015. Waddell Family Collection.

There was a second old gent beside the fellow who formerly owned Biegel's, and he (like me) though very drunk (not like me) mostly kept quiet, now and then leaning forward to catch the jokes from Ted, whom he did not know. But as we said goodbye and moved to leave, he put his hand out and stopped Ted for just a moment. "Thank you, sir," he said. "Thank you for coming here today."

Serendipity in the afternoon: We stopped at the Yellowstone Art Museum in order to say hello to the museum director, Robyn Peterson, and for Ted to thank her for nominating him for the Montana Arts Council Governor's Award; and also to pick up museum curator Bob Durden who is a friend and supporter of Ted's, indeed who Ted credits with bringing about his grand retrospective exhibition back in 2000. We headed with Bob directly for the sidewalk bar of the Montana Brewing Company downtown and proceeded to discuss their current projects as well as those past. We hadn't been seated long when I noticed Ted's face light up with surprise and recognition, then Bob's too. As it happened, Ted's longtime friend and co-conspirator Fred Longan was strolling innocently past the tavern with a neighbor, Peggy Hammond, whom Fred had been helping to do some shopping. Fred glanced over, did a double-take, and lit up as well: "Waddell, for God's sake, is that you?"

They sat down for at least a few more beers than they had planned, Ted and Fred happily discussing their earliest days as working artists in Billings: the old names tripped by again: Zentz, Voss, Freeman (Edith and Butts), Isabelle, Buck and Butterfield, Lodge, and many others. Fred is known chiefly for his photography and, for decades, as a purveyor of books, photographs, and other fine collectibles in his elegant store in the old Northern Hotel; but he has also been a proponent of and friend of artists who could be always be counted on to help with a show, to make a fine poster, and to give a hand to a colleague in need. Ted spoke of their early plottings and dreams, and of the importance of Fred's confidence in their earliest efforts, pointing out that he still had a copy of the poster from that first opening at the Billings Livestock building. Fred provided the perfect capsule description of the situation at the time: "I looked around and there was all this wonderful art being made, but no one knew a thing about it. It needed to be seen!"

Speaking of which: Fred's neighbor Peggy Hammond had been chatting and enjoying her beer when she patted my arm, then pointed at Ted: "But who is this fellow?"

"This? This guy?" Everyone laughed, including Ted, as he was introduced.

"Really? You are Ted Waddell? The artist Ted Waddell?" The excitable Peggy was more excited now. She fumbled with the buttons to her light summer jacket, and finally pulled the coat wide to unveil a pristine 1980s-vintage pink-and-blue Waddell Artworks tee-shirt, one of the edition Ted had produced for the Montana Centennial book and arts festival held at his Ryegate ranch in 1989.

Turns out Ms. Hammond's son had dated Ted's daughter Shanna back in those days, and Shanna had given her one of the shirts.

"To think I almost didn't wear it today!" she said.

Wednesday, September 17

Wednesday morning brought an immersion, however brief, in the art rather than the artists. We went first to the lovely, manicured home and grounds of Donna Forbes. There we saw the work of Bill Stockton, Edith Freeman, Isabelle Johnson, John Buck, and many others, including Ted, of course—a varied, tasteful, masterly collection that lends her home an almost cathedral air. Donna, reserved and self-possessed as always, did sit to talk with us about the old days, the personalities, the excitement, the give-and-take, the laughter and tears. It was amusing to hear her perspective of the different moods and currents of the times, the tiny lady, soft-spoken, always slightly above it all, surrounded by the young wild bunch at lunches and meetings during which, she said (echoing Pat Zentz a day earlier), she would try to agree with one plan or another, or maybe one plan and part of another—*but*. But—the glorious plans and ideas and dreams had to be paid for somehow. One could see, during her modest recounting of events, the great pleasure she had taken being in the center, and at the top, of all the plans and goals and successes. I told her that in all our discussions the various artists had referred to her as the pillar, the rock, at the base of it all. Donna wagged her finger. "The queen bee," she corrected.

It can't help but occur that Donna herself was an artist of sorts, shaping and building what would become the Yellowstone Art Museum, a labor of love similar to the inspired efforts of the artists in her fold. And it must be said that one of the paintings by Ted that she has displayed, a very early *Angus* oil, in the hallway outside her bedroom, was so simple and clear, and quietly powerful, as to stop one in his tracks. The work was from the early 80s (painted in house paints, Ted pointed out, because that's what he could best afford), and is of the same period as one chosen by Mark Stevens to illustrate his watershed *Newsweek* article. The thought of the young man knocking together one of his first cattle paintings with such deftness and force—you have to wonder if he realized just how good he was.

Next came the home of the collectors, John and Carol Green, whose works come from around the world (including a Braque sculpture) and deep into the Montana catalog, from Autio to Zentz. Ted says that he greatly values the Greens, owing to their enthusiasm about art; and it is plain that they hold him in high regard as well and are working to ensure Ted's legacy in first-class galleries and museums around the country.

They proudly and fondly display his work throughout their home, including another breathtaking early painting, hung in the front hall, from the same period as Donna's astonishing piece, but this one at the other end of the methodical scale: the work is abstract and very heavily painted in oils, paint at least a half-inch thick, and weighing—so they testified—one hundred and twenty-nine pounds. Ted likes to say that for twenty-five

years his phone never rang and I remember him telling me long ago, perhaps in jest, that he could paint so heavily then (once he could afford the paints) because he had all the time in the world.

Once again I stood before a painting, completed very early in his career, and wondered at the brilliant execution of the work, the bold colors and fearless sculpture-like strokes and shapes—it made me think of a quote I once read elsewhere: "(He is) a potentially great artist—the potential betimes disappearing, leaving a great artist standing revealed." Afternoon brought a return to Columbus, and up the Stillwater Valley past Absarokee, a return to the beginning of things. Working from memory Ted was elated to find, without a false turn, the old farmstead of his professor and friend Isabelle Johnson. Opposite her farm the riverbank has sprouted a rude enclave of colorful "cabins" and condos, but Ted was greatly pleased to see the old Johnson mailbox still standing, with the name ALBERT JOHNSON (Isabelle's father) stenciled across; better yet was the weathered but sturdy wooden entrance sign, announcing in large letters JOHNSON LAND & LIVESTOCK Co. Inc. and, below that, the names of the three sisters who once lived there:

Isabel ~ Grace & Pearl

The farmhouse was aged but intact, as was the smaller stone-chimneyed studio. Ted took pictures and talked about visiting the ladies and sitting in the kitchen—always the kitchen, never the parlor—where there were only three chairs at the table, so Pearl would take a seat alone over behind the refrigerator, where there was an extra stool, from which she would rise and step forth to make her points during the conversations. He said that eventually he and Isabelle, who had taken a close interest in him at Eastern Montana College, would repair to the studio where she would show him her latest work and, according

to Ted, invariably "lecture" him on "burning both ends" against the middle. Obviously one lesson that never seemed to take.

Ted was moved and comforted by the visit. After three busy days on the road he seemed happier, more restful to have paid homage to the artist usually cited as his most influential teacher and friend. A long, difficult, and productive journey, indeed, a candle burning all the way.

This might have been enough, the kind of sweet grace note on which to end the travels, but Ted—the candle again—had one more idea. We swung into Beartooth Motors in Columbus, to learn even before entry (a paper sign at the door named the new owner) that the Davy family had long since moved on, as apparently had the plow art that Ted had made and traded so long ago. He explained to me that it used to sit on display in the showroom—but no more, it seemed. The showroom was empty but for dust. The place seemed moribund. As we turned to leave, a lady behind a counter called out: "Can I help you?"

Not particularly welcoming. We shook our heads and again made to leave. But Ted swung around. One more try. He mentioned the Davy family, his long years of friendly business with them. The lady, in what turned out to be a Louisiana accent, made it known that the Davys were history, that the days here were long (she later told us she hated Montana and was leaving—alas!—by year-end), and that tired, scruffy memory-merchants weren't exactly high on her list of priorities. We turned again to shuffle out, then. . . .

Ted tried once more. "I made a single-plow display for Mr. Davy years ago, traded him for a stereo—"

"Yes. It's still here, in the back. We want to get rid of it. It's always in the way."

Words into plowshares. The talented Mr. Waddell. Because the deep talent is there, of course. But so is the ethic, the will, the credo: work, work, persevere, try and try again and again.

"I want to buy it," he said.

About the Contributors

In 1977, along with a small group of arts lovers, **MARK BROWNING** began restoring the old Miles City [Montana] Water Works into a museum and art center. After nearly thirty years as the curator and director of the Custer County Art Center, now the WaterWorks Art Museum, Mark has retired. His contributions to the recognition of contemporary art in eastern Montana are many and far reaching.

BOB DURDEN is senior curator at the Yellowstone Art Museum. Before returning to the YAM in 2012 (now having served for a combined nearly fifteen years), Durden served for nearly four and a half years as curator at the Paris Gibson Square Museum of Art in Great Falls, Montana, and before that as director and curator of the Yeiser Art Center in Paducah, Kentucky. Durden has also taught in the theater and art departments of Montana State University–Billings and Rocky Mountain College, Billings.

While at the Paris Gibson Square, Durden curated the exhibition, *Theodore Waddell: The Weight of Memory*, and contributed the principal essay, "The Weight of Memory: A Historical and Observational View," to the exhibition's catalog. Durden most recently curated the Theodore Waddell sculpture exhibition *Hallowed Absurdities* at the Yellowstone, which opened in September 2013.

Legendary museum director **DONNA FORBES** received the Montana Governor's Arts Award in 2010. The fourth director of the Yellowstone Art Museum, Forbes had a close friendship with her great teacher and mentor, the painter and rancher Isabelle Johnson, and became friends with Johnson's Montana modernist compatriots: Bill Stockton, Edith Freeman, Lyndon Pomeroy, Jessie Wilber, Frances Senska, Bob and Gennie DeWeese, and Rudy and Lela Autio.

During her tenure, the Yellowstone became the first museum in Montana to actively collect the works of the state's leading contemporary artists. The Montana Collection encompassed works by both the older generation and younger artists, such as Theodore Waddell, Russell Chatham, Deborah Butterfield, and Jaune Quick-to-See Smith.

"Donna Forbes has been the single most influential person in shaping and professionalizing the museum field in Montana," writes Liz Gans, former director of the Holter Museum of Art in Helena.

WILLIAM "GATZ" HJORTSBERG is an acclaimed author of novels and screenplays. Born in New York City, he attended college at Dartmouth and spent a year at the Yale School of Drama before leaving to become a writer. For the next few years he lived in the Caribbean and Europe, writing two unpublished novels, the second of which earned him a creative writing fellowship at Stanford University. When his fellowship ended in 1968, Hjortsberg was discouraged, still unpublished, and making ends meet as a grocery store stock boy. No longer believing he could make a living as a novelist, he began writing strictly for his own amusement. The result was *Alp* (1969), an absurd story of an Alpine skiing village which Hjortsberg's friend Thomas McGuane called, "quite possibly the finest comic novel written in America."

In the 1970s, Hjortsberg wrote two science fiction works: *Gray Matters* (1971) and *Symbiography* (1973). The first, a novel about human brains kept alive by science, was inspired by an off-the-cuff remark Hjortsberg made at a cocktail party. The second, a post-apocalyptic tale of a man who creates dreams, was later published in condensed form in *Penthouse*.

After publishing *Toro! Toro! Toro!* (1974), a comic jab at the macho world of bullfighting, Hjortsberg wrote his

best-known novel, *Falling Angel* (1978). This hard-boiled detective story with an occult twist was adapted for the screen as *Angel Heart* (1987), starring Robert De Niro. Hjortsberg also wrote the screenplay for *Legend* (1986), a dark fairy tale directed by Ridley Scott. In addition to being nominated for an Edgar Award for *Falling Angel*, Hjortsberg has won two *Playboy* Editorial Awards, for which he beat out Graham Greene and Nobel Prize winner Gabriel García Márquez.

His most recent works are *Jubilee Hitchhiker* (2012), a biography of author Richard Brautigan, and the novel *Mañana* (Open Road Media Mystery & Thriller, 2015). Hjortsberg lives with his family in Montana.

Poet, satirist, and memoirist **Greg Keeler**, professor emeritus of English at Montana State University, Bozeman, taught at MSU from 1975 to 2013. Keeler's areas of specialization are in the writing of poetry and fiction and in contemporary literature. He has published three books and three chapbooks of poetry, has had six plays produced, has produced ten tapes and CDs of his satirical songs, and published many articles in magazines and journals. Keeler's books include *Trash Fish: A Life*; *Waltzing with the Captain: Remembering Richard Brautigan*; *Epiphany at Goofy's Gas*; and *American Falls*. He illustrated Jim Harrison's 2005 chapbook, *Livingston Suite*. In 2001 he received the Montana Governor's Award in the Humanities.

Besides being one of Montana's most accomplished postmodern painters, **Gordon McConnell** is the state's leading writer on contemporary art. Today an independent studio artist, curator, and critic, Gordon was for many years chief curator at the Yellowstone Art Museum in Billings, where he was instrumental in assembling and shaping that museum's unparalleled Montana Collection.

Since leaving the Yellowstone, McConnell has continued to write and curate exhibitions, most notably as a consultant to the Ucross Foundation, from 2000 to 2006, and he is recognized as a leading authority on contemporary Western art. Recently, he's spoken at symposia at the Denver Art Museum and the Booth Western Art Museum and has been a keynote speaker at the Mountain-Plains Museums Association and the Montana Art Education Association.

McConnell has been one of the foremost interpreters of Waddell's work, from his essay on Waddell's early *Angus* paintings in the Summer 1983 *Artspace* to his authoritative 2011 contribution to *Theodore Waddell: Five Decades, Selected Paintings & Works on Paper* (Churchill Arts Council, Fallon, Nevada).

Veteran journalist **Scott McMillion** is editor in chief of *Montana Quarterly*. He is the author of *Mark of the Grizzly*, a finalist in creative nonfiction for the 1999 Independent Publisher Awards and now in its fifteenth printing. His essays have been collected in *Where We Live: The Best of the Big Sky Journal*; *Ring of Fire: The Writers of Greater Yellowstone*; *An Elk River Books Reader: Livingston and Billings Area Writers*; and *Farming and the Fate of Wild Nature: Essays in Conservation-based Agriculture*. He coauthored, with Robin Tawney Nichols, *Len and Sandy Sargent: A Legacy of Activist Philanthropy*, and he is the editor of *Montana, Warts and All*, a collection of the best writing from the first decade of *Montana Quarterly*.

Poet, editor, and independent scholar **Rick Newby** writes regularly about modern and contemporary art. His contributions to the field include major essays in the exhibition catalogs *The Most Difficult Journey: The Poindexter Collections of American Modernist Painting* (Yellowstone

Art Museum, 2002); *A Ceramic Continuum: Fifty Years of the Archie Bray Influence* (Holter Museum of Art/University of Washington Press, 2001); and *Matter + Spirit: Stephen De Staebler* (Fine Arts Museums of San Francisco/University of California Press, 2012). Newby edited *In Poetic Silence: The Floral Paintings of Joseph Henry Sharp* (Settlers West Gallery, 2010), by Thomas Minckler, and his essays on ceramic artists, painters, sculptors, and photographers have appeared in national and international journals and in numerous exhibition catalogs.

Newby is also an authority on Montana literature, having edited or coedited the anthologies *Writing Montana: Literature Under the Big Sky* (1996); *An Ornery Bunch: Tales and Anecdotes Collected by the W.P.A. Montana Writers' Project* (1999); and *The New Montana Story* (2003).

Newby's other credits as editor or coeditor include *On Flatwillow Creek: The Story of Montana's N Bar Ranch* (1991), by Linda Grosskopf; *A Most Desperate Situation: Frontier Adventures of a Young Scout, 1858–1864* (2000), by Walter Cooper (illustrations by Charles M. Russell); *The Rocky Mountain Region*, Greenwood Encyclopedia of American Regional Cultures (2004); and *"The Whole Country was . . . 'One Robe'": The Little Shell Tribe's America* (2012), by Nicholas C. P. Vrooman.

A past member of the Montana Arts Council and the Board of Directors of the Montana Center for the Book, Newby received the Montana Governor's Award for the Humanities in 2009 and the Montana Governor's Award for the Arts in 2016. He is currently executive director of Drumlummon Institute, a nonprofit dedicated to fostering research, writing, and publishing on the arts and culture of Montana and the broader West.

Brian Petersen has written for newspapers and other publications in Montana, North Dakota, and Idaho. He is the author of the novel *Vanish: A Story of the Boom* (Prong-horn Press, 2016). His essay "Guns of Plenty, Bones of Dust" appeared in *Theodore Waddell: Hallowed Absurdities, Mixed Media Sculpture* (Yellowstone Art Museum, 2013).

Robyn G. Peterson was born and raised in California. She holds a B.A., M.A., and Ph.D. in a variety of subjects that all have to do with the arts and/or Scandinavia. Since graduate school, she has spent her entire career in museums. She was Curator of Collections and Exhibitions at the Rockwell Museum in Corning, New York, from 1988 to 1999. From 1999 to 2006, she was Director of Exhibitions and Programs at Turtle Bay Exploration Park, in Redding, California, a 300-acre multidisciplinary museum and environmental education center. She has been Executive Director of the Yellowstone Art Museum since 2006. She is the author of *American Frontier Photography* (1993), *Edward Borein: The Artist's Life and Work* (1997), and *Second Nature: The Art of Michael Haykin* (2006), and coauthor of *Sudden and Solitary: Mount Shasta and Its Artistic Legacy, 1841–2008* (2008).

The **Honorable Pat Williams**, who served Montana as its U.S. Congressman for nine terms from 1979–1997, is well known for his staunch advocacy to save the National Endowment for the Arts during the early 1990s. "He is a tireless and fearless supporter of the arts," reports John Frohnmayer, a past chairman of the NEA. "How could one ask for a better champion for the arts?"

A Butte native, Williams has referred to artists as society's "canaries in the mines," pointing to the artist's ability to portend and depict our condition as a society.

Williams is a Senior Fellow Emeritus at the O'Connor Center for the Rocky Mountain West (University of Montana), and for his extraordinary advocacy for the arts, he received the Montana Governor's Award for the Arts in 2010.

Paul Zarzyski, the recipient of the 2005 Montana Governor's Arts Award for Literature, has been spurring the words wild across the open range of the page and calling it "Poetry" for forty years. In the early '70s, he heeded Horace Greeley's "go west young man, go west" advice and received his Master of Fine Arts degree in creative writing from the University of Montana, where he studied with Richard Hugo. In the same breath, he took up a second *lucrative* vocation—bareback bronc riding—and rode the amateur, ProRodeo, and Senior circuits into his early forties.

Paul has been a featured performer at the Elko Cowboy Poetry Gathering for the past twenty-six years, has toured Australia and England, and has recited at the National Book, Folk, and Storytelling Festivals, the ProRodeo Hall of Fame, the Library of Congress, the Kennedy Center Millennium Stage, and with the Reno Philharmonic Orchestra. He was also featured in 1999 on Garrison Keillor's *A Prairie Home Companion,* aired from the Mother Lode Theater in Butte, Montana.

Paul Zarzyski and Theodore Waddell collaborated on a series of ten broadsides with poems by Zarzyski and woodcuts by Waddell, published by Tucker Press, and Waddell's painting *Sun River Horses* graces the cover of Zarzyski's poem collection, *Wolf Tracks on the Welcome Mat.*

Patrick Zentz grew up on a ranch southwest of Billings, Montana. He majored in biology (B.A., 1969, Westmont College, Santa Barbara, California) and sculpture (M.F.A., 1974, University of Montana). While pursuing graduate studies, he taught in a seventeen-student rural elementary school along with his wife, Suzie. He also taught sculpture at Bozeman High School for a few years thereafter and then returned to ranching in 1978.

Now, after almost forty years of ranching and art making, Zentz continues his inquiry into the compelling power of the landscape. Although widely known for numerous major public art commissions as well as unique instrument systems that transform wind, water, and the horizon line into sound, he has modified his approach. The ranch land now fosters projects dedicated to native range restoration and the development of wildlife habitat. Artistically, he has shifted his efforts to the creation of virtual instruments that are implemented with computer code.

Years spent building investigative acoustic systems coupled with day-to-day agricultural labors provide a unique springboard for the current work that will place lightweight, migratory robotic systems into the landscape. These semiautonomous robots will carry scripted instruments, designed to visualize augmented perspectives of the environment, accessible through virtual reality technologies via the Internet.

Author's Acknowledgments

First and foremost, I want to thank Theodore Waddell and Lynn Campion Waddell for their vision, generosity, and patience as I composed my monographic essay. I could never have completed this project without their kindness, good humor, and support. Ted has been unstinting in providing all manner of hitherto-unseen materials: letters to his family written during the crucial year he spent at the Brooklyn Museum Art School, his personal journal from 1962 to the present, and an always marvelous fund of stories.

The amazing Lynn Chaldu, Ted's assistant, did so many things to make this book happen. I am eternally grateful for her expert assistance in tracking down images of artworks, biographical materials, family photographs, permissions, and all the myriad details that this project required.

Theodore Waddell has been the beneficiary of eloquent and insightful words from many fine writers, and I benefited greatly from the essays and reviews penned by curators and critics who have previously addressed his work. I'm especially grateful for the contributions of Terry Melton, Donna Forbes, Bob Durden, Dean Sobel, Kirk Robertson, Jennifer Complo, Ben Mitchell, Shanna Shelby, Mark Stevens, Marie-Christine Loiseau, Sam Curtis, Robyn Peterson, Jim Poor, Michele Corriel, Brian Petersen, and Gordon McConnell.

Gordon McConnell, whom I esteem as Montana's finest writer on contemporary art, has written brilliantly about Ted's work since he met the artist in 1982, and Gordon has graciously shared several difficult-to-find texts that shed light on the cultural context for the emergence of Ted's mature style(s) and on the importance and impact of his work.

The contributors to the *festschrift*, "Theodore Waddell: A Tribute," in this volume deserve great thanks for the exceptional light they shine on the many facets of Ted and his life of work. They are the Honorable Pat Williams, Robyn Peterson, Bob Durden, Gordon McConnell, Mark Browning, Donna Forbes, Greg Keeler, Patrick Zentz, Scott McMillion, William "Gatz" Hjortsberg, Paul Zarzyski, and Brian Petersen.

Special thanks, too, to Tracy Linder, who graciously contributed her thoughts on Theodore Waddell's influence and impact on younger artists.

The following professionals have been wonderfully helpful in providing information, images, and permissions: Yvonne Seng, former chief curator, and Renee Erb, assistant curator and collection manager, Holter Museum of Art, Helena, Montana; Bill Farr, senior fellow, O'Connor Center for the Rocky Mountain West, Missoula, Montana; Robyn Peterson, executive director, and Bob Durden, chief curator, Yellowstone Art Museum, Billings, Montana; Brandon Reintjes, chief curator, and Ted Hughes, former registrar, Missoula Art Museum, Missoula; Brandon Reintjes and Jeremy Canwell, former and current curators of art, Montana Museum of Art & Culture, University of Montana, Missoula; Kristi Scott, curator of art, and Aaron Kueffler, operations director, Paris Gibson Square Museum of Art, Great Falls, Montana; Leanne Gilbertson, gallery director, Northcutt Steele Gallery, and Patrick Williams, University Relations and Communications, Montana State University–Billings; Lory Morrow, manager, and Becca Kohl, former archivist, Montana Historical Society Photograph Archives, Helena; Jennifer Bottomly-O'looney, senior curator, and Kendra Newhall,

registrar, Montana Historical Society Museum; Lorrie Vennes, Montana Stockgrowers Association; Emily Lawhead, museum staff, Northern Arizona University Art Museum, Flagstaff; Alison Seeberger, assistant registrar, Rights and Permissions, Denver Art Museum; and Carroll Van West, creator of the exemplary blog, *Re-visiting Montana's Historic Landscape: 30 Years in the Big Sky Country*; https://montanahistoriclandscape.com/.

I am grateful, too, to friends who helped sustain me during this project: the sculptor and painter Joseph Baráz, who shared his rich library of monographs on European neo-expressionists; Melissa Kwasny, poet, editor, and essayist, who cheered me on as she finished her own three-year book project; bookseller and polymath Bill Borneman, who kept me supplied with reading material; and Maxwell Milton and Matt Pavelich, who always offer great conversation and hard-won wisdom.

Other friends offered sanctuary while I worked on this project, and I thank them for their hospitality: Joe Freeman Gans, Telegraph Hill, San Francisco; Marc Brenman, the Mission, San Francisco; and Steve and Kathleen Straley, at the foot of the Mission Mountains, St. Ignatius, Montana.

I am ever grateful to the board members of Drumlummon Institute for their ongoing support and counsel: Aaron Parrett, Dennis Taylor, Krys Holmes, Randy LeCocq, and Melissa Kwasny.

A special thanks to Jeff Wincapaw of Tintype Design, who worked his always award-worthy magic to create this beautiful book, and to Jon Lodge of Artcraft Printers, who is a true master of his trade. And thank you to Dana Marie Henricks, copyeditor, and Beth Judy, proofreader, both of whom did exceptional work on the manuscript.

And finally, I thank my beloved wife, Liz Gans, who revealed even greater depths of patience than usual and proved—as always—my steadfast partner and best critic while I worked to complete this book.

Author's Bibliography

(See **Publications By and About Theodore Waddell,** page 269, for all published materials related to Theodore Waddell)

BOOKS AND ARTICLES

Alcosser, Sandra. "Glyphs." In *Paintings, Prose, Poems and Prints: Missouri River Interpretations*, ed. Barbara Racker. Great Falls, MT: Paris Gibson Square Art Museum, 1993.

Alloway, Lawrence. "Systemic Painting." In Gregory Battcock, *Minimalism: A Critical Anthology*. Berkeley: University of California Press, 1995.

An Ornery Bunch: Tales and Anecdotes Collected by the W.P.A. Montana Writers' Project, eds. Megan Hiller, Alexandra Swaney, Elaine Peterson, and Rick Newby. Helena, MT: TwoDot Books, 1999.

Berry, Wendell. *A Continuous Harmony: Essays Cultural and Agricultural*. Berkeley: Counterpoint, 2012.

Blew, Mary Clearman. *Bone Deep in Landscape: Writing, Reading, and Place*. Norman: University of Oklahoma Press, 1999.

Bramlett, Jim. *Ride for the High Points: The Real Story of Will James*. Missoula, MT: Mountain Press Publishing, 1987.

Brown, Milton W. *The Story of the Armory Show*. Washington, DC: The Joseph H. Hirshhorn Foundation, 1963.

Burns, Sarah. *Inventing the Modern Artist: Art and Culture in Gilded Age America*. New Haven, CT: Yale University Press, 1996.

Casey, Edward S. *Representing Place: Landscape Painting & Maps*. Minneapolis: University of Minnesota Press, 2002.

Cheney, Truman McGiffin with Roberta Carkeek Cheney. *So Long, Cowboys of the Open Range*. Helena, MT: Falcon Publishing, 1990.

Codell, Julie F. "Scene/Seen Out the Window: The Works of Gennie DeWeese." In *Gennie DeWeese: Retrospective*. Missoula, MT: Missoula Art Museum, 1996.

Conn, Cyndi. "Nerve Endings: Betty Parsons, Marcia Tucker, and Alanna Heiss." Master's thesis, Skidmore College, 2010. Http://creativematter.skidmore.edu/cgi/viewcontent. cgi?article=1078&context=mals_stu_schol.

Cook, Julia A., and Jane D. Fudge, *Contemporary Sculpture in Montana*. Miles City, MT: Custer County Art Center, 1983.

Cox, Kenyon. "Two Ways of Painting." *Bulletin of the Metropolitan Museum of Art* 7, no. 11 (November 1912).

Cristy, Raphael James. *Charles M. Russell: The Storyteller's Art*. Albuquerque, NM: University of New Mexico Press, 2004.

Dana, Fra. Unpublished journal, September 28, 1911. Transcribed by Mildred Walker and quoted in Valerie Hedquist, "Travels with Fra: From Pass Creek to Paris." In Hart and Hedquist, *Fra Dana: American Impressionist in the Rockies*.

———. Unpublished journal, undated. Transcribed by Mildred Walker and quoted in Ripley Hugo, *Writing for Her Life: The Novelist Mildred Walker*, 106. Lincoln: University of Nebraska Press, 2003.

Dorn, Edward. "Idaho Out." In *The Collected Poems, 1956–1974*. Bolinas, CA: Four Seasons Foundation, 1975.

———. "The Testicle Festival in Ryegate, Montana." In Dorn, *Way West: Stories, Essays & Verse Accounts: 1963–1993*. Santa Rosa, CA: Black Sparrow Press, 1993.

Doss, Erika. "'I *Must* Paint': Women Artists of the Rocky Mountain Region." In *Independent Spirits: Women Painters of the American West, 1890–1945*, ed. Patricia Trenton. Berkeley: University of California Press, 1995.

Durden, Bob. *Jim Poor: Confluences*. Great Falls, MT: Paris Gibson Square Museum of Art, 2009.

Dusard, Jay. Introduction to Ian Tyson, *Ian Tyson* LP. Calgary, AB: Columbia Records, 1984.

"Edward Dorn, 70, Writer on the American West." *New York Times,* December 21, 1999. Http://www.nytimes. com/1999/12/21/arts/edward-dorn-70-writer-on-the-american-west.html.

Farr, William E. *Julius Seyler and the Blackfeet: An Impressionist at Glacier National Park*. Charles M. Russell Center Series on Art and Photography of the American West, Book 7. Tulsa: University of Oklahoma Press, 2009.

———. "Julius Seyler: Painting the Blackfeet, Painting Glacier Park, 1913–1914." *Montana The Magazine of Western History* 51, no. 2 (Summer 2001), 61.

Flores, Dan. *Visions of the Big Sky: Painting and Photographing the Northern Rocky Mountain West.* Norman: University of Oklahoma Press, 2010.

Foster, Hal. *The Return of the Real: The Avant-Garde at the End of the Century.* Cambridge: MIT Press, 1996.

Guide to the Records of the Brooklyn Museum Art School, 1941–1985. Brooklyn, NY: Brooklyn Museum, n.d., 10. Https://d1lfxha3ugu3d4.cloudfront.net/archives/BMAS_final.pdf.

Hagerty, Donald J. "Maynard Dixon and a Changing West, 1917–1935." *Montana The Magazine of Western History* 51, no. 2 (Summer 2001).

Hart, Sue, and Valerie Hedquist. *Fra Dana: American Impressionist in the Rockies.* Missoula: Montana Museum of Arts & Culture, 2011.

Hibbard, Scott. "A Matter of Blood." *Montana Spaces: Essays and Photographs in Celebration of Montana,* ed. William Kittredge. New York: Nick Lyons Books, 1988.

Huidekoper, Wallis. "The Story Behind Charlie Russell's Masterpiece *Waiting for a Chinook.*" In *Charlie Russell Roundup: Essays on America's Favorite Cowboy Artist,* ed. Brian W. Dippie, 99–102. Helena, MT: Montana Historical Society Press, 1999.

Johnson, Isabelle. "Folks Called Johnson." In Jim Annin, *They Gazed on the Beartooths,* vol. 1, 272. Billings, MT: J. Annin, 1964.

———. "For What Is the Amateur Painter Working?" *The Arts in Montana,* ed. Merriam.

———. "That Wonderful World of Color." *The Arts in Montana,* ed. Merriam.

Judd, Donald. "Specific Objects." In Judd, *Complete Writings 1959–1975: Gallery Reviews, Book Reviews, Articles, Letters to the Editor, Reports, Statements, Complaints.* Halifax, Nova Scotia / New York: The Press of Nova Scotia College of Art and Design / New York University Press, 1975.

Jullien, François. *The Great Image Has No Form, or On the Non-object through Painting,* tr. Jane Marie Todd. Chicago: University of Chicago Press, 2009.

Kashey, Robert. *Winold Reiss, 1886–1953: Works on Paper: Architectural Designs, Fantasies and Portraits.* New York: Shepherd Gallery, 1986.

Kingsley, April. *Emotional Impact: New York School Figurative Expressionism.* San Francisco: Art Museum Association of America, ca. 1984.

Kittredge, William, ed. *Montana Spaces: Essays and Photographs in Celebration of Montana.* New York: Nick Lyons Books, 1988.

——— and Annick Smith, eds. *The Last Best Place: A Montana Anthology.* Helena: Montana Historical Society Press, 1988.

Koch, [Hans] Peter. "Historical Sketch: Bozeman, Gallatin Valley and Bozeman Pass." In *Contributions to the Montana Historical Society,* vol. 2, 126–127. Helena, MT: Rocky Mountain Publishing Co., 1896.

Kristy, Thomas Dacosta. *Toward a Geography of Art.* Chicago: The University of Chicago Press, 2004.

Leach, Mark, and Lawrence Campbell. *Robert De Niro: Expression as Tradition—Modern Classicism Redefined.* Great Falls, MT: Paris Gibson Square Center for Contemporary Arts, 1986.

Linderman, Frank Bird. *Recollections of Charley Russell,* ed. H. G. Merriam. Norman: University of Oklahoma Press, 1963.

Lippard, Lucy R. *The Lure of the Local: Senses of Place in a Multicentered Society.* New York: The New Press, 1997.

Malone, Michael P., Richard B. Roeder, and William L. Lang. "Stockmen and the Open Range." In *Montana: A History of Two Centuries.* Seattle: University of Washington, 1997.

Mancini, J. M. *Pre-Modernism: Art-World Change and American Culture from the Civil War to the Armory Show.* Princeton, NJ: Princeton University Press, 2005.

Martin, Sister Kathryn A., James G. Todd, Ted Waddell, and Matthew Kangas. *Autio: A Retrospective.* Missoula, MT: University of Montana, School of Fine Arts, 1983.

Maximilian, Prince of Wied's Travels in the Interior of North America, vol. 1, trans. Hannibal Lloyd. Carlisle, MA: Applewood Books, 2007.

McConnell, Gordon, and Donna Forbes. *Dennis Voss: The Mechanic of Isolation/Patrick Zentz: Instruments for Day—Exhibition and Performances, 1985.* Billings, MT: Yellowstone Art Center, 1986.

———. *Gennie DeWeese/Bill Stockton: The Rural Avant Garde.* Clearmont, WY: Ucross Foundation Art Gallery, 2002.

———, and Elizabeth Guheen. *Making Connections: Works from the Permanent Collection of the Yellowstone Art Museum—Modern and Contemporary Art on the High Plains, 1945–Present.* Billings, MT: Yellowstone Art Museum, 2005.

———. *New Montana Painting: Anne Appleby, Jerry Iverson, Sara Mast, Sandra Dal Poggetto, Harold Schlotzhauer, Phoebe Toland.* Casper, WY/Clearmont, WY: Nicolaysen Art Museum/Ucross Foundation, 2001.

———, Donna Forbes, and Mark Stevens. *Yellowstone Art Museum: The Montana Collection.* Billings, MT: Yellowstone Art Museum, 1998.

McFarland, Ron. "Literature." In *The Rocky Mountain Region,* Greenwood Encyclopedia of American Regional Cultures, ed. Rick Newby. Westport, CT: Greenwood Press, 2004.

Melton, Terry, et al. *Montana Sketchbook.* Billings: Montana Institute of the Arts, 1989.

———. *Paintings by Isabelle Johnson.* Fort Worth, TX: Amon Carter Museum of Western Art, 1971.

Merriam, H. G., editor. *The Arts in Montana*. Missoula, MT: Mountain Press, 1977.

———. "Endlessly the Covered Wagon." The Frontier, November 1928. "Aggressive Regionalism: Texts: 4. The Frontier," University of Washington, Center for the Study of the Pacific Northwest website. Https://www.washington.edu/uwired/outreach/cspn/Website/Classroom%20Materials/Reading%20the%20Region/Aggressive%20Regionalism/Texts/4.html.

Miller, Jim Wayne. "Anytime the Ground Is Uneven: The Outlook for Regional Studies and What to Look Out For." In *Geography and Literature: A Meeting of the Disciplines,* ed. William E. Mallory and Paul Simpson-Housley. Syracuse, NY: Syracuse University Press, 1987.

Minckler, Thomas. *In Poetic Silence: The Floral Paintings of Joseph Henry Sharp*, ed. Rick Newby. Tucson, AZ: Settlers West Galleries, 2010.

Motherwell, Robert. Quoted in Grace Glueck, "The Creative Mind: The Mastery of Robert Motherwell." *New York Times,* December 2, 1984. Http://www.nytimes.com/1984/12/02/magazine/the-creative-mind-the-mastery-of-robert-motherwell.html?pagewanted=all.

Myers, Winslow. *The Recreated Image: Walter Tandy Murch at Sixty.* New York: The Artist Book Foundation, 2016, forthcoming.

Nadler, Helen Sturges. "Harry Nadler: Biography: Description Without Place." Harry Nadler website. Http://www.harrynadler.com/biography.html.

Neff, Emily Ballew, and Barry Lopez. *The Modern West: American Landscapes, 1890–1950.* New Haven, CT/Houston, TX: Yale University Press in association with The Museum of Fine Arts, Houston, 2006.

Newby, Rick. "The Archie Bray Foundation for the Ceramic Arts: Origin and Impact." In Rick Newby, Hipólito Rafael Chacón, and Stephen Glueckert, *Persistence in Clay: Contemporary Ceramics in Montana.* Missoula, MT: Missoula Art Museum, 2011.

———. "Artists Who Also Teach: Frances Senska, Gennie DeWeese, and Jim Poor, Part II." *State of the Arts,* Montana Arts Council, 22–23. January/February 2000.

——— and Chere Jiusto. "'A Beautiful Spirit': Origins of the Archie Bray Foundation for the Ceramic Arts." In Rick Newby and Chere Jiusto, Janet Koplos, Patricia Failing, and Peter Held, *A Ceramic Continuum: Fifty Years of the Archie Bray Influence.* Helena, MT/Seattle, WA: Holter Museum of Art/University of Washington Press, 2001.

———. "Gritty and Un-Housebroken: Origins, Reception, and Dispersion of Funk Ceramics." In Peter Held, John Natsoulas, and Rick Newby, *Humor, Irony, and Wit: Ceramic Funk from the Sixties and Beyond.* Tempe, AZ: Arizona State University Art Museum, Ceramics Research Center, 2004.

———. "Missionaries for Modernism: George and Elinor Poindexter and Montana's Poindexter Collections of Postwar American Painting." In Rick Newby and Andrea Pappas, *The Most Difficult Journey: The Poindexter Collections of American Modernist Painting,* ed. Ben Mitchell. Billings, MT: Yellowstone Art Museum, 2002.

———. "The Past As It Was: Gordon McConnell's *West of Everything: New & Selected Paintings.*" In Marci Rae McDade and Rick Newby, *West of True: Jane Waggoner Deschner & Gordon McConnell.* Fallon, NV: Churchill Arts Council, 2014.

———. "Rudy Autio: Coming Home to the Figure." In Liz Gans, Marcia Eidel, and Rick Newby, *Rudy Autio: The Infinite Figure.* Helena, MT: Holter Museum of Art, 2006.

———. "The Montana-Paris Axis, or Unpacking My Grandfather's Library: On the Track of a Bookish Tradition." In *Writing Montana: Literature under the Big Sky,* ed. Rick Newby and Suzanne Hunger. Helena, MT: Montana Center for the Book, 1996.

Nottage, James H. "Art Inclusive: Evolving Collections of the Eiteljorg Museum." In *Frontiers and Beyond: Visions and Collections from the Eiteljorg Museum of American Indians and Western Art,* 27. Indianapolis, IN: Eiteljorg Museum of American Indians and Western Art, 2005.

O'Neill, Máire. "Corporeal Experience: A Haptic Way of Knowing." *Journal of Architectural Education,* September 2001, 3–12.

Pappas, Andrea. "Tradition and Innovation at the Poindexter Gallery." *The Most Difficult Journey: The Poindexter Collections of American Modernist Painting,* ed. Ben Mitchell. Billings, MT: Yellowstone Art Museum, 2002.

Parsons, Betty. Quoted in John Russell, "Betty Parsons." *Reading Russell: Essays 1941–1988 on Ideas, Literature, Art, Theater, Music, Places, and Persons.* New York: Harry N. Abrams, Inc., 1989.

Parsons, Neil, Cathryn Mallory, and Vicki Everson. *Spirit of Modernism: An Exhibition of Thirteen Montana Artists.* Great Falls, MT: Paris Gibson Square Center for Contemporary Arts, 1987.

Peterson, Robyn G., Bob Durden, Patricia Vettel-Becker, Donna Forbes, Theodore Waddell, and Peter Halstead. *"A Lonely Business": Isabelle Johnson's Montana.* Billings: Yellowstone Art Museum, 2015.

Poindexter, Everton Gentry, and Frank O'Hara. *The Poindexter Collection of Contemporary American Art.* Helena, MT/Billings, MT: Montana Historical Society/Yellowstone Art Center, ca. 1965.

Poindexter Collection/Poindexter Legacy, ed. Yvonne Seng. Helena, MT: Holter Museum of Art, 2012. Http://www.holtermuseum.org/janda/files/home/1357147098_MT%20AB%20EX_Booklet.pdf

"Reading the Region: Aggressive Regionalism." University of Washington, Center for the Study of the Pacific Northwest website. Http://www.washington.edu/uwired/outreach/cspn/Website/Classroom%20Materials/Reading%20the%20Region/

Aggressive%20Regionalism/Aggressive%20Regionalism%20 Main.html.

Robbins, Daniel. *Walter Murch: A Retrospective Exhibition.* Providence: Museum of Art, Rhode Island School of Design, 1966. Http://www.paintingperceptions.com/wp-content/ uploads/2011/07/Walter_Murch.pdf.

Robertson, Campbell. "Ibram Lassaw, 90, a Sculptor Devoted to Abstract Forms." *New York Times*, January 2, 2004. Http:// www.nytimes.com/2004/01/02/arts/ibram-lassaw-90-a-sculp-tor-devoted-to-abstract-forms.html?_r=0.

Rostad, Lee. "From an Alien Land: An Introduction." In *Food of Gods and Starvelings: The Selected Poems of Grace Stone Coates,* eds. Lee Rostad and Rick Newby. Helena, MT: Drumlummon Institute, 2007.

Rubey, Dan. "Critic Leads the Way to Art World." *Missoulian,* May 6, 1983, A-5.

Russell, Bruce Hugh. "John Singer Sargent in the Canadian Rockies: 1916." *The Beaver: Canada's History Magazine* 77, no. 6. December 1997/January 1998.

Russell, Charles M. *Trails Plowed Under.* New York: Doubleday, Doran & Company, 1931.

Sanders, Helen Fitzgerald. "Thomas J. Waddell." In Sanders, *A History of Montana*, vol. 2, 1083. Chicago and New York: The Lewis Publishing Company, 1913.

Sargent, John Singer. Letter to Evan Charteris, July 25, 1916. Quoted in Bruce Hugh Russell, "John Singer Sargent in the Canadian Rockies: 1916." *The Beaver: Canada's History Magazine* 77, no. 6, 4. December 1997/January 1998.

Selz, Peter. *German Expressionist Painting.* Berkeley: University of California Press, 1974.

———. *Max Beckmann.* New York: Museum of Modern Art, 1964.

———. "Notes on Funk." In Peter Selz, *Funk.* Berkeley: University Art Museum, University of California, Berkeley, 1967. Reprinted in Peter Selz, *Art in a Turbulent Era*, 325–330. Ann Arbor, MI: UMI Research Press, 1985.

Smith, Thomas Brent. *Elevating Western American Art: Developing an Institute in the Cultural Capital of the Rockies.* Denver, CO: Denver Art Museum, 2012.

Steffenson, Erik. "Per Kirkeby: The 1960s." In Siegfried Gohr, editor, *Per Kirkeby and the "Forbidden Paintings" of Kurt Schwitters: Retrospective.* Brussels, Belgium: Bozar Books, 2012.

Stevens, Mark. "Art Under the Big Sky." *Newsweek*, October 31, 1983, 98–99.

Stevens, Wallace. "Description without Place." In Stevens, *The Palm at the End of the Mind: Selected Poems and a Play,* ed. Holly Stevens, 270–277. New York: Alfred A. Knopf, Inc., 1971.

Stories from An Open Country: Essays on the Yellowstone River Valley, ed. William L. Lang. Billings, MT: Western Heritage Press, 1995.

Strong, David. *Crazy Mountains: Learning from Wilderness to Weigh Technology.* Albany: State University Press of New York, 1995.

Taliaferro, John. *Charles M. Russell: The Life and Legend of America's Cowboy Artist.* Norman, OK: University of Oklahoma Press, 2003.

"Thomas J. Waddell." In *Progressive Men of the State of Montana, Illustrated*, vol. 2, 1290. Chicago: A. W. Bowen & Co., Engravers and Publishers, 1902.

"Thomas J. Waddell in State 56 Years." *Independent Record*, Helena, MT. October 18, 1943.

"T. J. Waddell, Pioneer Justice of Peace, Came to Montana in 1878." *Three Forks* [MT] *News*. July 2, 1931.

Todd, Jim. "The Crisis of Modernism in 'The Last Best Place.'" *The Montana Professor* 5:1 (Winter 1995). Http://mtprof. msun.edu/Win1995/todd.html

Tuan, Yi-Fu. *Space and Place: The Perspective of Experience.* Minneapolis: University of Minnesota Press, 1977.

Vettel-Becker, Patricia. "Isabelle Johnson and the Visual Poetics of Home." In Peterson et al, *"A Lonely Business."*

Waddell, Thomas [Jefferson]. "Thawing Out." In *An Ornery Bunch*, vii.

———. "Looking Back." *Judith Basin Star*, 5. August 31, 1941.

Wallis, Brian, editor. *Art After Modernism: Rethinking Representation.* New York/Boston: The New Museum of Contemporary Art/David R. Godine, Publisher, Inc., 1984.

Weltzien, O. Alan. "The Literary Northern Rockies as The Last Best Place." In *A Companion to the Literature and Culture of the American West,* ed. Nicolas S. Witschi. Oxford: Wiley-Blackwell, 2011.

Whitney, Kathleen. "Little Changes." In Paula Owen, Patrick Schuchard, Kathleen Whitney, and Dave Hickey, *Ken Little: Little Changes—A Survey Exhibition and New Works.* San Antonio, TX: Southwest School of Art & Craft, 2003.

UNPUBLISHED/ARCHIVAL MATERIALS

Autio, Rudy. Interview by Rick Newby, Missoula, MT, April 7, 2006. In author's possession.

Linder, Tracy. Email to Rick Newby. October 25, 2014. In author's possession.

Newby, Rick. "Missionaries for Modernism: Enigmas, Outtakes, and Extrapolations." Exhibition opening remarks, *The Most Difficult Journey: The Poindexter Collections of American Modernist Painting.* Yellowstone Art Museum, Billings, MT. March 2002.

———. "A Regionalism that Travels: Thoughts on Montana Literature." Lecture originally presented to Regionalism class taught by Pat Williams and William Farr. O'Connor Center for the Rocky Mountain West, University of Montana, Missoula, MT. Spring 2003.

O'Neill, Máire. "Learning Rural Perceptions of Place: Farms and Ranches in Southwest Montana." PhD diss., Montana State University, 1997.

Poor, Jim. "Thoughts about Art & Healing." Presented at St. Patrick's Hospital, Missoula, MT, May 12, 2003.

Senska, Frances. Interview by Chere Jiusto and Rick Newby. Bozeman, MT. June 9, 1998. Archie Bray Foundation for the Ceramic Arts Archives, Helena, MT.

Waddell, Theodore. "Cheatgrass Dreams." Unpublished manuscript, Version 2. Edited January 8, 2009. In artist's possession.

———. Interview by Rick Newby. Hailey, Idaho. March 14, 2013. In author's possession.

———. Letter to "Dear Mom, Dad and Jacque," September 12, 1962. In artist's possession.

———. Letter to "Dear Family." September 24, 1962. In artist's possession.

———. Letter to "Dear Mom & Dad & Jacque." October 2, 1962. In artist's possession.

———. Letter to "Dear Peoples." October 20, 1962. In artist's possession.

———. Letter to "Dear Dad." November 10, 1962. In artist's possession.

———. Letter to "Dear Family." December 10, 1962. In artist's possession.

———. Letter to "Dear Mooma, Dadio, & Boy chaser." April 18, 1963. In artist's possession.

———. Letter to "Dear Family." May 20, 1963. In artist's possession.

———. Letter to "Dear Family." June 3, 1963. In artist's possession.

———. Letter to "Dear Family." July 16, 1963. In artist's possession.

———. Letter to "Dear Family." September 2, 1963. In artist's possession.

———. Letter to "Dear Dad." June 30, 1964. In artist's possession.

———. Letter to "Dear Family." July 13, 1964. In artist's possession.

———. Letter to "Dear favorite Mooma and family." Undated. In artist's possession.

———. "New York Notes, etc." Unpublished reminiscence. In artist's possession.

———. Oral history (self-interview). Unpublished transcript. Fall 2014/Winter 2015. In artist's possession.

———. Unpublished journal. 1962–1994. In artist's possession.

Waddell, T[homas]. J[efferson]. Writings. Greenfield Family Papers, 1807–1975. Manuscript Collection 166, Box 6, Folder 12. Montana Historical Society Research Center, Archives. Helena, MT.

Publications By and About Theodore Waddell

BOOKS, CATALOGS, & VIDEOS

2015

Peterson, Robyn G., Bob Durden, Patricia Vettel-Becker, Donna Forbes, Theodore Waddell, and Peter Halstead. *"A Lonely Business": Isabelle Johnson's Montana.* Billings, MT: Yellowstone Art Museum, 2015.

Poulton, Donna, and James Poulton. *Painters of Grand Teton National Park.* Layton, UT: Gibbs Smith, 2015.

2014

Peterson, Robyn G., Bob Durden, Terry Melton, Shanna Shelby, Bob Roughton, Theodore Waddell, Billy Bliss, and Brian Petersen. *Theodore Waddell: Hallowed Absurdities, Mixed Media Sculpture.* Billings, MT: Yellowstone Art Museum, 2014.

2012

Seng, Yvonne, ed. *Poindexter Collection/Poindexter Legacy.* Helena, MT: Holter Museum of Art, 2012.

Sobel, Dean. "Whose Cattle Are These? *Motherwell's Angus* by Theodore Waddell." In *Elevating Western American Art: Developing an Institute in the Cultural Capital of the Rockies,* edited by Thomas Brent Smith, 170–173. Denver, CO: Denver Art Museum; Petrie Institute of Western American Art, 2012.

Taylor-Gore, Victoria. *Conversations with Theodore Waddell.* Parts 1–4. Video interview, in conjunction with the exhibition *Theodore Waddell: For Love of the Horse,* at the Amarillo [Texas] Museum of Art, 2012, https://vimeo.com/43203514.

2011

Lear, Kathy, Bob Durden, and Theodore Waddell. *Theodore Waddell: The Weight of Memory, Selections from the Permanent Collection.* Great Falls, MT: Paris Gibson Square Museum of Art, 2011.

McConnell, Gordon, and Theodore Waddell. *Theodore Waddell: Five Decades, Selected Paintings and Works on Paper.* Fallon, NV: Oats Park Art Center, Churchill Arts Council, 2011.

2009

Navas-Nieves, Tariana. "Theodore Waddell." In Navas-Nieves, *Personal Paradise: Contemporary Perspectives on Landscape Painting: Eric Perez, Kay Walkingstick, Theodore Waddell, Julia Fernandez-Pol,* 29–34; 63–68; 87. Colorado Springs, CO: Colorado Springs Fine Arts Center, 2009.

Oldham, Terry, Theodore Waddell, Terry Melton, Shanna Shelby, and Kirk Robertson. *Angus Anthem: Theodore Waddell.* St. Joseph, MO: Albrecht-Kemper Museum of Art, 2009.

2006

Robertson, Kirk. *Theodore Waddell.* Ketchum, ID: Gail Severn Gallery, 2006.

2005

McConnell, Gordon, and Elizabeth Guheen. *Making Connections: Modern and Contemporary Art on the High Plains, 1945–Present: Works from the Permanent Collection of the Yellowstone Art Museum,* 18, 44–45. Billings, MT: Yellowstone Art Museum, 2005.

2003

New Art of the West 8. The Eighth Eiteljorg Museum Biennial Exhibition. Indianapolis, IN: Eiteljorg Museum of American Indian and Western Art, 2003.

2001

Mitchell, Ben, Peter H. Hassrick, Terry Melton, and Kirk Robertson. *Theodore Waddell: Into the Horizon, Paintings and Sculpture, 1960–2000.* Billings, MT: Yellowstone Art Museum, in association with the University of Washington Press, Seattle and London, 2001.

1998

McConnell, Gordon, Donna Forbes, and Mark Stevens. *Yellowstone Art Museum: The Montana Collection,* 47–50. Billings, MT: Yellowstone Art Museum, 1998.

1995

Davis, Bruce. *Made in L.A.: The Prints of Cirrus Editions*. Los Angeles: Museum Associates, Los Angeles County Museum of Art, 1995.

Denholm, Jeannie, and Maggi Owens. *Confronting Nature: Silenced Voices*. Fullerton: California State University, Fullerton/Orange, CA: Chapman University, 1995.

Zevitas, Steven, ed. *New American Paintings: The Open Studios Competitions, A Quarterly Exhibition: Number III*. Needham, MA: The Open Studios Press, 1995.

1994

Hayes, Johanna, curator. *Theodore Waddell: Painting & Sculpture*. Video. Helena, MT: Holter Museum of Art, 1994.

Steinbaum, Bernice, Judith Rovenger, and Roslyn Bernstein. *Memories of Childhood . . . so we're not the Cleavers or the Brady Bunch*. New York: Steinbaum Krauss Gallery, 1994.

1993

Racker, Barbara, ed. *Paintings, Prose, Poems and Prints: Missouri River Interpretations*. Great Falls, MT: Paris Gibson Square Art Museum, 1993.

1992

Art and the Law. Eagan, MN: West Publishing Company, 1992.

Leslie, Mike, Jennifer Complo, David G. Turner, and Theodore Waddell. *Theodore Waddell: Seasons of Change*. Indianapolis, IN: Eiteljorg Museum of American Indian and Western Art, 1992.

New Editions. Albuquerque, NM: Tamarind Institute, 1992.

Steinbaum, Bernice. *Theodore Waddell: Western Mythology Paintings*. Video interview. New York: Bernice Steinbaum Gallery, 1992.

1991

Ehrlich, Gretel. *Islands, the Universe, Home*. Cover painting. New York: Viking, 1991.

Mystical Reflections of the Big Sky. Bozeman, MT: Haynes Fine Arts Gallery, Montana State University, 1991.

New Art of the West: The Artist's Response to Nature. Eiteljorg Invitational 2. Indianapolis, IN: Eiteljorg Museum of American Indian and Western Art, 1991.

Theodore Waddell. Santa Fe, NM: Munson Gallery, 1991.

1990

Montana 3D. Kalispell, MT: Hockaday Art Center, 1990.

New Art of the West: The First Annual Invitational at the Eiteljorg Museum of American Indian and Western Art. Indianapolis, IN: Eiteljorg Museum of American Indian and Western Art, 1990.

Post-Westerns. Billings, MT: Yellowstone Art Center, 1990.

Rocky Mountain National Park, Seventy-Fifth Anniversary Exhibition. Boulder, CO: Boulder Art Center, 1990.

1989

Montana Sketchbook. Cover image. Billings, MT: Montana Institute of the Arts, 1989.

1988

Nelson, David, Julie Cook, Dianne Carroll, Jim Poor, and Patrick Zentz. *Artists in Schools/Communities: Retrospective Catalogue of Montana Arts Council Visual Artists in Schools/Communities Program, 1972–1988*. Helena: Montana Arts Council, 1988.

1987

Forbes, Donna, and Gordon McConnell. *A Montana Collection: 1985–1987, Recent Acquisitions by the Yellowstone Art Center*. Billings, MT: Yellowstone Art Center, 1987.

Montana Collects Montana. Billings, MT: Montana Art Gallery Directors Association, 1987.

1986

Forbes, Donna, Terry Melton, Bill Stockton, and Theodore Waddell. *Isabelle Johnson: A Retrospective*. Billings, MT: Yellowstone Art Center, 1986.

The New West. Colorado Springs, CO: The Colorado Springs Fine Arts Center, 1986.

1985

The Dedication of Art for the Justice Building and Montana State Library. Helena, MT, 1985.

1984

McConnell, Gordon, and Donna Forbes. *Theodore Waddell*. Billings, MT: Yellowstone Art Center, 1984.

1983

Cook, Julia A., and Jane D. Fudge. *Contemporary Sculpture in Montana*. Miles City, MT: Custer County Art Center, 1983.

List, Clair. *The 38th Corcoran Biennial Exhibition of American Painting, Second Western States Exhibition*. Washington, DC: The Corcoran Gallery of Art, 1983.

ESSAYS, ARTICLES & REVIEWS

2015

Wyoming Tribune Eagle. "Hallowed Absurdities." January 2015.

Missoulian. "MMAC 120: Waddell's Modernist Montana Vision." November 25, 2015.

Western Home Journal. "Western Modern Allure and Classic Abstraction at Gail Severn Gallery." Winter 2015.

2014
Big Sky Journal Arts 2014. "Expressionism of Theodore Waddell." July 2014. [On the cover, Theodore Waddell's *Rapelje Horses #3*]
Sun Valley Magazine. "The Art of Printmakers." Fall 2014.

2013
Billings Gazette. "Internationally known painter Theodore Waddell presenting work to Laurel High School." January 30, 2013.
Billings Gazette. "Hallowed Absurdities: Work by Theodore Waddell at the YAM." September 12, 2013.

2012
Weekly Sun. "Gallery Walk Features Waddell Solo Exhibit." February 15, 2012.
Billings Gazette. "YAM's biggest seller—Ted Waddell—to show works at Denver Art Museum." March 5, 2012.

2011
Western Art Collector. "Intimate Landscapes." January 2011, 96–97.
Great Falls Tribune. "This House of Sky." February 25, 2011, 1–2L.
Ocala Star-Banner. "'Out West' in East Ocala." April 7, 2011, 4.
Western Art Collector. "The Weight of Memory." May 2011, 142–143.
Jackson Hole News & Guide. "Landscapists Transfer Energy to Canvas." June 1, 2011, 9.
Billings Gazette. "New Federal Courthouse Will Display Yellowstone Art Museum Works." December 30, 2011.

2010
Denver Post. "Not Painted in a Corner." January 22, 2010.
Western Horseman. "Bailey & Friends." June 2010, 120–121.
Western Art & Architecture. "Artistic Evolution: A Daughter's Perspective." Spring–Summer 2010.

2007
Skagit Valley Herald. "Art on the Range." January 18, 2007.
Wood River Journal. "Ted to tell Tucker's tale at ten." April 25, 2007.
Montana Arts Council State of the Arts. "The China Connection." May/June 2007.
Curtis, Sam. "On Home Ground: Montana master Theodore Waddell embraces the contradictions of contemporary western art." *Montana Quarterly.* Fall 2007, 104.

2006
Wood River Journal. "Painting the Land." October 16, 2006.

2005
Billings Gazette. "Best Ever YAM auction raises funds." March 6, 2005.
The Billings Outpost. "Auction draws partygoers, serious bidders." March 10, 2005.
Artweek. "Theodore Waddell and Bill Bliss at Stremmel Gallery." September 2005.

2004
Laurel Outlook. "White House honors Waddell as embassy artist." June 2, 2004.
Wood River Journal. "Impressions of ranch life at the Gail Severn Gallery." October 6, 2004.

2003
Rapid City Journal. "Ennis Horses." January 12, 2003.
ARTnews. "Home Place." Spring 2003.

2002
Missoulian. Entertainer. "Into the Horizon." February 7, 2002.
Montanan, University of Montana–Missoula. "Into the Horizon." Spring 2002.
Southwest Art. "At Home in the West." April 2002.
The Arizona Republic. "'Cowboy Artist' isn't the Same as an Artist Who Cowboys." April 22, 2002.
Big Sky Publishing. "Botanica Hosts Work of Theodore Waddell." July 12, 2002.

2001
Loiseau, Marie-Christine. "Artist: Ted Waddell." *Sun Valley Magazine.* Summer/Fall 2001.
Lawrence, Anne. "See and B Scene—Theodore's Montana." *San Francisco Examiner.* December 4, 2001.

2000
Jones, Sherry. "Inspired by Their Land." *Missoulian.* Entertainer. May 5, 2000.

1999
Lively Times. "Old Paint New." January 1999.
Kydland, Suzanne. "YAM Art Auction." *Billings Gazette.* January 22, 1999.
Thorson, Alice. "Landscape and livestock." *Kansas City Star.* February 12, 1999.
Sundstrom, Nancy. "West meets North." *Traverse City Record-Eagle.* March 5, 1999.
Billings Gazette. "Museum hangs work of Waddell and mentor." April 30, 1999.
The Equine Image. "Two Parts of Heaven." June-July 1999.
The Contemporary Art Center of Virginia. "Horse Attitudes: Examining the Equine." July 1, 1999.

Jarrett, Dennis. "The Horses of Old Billy Hell." *Santa Fe Reporter*. August 17, 1999.

Macomber, Bill. "Quiet Heros of the West." *Art-Talk*. October 1999.

Wood River Journal. "Portraits." November 17, 1999.

1998

Pearson, Jean. "New Art of the West 6." *Eiteljorg Museum*. March 1998.

Woods, Rachel Malcolm. "The Visual Arts Journal of Kansas City." *Kansas City Forum*. June 30, 1998.

Reynolds, Judith. "A Banquet on the Mesa." *The Durango Herald*. August 27, 1998.

Votel, Missy. "Soho by way of Durango." *Cross Currents*. September 4, 1998.

Deenihan, Tara S. "Western Contemporary." *A&E*. October 1998.

Wilkinson, Jeanne C. "Beyond the West." Review, New York. Jeanne C. Wilkinson, October 1, 1998.

Minor, Kyle E. "Double your pleasure." *Good Living, Minuteman Newspapers*. October 22, 1998.

The Laramie Daily Boomerang. "Public reception set for new UW Art Museum exhibitions." November 1998.

Forbes, Donna M. "The Montana Collection." *Yellowstone Art Museum*. November 1998.

Bauer, Marilyn. "Perchance to dream." *Idaho Mountain Express*, Ketchum, Idaho. November 25, 1998.

1997

Duffey, Joan Good. "Animal Kingdom." *New Jersey Center for Visual Arts*. February 1997.

Updike, Robin. "Waddell's animal paintings: an immense, poetic dignity." *Seattle Times*. March 1995.

Landi, Ann. "Contemporary American Art from Five Towns," *Newsday*, Woodmere, New York. May 9, 1997.

Whiting, Russ. "White Horses." *Pasatiempo*. August 22, 1997.

Southwest Art. "The Abstracted Landscape." September 1997, 115.

Baker, Shannon. "To greener pastures." *Wood River Journal*. September 3, 1997.

Stewart, Marilyn. "The Essence of Place in the Work of Ted Waddell." *School Arts*. November 1997.

1996

Waddell, Theodore. "Horses." *Northern Lights*. July 21, 1996.

Meyers, Christene. "Life with Art is All in the Family." *Billings Gazette*. August 2, 1996.

Waddell, Ted. "Rodeo Time!" *Times-Clarion*. August 29, 1996.

Waddell, Theodore. "Chili Stop." *Times-Clarion*. October 3, 1996.

Harrison, Helen A. "Memories of Childhood." *New York Times*. December 8, 1996.

1995

New Art Center Campaign. Yellowstone Art Center, 1995.

San Diego Arts Monthly, San Diego, California. "Art in View: Soma Gallery." January 1995, vol. 9, no. l, 4.

San Diego Union, San Diego, California. "With a peaceful palette, Montana artist lights up Big Sky." Robert L. Pincus, February 16, 1995, 47.

The McAllen International Museum. Newsletter. "Theodore Waddell: A Landscape of Animals." March/April 1995, 1.

Fritz, Berry. "Theodore Waddell: A Landscape of Animals." *Valley Town Crier*, McAllen, Texas. March 8, 1995, sec. 1, 4.

San Antonio Express-News. "Rural roots inspire two generations." Dan R. Goddard, March 19, 1995, 2G.

El Mañana, Valle De Texas, Cd. Reynosa, Tamaulipas. "Un artista calidamente inmerso en la naturaleza." March 29, 1995, D10.

Fritz, Berry. "What's Up at M.I.M [McAllen International Museum]." *Valley Town Crier*, McAllen, Texas. March 29, 1995, sec. 1, 4.

Fritz, Berry. "What's Up at M.I.M." *Valley Town Crier*, McAllen, Texas. April 26, 1995, sec. 1, 4.

Billings Gazette. Enjoy. "Artists gather for 'river' reading." May 12, 1995, 10D.

Meyers, Christene. "Couples share journey." *Billings Gazette*. May 18, 1995, 3C.

Wood River Valley Tempo, Hailey, Idaho. May 24, 1995, B1, B6.

Art News/Summer 95. "Theodore Waddell/New Work, number eight." Susan Duval Gallery, Aspen Colorado. Summer 1995.

Boehme, Sarah E. "Kriendler Gallery Focuses on Contemporary Art." *Buffalo Bill Historical Center News*. Summer 1995, cover & 4–5.

Abbe, Mary. "Exhibit shows memories of real childhoods." *Star-Tribune*, Twin Cities, Minnesota. August 6, 1995, F4.

Articles from Stremmel Gallery. "'Montana,' and exhibition of recent works by Theodore Waddell." Vol. 1, Fall/Winter 1995.

Hackett, Regina. "The modern-day West makes its way onto a painter's canvas." *Seattle Post-Intelligencer*. What's Happening. September 22, 1995, 16.

New American Paintings. Winter 1995, no. 5, 102–103.

1994

Art Museum of South Texas. Newsletter. "Theodore Waddell." January/February 1994, 1.

Luminaria, Corpus Christi, Texas. "Rocky Mountain Seasons the Modernist Way." January 1994, vol. 1, no. 7, 11.

Myers, Richard. "Theodore Waddell: Paintings and Sculpture." *Helena Independent Record*, Helena, Montana. January 7, 1994. 10D–11D.

Smith, Chris. "Sun Valley Preview." *Art-Talk*. February 1994, 38.

Richardson, Bruce. "New twist to cowboy art at the Nicolaysen." *Casper Star-Tribune*. Wyoming Weekend. April 17, 1994.

Berna-Heath, Diane. "Best of the West: New West." *Southwest Art*. May 1994, 30–32.

Yellowstone Art Center. Newsletter. "In Context: Theodore Waddell." June/July/August 1994.

Billings Gazette. Enjoy. "Museum celebrates collection." June 17, 1994, 7D.

Thorson, Alice. "Small works shine at new Leedy show." *The Kansas City Star*. July 17, 1994, K7, K8.

The Wood River Journal, Idaho, "Anne Reed Gallery welcomes Montana artist Theodore Waddell," August 24, B2.

Thorson, Alice. "A sweeping stroke of the Heartland." *The Kansas City Star*. October 18, 1994.

BoZone, Bozeman, Montana. "Prints, Paintings, Sculptures." November 1994.

McCann, Lee. "Artist Spotlight: Theodore Waddell." *The Tributary Magazine*, Bozeman, Montana. November 1994, 4–5.

1993

Nancrede, Sally Falk. "Museums Plan Contemporary Exhibits." *The Indianapolis Star*, Indianapolis, IN. January 24, 1993, Arts & Entertainment, G1, G14.

Hoffman, Nan. "Montana figures in artist's work." *The Indianapolis News*. January 28, 1993, F8.

Villani, John. "Gallery acknowledges artists' achievements in new exhibit." *Santa Fe New Mexican*. January 29, 1993.

The Times Clarion, Harlowton, Montana. "Missouri River float trip source of new exhibition and seminar." February 4, 1993, 10.

Mannheimer, Steve. "Waddell's paintings present a primal home on the range." *The Indianapolis Star*, Indianapolis, Indiana. February 7, 1993, G6.

Great Falls Tribune, Great Falls, Montana. Montana Parade. "The Missouri as muse." February 12, 1993, D1.

Arts Indiana. "Seasons of Change." March 1993, 15.

Lehnert-Feldhaus, J. "Ryegate rancher's art featured at Eiteljorg Museum," *Laurel Outlook*, Laurel, Montana. March 3, 1993, 5.

The Times Clarion, Harlowton, Montana. "Ted Waddell has solo art exhibition in Indiana." March 4, 1993, 1.

McConnell, Gordon. "Ted Waddell: Country Flesh & Bones." *ArtSpace*. Summer 1993, 93.

Nevada Museum of Art. Newsletter. "Contemporary Seasons." August/September 1993, 3.

Bison Briefs. "Union Gallery Features Montana Artist/Rancher During Homecoming." North Dakota University Alumni Association, Fargo, North Dakota. August 1993, vol. 31, no. 1, 7.

Encore, Sierra Arts Foundation, Reno, Nevada. "Waddell at NMA." August 1993, vol. 18, no. 6, 4.

Encore, Sierra Arts Foundation, Reno, Nevada, "Small Works, Big Friends at Stremmel." August 1993, vol. 18, no. 6, 4–5.

Presser, Alfred. "Something entirely different." *Hello Belgrade, Inc.* August 1993, vol. 1, no. 5.

Macias, Sandra. "It's Waddell Week in Reno galleries." *Reno Gazette-Journal*. August 15, 1993, 4C.

Olstad, Krista. "Montana artist's painting exhibits open today at SU." *The Spectrum,* North Dakota State University, Fargo, North Dakota. September 24, 1993, vol. 109, no. 8, 10.

Hackett, Regina. *Seattle Post-Intelligencer*. Review. September 25, 1993.

Eiteljorg Museum of American Indian and Western Art. Newsletter. "Theodore Waddell's Seasons of Change." Winter 1993.

Jones, Dan. "A Critical Point of View: Theodore Waddell, 'Figurative Works,'" *The Art Forum*, Moorhead Minnesota. Vol. 2, no. 1. 1993.

Missouri River Interpretations. "Paintings, Prose, Poems & Prints." 1993, 45.

1992

Meyers, Christene C. "Auction unveils fine contemporary mix." *Billings Gazette*. January 24, 1992, D8.

Lynch, Jim. "Artists' medium still has a few bugs." *Spokesman Review* and *Spokane Chronicle*. February 19, 1992, A1, A3.

Missoulian. "Road kill art exhibit has Spokane museum a buzzing." February 20, 1992.

Great Falls Tribune. "Flies really liked road kill art show." February 21, 1992.

Glowen, Ron. "True Objects and Stories from Two Dot: Dennis Voss and Theodore Waddell." *Artweek*. February 27, 1992, 22.

Webster, Dan. "The Road-kill Show." *Spokesman Review* and *Spokane Chronicle*. February 28, 1992, D1, D6.

Berger, David. "From surreal to the pleasurist, works beg for viewer response." *Seattle Times*. March 1992.

Peterson, William. "New Mexico: Growing Internationalism." *ARTnews*. April 1992, vol. 91, no. 4.

De Vuono, Frances. "Rancher Art." *Reflex*, Seattle, Washington. May/June 1992, vol. 6, no. 3, 22–23.

McCoy, Mary. "'Cattle Crossing' at Montana." *The Washington Post*. May 30, 1992, B2.

Smith, Marjorie. "Putting Art in its Place." *Yokoi, Issue #5.* Summer 1992, 39–43.

Mantooth, Carrie. "Seeing art in death." *Great Falls Tribune*, Montana Parade. July 5, 1992, E1.

Thorson, Alice. "Animal Imagery." *The Kansas City Star*. July 12, 1992, J8.

Great Falls Tribune. "Missouri River source of art project now, exhibition later." August 6, 1992.

Johnson, Eric. "Time and the river that runs through it." *Missoula Independent*. August 21, 1992, 19.

Billings Gazette. Enjoy. "Waddell and Waddell in Miles City." October 9, 1992.

Von Ziegesar, Peter. "Art Reviews: Theodore Waddell." *The Kansas City Star*. November 8, 1992, K4.

Wiegers, Alex. "Montana's beauty in abstract painting." *The Vail Trail's Daily Options*, Vail, Colorado. December 18, 1992.

1991

Reno Gazette Express. "On the Wall." March 24, 1991.

Cuba, Stanley. "A Park for all Seasons." *Southwest Art*. April 1991, 68–74.

Waddell, Betty, and Theodore Waddell. "Acquiring Knowledge: Similarities in Art and Science." *Yokoi*. Summer l991.

Bradley, Jeff. "Montana themes prevail in Boulder exhibit." *Denver Post*. June 10, 1991, 1E–2E.

Heath, Jennifer. "Yellowstone show displays diversity of Western art." *Daily Camera*, Boulder, Colorado, June 14, 1991, 20D–21D.

Alan, David. "Western art celebrated in 2 fine shows." *Colorado Daily*, Boulder, Colorado. 1991.

Times Clarion, Harlowton, Montana. "Ted Waddell displays art at Absarokee exhibition." June 20, 1991.

Moses, Lucile. "Two friends exhibit." *Billings Gazette*. Enjoy. June 28, 1991, 12.

Allison, Lesli. "Horsing Around." *Santa Fe New Mexican*. Pasatiempo. August 9, 1991, 4–5.

Artner, Alan G. "Field work." *Chicago Tribune*, Chicago, Illinois. Tempo. October 3, 1991, E11.

Times Clarion, Harlowton, Montana. "Ted Waddell's art works to be displayed at bank." October 3, 1991.

Sunday World-Herald, Omaha, Nebraska. "Taking Art to the People." October 6, 1991, E1–E2.

Times-Clarion, Harlowton, Montana. "Art Club views paintings." October 17, 1991.

1990

Miller, Robert. *Dallas Morning News*. February 5, 1990, D3.

Billings Gazette. Enjoy. February 23, 1990. Cover.

Wood River Journal. Tempo. "Theodore Waddell's New Paintings." February 28, 1990.

Idaho Mountain Express. "Anne Reed Gallery." March 2, 1990.

The Denver Post. "4 Galleries Show State of the Arts." March 17, 1990, B8.

Powell, Jackie. "Paintings deal with illusions." *Birmingham O&E*, Michigan. June 21, 1990, E6.

Mosgrove, Leanne. "Montana artist creates reality of pink snow, purple horses." *Campus Press*, University of Colorado–Boulder. November 29, 1990.

1989

Wood River Journal. Tempo. August 30, 1989.

Macias, Sandra. "Painting a whirligig of Nature." *Reno Gazette-Journal*. Arts. September 10, 1989.

Idaho Mountain Express. Guide Section. December 28, 1989.

1988

Waite, Jean. "Johannesburg." *The Sunday Star*. March 13, 1988.

Arts Dallas Magazine. May 1988.

Meyers, Christine. *Billings Gazette*. Enjoy. November 18, 1988.

Haga, Chuck. "On the Road." *Great Falls Tribune*. Montana Parade. October 23, 1988.

Idaho Mountain Express. Guide Section. "Anne Reed Gallery." December 28, 1988, C4–C5.

1987

Koehler, Darrel. "Theodore Waddell's Bold Impressions of the West." *Grand Forks Herald*. April 10, 1987, D1.

Kutner, Janet. "Exhibits of a Different Color." *Dallas Morning News*. April 16, 1987, C4.

Nixon, Bruce. "'About Horses' Exhibit." *Dallas Times Herald*. April 26, 1987.

Goddard, Dan R. "Rancher/Sculptor Combines Modernism with Rural Genre." *San Antonio Express News*. May 20, 1987, B5.

Wilson, Steve. "On the Scene." *San Antonio Express News*, San Antonio, Texas. May 21, 1987, D2.

Bennett, Steve. "Death and Dying: New Perspective, Sculptor Finds Life in Figures of the Dead." *San Antonio Light*. May 28, 1987.

Goddard, Dan R. "Waddell Gives Twist to Western Myth." *The Sunday Express-News*, San Antonio, Texas. May 31. 1987.

Art-Talk, "The 'Mucky Sublime' of Theodore Waddell," October 1987.

1986

Leach, Mark. "Theodore Waddell: Recent Work." *Paris Gibson Square Exhibition Quarterly*, Great Falls, Montana. 1986, vol. 2, no. 1.

Montana Portraits. Yellowstone Art Center, Billings, Montana. 1986. Published in conjunction with a series of one-minute public service TV documentaries featuring individual Montana artists.

Northern Lights. "Who Cares About New York Anyway?" January/February 1986.

Price, Max. "Colorado Springs Gallery Is Noting Its 50th Year." *The Denver Post*. January 5, 1986, 16.

Colorado Springs Sun. "Art in the New West." January 10, 1986.

Peterson, William. "The New West." *Artspace*. Spring 1986, 24.

The Print Collector's Newsletter. March/April 1986, 18.

The Stillwater Sun. April 3, 1986, 8.

1985

Print Collector's Newsletter. "Ted Waddell, 1985." 1985, 18.

Art-Talk, Santa Fe, New Mexico. "Scholder and Waddell: Giants at Marilyn Butler." June/July 1985.

California Magazine. Art Section. Vol. 10, No. 9, September 1985.

Brown, Kim. "A Montana Perspective." *Bozeman Daily Chronicle.* September 13, 1985, A4.

Morch, Al. "Exhibits with a Bit of Country." *San Francisco Examiner.* September 16, 1985, E4.

1984

Singh, Saunthy. "Exhibit: The Function of a Commercial Art Gallery." *Chico Enterprise.* Special to the E-R. 1984.

San Francisco Chronicle. February 1, 1984.

Lawson, Kyle. *The Phoenix Gazette.* General. May 9, 1984, C3.

The Arizona Republic. Art Notes. May 13, 1984.

Los Angeles Times. May 18, 1984, part 4.

Heartney, Eleanor. "West of the Hudson: Regional Art on Exhibition in New York." *Arts Magazine.* Summer 1984, 99–101.

Young, Joseph. "Cows, Chaos: Compelling Compositions." *Scottsdale Daily Progress*, Scottsdale, Arizona. Weekend, Art Critic. June 1, 1984, 20.

Ewing, Robert. "Enduring Romantic Idioms." *Artweek,* Costa Mesa, California, June 2, 1984.

Gottlieb, Shirle. "A Condescending Catalog Mars a Fine Exhibition." *Weekend*, Long Beach, California. June 29, 1984, 22.

Pate, Pattie. "Translating the Western Vision." *ArtWeek.* July 28, 1984.

Bernstein, Benita. "Waddell Rounds Up Aesthetics of Cows." *Birmingham Eccentric Newspaper*, Birmingham, Michigan. September 1984.

Miro, Marsha. "Abstract Cows on the Wide Prairie." *Detroit Free Press.* September 1984.

UCSD Calendar. October 29–November 4, 1984, vol. 10, no. 6.

Speer, Robert. "Art: Take a Look . . ." *CN&R*, Chico, California. October 4, 1984, 42.

Meedon, Carol. "Commercial Garbage Adorns Gallery Walls." *The Orion.* October 17, 1984.

La Jolla Light. November 4, 1984.

Lewinson, David. "Abstract Expressionism Finds a Home on the Range." *San Diego Union.* November 8, 1984.

Colby, Joy Hakanson. "Ruby Goes to Birmingham." *The Detroit News.* November 23, 1984.

1983

Anresen, Chuck. "The Stylistics." *New Times.* Art. 1983.

Seltzer, Ruth. "Arts of the American West in Fox Chase Exhibit Sale." *New Times.* 1983.

Berger, Leslie. "Visions of a New West." *The Washington Post.* February 2, 1983.

Richard, Paul. "The Range of the West." *The Washington Post.* Style. February 2, 1983.

McConnell, Gordon. "Western art lives on in D.C. long after the Super Bowl fades." *Billings Gazette.* Enjoy. February 11, 1983, D2.

Souder, Linda. "Wheat Producer Recreates Ranch Life on Canvas," *The Wheat Grower.* March 1983, vol. 6, no. 3, 14.

Fleming, Lee "The Corcoran Biennial / Second Western States Exhibition." *ART News*, Washington, DC. May 1983.

McConnell, Gordon. "Ted Waddell: Country Flesh and Bones." *Artspace.* Summer 1983, 22–23.

Stevens, Mark. "Art Under the Big Sky." *Newsweek.* October 31, 1983, 98–99.

1982

The Stillwater County Citizen. "He Captures the Land and the Angus in Oil." December 2, 1982, 13.

1981

The Windmill. "Dealing with Horizons: As Farmer, as Artist: Theodore J. Waddell." September/October 1981.

WORKSHOPS, PANELS, & SPEECHES

1998

Waddell art workshop, monoprint workshop. Hailey, Idaho.

1995

ZooMontana. Talk, demonstrations for children. Billings, Montana.

Western Montana College. Lecture, demonstrations. Dillon, Montana.

Sun Valley Art Center. Drawing workshop. Ketchum, Idaho.

Buffalo Bill Historical Museum Board of Trustees. Cody, Wyoming.

Waddell Art Workshop. Ryegate, Montana.

Western Heritage Center. Writer's Voice. "Missouri River Interpretations." Speech. Billings, Montana.

Montana State University–Billings. Classroom lecture. Billings, Montana.

SOMA Gallery. Gallery lecture. San Diego, California.

1994

Holter Museum. ANA speech as judge. Helena, Montana.

Leedy Voulkos Gallery. Luncheon speaker. Kansas City, Missouri.

Owlpen Manor. Art workshop/tour. Near Dursley, England.

Sun Valley Art Center. Drawing workshop. Ketchum, Idaho.

Yellowstone Art Center annual meeting. Slide lecture. Billings, Montana.

Festival of Cultures. Art Walk, RMC. Billings, Montana.

Art Museum of South Texas. Public gallery tour, slide lecture to docents, luncheon speaker. Corpus Christi, Texas.

1993

Marian College. Convocation Speaker. Indianapolis, Indiana.

Eiteljorg Museum. Public lecture. Indianapolis, Indiana.

Eiteljorg Museum. Staff tour. Indianapolis, Indiana.

Eiteljorg Museum. Docent tour. Indianapolis, Indiana.

District High School. Judge, Academic Olympics. Ryegate, Montana.

Nevada Museum of Art. Docent tour. Reno, Nevada, August 19, 1993.

Yellowstone Art Center/Radisson Northern Hotel. Virginia Snook Dinner Address on Will James. Billings, Montana, August 24, 1993.

Munson Gallery. Public gallery tour. Santa Fe, New Mexico.

1992

District High School. Judge, Academic Olympics. Ryegate, Montana.

Big Sky Indian Market. Judge. Billings, Montana.

Yellowstone Art Center. Reflections on the art and life of Isabelle Johnson. Billings, Montana.

1991

Eastern Montana College. Judge, student art show. Billings, Montana.

District High School. Judge, Academic Olympics. Ryegate, Montana.

Federal Reserve Bank. Hugh Galusha Park Dedication. Helena, Montana.

1989

Waddell Ranch. *Montana '89: Our Place and Time,* Centennial Arts Conference. Ryegate, Montana.

1988

Nevada State Council on the Arts. Visual arts panelist.

University of Wyoming. Workshop. Laramie, Wyoming.

Utah State Council on the Arts. Visual arts panelist.

1987

Idaho Commission on the Arts. Visual arts panelist.

Nevada State Council on the Arts. Visual arts panelist.

1986

Paris Gibson Square Center for Contemporary Arts. "The Landscape as Values" Symposium, panel discussion member: "East Meets West— The Land as Social and Moral Metaphor." Great Falls, Montana.

Idaho Commission on the Arts. Visual arts panelist.

1985

Idaho Commission on the Arts. Visual arts panelist.

1980

Fort Shaw and Great Falls High Schools, Montana.

1978

Art Interscholastics, Great Falls, Montana.

Bozeman High School. Drawing workshop. Bozeman, Montana.

1977

University of Wyoming. Laramie, Wyoming.

1976

Spokane Falls Community College. Spokane, Washington.

1975

Montana Art Educational Association. Yellow Bay, Montana.

Phoenix College. Phoenix, Arizona.

Northern Arizona University. Flagstaff, Arizona.

Bozeman High School. Bozeman, Montana.

Exhibition History

SOLO EXHIBITIONS

2016
Mulvane Art Museum, Topeka, KS

2015
Altamira Fine Art, Jackson, WY
Fort Collins Museum, Fort Collins, CO
Gail Severn Gallery, Ketchum, ID
Visions West Gallery, Denver, CO

2014
Albany Museum, Albany, GA
Altamira Fine Art, Jackson, WY
The Art Museum of Eastern Idaho, Idaho Falls, ID
Gail Severn Gallery, Ketchum, ID
Visions West Gallery, Bozeman, MT

2013
Altamira Fine Art, Jackson, WY
Booth Western Art Museum, Cartersville, GA
Foosaner Art Museum, Florida Institute of Technology,
 Melbourne, FL
Gerald Peters Gallery, Santa Fe, NM
Visions West Gallery, Bozeman, MT
Yellowstone Art Museum, Billings, MT

2012
Amarillo Museum of Art, Amarillo, TX
Denver Art Museum, Denver, CO
Gail Severn Gallery, Ketchum, ID
Visions West Gallery, Denver, CO

2011
Altamira Fine Art, Jackson, WY
Appleton Museum of Art, Ocala, FL
J. Willott Gallery, Palm Desert, CA

Oats Park Arts Center, Fallon, NV
Visions West Gallery, Denver, CO

2010
Altamira Gallery, Jackson, WY
J. Willott Gallery, Palm Desert, CA
Valley Fine Art, Aspen, CO
Visions West Gallery, Denver, CO

2009
Albrecht-Kemper Museum of Art, St. Joseph, MO
Fresno Art Museum, Fresno, CA
Gail Severn Gallery, Ketchum, ID
J. Willott Gallery, Palm Desert, CA
Meyer East Gallery, Santa Fe, NM
Visions West Gallery, Bozeman, MT

2008
The Art Museum of Eastern Idaho, Idaho Falls, ID
Gail Severn Gallery, Ketchum, ID

2007
Bryant Street Gallery, Palo Alto, CA
Dana Gallery, Missoula, MT
Lyndsay McCandless Contemporary, Jackson, WY
Museum of Northwest Art, La Conner, WA
Paige Gallery, San Francisco, CA

2006
Gail Severn Gallery, Ketchum, ID
Hockaday Museum of Art, Kalispell, MT
Meyer Munson Gallery, Santa Fe, NM
Paige Gallery, San Francisco, CA
Paris Gibson Square Museum of Art, Great Falls, MT
Sardella Fine Art, Aspen, CO

2005
Botanica Fine Arts, Bozeman, MT
Dana Gallery, Missoula, MT
Jackson Street Gallery, Jackson, WY
Oats Park Art Center, Fallon, NV
Paige Gallery, San Francisco, CA
Stremmel Gallery, Reno, NV

2004
Gail Severn Gallery, Ketchum, ID

2003
A.V.C. Contemporary Arts Gallery, New York, NY
Gail Severn Gallery, Ketchum, ID
Munson Gallery, Santa Fe, NM
Nicolaysen Art Museum, Casper, WY
St. Patrick Hospital & Health Sciences Center, Missoula, MT,
 Traveling Exhibit
South Dakota School of Mines & Technology, Apex Gallery,
 Rapid City, SD
Susan Duval Gallery, Aspen, CO
Vanier Galleries, Tucson, AZ

2002
Botanica Fine Arts, Bozeman, MT
Custer County Art Center, Miles City, MT
Holter Museum, Helena, MT
Museum of Fine Arts, University of Montana, Missoula, MT,
 Retrospective Exhibition
Vanier Galleries, Scottsdale, AZ

2001
Friesen Gallery, Ketchum, ID
Martin Harris Gallery, Jackson Hole, WY
Munson Gallery, Santa Fe, NM
Museum of the Southwest, Midland, TX
Paige Gallery, San Francisco, CA
Plains Art Museum, Fargo, ND, Retrospective Exhibition
Polk Museum of Art, Lakeland, FL, Retrospective Exhibition

2000
Botanica Fine Arts, Bozeman, MT
Laura Russo Gallery, Portland, OR
Memorial Union Gallery, North Dakota State University, Fargo,
 ND, Printmaking Survey, Traveling Exhibit
Northwest Art Center, Minot State University, Minot, ND, Print-
 making Survey
Susan Duval Gallery, Aspen, CO
Two-Person Exhibition, Bernice Steinbaum Gallery, Miami, FL
Yellowstone Art Museum, Billings, MT, Early Works on Paper,
 Traveling Exhibit

Yellowstone Art Museum, Billings, MT, Retrospective Exhibition
 1960–2000 (catalog available), Traveling Exhibit

1999
Botanica Fine Arts, Bozeman, MT
The Dennos Museum Center, Traverse City, MI, One-Man Show
Friesen Gallery, Ketchum, ID
Friesen Gallery, Seattle, WA
I. Wolk Gallery, St. Helena, CA
Kass Family Portraits, Yellowstone Museum, Billings, MT
Laura Russo Gallery, Portland, OR, Works on Paper
Munson Gallery, Santa Fe, NM
Two-Person Exhibition, Suzanne Brown Gallery, Scottsdale, AZ
Two-Person Exhibition with Lynn Campion, Sherry Leedy Con-
 temporary Art, Kansas City, MO

1998
Martin Harris Gallery, Jackson, WY
Sacred Heart University, Center for Contemporary Art, Fairfield,
 CT
Steinbaum Krauss Gallery, New York, NY
Two-Person Exhibition, Suzanne Brown Gallery, Scottsdale, AZ

1997
Linda Hodges Gallery, Seattle, WA
Lone Star Park, Grand Prairie, TX
Munson Gallery, Santa Fe, NM
Two Visions, Two-Person Exhibition with Lynn Campion, Anne
 Reed Gallery, Ketchum, ID

1996
I. Wolk Gallery, Napa, CA
Steinbaum Krauss Gallery, New York, NY (poster available)
Susan Duval Gallery, Aspen, CO

1995
Anne Reed Gallery, Ketchum, ID
Copper Village Museum & Arts Center, Anaconda, MT, Print
 Exhibit
International Museum of Art and Science, McAllen, TX
Liberty Village Arts Center & Gallery, Chester, MT, Print Exhibit
Linda Hodges Gallery, Seattle, WA
Munson Gallery, Santa Fe, NM
Parchman Stremmel Gallery, San Antonio, TX
Soma Gallery, San Diego, CA
Stremmel Gallery, Reno, NV
Susan Duval Gallery, Aspen, CO

1994
Anne Reed Gallery, Ketchum, ID
Art Museum of South Texas, Corpus Christi, TX

Beall Park Art Center, Bozeman, MT, Print Show, Traveling
 Exhibit in Montana
Holter Museum, Helena, MT (catalog available)
Leedy-Voulkos Art Center, Kansas City, MO
Nicolaysen Art Museum, Casper, WY
Steinbaum Krauss Gallery, New York, NY
Yellowstone Art Center, Billings, MT

1993
Eiteljorg Museum, Indianapolis, IN (catalog available)
Gallery 44, Boulder, CO
Linda Hodges Gallery, Seattle, WA
Munson Gallery, Santa Fe, NM (poster available)
Nevada Museum of Art, Reno, NV
Student Union Memorial Gallery, North Dakota State University,
 Fargo, ND

1992
Bernice Steinbaum Gallery, New York, NY (poster available)
Leedy-Voulkos Art Center, Kansas City, MO
Liberty Village Art Center and Gallery, Chester, MT
Linda Hodges Gallery, Seattle, WA
Stremmel Gallery, Reno, NV
Two-Person Exhibition, Cheney Cowles Museum, Spokane, WA
Young Gallery, Los Gatos, CA

1991
Anne Reed Gallery, Ketchum, ID (poster available)
Continental National Bank, Harlowton, MT
Jan Cicero Gallery, Chicago, IL
Munson Gallery, Santa Fe, NM
Stremmel Gallery, Reno, NV

1990
Anne Reed Gallery, Ketchum, ID
Clarks Fork Gallery, Missoula, MT
Halsted Gallery, Birmingham, MI
Lone Pine Gallery, Irvine, CA
Marvin Seline Gallery, Houston, TX

1989
Art Museum of Southeast Texas, Beaumont, TX
Bridge Street Gallery, Bigfork, MT
Munson Gallery, Santa Fe, NM
Richard Iri Gallery, Los Angeles, CA
Stremmel Gallery, Reno, NV
Young Gallery, Saratoga, CA

1988
Anne Reed Gallery, Ketchum, ID
Everard Read Gallery, Johannesburg, South Africa

Lewistown Art Center, Lewistown, MT
Mary Wright Gallery, Dallas, TX
Read Stremmel Gallery, San Antonio, TX
San Antonio Art Institute, San Antonio, TX
University of Wyoming, Laramie, WY

1987
Artmain, Minot, ND
North Dakota Museum of Art, Grand Forks, ND
Northern Arizona University, Flagstaff, AZ
Read Stremmel Gallery, San Antonio, TX
Stremmel Gallery, Reno, NV

1986
Halsted Gallery, Birmingham, MI
Marvin Seline Gallery, Austin, TX
Paris Gibson Square Museum of Art, Great Falls, MT
Sun Valley Center, Sun Valley, ID

1985
Artifacts Gallery, Bozeman, MT
Bozeman High School, Bozeman, MT
Cheney Cowles Memorial Museum, Spokane, WA
Marilyn Butler Fine Arts, Santa Fe, NM
Stephen Wirtz Gallery, San Francisco, CA
Stremmel Gallery, Reno, NV

1984
Cirrus Gallery, Los Angeles, CA
Halsted Gallery, Birmingham, MI
Hockaday Museum of Art, Kalispell, MT
Mandeville Art Gallery, University of California, San Diego, CA
Stephen Wirtz Gallery, San Francisco, CA
Stremmel Gallery, Reno, NV
Turnbull, Lutjeans & Kogan, Costa Mesa, CA
Yellowstone Art Center, Billings, MT

1982
Gallery 16, Great Falls, MT
Horizon Gallery, Butte, MT
Longan Galleries, Billings, MT
Longan Galleries and Billings Livestock Commission Company,
 Billings, MT

1980
Paris Gibson Square Museum of Art, Great Falls, MT
Yellowstone Art Center, Billings, MT

1975
One-Person Exhibition, Arizona, Traveling Exhibit

1971
Cartwheel Gallery, Missoula, MT

1970
Cartwheel Gallery, Missoula, MT
Montana State University, Bozeman, MT
University of Wisconsin, Green Bay, WI

1969
Cartwheel Gallery, Missoula, MT
C. M. Russell Museum, Great Falls, MT
Yellowstone Art Center, Billings, MT

1968
Albany Art Gallery, Albany, NY

1966
34th Street Gallery, Billings, MT

1965
Albany Art Gallery, Albany, NY

GROUP EXHIBITIONS

2016
Visions West Gallery, Denver, CO
Western Visions, National Museum of Wildlife Art, Jackson, WY

2015
Altamira Fine Art, Jackson, WY
Altamira Fine Art, Scottsdale, AZ
The Brinton Museum, Big Horn, WY
Buffalo Bill Art Show, Cody, WY
J. Willott Gallery, Palm Desert, CA
Sagebrush Community Art Center, Sheridan, WY
Visions West Gallery, Bozeman, MT
Western Visions, National Museum of Wildlife Art, Jackson, WY
Wilding Museum, Solvang, CA

2014
Altamira Fine Art, Jackson, WY
Altamira Fine Art, Scottsdale, AZ
Buffalo Bill Art Show, Cody, WY
Coors Western Art Exhibit, Denver, CO
National Cowboy & Western Heritage Museum, Oklahoma City, OK
Visions West Gallery, Bozeman, MT

2013
Buffalo Bill Art Show, Cody, WY

Coors Western Art Exhibit, Denver, CO
Tacoma Art Museum, Tacoma, WA
"Today's West!": Contemporary Art from the Buffalo Bill Center of the West, Cody, WY, Booth Western Art Museum, Cartersville, GA
Tory Folliard Gallery, Milwaukee, WI
Valley Fine Art, Aspen, CO
Visions West Gallery, Bozeman, MT
Visions West Gallery, Denver, CO

2012
Coors Western Art Exhibit, Denver, CO
Gail Severn Gallery, Ketchum, ID
Poindexter Collection/Poindexter Legacy, Holter Museum of Art, Helena, MT
Yellowstone Art Museum, Billings, MT

2011
Belger Arts Center, Kansas City, KS
Wichita Art Museum, Wichita, KS

2010
Coors Western Art Exhibit, Denver, CO
Gail Severn Gallery, Ketchum, ID
Holter Museum of Art, Helena, MT
Paris Gibson Square Museum of Art, Great Falls, MT
VC Gallery of Fine Art, Sedona, AZ
Watts Fine Art, Indianapolis, IN

2009
511 Gallery, Lake Placid, NY
Colorado Springs Fine Arts Center, Colorado Springs, CO
Gail Severn Gallery, Ketchum, ID
Jundt Art Museum, Gonzaga University, Spokane, WA
Whitney Gallery of Western Art, Buffalo Bill Historical Center, Cody, WY

2008
511 Gallery, New York, NY
Boise Art Museum Idaho Triennial, Sun Valley Center for the Arts, Ketchum, ID, Traveling Exhibit
Gail Severn Gallery, Ketchum, ID
Out West: The Great American Landscape, Missoula Art Museum, Missoula, MT, Traveling Exhibit
Visions West Gallery, Denver, CO
Visions West Gallery, Livingston, MT
Yellowstone Art Museum, Billings, MT
Yosemite: Art of an American Icon, Eiteljorg Museum of the American Indians and Western Art, Indianapolis, IN, Traveling Exhibit

2007

Out West: The Great American Landscape, Traveling Exhibit:
 Cafritz Gallery, Meridian International Center, Washington DC
 Guangzhou Museum, Guangzhou, China
 Hong Kong Heritage Discovery Centre, Hong Kong, China
 National Art Museum of China, Beijing, China
 Qingdao Modern Art Centre, Qingdao, China
 Shanghai Art Museum, Shanghai Painting Institute, Shanghai, China
 Shanxi Art Museum, Xi'an, China
 Urumqi Art Museum, Urumqi, China
Yosemite: Art of an American Icon, Traveling Exhibit:
 Nevada Art Museum, Reno, NV
 Oakland Museum, Oakland, CA

2006

Crosscurrents in Printmaking, Wheatdog Studio & Gallery, Kansas City, MO
Drawn to Yellowstone: Artists in America's First National Park, Traveling Exhibit:
 Northwest Museum of Arts and Culture, Spokane, WA
 Museum of the Rockies, Montana State University, Bozeman, MT
Yosemite: Art of an American Icon, Autry National Center, Los Angeles, CA, Traveling Exhibit

2005

About Paint, Westport Arts Center, Westport, CT
Drawn to Yellowstone: Artists in America's First National Park, Traveling Exhibit:
 Buffalo Bill Historical Center, Cody, WY
 Museum of the American West, Los Angeles, CA
Gail Severn Gallery, Ketchum, ID
Montana Connections, Yellowstone Art Museum, Billings, MT
U.S. Embassy, Stockholm, Sweden

2004

Best of the West Exhibition, Palm Springs Desert Museum, Palm Springs, CA
Drawn to Yellowstone: Artists in America's First National Park, Museum of the American West, Los Angeles, CA, Traveling Exhibit
Gail Severn Gallery, Ketchum, ID
Montana Modern, Hockaday Museum of Art, Kalispell, MT

2003

Austin Museum of Art, Austin, TX
Botanica Fine Arts, Bozeman, MT
Eloquent Flower VII, Gail Severn Gallery, Ketchum, ID
Nicolaysen Art Museum & Discovery Center, Casper, WY

2002

75th Anniversary, Alumni Exhibit, Montana State University, Billings, MT
Big Horn Gallery, Cody, WY
From Nature—Part II, A.V.C. Contemporary Arts Gallery, New York, NY
Laura Russo Gallery, Portland, OR
New Art of the West 8, Eiteljorg Museum, Indianapolis, IN
Parchman Stremmel Gallery, San Antonio, TX
Vanier Galleries, Scottsdale, AZ
Western Art Roundup Exhibit, Custer County Art Center, Miles City, MT

2001

Big Horn Gallery, Cody, WY
Botanica Fine Arts, Bozeman, MT
Safeco Collection, Frye Museum, Seattle, WA
Stremmel Gallery, Reno, NV

2000

The Animal in Contemporary Art, Stremmel Gallery, Reno, NV
Bernice Steinbaum Gallery, Miami, FL
Friesen Gallery, Sun Valley, ID
Northwest Views, Selections from the Safeco Collection, Frye Art Museum, Seattle, WA
Unfettered Spirit: Art & History on the Open Plain, Custer County Art Center, Miles City, MT
University of Montana, Museum of Fine Arts, Missoula, MT
Yellowstone Art Museum, Billings, MT

1999

Contemporary Art Center of Virginia, Virginia Beach, VA
Holter Museum of Art, Helena, MT
Leedy-Voulkos Gallery, Kansas City, MO
Yellowstone Art Museum, Billings, MT

1998

Anne Reed Gallery, Ketchum, ID
Cheney Cowles Museum, Spokane, WA
Eiteljorg Museum, Indianapolis, IN
Leedy-Voulkos Gallery, Kansas City, MO
Montana State University, Bozeman, MT
Paris Gibson Square Museum of Art, Great Falls, MT
Steinbaum Krauss Gallery, New York, NY
University of Wyoming, Laramie, WY
Yellowstone Art Museum, Billings, MT

1997

Adair Margo Gallery, El Paso, TX
Anne Reed Gallery, Ketchum, ID
Beall Park Art Center, Bozeman, MT

Buffalo Bill Historical Center, Cody, WY
Missoula Museum of Art, Missoula, MT
Paris Gibson Square Museum of Art, Great Falls, MT
Steinbaum Krauss Gallery, New York, NY
Stremmel Gallery, Reno, NV
Toucan Gallery, Billings, MT
Yellowstone Art Center, Billings, MT

1996
Anne Reed Gallery, Ketchum, ID
Cody Museum, Cody, WY
Cornish College of Art, Seattle, WA
Leedy-Voulkos Gallery, Kansas City, MO
McLaren Markowitz Gallery, Boulder, CO
Munson Gallery, Santa Fe, NM
Parchman Stremmel Gallery, San Antonio, TX
Prints from Lawrence Lithography Workshop, Topeka Public
 Library, Topeka, KS
Steinbaum Krauss Gallery, New York, NY
Stremmel Gallery, Reno, NV
Sutton West, Missoula, MT
Toucan Gallery, Billings, MT

1995
Animal Images, Joan Roebuck Gallery, Lafayette, CA
The Armory, Steinbaum Krauss Gallery, New York, NY
Confronting Nature: Silenced Voices, curated by Jeannie Denholm,
 California State University, Fullerton and Chapman Univer-
 sity, Orange, CA
Custer County Annual Art Exhibition and Auction, Miles City,
 MT
East of the Rockies, 3 Artists, Sutton West Gallery, Missoula, MT
Festival of Cultures, Rocky Mountain College, Billings, MT
Gallery Group Exhibit, Linda Hodges Gallery, Seattle, WA
Grand Opening Exhibition, Museum of Northwest Art, La Con-
 ner, WA
Happening, Art Auction, Children's Museum of San Diego, CA
The Heart of Art, Healy Murphy Center Benefit, Parchman
 Stremmel Gallery, San Antonio, TX
Holiday Exhibition, Martin-Harris Gallery, Jackson, WY
Hotel Triton Contemporary Art Fair, Soma Gallery, San Fran-
 cisco, CA
Inaugural Exhibition, Noice Studio & Gallery, Kalispell, MT
I. Wolk Gallery, Napa, CA
Lawrence Lithography Exhibit, Strecker Gallery, Manhattan, KS
Lewistown Art Center Exhibit and Auction, Lewistown, MT
Made in LA: The Prints of Cirrus Editions, Los Angeles County
 Museum of Art, Los Angeles, CA
Memories of Childhood, sponsored by Steinbaum Krauss Gallery,
 New York, NY, Traveling Exhibit:
 Diggs Gallery, Winston-Salem State University, Winston-
 Salem, NC

McAllen International Museum, McAllen, TX
Sharadin Art Gallery, Kutztown University, Kutztown, PA
The St. Paul Companies, St. Paul, MN
Wellington B. Gray Gallery, Jenkins Fine Arts Center,
 Greenville, NC
Missoula Art Museum Annual Exhibition and Auction, Missoula,
 MT
Permanent Collection, Buffalo Bill Historical Center, Cody, WY
Permanent Collection, Missoula Art Museum, Missoula, MT
Rocky Mountain College Black Tie Blue Jeans Auction, Billings,
 MT
Ryegate Art in Business Exhibition, Ryegate, MT
Seattle Art Fair, Anne Reed Gallery, Seattle, WA
Summer Group Exhibition, Steinbaum Krauss Gallery, New
 York, NY
Terrain: Observations of Nature, Soma Gallery, San Diego, CA
USART, San Francisco's International Art Expo, Festival Pavil-
 ion, Fort Mason Center, Munson Gallery, Santa Fe, NM
Yellowstone Art Center Auction and Exhibition, Billings, MT

1994
Alberta Bair Memorial Hospital Auction, Harlowton, MT
All Things Great but Small, Stremmel Gallery, Reno, NV
American Royal Art and Antique Show, Featured Artist, Kansas
 City, MO
Animals: Culturally Constructed, Kohler Art Center, Sheboygan,
 WI
Custer County Art Museum Auction, Miles City, MT
Equux, Sutton West Gallery, Missoula, MT
Festival of Cultures, Art Exhibit, Rocky Mountain College,
 Billings, MT
Growth Through Art Exhibit and Auction, Billings, MT
Laurel Little League Auction, Laurel, MT
Memories of Childhood, Steinbaum Krauss Gallery, New York, NY
Missoula Art Museum Exhibition and Auction, Missoula, MT
Missouri River Interpretations: Paintings, Prose, Poems, & Prints,
 Traveling Exhibit in Montana:
 Beall Park Art Center, Bozeman, MT
 Hockaday Museum of Art, Kalispell, MT
 Liberty Village, Chester, MT
 Missoula Art Museum, Missoula, MT
 Western Montana College, Dillon, MT
Montana Sculptures, Anne Reed Gallery, Ketchum, ID
North Dakota University Art Auction, Grand Forks, ND
Opening Exhibit of Gallery, Parchman Stremmel, San Antonio,
 TX
Owlpen Manor, near Dursley, England
Rock Art, Old Main Museum, Northern Arizona University,
 Flagstaff, AZ
Summer Show, Leedy-Voulkos Gallery, Kansas City, MO
Summer Show, Stremmel Gallery, Reno, NV

Summer Show, Susan Duval Gallery, Aspen, CO
Town and Country, Museum of Modern Art, Art Advisory Service
 for General Electric, New York, NY
Yellowstone Art Center Invitational Auction, Billings, MT

1993
Alberta Bair Memorial Hospital Auction, Harlowton, MT
All Things Great but Small, Stremmel Gallery, Reno, NV
Art Fair, Linda Hodges Gallery, Seattle, WA
Bridge Street Summer Show, Bigfork, MT
Cheney Cowles Museum Annual Heart Auction, Spokane, WA
Custer County Art Center Annual Auction, Miles City, MT
Fine-Art Prints, Joan Roebuck Gallery, Lafayette, CA
Holiday Greetings Exhibit, Steinbaum Krauss Gallery, New York,
 NY
Honoring Artists with Museum Shows, Munson Gallery, Santa
 Fe, NM
Illinois Center, the Chicago Art Dealers Association, Chicago, IL
Magnifico, Tamarind Institute Prints, Albuquerque, NM
Missouri River Interpretations: Paintings, Prose, Poems, & Prints,
 Paris Gibson Square Museum of Art, Great Falls, MT
Montana Landscapes, Beall Park Art Center, Bozeman, MT, Sum-
 mer Traveling Exhibit for Green Belt Protection Association
Reflective Environments, Bush Barn Art Center, Salem, OR
Small Works, Big Friends, Two-Person Exhibition, Stremmel
 Gallery, Reno, NV
Waddell Family Exhibition, Studio, Ryegate, MT
Walker's Bar & Grill, Billings, MT
Yellowstone Art Center Invitational Auction, Billings, MT

1992
ACLU Art Auction, Chico Hot Springs, Pray, MT
All Things Great but Small, Stremmel Gallery, Reno, NV
Altars and Icons, Installation, Sandpiper Gallery, Polson, MT
Animal Imagery, Leedy-Voulkos Gallery, Kansas City, MO
Art and the Law, West Publishing Company, Eagan, MN, Travel-
 ing Exhibit:
 Artspace, Inc., Raleigh, NC
 Bank America Security Pacific Gallery, San Francisco, CA
 University of Puget Sound School of Law, Tacoma, WA
Auto Exotica, Nevada Museum of Art, Reno, NV
Coeur d'Alene Idaho Art Auction, Stremmel Gallery
Dancing Colors Gallery, Group Show, Bozeman, MT
Dealer's Choice, Stillife, Santa Monica, CA
Figures, Munson Gallery, Santa Fe, NM
Growth Through Art Auction, Billings, MT
Hockaday Museum of Art Auction, Kalispell, MT
Hoops 'n Art, Eastern Montana College, Billings, MT
Horses, Dahl Fine Arts Center, Rapid City, SD
Missoula Art Museum Art Auction, Missoula, MT
Montana Abstracts, Sutton West, Missoula, MT

Nevada Museum of Art Auction, Reno, NV
Paris Gibson Square Museum of Art Auction, Great Falls, MT
Sculpture: Waddell & Voss, Cheney Cowles Museum, Spokane,
 WA
Seattle Art Fair, Linda Hodges Gallery, Seattle, WA
Stanford Faculty Club, Stanford University, Stanford, CA
Summer Show, Jan Cicero Gallery, Chicago, IL
Waddell & Waddell, curated by Jeannie Denholm, Vail, CO and
 Los Angeles, CA
Waddell & Waddell: Works on Paper, Custer County Art Center,
 Miles City, MT
Waddell & Waddell: Works on Paper, Jailhouse Gallery, Hardin,
 MT
Works of Heart Exhibition and Auction, Cheney Cowles Museum,
 Spokane, WA
Yellowstone Art Center Auction, Billings, MT

1991
All Creatures Great & Small, John Natsoulas Gallery, Davis, CA,
 DeWeese Gallery, Bozeman, MT
All Things Great but Small, Stremmel Gallery, Reno, NV
*Big Sky/Bold Wind: Montana Collection of the Yellowstone Art
 Center*, Boulder Art Center, Boulder, CO
Billings Exchange Club Auction, Billings, MT
Bozeman Friends of Rivas, Nicaragua, Art Auction, Bozeman,
 MT
Churchill County Art Auction, Fallon, NV
Experimental Workshop Prints, Richard H. Reynolds Gallery,
 University of the Pacific Art Center, Stockton, CA
Faculty + Faculty, University of Puget Sound, Tacoma, WA
Growth Through Art Auction, Billings, MT
Hoops 'n Art, Eastern Montana College, Billings, MT
Laurel High School Student and Graduate Art Show, Laurel, MT
Leedy-Voulkos Gallery, Summer Show, Kansas City, MO
Members' Gallery, Albright-Knox Art Gallery, Buffalo, NY
Montana Food Bank Network Art Auction, Bozeman, MT
Mystical Reflections of the Big Sky, Traveling Exhibit in Montana:
 Blaine County Museum, Chinook, MT
 Custer County Museum, Miles City, MT
 Haynes Fine Arts, Bozeman, MT
 Hockaday Museum of Art, Kalispell, MT
 Holter Museum of Art, Helena, MT
 Western Montana College, Dillon, MT
Nevada Art Museum Auction, Reno, NV
Print Show, Gallery 44, Boulder, CO
Sixth Annual Works of Heart Exhibition, Cheney Cowles
 Museum, Spokane, WA
Three-Person Exhibition, Montana Gallery, Alexandria, VA
Tory Folliard Summer Show, Milwaukee, WI
Two-Person Exhibition, Absarokee Fine Arts, Absarokee, MT
Yellowstone Art Center Auction Invitational Exhibition, Billings,
 MT

1990

75th Anniversary of Rocky Mountain Park, Boulder Art Center, Boulder, CO, and University of Wyoming Art Museum, Laramie, WY

ACLU Art Auction, Chico Hot Springs, Pray, MT

All Creatures, Great & Small, Natsoulas/Novelozo Gallery, Davis, CA

Bovine Divine, Anne Reed, Ketchum, ID

Buffalo Bill Art Show & Benefit Sale, Cody, WY

Buffalo Bill Historical Museum, Cody, WY

Dallas Museum of Art Auction Exhibition, Dallas, TX

Downs Syndrome Benefit, Halsted Gallery, The Armory, New York, NY

Experimental Workshop Prints, Elizabeth Leach Gallery, Portland, OR

Gallery 44, Boulder, CO

Golden West, Telluride, CO

International Contemporary Art Fair, Natsoulas/Novelozo Gallery, Los Angeles, CA

Landscapes, Jan Cicero Gallery, Chicago, IL

Looking at the Land, Griffith Gallery, Stephen F. Austin State University, Nacogdoches, TX

Montana 3-D, Hockaday Museum of Art, Kalispell, MT

Museum of the Rockies, Bozeman, MT

The National Rodeo Finals Art Auction, Las Vegas, NV

The New Art of the West, Eiteljorg Museum, Indianapolis, IN

The New West, Bernice Steinbaum Gallery, New York, NY

Post Westerns, Yellowstone Art Center, Billings, MT

Sun Valley Art Auction, Ketchum, ID

Two-Person Exhibition, Sandy Carson Gallery, Denver, CO

William Campbell Gallery, Fort Worth, TX

Winter Country, Yellowstone Art Center, Billings, MT

Yellowstone Art Center Auction Exhibition, Billings, MT

1989

ACLU Art Auction, Chico Hot Springs, Pray, MT

Anne Reed Gallery, Ketchum, ID

Art Museum of Southeast Texas, Beaumont, TX

Downs Syndrome Benefit, Halsted Gallery, The Armory, New York, NY

Hockaday Museum of Art, Kalispell, MT

International Art Exhibition, Iri Gallery, Los Angeles, CA

Lewistown Art Auction, Lewistown, MT

Montana '89: Our Place & Time, Ryegate, MT

Nicolaysen Art Museum, Casper, WY

Prints and Multiples from the Experimental Workshop, University of Wisconsin, Milwaukee, WI

Sandy Carson Gallery, Denver, CO

Sun Valley Art Auction, Ketchum, ID

Ucross Foundation, Big Red Gallery, Ucross, WY

William Campbell Gallery, Fort Worth, TX

Yellowstone Art Center Auction, Billings, MT

1988

Art from Montana, Cultural Exchange Exhibition, Tokyo and Kumamoto, Japan

Editions from the Experimental Workshop, Redding Museum and Shasta College, Redding, CA

Gallery 54, New York, NY

Helena Film Society, Helena, MT

International Contemporary Art Exposition, Read Stremmel Gallery, Los Angeles, CA

Scottsdale Center for the Arts, Scottsdale, AZ

Stephen Wirtz Gallery, San Francisco, CA

Virginia Miller Gallery, Coral Gables, FL

Yellowstone Art Center Auction Exhibition, Billings, MT

1987

ACLU Benefit Auction, Livingston, MT

American Academy of Arts and Letters, New York, NY

Ankrum Gallery, Los Angeles, CA

Arts in Company, Kalispell, MT

Experimental Workshop: New Graphics, Pacific Grove, CA

First Interstate Bank Collection, Las Vegas, NV

Helena Film Society Exhibition and Auction, Helena, MT

Hockaday Museum of Art, Kalispell, MT

Missoula Art Museum, Missoula, MT

Montana Collection 1985–87, Yellowstone Art Center, Billings, MT

Montana Landscape, Hockaday Museum of Art, Kalispell MT

Montana State University, Bozeman, MT

Northern Arizona University, Flagstaff, AZ

Paris Gibson Square Museum of Art, Great Falls, MT

University of Tennessee, Knoxville, TN

Van Straaten Gallery, Chicago, IL

Wright Gallery, Dallas, TX

Yellowstone Art Center Auction Exhibition, Billings, MT

1986

Gallery Two Nine One, Atlanta, GA

Georgia Museum of Art, Athens, GA

Helena Film Society Auction Exhibition, Helena, MT

Hockaday Museum of Art, Kalispell, MT

Mariana Gallery, University of Northern Colorado, Greeley, CO

The New West, Colorado Springs Fine Art Center, Colorado Springs, CO

Paris Gibson Square Museum of Art, Great Falls, MT

Works on Paper, Stephen Wirtz Gallery, San Francisco, CA

1985

Animal Sculpture, San Francisco International Airport, San Francisco, CA

Horse Show, California State Stanislaus, Turlock, CA

Marilyn Butler Fine Arts, Scottsdale, AZ

Salt Lake Art Center Auction Exhibition, Salt Lake City, UT
Selections for the Michener Collection, University of Texas Art
 Gallery, Ransom Center, Austin, TX
Works on Paper, Stephen Wirtz Gallery, San Francisco, CA
Yellowstone Art Center Auction Exhibition, Billings, MT

1984
Austin, Brown, and Butler Galleries, Scottsdale, AZ
Four from Wirtz, University Art Gallery, California State University, Chico, CA
Invitational Sculpture Show, Custer County Art Center, Miles
 City, MT
Invitational Show, Yellowstone Art Center, Billings, MT
San Francisco Museum of Modern Art, San Francisco, CA
Second Western States Exhibition and *38th Corcoran Biennial*
 Exhibition of American Painting, Long Beach Museum of Art,
 Long Beach, CA
Summer Exhibition, Stephen Wirtz Gallery, San Francisco, CA
Van Straaten Gallery, Chicago, IL

1983
Second Western States Exhibition and *38th Corcoran Biennial*
 Exhibition of American Painting, Corcoran Gallery,
 Washington, DC, Traveling Exhibition:
 Albuquerque Museum, Albuquerque, NM
 Lakeview Museum of Arts and Sciences, Peoria, IL
 The Scottsdale Center for the Arts, Scottsdale, AZ

1982
Invitational Exhibition, Yellowstone Art Center, Billings, MT

1981
American Art Show, Pillsbury Company, Minneapolis, MN,
 Painting Purchase

1980
Invitational Exhibition, Yellowstone Art Center, Billings, MT

1979
Custer County Art Center, Miles City, MT
Invitational Exhibition, Yellowstone Art Center, Billings, MT
Silver Spur Supper Club, Vaughn, MT

1978
Invitational Drawing Show, Missoula Art Museum, Missoula, MT
Invitational Exhibition, Yellowstone Art Center, Billings, MT

1977
Invitational Drawing Show, University of Montana, Missoula, MT
Invitational Sculpture Show, Boise State University, Boise, ID
Invitational Sculpture Show, Spokane, WA

1976
Invitational Sculpture Show, Yellowstone Art Center, Billings,
 MT
University of Montana, Missoula, MT

1975
Danforth Gallery, Livingston, MT
Jaid Gallery, Richland, WA
Ketterer Gallery, Bozeman, MT
Missoula Art Museum, Missoula, MT

1974
Anaconda Museum, Anaconda, MT
Yellowstone Art Center, Billings, MT

1973
Anaconda Art Festival, Anaconda, MT
Faculty Show, University of Montana, Missoula, MT
Spokane Annual, Cheney Cowles Museum, Spokane, WA

1972
Fountain Gallery, Portland, OR
Hundred Acres Gallery, New York, NY
Jaid Gallery, Richland, WA
Spokane Annual, Cheney Cowles Museum, Spokane, WA

1971
Cheney Cowles Museum, Spokane, WA
Idaho State University, Pocatello, ID
Northwest Annual Art Exhibition, Seattle Museum, Seattle, WA
Western Invitational, Denver Museum, Denver, CO

1970
Annual Drawing and Small Sculpture Show, Western Washington
 State, Bellingham, WA
Contemporary Ideas Gallery, Great Falls, MT
Salt Lake Art Center, Salt Lake City, UT

1969
Annual Drawing and Small Sculpture Show, Ball State University,
 Muncie, IN
Cartwheel Gallery, Missoula, MT
Contemporary Ideas Gallery, Great Falls, MT
Eastern Montana College, Billings, MT
Hockaday Museum of Art, Kalispell, MT
Mississippi Art Association, Jackson, MS
Student Center, University of Montana, Missoula, MT
Twenty-First Spokane Annual, Cheney Cowles Museum, Spokane, WA

1968

Cartwheel Gallery, Missoula, MT
Contemporary Ideas Gallery, Great Falls, MT
Invitational Sculpture Show, Michigan State Arts Council,
 Detroit, MI
Jaid Gallery, Richland, WA

1967

Lafayette Park Art Show, Detroit, MI
Midwest Sculpture Show, Waupan, WI
Wayne State University, Detroit, MI

1966

Eastern Montana College, Billings, MT

1965

Fort Sam Houston, TX
San Antonio Artists Association Show, San Antonio, TX

1962

Eastern Montana College, Billings, MT
Two-Person Exhibition, Northern Hotel, Billings, MT

ART IN EMBASSIES

2012

U.S. Embassy, Moscow, Russia, three works consigned

2010

U.S. Embassy, Ulaanbaatar, Mongolia, one work consigned

2009

U.S. Ambassadorial Residence, Ulaanbaatar, Mongolia

2006

U.S. Embassy, Almaty, Kazakhstan, two works purchased
U.S. Embassy Residence, Lomé, Togo, West Africa, eighteen
 works consigned
U.S. Embassy, Johannesburg, South Africa

2004

U.S. Ambassadorial Residence, Stockholm, Sweden, five works
 consigned

2000

U.S. Ambassadorial Residence, Niamey, Niger, one work
 consigned

1999

U.S. Ambassadorial Residence, Lusaka, Zambia, two works
 consigned

PERMANENT COLLECTIONS

Amarillo Art Museum, Amarillo, TX
Apple Computer, Inc., Saratoga, CA
Arco Corporation, Los Angeles, CA; Philadelphia, PA
Autry Museum, Los Angeles, CA
Bank of America, San Francisco, CA
Boise Art Museum, Boise, ID
Booth Western Art Museum, Cartersville, GA
Buffalo Bill Historical Museum, Cody, WY
Carnation Company, Los Angeles, CA
Cheney Cowles Museum, Spokane, WA
Citadel Corporation, Scottsdale, AZ
Clorox Corporation, San Francisco, CA
Custer County Art Center, Miles City, MT
Dallas Museum of Art, Dallas, TX
Dennos Museum, Traverse City, MI
Denver Museum of Art, Denver, CO
Eiteljorg Museum, Indianapolis, IN
El Paso Museum of Art, El Paso, TX
Eureka Opera House, Eureka, NV
Federal Reserve Bank, Minneapolis, MN, and Helena, MT
First Interstate Bank, Las Vegas, NV
Frederick R. Weisman Company, Los Angeles, CA
Frito-Lay Corporation, Dallas, TX
Goddard Center for Performing and Visual Arts, Ardmore, OK
Gonzaga University, Spokane, WA
Hallie Ford Museum of Art, Willamette University, Salem, OR
Hallmark Art Collection, Kansas City, MO
Hallmark Corporation, Kansas City, MO
Harrah's Enterprises, Reno, NV
Hockaday Museum of Art, Kalispell, MT
Holter Museum, Helena, MT
International Business Machines
Kohler Art Center, Sheboygan, WI
Los Angeles County Museum of Art, Los Angeles, CA
Marriott Corporation, San Antonio, TX
Merck Corporation, West Point, PA
Michener Collection, University of Texas, Austin, TX
Microsoft Corporation, Seattle, WA
Missoula Art Museum, Missoula, MT
Mobil Oil, New York, NY
Mulvane Art Museum, Topeka, KS
National Museum of Wildlife Art, Jackson Hole, WY
Nestlé Corporation, Los Angeles, CA
Nicolaysen Art Museum, Casper, WY
Nordstrom, Seattle, WA
North Dakota Museum of Art, Grand Forks, ND
North Dakota State University Memorial Union Gallery, Fargo,
 ND
Northern Arizona University, Flagstaff, AZ
Northwest Museum of Arts & Culture, Spokane, WA

Oats Park Art Center, Fallon, NV
Omaha National Bank, Omaha, NE
Palm Desert Museum, Palm Springs, CA
Paris Gibson Square Museum of Art, Great Falls, MT
Pillsbury Corporation, Minneapolis, MN
Progressive Corporation, Pepper Pike, Ohio
Quad Graphics, West Allis, WI
Rayovac Corporation, Madison, WI
Robert Redford
Rocky Mountain College, Billings, MT
San Jose Museum of Art, San Jose, CA
Security Pacific Bank, Los Angeles, CA
Sheldon Memorial Museum, Lincoln, NE
Sierra Pacific Power, Reno, NV
Spencer Museum of Art, Lawrence, KS
Springfield Art Museum, Springfield, MO
Stanford University Hospital, Stanford, CA
Ringo Starr
Topeka Public Library, Topeka, KS
United Airlines, Chicago, IL
United Missouri Bank, Kansas City, MO
University Hospital, University of Washington, Seattle, WA
University of Kansas, School of Arts, Lawrence, KS
University of New Mexico, Albuquerque, NM
University of North Dakota, Fargo, ND
University of Texas, Austin, TX
University of Wyoming, Laramie, WY
Yellowstone Art Museum, Billings, MT

COMMISSIONS

2003
John and Carol Green

1995
Cameron and Tito Bianchi, Atherton, CA
Jim Taggart, Cody, WY

1994
American Royal Auction, Kansas City, MO
Tapestry for Merck Corporation, West Point, PA, made by
 Edward Fields, New York, from *Ross Fork Reds*

1993
Donn Roberts, Bellevue, WA
Dr. Richard Melcher, Billings, MT
Paige Miller, Morrison, CO

1992
Jack and Susan Heyneman, Fishtail, MT
Mr. and Mrs. Ralph Manton, Pinehurst, NC

Richard Anderson, Land's End, WI
Robert Hunter Jr., Sonoma, CA

1991
Danzey Treanor, Santa Ynez, CA
Janet Petros, San Francisco, CA
Mr. and Mrs. Peter Lazetich, Reno, NV

1990
Mr. and Mrs. John Berry, Potomac, MD
Mr. and Mrs. Ralph Manton, Pinehurst, NC

1977
City of Helena, MT

1976
Blegen Family, University of Montana, Missoula, MT
City of Great Falls, MT

1975
Eastern Montana College, Billings, MT
Edsall Family, Bozeman High School, Bozeman, MT

AWARDS

Artist of the Year, Yellowstone Art Museum, Billings, MT, 2015
Montana Governor's Award for the Arts, Montana Arts Council,
 2015
Distinguished Alumni Award, Professional Recognition in Arts &
 Sciences, Eastern Montana College, Billings, MT, 1988
Sculpture Award, Purchase Prize, Spokane Annual, Cheney
 Cowles Museum, Spokane, WA, 1971
First Place, Art in the Park, Great Falls, MT, 1970
Cash Award, Spokane Annual, Cheney Cowles Museum,
 Spokane, WA, 1970
Best of Show, Flathead International, Hockaday Museum of Art,
 Kalispell, MT, 1970
Annual Small Sculpture and Drawing Show, Western Washington
 State College, Bellingham, WA, Purchase Prize, 1969
Annual Drawing and Small Sculpture Show, Ball State University,
 Muncie, IN, Cash Award, 1968
Graduate Professional Scholarship, Wayne State University,
 Detroit, MI, 1967–68
Faculty Award, Eastern Montana College, Billings, MT, 1966
First Place, Painting, Student Show, Eastern Montana College,
 Billings, MT, 1966
Best of Show, Fourth Army Art Contest, Fort Houston, TX, 1965
First Prize, Eastern Montana College, Billings, MT, Two-
 Dimensional Work, 1962

Drumlummon *Montana Contemporary Artists Series*

Published by Drumlummon Institute, Helena, Montana

© 2016 by Drumlummon Institute

Distributed by the University of Oklahoma Press, Norman.

Cover image: Theodore Waddell. *Ruby Valley Angus*, 2009. Oil and encaustic on canvas, 120 × 218 in. Collection of the Booth Western Art Museum, Cartersville, Georgia.

Softcover: ISBN-10: 0976968479
ISBN-13: 978-0-9769684-7-4

Hardcover: ISBN-10: 0976968487
ISBN-13: 978-0-9769684-8-1

Cataloging-in-Publication Data on file at the Library of Congress.

Drumlummon Institute is a 501(c)(3) nonprofit that seeks to foster a deeper understanding of the rich culture(s) of Montana and the broader American West through research, writing, and publishing.

Design by Jeff Wincapaw, Tintype Studio

Prepress & printing by Artcraft Printers, Billings, Montana

Manufactured in the United States of America.

10 9 8 7 6 5 4 3 2 1

DRUMLUMMON
INSTITUTE

418 West Lawrence Street
Helena, Montana 59601
www.drumlummon.org
info@drumlummon.org